Kwakiutl Art

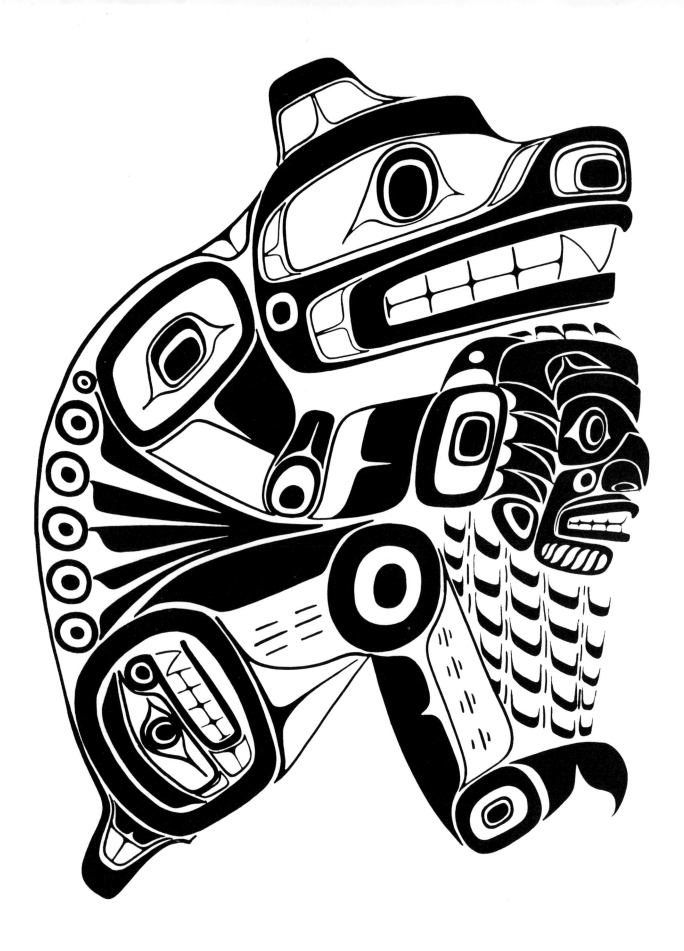

KWAKIUTL ART

Audrey Hawthorn

Douglas & McIntyre *Vancouver/Toronto*

To Harry Hawthorn

Douglas & McIntyre Ltd.
1615 Venables Street
Vancouver, British Columbia V5L 2H1

Canadian Cataloguing in Publication Data

Hawthorn, Audrey.
 Kwakiutl art.

 " . . . includes much that was contained in Mrs.
Hawthorn's *Art of the Kwakiutl Indians and other Northwest
coast tribes,* published in 1967"
 Bibliography: p.
 Includes index.
 ISBN 0-88894-612-0 (pbk.)

 1. Kwakiutl Indians—Art. I. Title.
E99.K9H32 709.011 C79-091121-3

Printed and bound in the United States of America

Frontispiece: Sea bear with mask of octopus, painting by Roy Hanuse. See Figure 504

Foreword

Much has happened since Audrey Hawthorn's earlier book, *Art of the Kwakiutl Indians and Other Northwest Coast Tribes,* was published in 1967.

Art of the Kwakiutl Indians made the important Northwest Coast collections in the University of British Columbia Museum of Anthropology accessible to everyone, and this principle of accessibility became the cornerstone of the museum's operating philosophy. Publication of the collections attracted worldwide attention and led to an invitation to display Northwest Coast masterpieces at Montreal's "Man and His World" exhibition in 1969-70. The exhibition was a spectacular success and certainly aided local efforts to raise money for a new museum building. The new Museum of Anthropology, made possible by funds from the governments of Canada and British Columbia and the donation of the Masterpiece Collection of Walter and Marianne Koerner, opened to the public on 30 May 1976. In keeping with the principle demonstrated earlier by Audrey Hawthorn, the new museum was designed to enhance the public's access to and appreciation of museum collections while also preserving them in a controlled environment. Perhaps the most innovative feature was the opening of the storage area to the public, an arrangement we called visible storage, and one which has proved to be popular with both students and the general public.

The publication of Audrey Hawthorn's monograph in 1967, this fine new volume, and the growth of the Museum of Anthropology are all part of a larger social movement concerned with Northwest Coast Indian art and culture. As early as 1943 the French social anthropologist Claude Lévi-Strauss wrote about Northwest Coast Indian art as a fine art. But it was the writings and exhibits produced during the 1950s and 1960s by people like Audrey Hawthorn and the late Wilson Duff in British Columbia, and Bill Holm in Seattle, that publicly established three important "facts" about Northwest Coast Indian art: it was derived from a rich ceremonial tradition, it was based on sophisticated principles of design, and it was equal in aesthetic quality to the fine arts of great civilizations.

This growing interest was not limited to traditional Northwest Coast Indian art. As Mrs. Hawthorn notes in her Preface, museums and their benefactors actively promoted not only the preservation of earlier cultural materials but also the production of new works. Museums, along with private collectors and tourists seeking souvenirs, provided the market stimulus for a resurgence in Indian arts and crafts. Equally, if not more, important have been recent political and social developments among Indian people themselves, including the establishment of cultural educational centers, introduction of Indian language programs, promotion of traditional craft and ceremonies, and an increase in potlatching (especially among the Kwakiutl). People now talk about the "renaissance" of Northwest Coast Indian art and culture, though we should be cautious about transposing from another time in history such a loaded word.

The establishment of Indian museums and cultural centers, operated by the Indians on their own land and for their own purposes, is one of the more exciting developments. There are two Kwakiutl museums: one, operated by the Nuyombolees Society, opened at Cape Mudge, Quadra Island, in June 1979; another is planned for Alert Bay by the O'Mista Cultural Society. These two museums are to house the famous "Potlatch Collection," regalia taken away by the Canadian government in 1922 when a potlatch was raided, and now to be returned to the Kwakiutl people. These museums may also store regalia still owned and used by Kwakiutl families, and they will promote the study of Kwakiutl heritage and the practice of arts and crafts. The Kwakiutl will now have places of their own to preserve, display, and promote their heritage. Perhaps the older museums, as a result, will be encouraged to re-examine their own purposes and to seek new relationships with Indian cultural organizations. The National Museum of Man, the British Columbia Provincial Museum, the University of British Columbia Museum of Anthropology, and the Campbell River Museum are examples of Canadian museums that are already taking steps in this direction with respect to the two Kwakiutl

museum societies. The Thomas Burke Memorial Washington State Museum in Seattle is developing new linkages with Indian museums in Washington State.

Kwakiutl Art, like its predecessor, is likely to have an important influence on events. It is also very welcome as a tribute, both to the author and to the culture she describes. The book is first of all a measure of the indefatigable energies of our respected colleague, the first curator of the Museum of Anthropology and a person who has contributed so much to our knowledge and appreciation of other cultures and to the development of Northwest Coast Indian arts. Second, and equally important, the book is an indisputable record of a great cultural tradition that continues to flourish in this land, one which, as we come to know it better, inspires ever greater wonder, admiration, and respect.

Michael M. Ames
DIRECTOR
Museum of Anthropology
Vancouver, Canada
June 1979

Preface

The earlier version of this book was written almost four decades after we began collecting the first massive carvings of the coastal peoples, purchased from families who were no longer living in the great flowering of Northwest Coast culture, with its vital center of proud ancestral celebration. Old houses were decaying along deserted village sites, facing the sea. Inheritance of great houses, with traditional family names and with appropriate crest poles and house posts, seemed to be disappearing, as families coped with the problems of postdepression economic adjustment to a national society with new standards. It seemed then that the magnificent creations of Northwest Coast culture, after a century of flourishing, were doomed; disease, disruption, outside administrative control, and missionary insistence on changes in ideology—all combined to overwhelm the native people and their culture.

Along with the ethnologists at the Provincial Museum in Victoria, our early concern was to survey the remaining great houses and house posts and house furnishings, and to take steps necessary to purchase and preserve them, thinking that these would be the last great monuments.

The collection of massive carvings in the University of British Columbia Museum of Anthropology had begun in 1927, when two Salish house posts from Musqueam Reserve were purchased with funds from the Alumni Association. In 1947 Marius Barbeau called to the attention of the university a number of fine old carvings from Alert Bay and Fort Rupert; these included an eleven-piece house frame, with carved upright crest posts, adzed house beams, and a frontal pole. Also from Fort Rupert was a large dugout canoe with a sea wolf on the prow, and a large wolf feast dish. Two Eagle crest poles had been carved by Spruce Martin, brother of Mungo Martin, who was later hired to restore the rotted carvings. In all, eighteen Kwakiutl large pieces were in this collection, which was purchased by Eric and Mrs. Hamber. Shortly after, a Nishka (Tsimshian) piece of a large sixty-foot pole was purchased for the collection.

In 1949 Ellen Neel, a Kwakiutl carver from Alert Bay who was living in Vancouver, was hired as consultant for the restoration of the poles but found the job too extensive and asked for help, and in 1950 Mungo Martin (Nakapenkem) of Fort Rupert was engaged to supervise the restoration work. He had been a master carver in his time, but in his old age had turned to fishing for a livelihood. Among the collection of poles was one (Fig. 57) which he had carved many years earlier, commissioned by his stepfather, Charlie James. Mungo Martin worked on the restoration of the poles, but the work was slow, and Harry Hawthorn, who was in charge of the program, felt that his great skill should be applied to original poles. In 1950-51, therefore, Mungo carved two forty-foot poles of his own family crest figures.

With the aid of the university's carpenters and engineers, the house frames and eighteen pieces of carving were erected in a four-acre wooded section of the university campus, which it was hoped would eventually hold other tribal carvings as well (Hawthorn 1963, 1971). The Kwakiutl section was formally opened in 1953. These carvings have now been placed in the museum or relocated near it.

The staff of the Department of Anthropology and President N. A. M. MacKenzie of the University of British Columbia, as well as the Provincial Museum staff, were all concerned with the possible collection and preservation of the remaining totem poles still standing—and decaying—in deserted villages. H. R. MacMillan was determined that these should be assessed and, where possible, saved. He instigated the formation of a British Columbia Totem Pole Conservation Committee (BCTPCC), chaired by Harry Hawthorn, and this was formally set up, with members of the Department of Anthropology, the Provincial Museum, and the Provincial Government, in addition to H. R. MacMillan, Walter C. Koerner, Powell River Lumber Co., B.C. Packers Ltd., and Union Steamships, all agreeing to support the exploration and purchase of totem poles as recommended by the university and the Provincial Museum.

Wilson Duff, then on the staff of the Provincial Museum, went to Skedans and Tanoo, deserted villages of the Queen Charlotte Islands, and received permission to collect six poles, which were divided between the two museums. In 1955 an exploratory expedition went to the Kwakiutl villages on the northern tip of Vancouver Island and the islands offshore. Helen Codere, Michael Kew, and Wayne Suttles of the Department of Anthropology visited twenty-two deserted sites and saw sixty-six poles and massive carvings. Of these, they purchased from Indian owners, with the approval of band councils, a number of house posts, portal poles, and free-standing carvings. All of these poles were crated and brought down by the Union Steamship Company. In later years other poles, not Kwakiutl, were collected by the BCTPCC.

From 1950 onward, the same wish to preserve and record the details of meaning and ownership and inheritance turned us to buying, from their Indian owners, family collections they were no longer using, as many families abandoned the potlatch feasts and gift giving that had been the core of their social life. The flood of incoming materials, the visits from their owners, keeping records, and storing the materials in our makeshift museum space in the basement of the University of British Columbia Library kept us so fully interested and occupied that it was many years before we realized that what we had was a reasonably representative array of the domestic and ceremonial life of most of the tribal groups on the Northwest Coast.

Because our museum was so limited in size (60 by 60 feet), and our storage facilities too cramped and inconvenient for general study, we set about to make this collection available in book form, as "a true 'museum without walls,' in which the masks, blankets and other costumes, feast dishes, spoons, rattles, and drums could be seen side by side and in their whole range" (Hawthorn 1967:x). *Art of the Kwakiutl Indians and Other Northwest Coast Tribes,* published in 1967, encompassed all of the ceremonial and crest art in our collection. The following excerpt from the Preface to that book, which is now out of print, relates in fuller detail the story of how the collection developed:

The years after the Second World War were years of social change in this coastal region, and a large number of Indian families chose to discontinue their family participation in some aspects of traditional ceremonial life. In 1950 Mungo Martin, Chief Nakapenkem of Fort Rupert of the Ma'mtagila clan, was brought to the University of British Columbia to repair some old totem poles in the university collection and to carve some new ones.

While he was at the university, Mungo became intensely interested in the concept of a museum as a place in which to preserve and interpret material culture, and he was influential in directing to the museum many of the Kwakiutl people who were at a point of culture change where they wished to abandon their places in the potlatch system and had no wish to hold onto the materials of the potlatch, which had lost its importance.

Money was made available by Dr. H. R. MacMillan, who had been purchasing collections for the museum since 1947. Others also added their support, among them Dr. Walter C. Koerner and the Leon and Thea Koerner Foundation, which made considerable grants to support special purchases. Several pioneer missionaries had spent their lives collecting objects in the region of their special endeavors and had amassed outstanding collections. Among these were the Reverend G. H. Raley of the United Church, the first missionary at Kitamaat; Dr. G. H. Darby of Bella Bella; and the Reverend W. E. Collison of Skidegate. They desired permanent housing for their collections, which were purchased for the museum. In addition, many fine gifts were made by families and individuals whose lives were intertwined with the history of this region.

Already in his seventies, Mungo Martin was keenly aware of the great changes brought by the years, and was anxious to record what he knew of the culture in which he had grown up, and in which he had seen the changes come. While he was at the museum he helped to identify and describe the materials as they came in. Once the machinery of purchasing was established, many Kwakiutl people traveling to Vancouver on their own concerns began to come to the university. Some were careful informants, and all gave some assistance in identifying the owners, area of provenience, and uses of the various objects, and helped in other ways to sort out the materials and their meanings. Meanwhile, various faculty members got to know the families of several tribal groups of the coastal areas and extended the interpretations.

During the days when Mungo and his wife, Abayah, were at the university, Mungo visited the museum frequently to see what had arrived during the week. At the height of the flow of materials, wooden crates, old trunks, sea chests, and cardboard boxes came in by every ship from the north. Addressed to the university, to Mungo Martin himself, and to a number of other addresses, these reached their destination with the help of the wonderfully understanding post office. Mungo awaited the unpacking with keen interest. Being a full participant in the ceremonial system, he recognized many individual pieces and identified almost all of them with assurance. He gave both the Kwakiutl name and a translation, based on his clear comprehension of the use and background of the piece. He was concerned that his words should not be wasted. "Write that down, now," he often said, and then, "Say it back," until he was satisfied that the transcription was reasonably correct. He himself had some command of an orthographic system introduced by a missionary.

Sometimes Mungo would counsel against buying a mask because the owner had no right to it and was selling someone else's property, or because it did not belong in the inherited myth but had simply been "invented" by somebody. Should "people see it here, they would laugh" and say that the museum had bought a mask that was not genuine. Abayah also recognized old pieces with pleasure and would often be moved to communicate anecdotes about the time she had seen them used. Unfortunately, Mungo could not stay with the museum forever, and the carving program he was engaged in moved to Victoria. Over the years he returned from time to time, and the major new acquisitions were always brought for his inspection. Dan Cranmer, Pelnagwela Wakas of the Nimpkish band at Alert Bay, who was married to Mrs. Martin's daughter, also came a few times and gave the same sort of guidance in the naming and identification of materials.

Many other Kwakiutl showed an interest when they came to Vancouver on their own business. They came out to see what was new or to see the collection for the first time. Those who came were those who cared most about the ceremonial art, and usually they were able to add information, perhaps about the pieces they had been associated with in their own lives. Sometimes in the trunks and boxes there would be a letter from an old person making the effort to communicate some of the knowledge that should go with the pieces sent down. Others had prevailed on a child or grandchild to write for them.

We had facilities for making tea and coffee in the workrooms, and on many afternoons an old couple sat with their grandchildren in the midst of the bustle and turmoil of work going on around them, drinking tea and looking at the things still on the storeroom shelves, and then offering reminiscences and anecdotes with the humor and wistfulness a time now distant evoked for them.

With the achievement of greater prosperity and the return of open potlatching, materials came in from the southern Kwakiutl less frequently. There were no longer any men who had the depth of knowledge of Mungo Martin and Dan Cranmer. In order to obtain additional identifications and other information that was still needed, Gloria Webster, oldest daughter of Dan Cranmer, agreed to work in Alert Bay for a time. Mrs. Webster is a graduate in anthropology who has successfully lived in both worlds and has maintained her bonds with young and old. She was initiated as a Tokwit dancer in 1949, and some of the materials used on that occasion are illustrated in this book.

Mrs. Webster's mother, actively interested and hospitable, made her house available as a headquarters where those who wished to visit and assist in the project could come and talk. Gloria took the file of photographs from the museum and worked systematically through them. She also traveled into Fort Rupert at a time when a number of people from various islands were visiting there. The many comments and interpretations she recorded, some of them following lengthy discussions among the old people, have been preserved in detail in the files of the museum [Hawthorn 1967:vii-x].

The need to make available the entire range of the art, which was so innovative and creative that there are no exact duplicates, has been satisfied with the visible storage facilities of the superb new Museum of Anthropology, designed by Arthur Erickson, which was formally opened in 1976. Consequently, in the present book a representative selection has been made, and at the same time the materials from groups other than the Kwakiutl have been omitted.

The collection of Kwakiutl art has been enriched by new materials of significance and aesthetic merit. Many massive carvings, not included in the 1967 study, have been brought out from storage where they had lain for two or more decades. Purchase from Indian owners, which had been the major source of the collection from 1947, has continued, though in lessened quantity. The magnificent gift from Walter Koerner, who has collected Northwest Coast art since his arrival in British Columbia from Czechoslovakia in 1938, can now be seen in the Walter and Marianne Koerner Gallery of the new museum, and all the other objects in the museum's possession are now either displayed or stored for open study, with documentation adjacent to the cases and available for public and student use.

The present volume incorporates much of the Kwakiutl material published in *Art of the Kwakiutl Indians and Other Northwest Coast Tribes*, but concentrates on the presentation of objects that can be viewed as representative, illustrating the variety of forms and styles that characterize this enormously rich tradition. The Kwakiutl, against great odds, continued without serious interruption their traditional cultural practices of potlatching, initiation into the winter dances, and the transmission of knowledge by men and women of the older generations. A few very gifted people who were well acquainted with the traditions were themselves master carvers who kept alive and vigorous all aspects of Kwakiutl carving: Mungo Martin, Willie Seaweed, Henry Speck, and others. In 1965 a large traditional house, decorated with carvings and paintings, was built at Alert Bay, and this has been an active center for family and lineage ceremonies. Several generations of younger carvers, following Mungo Martin, have continued to develop, and in some ways to extend, the old forms. The Kwakiutl portion of the Koerner collection complements the museum's own collection. This has resulted in a sizable representation of all aspects of Kwakiutl domestic and ceremonial life, portraying nearly the total range of the traditional and evolving art of these dynamic and gifted people.

A Note on Orthography

The orthography used in this volume, as in its predecessor, is based on the modifications by Bill Holm and Wilson Duff—two ethnographers with a direct knowledge of the spoken Kwakiutl language—of the transcriptions of Franz Boas, Edward S. Curtis, and others. Where Boas and Curtis are cited, their own orthography is, of course, retained.

Acknowledgments

I acknowledge with gratitude those whose work has contributed to this volume.

I have included the three maps originally provided by Wilson Duff for *Art of the Kwakiutl Indians and Other Northwest Coast Tribes,* and have again made use of his special information on Kwakiutl geography and place names. I have also, as already noted, used the transcriptions developed by Wilson Duff and Bill Holm to bring Kwakiutl terms to a standard pronounceable form.

I am especially indebted to Bill Holm for his comments on the manuscript and his specific advice on many points, notably those concerned with details of ceremony, nomenclature, and iconography. His knowledge of Kwakiutl culture is profound and extensive, stemming from his work as scholar and artist and from his participation in the ceremonial life. His generosity has been extraordinary, and I owe him the thanks due to that rare individual who willingly gives his own time to make another person's study a more solid work. Any mistakes are, of course, not his but mine.

Gloria Cranmer Webster, who was of great assistance in discussions with Kwakiutl informants in the research for *Art of the Kwakiutl Indians,* subsequently became a member of the museum staff and from 1971 to 1974 contributed enriching details during the documentation of the collection.

Madeline Bronsden Rowan helped greatly, first through her care of the records of the Walter and Marianne Koerner Collection and later with direct assistance in the preparation of this volume.

Audrey Shane exercised calm and meticulous control over every aspect of information, records, and photographs and provided invaluable assistance in many ways, including the checking of the information in the captions for the illustrations.

Others who as students helped in organizing the material were Deborah Taylor, Rod Paterson, Eric Waterton, Deirdre Stuckey Lott, and Stephen Inglis.

The color photographs in Plates III A, IV A and B, V A and B, VI A and B, VII B, VIII A and B, IX A, X A, XI A and B, XII C, XIII, XIV A and B, XV A and B, XVI A and B, XVII A and B, XVIII, XX, XXI, XXII, XXIII, XXIV, XXV, XXVI A and B, XXVII, and XXVIII B are by Johsel Namkung; those in Plates III B and C, IX B, XIX, and XXVIII A are by Eugene Horvath; others are courtesy of the Museum of Anthropology. Black-and-white photographs, unless otherwise indicated, are by museum staff photographers.

Since 1967 the museum has continued to be heavily indebted to Walter C. Koerner for his unfailing interest and support, both for the museum itself and for the carving program. In addition the museum was enriched by the gift of the collection made personally by him over many years and given by him and Marianne Koerner in 1976. The Leon and Thea Koerner Foundation also gave many special grants for specific purposes including the Indian carving program.

The publication of *Art of the Kwakiutl Indians* was made possible by special grants from the Canada Council and the University of British Columbia. For the preparation of *Kwakiutl Art,* grants were made by the University of British Columbia Alumni Fund, the McLean Foundation, and the Vancouver Foundation.

Audrey Hawthorn
Kumeu, New Zealand
February 1979

Contents

Illustrations

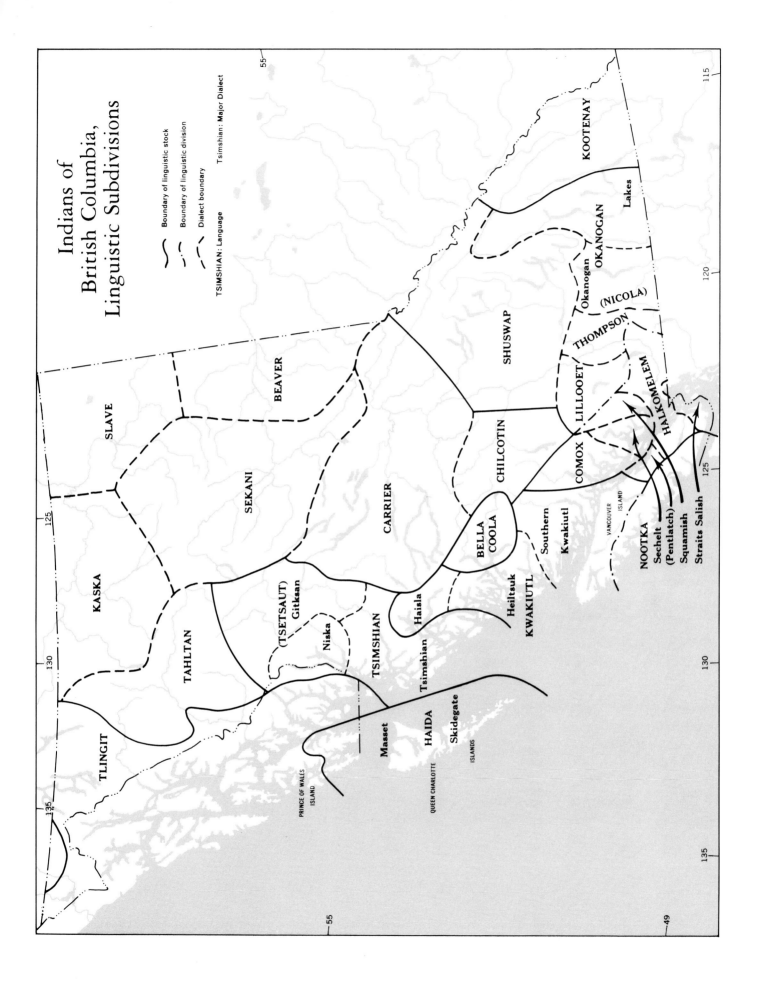

Indians of
British Columbia,
Linguistic Subdivisions

Boundary of linguistic stock
Boundary of linguistic division
Dialect boundary

TSIMSHIAN: Language
Tsimshian: **Major Dialect**

KOOTENAY

OKANOGAN

Okanogan · OKANOGAN · Lakes

(NICOLA)

THOMPSON

LILLOOET

SHUSWAP

BEAVER

SLAVE

CHILCOTIN

COMOX

HALKOMELEM

SEKANI

CARRIER

BELLA
COOLA

NOOTKA
Sechelt
(Pentlatch)
Squamish
Straits Salish

VANCOUVER
ISLAND

KASKA

Southern
Kwakiutl

Heiltsuk

KWAKIUTL

(TSETSAUT) Gitksan

Haisla

TAHLTAN

Niska

TSIMSHIAN

Tsimshian

TLINGIT

Masset

HAIDA

Skidegate

PRINCE OF WALES
ISLAND

QUEEN CHARLOTTE

ISLANDS

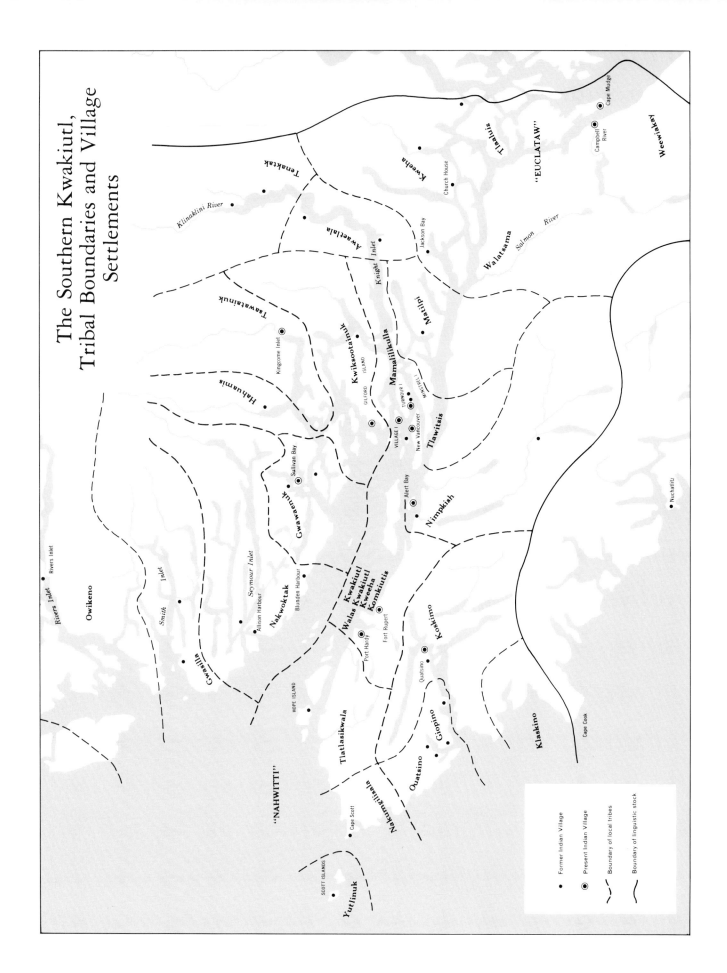

The Southern Kwakiutl,
Tribal Boundaries and Village
Settlements

Cape Mudge
Campbell River
Weewiakay
Tlaaluis
"EUCLATAW"
Kweeha
Church House
Tlaaluis
Walatsama
Salmon River
Tenaktak
Klinaklini River
Awaetlala
Jackson Bay
Knight Inlet
Matilpi
Tsawatainuk
Kwiksootainuk
GILFORD ISLAND
Mamalilikulla
TURNOUR I.
MINSTREL
Kingcome Inlet
Hahuamis
VILLAGE I.
New Vancouver
Tlawitsis
Sullivan Bay
Gwawaenuk
Alert Bay
Nimpkish
Nuchatlitz
Rivers Inlet
Owikeno
Smith Inlet
Seymour Inlet
Allison Harbour
Nakwoktak
Blunden Harbour
Walas Kwakiutl
Kwakiutl Kweeha
Komkiutis
Koskimo
Fort Rupert
Port Hardy
Gwasilila
HOPE ISLAND
Tlatlasikwala
Quatsino
Quatsino
Giopino
Klaskino
Cape Cook
"NAHWITTI"
Nakumgilisala
Ouatsino
Cape Scott
SCOTT ISLANDS
Yutlinuk

•	Former Indian Village
◉	Present Indian Village
- - -	Boundary of local tribes
—	Boundary of linguistic stock

xx

PART I
The Setting

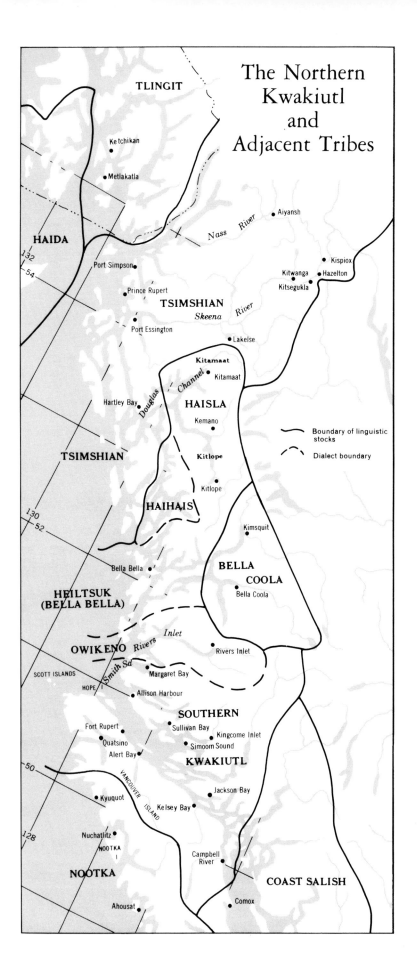

The Northern
Kwakiutl
and
Adjacent Tribes

TLINGIT

Ketchikan

Metlakatla

HAIDA

132

54

Nass River

Aiyansh

Port Simpson

Kispiox

Kitwanga Hazelton

Kitsegukla

Prince Rupert

TSIMSHIAN

Skeena River

Port Essington

Lakelse

Kitamaat

Kitamaat

Hartley Bay

HAISLA

Douglas Channel

Kemano

TSIMSHIAN

Kitlope

Kitlope

130

52

HAIHAIS

Kimsquit

Bella Bella

BELLA
COOLA

Bella Coola

HEILTSUK
(BELLA BELLA)

Boundary of linguistic
stocks

Dialect boundary

Inlet

OWIKENO Rivers

Rivers Inlet

SCOTT ISLANDS

Smith Sd

Margaret Bay

HOPE I

Allison Harbour

SOUTHERN

Fort Rupert

Sullivan Bay

Quatsino

Kingcome Inlet

Alert Bay

Simoom Sound

KWAKIUTL

50

Jackson Bay

Kyuquot

VANCOUVER ISLAND

Kelsey Bay

128

Nuchatlitz

NOOTKA I

Campbell
River

NOOTKA

COAST SALISH

Ahousat

Comox

The
Northwest
Coast

The Indians of the Northwest Coast inhabited the long, narrow strip of shoreline that stretches from Puget Sound up to the Alaskan panhandle—thirteen hundred miles long, deeply indented by fiords and rivers, and studded with islands heavily forested by the dark green conifers of the temperate rain forest.

The lives of these people were oriented toward the sea. Their villages of large plank houses were built facing the sea, and upon its waters they traveled in beautifully made canoes, both large and small. Parties of skilled seamen, setting out to trade, hunt, fish, wage warfare, or make social visits—all used the sea as their familiar path.

From the sea, the men harvested a rich profusion of sea mammals and fish, of which salmon was the preferred kind. An elaborate fishing technology supported a standard of living unrivaled among tribal cultures having no agriculture. The Indians preserved this abundance of fish by smoking, drying, and processing it for its oil, and sometimes built up a huge surplus which they used in ceremonial hospitality. Freed during the long winter months from the quest for food, they had leisure time to devote to their ceremonial life and to its material manifestations in painting, carving, and weaving.

The red cedar of the rain forest, with its straight, soft grain, made possible the building of their large permanent houses and the production of the great canoes, totem poles and house carvings, boxes and masks, and other materials of social and domestic life. The cedar tree also supported a variety of textile arts carried out by the women, who used fibers split from the narrow rootlets and bark stripped from the green living trunk to weave fine baskets, hats, mats, blankets, and the clothing of everyday use.

This propitious environment, with its abundance of food and of material for carving, made possible the elaborate social and ceremonial structure about which life on the Northwest Coast was centered.

Seven different linguistic groups shared a culture that was essentially common to all in the region, although, from north to south, the particular emphasis varied, and there were gradations of practice and custom. In the north lived the Tlingit and Tsimshian tribes. The Haida inhabited the Queen Charlotte Islands. On the west coast of Vancouver Island lived the Nootka, while the Kwakiutl inhabited the north region of Vancouver Island and the mainland directly opposite. The Salish occupied the delta of the Fraser River and some southern parts of Vancouver Island, and were distributed southward down the Washington coast; one of the groups of Salish people occupied territory to the north, near the Bella Coola River. There were an estimated 70,000 people living within these tribal boundaries at the end of the eighteenth century when the Europeans first arrived (Duff 1964:39).

Sharing a common environment and similar technologies, these tribes also shared a number of beliefs. Their mythologies involved legends in which primal ancestors had been given special privileges by the myth people, the supernaturally endowed beings of earth, sea, and sky. Such myths and privileges were valued property to be handed down to their descendants. In the three northern groups property was inherited through the maternal line; in the south, mainly through the paternal line; and in the central group, both maternal and paternal inheritance were the practice. All of the tribal groups organized their society according to social rank; those belonging to the most important inherited social ranks graded step by step into the larger number of those who had inherited positions of little importance—or none at all. Slaves taken in warfare were outside of the social system, but all took part as contributors in some way—donors, recipients, actors, or audience—in the elaborate social life of the potlatch, which was centered around the establishment of social claims and was marked by the ceremonial distribution of hospitality and gifts. On these occasions totem poles and heraldic carvings might be erected to mark the special cause of the celebration. Dances, songs, and theatrical performance demonstrated special inherited privileges, and the performances were witnessed by invited guests, often from other tribal areas.

The intensity and the emphasis of these ceremonies and the activities centered around them varied with the tribal group. This presentation centers about the social life and ceremony of the Kwakiutl, who borrowed, adapted, and elaborated many themes into complex series of dances, ceremonies, and theatrical performances employing an equally complex series of items of related material equipment.

Craft and
Technology
of the Artist

Among the Kwakiutl, labor was divided according to sex. Fishing and hunting, the manufacture and repair of gear, woodworking, carving, and painting were the tasks of men. To the women were left the gathering and cooking of foodstuffs, housekeeping, and the weaving of baskets, blankets, nets, mats, and clothing. Not all people were equally adept at all things. A particularly experienced man would become known in the community for his special skill in constructing a house or burning and steaming a dugout canoe. The carver was a specialist who was commissioned and well paid to make the various crests and masks for ceremonial occasions and who paid others to hunt for him and perform other routine duties.

The education of all young Kwakiutl consisted primarily of the imitation and perfection of the tasks and techniques executed by their elders for the maintenance of daily living. Young boys who showed artistic promise were encouraged to develop their skills, and underwent a period of apprenticeship which combined magical practices with the observation and imitation of expert craftsmen. By performing a number of routine duties, such as removing the heavy outer bark of a cedar log, under direction of the master craftsman, the apprentice became accustomed to using the tools. He was able to share in applying the finishing strokes with a D-adze, making small "scales" by chipping away the surface while his teacher worked at the same task at the other end of the log. An advanced helper, known as an "other side man," would copy on his side what the master carver did on the other (Bill Reid, personal communication). Experience in handling tools, observation, and participation in all the stages of carving might produce a new and independent master carver, who would be recognized by a commission to carve objects for an important occasion—perhaps a major massive carving, a mask, a rattle, a box, or any other of the numerous articles made of wood.

It should be noted, however, that not all ceremonial equipment was produced by skilled specialists. This can be seen in the range of concept and execution of masks, rattles, and other objects.

Whether because of poverty or indifference, unskilled individuals sometimes chose to make their own. Several contemporary participants in dancing ceremonials have told of repainting a basic mask form for various occasions, and an examination of photographs and of older objects collected in museums shows that even in the earliest times these were not always made by especially gifted craftsmen.*

The tools and techniques used by Kwakiutl carvers and painters were the same as those of other Northwest Coast craftsmen. Prehistoric artifacts in bone, ivory, and wood bear witness to an early establishment of a tradition of woodworking technology that reached a level of breathtaking range and virtuosity. The Northwest Coast collections in the major museums of the world offer some idea of the tremendous productivity of these craftsmen, and of the apparently endless variations within the traditional forms of representing the family crest themes.

The forests provided abundant wood for the carver's craft. Red cedar (*Thuya plicata*), a soft-grained, easily split wood, was used for such massive carvings as totem poles, house posts, memorial poles, large figure carvings, masks, feast bowls, and ladles. It was also used for split boards, as in house walls and roof planks; for the one-piece boards that were kerfed and bent into shape by steam; and for canoes, which were burnt out and steamed, and polished to a glassy finish. Yellow cedar (*Chamaecyparis nootkaensis*) was used for small totem poles, the frontal pieces of headdresses, some masks, kerfed boxes, chests, and canoe paddles.

*As a sidelight on Kwakiutl craftsmen, it is interesting to note that even a master carver such as Mungo Martin, who could meet any challenge in working with wood, might be unable to proceed with a new material in which he had not previously worked. As a boy, he had observed the making of a mountain goat horn spoon by steaming the horn and clamping it into a double wooden mold until it was bent into the proper form, after which the bowl was riveted to the handle. He expressed a desire to make such a spoon, and when two mountain goat horns were obtained, Mungo proceeded to build a fire-steam pit and boil the two horns. After a few days he laughingly confessed that he had never made a spoon before, and, with only a faint recollection of how he had seen it done, he found himself defeated by this new medium.

Alderwood *(Alnus rubra)*, a light white wood with a slight fragrance, relatively fine-textured and nonabsorbent, was favored for small dishes and spoons as well as for rattles, headdresses, and masks. Yew *(Taxus brevifolia)*, a very hard, close-grained wood, was used mainly for making bows, carpenters' wedges, and canoe paddles. Maple *(Acer macrophyllum)* was used for rattles, headdresses, frontlets, and skewer hairpins. Hemlock *(Tsuga heterophylla)* was used for making spoons.

A tree was cut down with a heavy-bladed chopping adze. To obtain planks for a house or a box, a log was split by inserting wedges of bone or antler, of graded sizes, into a small cut, and pounding with a heavy maul. These wedges were moved successively to produce a widening split on both sides of the log. The completed board was separated, trimmed evenly at each end, and smoothed with an adze.

A number of efficient, adaptable tools were used (Figs. 1-9). These included the hammer; the chisel; the curved knife; the elbow adze, for the first rough hewing of forms from the log; and the D-adze, whose blade could also be used as a chisel, for the fine, rippled finishing strokes. Whether these tools had stone blades, polished to a fine, sharp edge; shell blades; or blades of steel, they were very adaptable and provided all the precision and flexibility needed for the wide variety of strokes employed by the artist.

Simple drills—short cutting bits fastened to handles which were rotated between the palms—and pump drills were used to make holes. It is not certain if a pump drill was used aboriginally, but there is one in the museum in which an early iron drill is hafted into a twenty-eight-inch shaft and rotated by thongs attached to a crosspiece. A neat, smooth finish was given to the article through the use of fine sandstone and sharkskin abrasives.

All tools were made by the craftsmen themselves, and, although there appears to have been no prohibition against using another man's implements, it is said that each set was so fitted to individual work habits that it was difficult for even the most skilled carvers to achieve the same effect with tools made by anyone else. This expectancy that each man would make his own gear, tools, and weapons gave all the men a broad base of technological competence and familiarity.

The rewards offered by the culture to the specialist were sufficient to induce the development of special skills in woodworking. Canoes, for example, were highly valued, their standards of smooth and functional form extremely important, their lines much admired, and so it was with every class of carving. Thus, in addition to the artist's kin-

esthetic pleasure in the rhythmic, recurring motion of carving, he enjoyed the reward of having the appreciation of the social group for his fine mask, rattle, or house carving. Especially honored was the "supernaturally" inspired artist who was unusually gifted. This close integration of the artist with his society was a notable characteristic of the Northwest Coast culture.

Although local tribal styles of carving and decorating were distinctive, as artistic tradition varied from area to area, the objects themselves were likely to be similar in all groups in function and design. Thus, while the basic patterns of house and canoe building varied from north to south, the technology was everywhere similar. The carving of totem poles, house poles, dishes, rattles, masks, and similar gear also employed the same basic technology throughout the region.

Carving a Totem Pole

Working an eight-hour day, Mungo Martin took about twelve months to complete two 40-foot totem poles (see Figs. 9, 10).

He selected a log to be carved, not an easy task even with the great number available in the log booms, but vital if the sculptor's task were to be supported by the required dimensions, soundness, and suitable grain of the wood. The log was placed on the site in a position he judged convenient and raised on blocks at a height he requested, allowing him to prepare it by removal of the bark layers and the outer surface of the wood.

After the bark had been peeled off, Mungo chopped away the sapwood, using the D-adze, held with the beveled blade downward and backward.* When the pole was cleaned, he drew in charcoal on its fragrant surface a rough diagram of the characters to be carved, proceeding from the bottom figure upward. He explained that in his mind's eye he saw it already carved. It was clear to us that from his long experience in carving, the proportions and the flow of the crest characters were perfectly clear, and no other sketch was necessary, although for our interest he made one, which he clearly regarded as a souvenir for us.

When the very rough charcoal line indicating the height of each crest figure had been drawn, Mungo proceeded with the D-adze and a curved steel knife to make indentations separating the

*This is recorded in a short film, *Making a Totem Pole*, filmed by Ben Hill Tout of the University of British Columbia Extension Services and edited and put into sequence by Audrey Hawthorn. Original color print in the archives of the Museum of Anthropology of the University of British Columbia.

shapes along the length of the pole. The outline cuts, never more than about 2 inches deep, progressed from the bottom to the top of the pole. After they had been completed it was apparent that the beginnings of the figures on the pole had been established.

Next, using the same D-adze and curved knife, and occasionally a hammer and chisel, he roughed out the details of the figures on the pole, starting from the bottom and working on the figure until it was clear that a beaver, with its head, sharp incisors, upward-raised paws, and upward-hatched tail was outlined. Then he continued along the pole to create each character in turn.

The third stage was to refine the details. Taking the curved knife, Mungo bent over the cedar log and made two long, complete curves, the top and bottom of the eye form. The knife did not falter, and the result was a clear line that delineated the eye form, quite distinct from the plane of the swelling orb, which was formed by the D-adze. He called this "opening the eye." With the same attention to detail he proceeded up the pole, feature by feature. In the fourth stage he gave this kind of attention to every other detail of the figures. Thus the tail of the beaver was carefully crosshatched by using the knife to delineate crossing parallel lines and then cutting away the inner surface between the crosshatched lines.

It is worth noting that as a part of Mungo's approach to the rhythmic cutting and adzing he kept time as he worked with a constant humming. The song seemed to be an expression of the pleasurable kinesthetic tension he felt in his work. At times of complete absorption in a demanding process, such as the creation of the double parallel lines of the edge of the eye form, he held his breath while the curved knife cut cleanly and perfectly. Then the song resumed. The song he hummed was usually the one that belonged to the figure being carved, and occasionally he stopped carving to perform the dance steps appropriate to the song.

In order to keep the pole damp while he was carving it, Mungo poured pans of water over the part of the log he was working on first thing in the morning and last thing at night. This made the wood easier to carve and also kept it from checking, or cracking, by drying. After each stage of carving he would brush away the curled shavings, leaving the surface clean, then examine it carefully and perhaps take the curved knife again to complete the finishing process.

The finished pole was a cylinder, perfectly completed in proportions and features. Certain details, however, required additions to be made, for example, the dorsal fin of a killer whale or the beak of a raven. To add one of these, he started by finding a piece of cedar of appropriate size and roughing it

out to the approximate shape, larger than the finished feature would be. He then placed the new feature in position and, using charcoal, drew lines to show the desired form it would have when attached to the figure on the pole. Chisel and hammer were used to hollow out a rectangular form on the pole figure for a mortise, of approximately the same size as a tenon on the part to be added. The mortise and tenon would then be worked on with increasing precision, using knife, chisel, hammer, and adze, until the pieces fitted exactly. Mungo took about four hours to add the dorsal fin, and nearly a day to complete the beak. When they fitted perfectly and exactly, he carved two dowel pegs to fasten the added pieces into the completed features.

As the final stage before painting the pole, he used the blade of the D-adze to make a series of fluted finishing marks on the whole surface, eliminating the smooth surface, which he regarded as unfinished.

The completed poles were painted in the same position in which they were carved, lying on the blocks. Traditional painting used earth ochers and salmon eggs, collected and carefully prepared by the artist. Mungo used blue-green, black, red, and white formulas specially prepared for him by a paint manufacturer. Following in an early tradition, he used these colors sparingly to accentuate eyes, eyebrows, and teeth, leaving the main body of the poles unpainted.

The finished poles were treated with wood preservative and taken by flatcar and crane to be erected in the Kwakiutl section of the Totem Pole Park. They have now been relocated near the museum.

Carving a Mask

To make a mask, a log of suitable dimensions was cut into sections. Because of its clear and even grain, red cedar was the most commonly used wood. Yellow cedar was preferred by some for its color and smoothness. More frequently alder was used, because it is easier to carve than yellow cedar, checks less, takes detail well, and is very uniform in texture and hardness. A section with no flaw in its center was selected. The outer bark and sapwood were removed, and the log was split by wedge and hammer to the desired size. A human face mask, for example, which usually fitted over the visage of the wearer, was generally about 10 to 12 inches high and 4 to 6 inches deep from the surface of the face to the edge of the border (see Figs. 11, 12).

The work was begun by using a D-adze, chisel, and curved knife on the outer surface, blocking out in rough form the position and relationship of features—the elevation of eyebrows, eye sockets, nose, mouth, and cheek planes. The back of the piece of wood was then hollowed out by blows with chisel and hammer and strokes of the D-adze until 3 or 4 inches of the wood had been removed from the back of the log, leaving a hollow shell larger than the finished mask. The carver then returned to the front of the face and, holding it firmly on his lap with one hand, carved and refined the planes with the curved knife. As this continued, he proceeded to work with increasingly refined strokes, alternately on the front and the back. The completed mask might be a hollow shell a fraction of an inch thick, except for the protuberances on the face. Holes were drilled at the side for a thong or band, which fastened across the head to hold the mask in place. The mask was then painted. Some masks, such as the large Hamatsa masks, are considerably thicker since the mask is more massive and has more appendages, and thus needs to be structurally heavier.

Making a Box

One of the outstanding inventions of the Northwest Coast craftsman was the one-piece kerfed box, astonishingly strong, durable, and watertight. Making these required considerable practice before the craftsman became expert (see Figs. 13-16).

A flat strip or board of cedar was split away from the log by the use of wedges and a hammer. The board was adzed and smoothed to the desired thickness, according to the size of the box desired. It was then grooved with a sharp knife, in three equidistant cuts or kerfs, at right angles to the board.

Next the board was placed on a bed of wet seaweed over a pit of hot coals, covered with wet seaweed or wet sacking, and steamed. As the wood softened, the craftsman bent the board along the grooves into right angles, forming a four-sided box. Holes were drilled along the joining edges, which were then sewn with a strong and supple thread made of spruce rootlet.

A bottom board was cut to the correct size and carefully fitted to form a tight joint. Holes were drilled in the bottom edge of the box and in the bottom board, and pegs were driven through at an angle. A lid of the appropriate size was cut, and a rectangle was cut into one side in such a way that the margins of the lid would fit over the box. The box was then ready to be carved with incised lines or decorated on the surface with parallel fluted lines. The latter type of box was generally used for everyday storage of food, water, gear, and tools. Boxes decorated with carved and painted crest patterns were used for the storage of ceremonial gear or as gifts in the potlatch.

Examples of kerfed boxes are shown in Figures 485-93. Figure 17 shows a remarkable twelve-sided box, with eleven grooves or kerfs, pegged to a one-piece bottom board in the usual fashion. This box, which was found in the shop of a commercial dealer, is a tour de force, showing what can be achieved with skill and an uninhibited imagination. Nothing is known of its provenience or history, but it was heavily impregnated with fish oil and was undoubtedly used for this purpose.

Making Rattles and Whistles

To make a rattle or a whistle, a piece of wood was blocked out roughly to the desired size and shape of the finished article. After being further cut down and smoothed, it was split down the middle with a chisel, knife, and hammer. The interior wood was removed to the wanted thickness and finished as smoothly as desired by the craftsman. The external surface was carved, or lines were incised on it.

For the rattle, several small stones or shotgun pellets were placed between the two thin, hollowed wooden shells. The two halves were sewn together with split spruce root, sinew, or string through holes drilled along the edges, and the bottom handle was bound with twine, leather thong, or spruce root. The rattle was then completed by polishing or painting (see Figs. 18, 19 and p. 95). For examples of various types of rattles, see Figures 131-51.

To make the kind of whistle illustrated in Figures 111 and 112, the shaft, after being split and hollowed, was fitted with a small reed made in the following way. A piece of cedar was whittled to a cone shape, split and hollowed, and fitted into the mouthpiece of the shaft. It was held in place by the fitting together of the two halves of the shaft, which were bound together top and bottom with spruce rootlet or string. Pitch or spruce gum was often applied down both sides of the shaft. If one or two more shafts were added, they were made in a similar fashion but cut at the top of the shaft to fit onto the center shaft of the whistle. They were then bound onto the main shaft with twine and pitch. The typical winter dance whistles were made without a reed, as illustrated in Figures 20 and 21.

They could also be made with several chambers to produce more than one tone. The principle of the mouthpiece is the same as that of the modern recorder or policeman's whistle.

Painting

Painting was usually regarded as an adjunct to carving, and was used to enhance, emphasize, or embellish the basic forms. Precommercial paints included red earth ocher; white from burnt clamshells; blue from copper oxide or blue clay; and black from mud and charcoal ground up in small stone dishes or mortars and mixed with salmon eggs to provide an oily base (Fig. 22). Powdered graphite was sometimes used to produce a shiny, highlighted gray-black. Ground cinnabar mixed with oils gave a bright vermilion coloring. In the use of colors, the traditional Kwakiutl choices were dark red, black, and white. Sometimes a dark green was used, obtained from copper sulphide. The Bella Coola used an intense pale blue, plus white, red, and black. The Haida, Tsimshian, and Tlingit tended to leave more unpainted wood surface, limiting painting to decorative touches of black and red.

The brush was made by binding porcupine or other hair onto a stick and cutting the tips at an angle, so that they tapered to a narrow point (Fig. 22). For regular design forms, such as the symbols on a painted box front, tracing patterns or templates were cut out of leather or bark (Fig. 23).

Adaptations

Finally, a word should be said about the adaptation of materials. To denounce the craftsmen's use of store paint or factory-made buttons as degenerate or unauthentic is to miss the main point: that the mind of the craftsman concentrated on invention and improvement and was quick to seize on any material that added to the effect he was striving to create. It is precisely this eagerness to add, to experiment, and to improve that resulted in the rich proliferation and inventiveness of Kwakiutl art. It is probable that borrowing, adaptation, and invention went on throughout the development of Northwest Coast style.

Iron and steel blades, more effective carving tools than stone, led to an immense increase in output. A money economy aided the staging of huge potlatches and the further development of ceremonial life. Trade copper sheeting was used for the "copper," that most important symbol of wealth, which may have been previously made in a smaller form out of naturally occurring copper beaten flat. Store paint replaced earth ochers, but did not change the style of painting in any significant way, and traditional color choices tended to be continued. Blankets were turned into ceremonial robes of great brilliance by the addition of red flannel appliqués and cut shell buttons. Abalone was traded up from California because its brilliant dark blue-green color outshone the relatively colorless local product. Silver and gold coins from the Russians in Alaska gave the Indian craftsman a chance to reproduce his crest art in the portable and conspicuous form of jewelry, which was coveted by women of rank. String twine was substituted for cedar bark rope and was used in exactly the same way—dyed red for the head and neck rings of the winter ceremonies. Muslin cloth was used for the ceremonial curtain, replacing earlier cedar planks, and was similarly adorned with a painting of the house spirit.

Fig. 1. *Bone, wood, and antler wedges.* (Left to right) A8379, A1085, A6480, A11503C, A1063

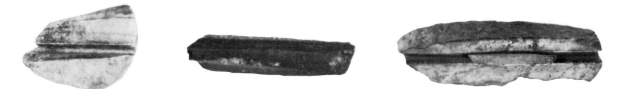

Fig. 2. *Greenstone blades.* (Left to right, top) *Finished:* A8191 (Lytton), A8887 (no data), A8549 (Fraser River); (bottom) *unfinished:* A6074 (Lytton), A8192 (Lytton), D1.482 (Lytton)

Fig. 3. Stone hammers. (Left to right, back) A7321 (no data), D1.385 (Yale), A1646 (Kitlope), A3055 (no data), A6417 (no data); (front) A2297 (no data), A1802 (Lytton), A4491 (no data)

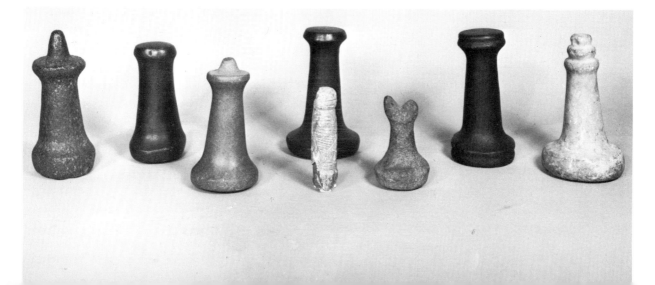

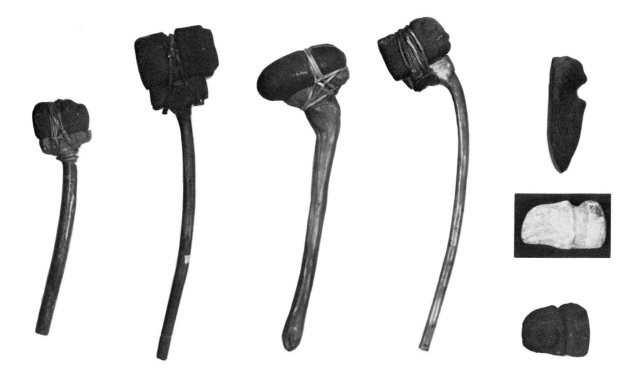

Fig. 4. Stone mauls. (Left to right) A108 (Rivers Inlet), A8749 (Kitlope), A8813 (Kitamaat), A1104 (Bella Bella); (top to bottom) A7157 (Queen Charlotte Islands), A7155 (Queen Charlotte Islands), A7322 (Skeena River)

Fig. 5. Stone "elbow" adzes. (Left to right) A1639 (Kitamaat), A8711 (no data), A8710 (Kitamaat), A6436 (Kispiox)

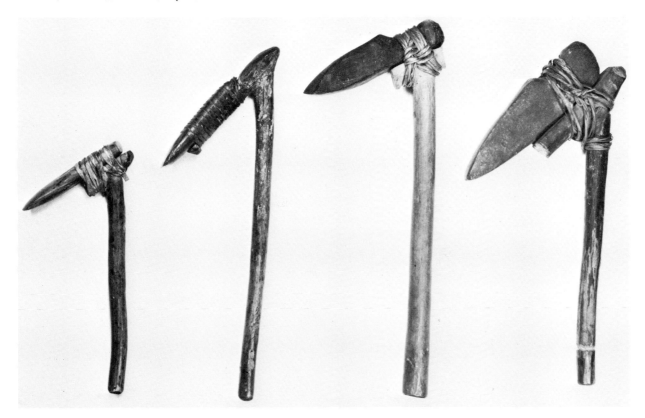

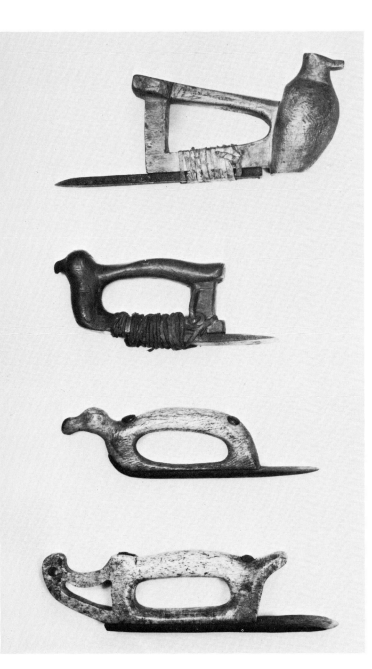

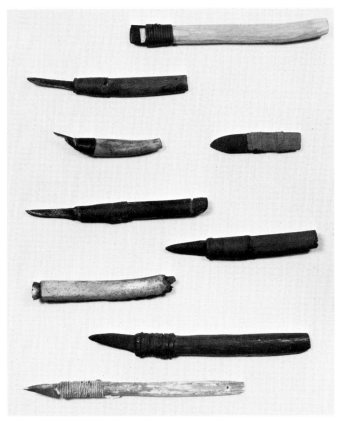

Fig. 6. D-adzes. (Top to bottom) *A2052 (Bella Coola), A7365 (no data), A6575 (Vancouver Island), A3518 (Vancouver Island)*

Fig. 7. Curved knives used by various carvers. (Top to bottom, left) *A7038 (Skidegate), A7040 (Skidegate), A1627 (Kitamaat), A159 (no data), A1626 (Kitamaat); (right) D1.234 (Lytton), A3493 (no data), A7238 (no data), A6894 (no data)*

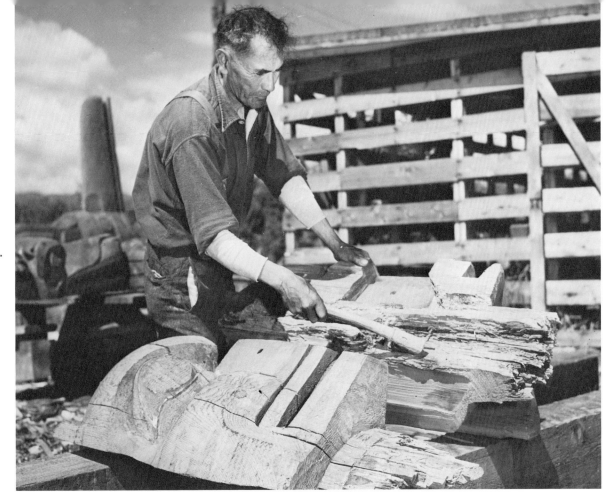

Fig. 8. Mungo Martin using the elbow adze to remove the decayed part of a totem pole he is restoring, 1950

Fig. 9. Mungo Martin finishing the surface of a totem pole using a D-adze

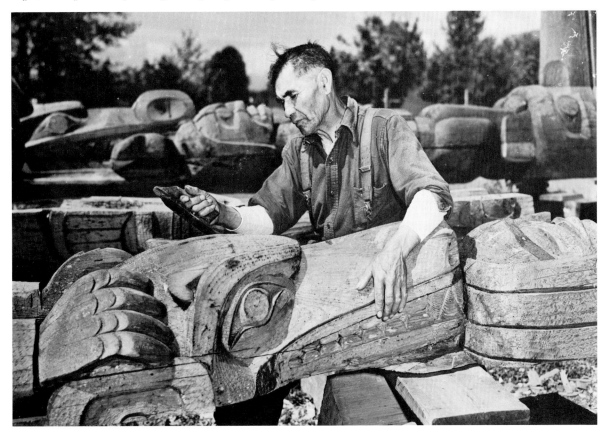

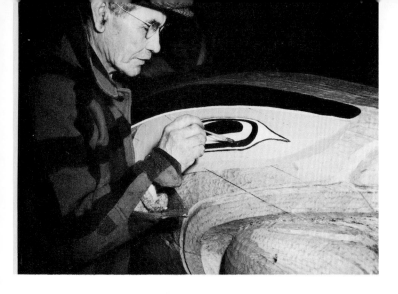

Fig. 10. Mungo Martin applying new paint
to a repaired pole

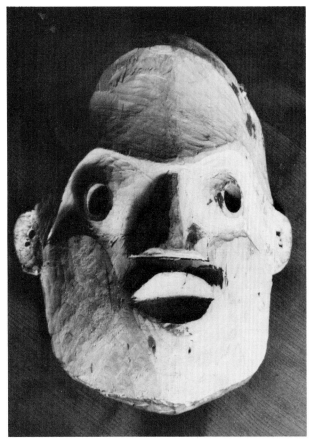

Fig. 11. Front of a mask in the process of being carved

Fig. 12. Back of a mask roughed out with the D-adze
and curved knife

Fig. 13. Kerfed board prepared for steaming and bending

Fig. 14. Detail of unfinished kerfed box, showing one corner
steamed and bent. A1764

Fig. 15. Finished box made by Mungo Martin

Fig. 16. Detail of finished box showing corner
sewn with spruce root

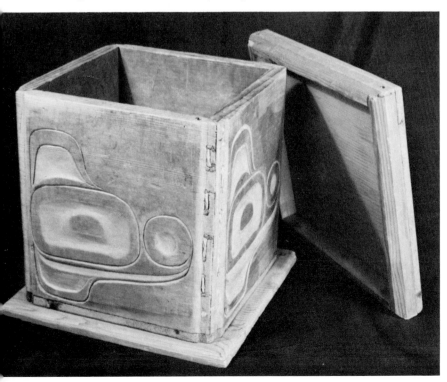

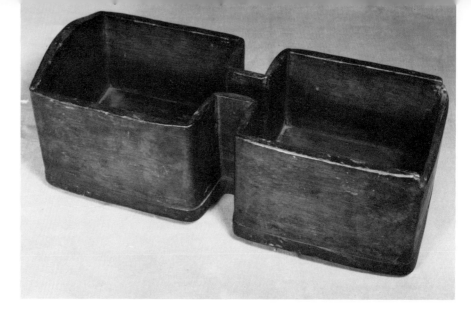

Fig. 17. *Twelve-sided kerfed box, provenience unknown.*
Wood. Length: 14 in. A17072

Fig. 18. *Round carved rattle, roughed out. Length: 12 in.*

Fig. 19. *Rattle opened up, showing strings at edges unfastened*

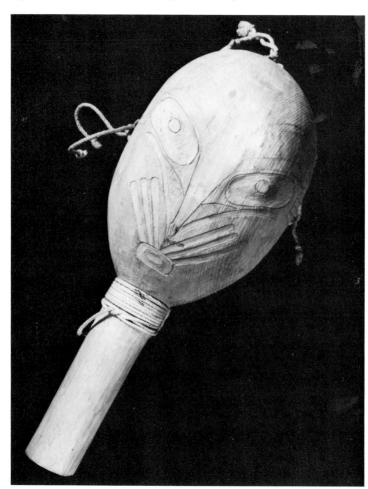

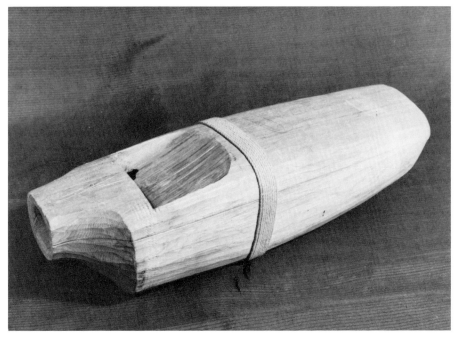

Fig. 20. Hollow whistle. Length: 14 in.

Fig. 21. Hollow whistle unfastened and opened up

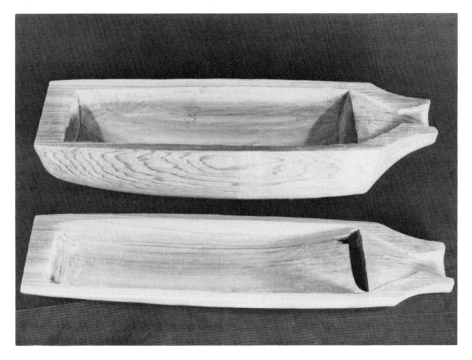

Fig. 22. (Top and right) *Earth ochers, blue clay, and clamshell paints,
A6070;* (left) *set of brushes, A3644*

*Fig. 23. Leather templates used as patterns for design forms, made and
used by Charles Gladstone, Skidegate. A4354.*

Style and Content in Northwest Coast Art

Certain similarities in all Northwest Coast carving and decoration gave it its characteristic style. Most commonly portrayed was the major theme of the Northwest Coast, the family crest and the heraldic figures, the family myth of the owner. These represented the ancestor and his special supernatural visitations or relations with the myth people, in their forms as birds, animals, and other beings. The basic iconography was understood and used by all tribal groups.

The planes of sculpture are plastic, curving and swelling freely into concavities and convexities, with rigid sharp lines used only for deliberate effect. In the masks, curves are emphasized on nostrils, eyes, and lips by deeply incised carvings, contrasting color, or both. Nearly all lines, whether incised or painted, have the tendency to run parallel and taper to a terminal point at each end.

Within the basic and characteristic style of the Northwest Coast, distinctions can be made among the rather flat, delicate, refined carving of the Tsimshian; the well-modulated, subtle carving of the Haida; and the strong, clear carving of the Kwakiutl. A highly distinctive style which apparently had a great influence on the Kwakiutl was that of the Bella Coola, who are regarded as late arrivals on the Northwest Coast. Theirs was a strongly sculptural form, characterized by deep planes of many levels of depth, each important in building up the whole. Most Bella Coola masks were of natural elements: echo, moon, sun, and birds and flowers. Many such masks have been found in Kwakiutl areas and have been labeled as Kwakiutl when there is no proof of provenience, but stylistically they are unmistakably Bella Coola The masks in Plates XVIII (Komokwa) and XXVI A (tentatively identified as Komokwa's wife) are probably Bella Coola, although they come from Village Island. They are beautifully painted in a combination of colors not found in any other examples: dark and light green, blue, orange, red, and black.

The Nootka varied from other stylistic traditions by a certain massive simplicity, less elaborated and with fewer planes of decoration, and less delicate painting.

The Salish carvings are still simpler and less elaborately carved, except in the case of their characteristic and unique mask, that of the Kwekwe, which is strongly and crisply formed with very careful and precise elaboration.

Special characteristics of Northwest Coast painting are:

1. The use of salient recognition features, such as beaks, claws, or fins, as a representation of the bird or animal portrayed.

2. Frequent use of a highly stylized symbol for the whole animal.

3. The use of "X-ray" painting to establish the design form of a whole animal, disposed over the area to be covered.

4. The establishment of a number of stylized design units such as sockets, joints, and eye forms, used interchangeably. The context reveals which anatomical feature they actually represent.

5. The avoidance of empty space where a design form or line will add to the interest of complexity. This embellishment is, however, done with sufficient restraint to maintain a proper integral balance of line, form, and carving. Bill Holm (1965:35) points out that the formline, usually established by the use of black paint, is the most characteristic element of the design.

6. The use of tapered and swelling lines to break the monotony of geometric form. A circle, rectangle, or oval, a feather or a claw, is depicted in such a way that it is a complete and pleasing design symbol in itself.

7. The use of texture to supply variation in design. The carved crosshatching of a beaver tail or a wing feather is echoed by the use of painted crosshatching—small parallel lines or shading. One or two colors are sufficient to add these important textural variations.

8. The acceptance of the form of the area to be treated. On columnar poles, the cylindrical form is the basic space determinant, and the figures rise one above another in relation to this shape, although occasionally a piece is mortised to the pole to form a bill, wings, arms, or hands. On a round crest hat, the painted design is constructed and placed quite differently.

One other important characteristic of Northwest Coast art that should be noted is the device of visual "punning," sometimes called "kenning" (Rowe 1962:15). A natural space in the carving or painting is used for the introduction of a new form with an independent meaning. See, for example, the house post from Kitamaat (Figs. 44-46), where there is a face in the ear of the bear and another in its paw, and the faces in the tails of the killer whales (Pls. XV, XVI A).

The subjects of both the carving and the painting were the animals and mythological beings claimed as family and clan ancestors by their descendants. The endless variations on the family crest theme are illustrated throughout this book. There were two basic approaches. The first was through more realistic three-dimensional carving with painting as an adjunct decoration, as illustrated in totem and house poles, masks, rattles, speakers' staffs, and headgear. The second was a highly stylized, symbolic representation, as in most canoe and paddle paintings, house fronts, storage boxes, stage screens and curtains, crest hats, cloaks, mats, and some baskets.

The iconography of the culture—the family crests and certain traditional forms of representing them—offered a framework within which the artist was free to embellish. The gifted artist emerged as an individual with a distinctive style that can often be recognized even without written records. For further notes on style and attribution and on some of the outstanding artists among the Kwakiutl, see Appendix I.

The Definition of Art Given by Boas

In any consideration of Northwest Coast art it is rewarding to look at the exposition made by Franz Boas in *Primitive Art* (1927), where he states that art cannot be considered to exist until a set of conditions have been met. The four prerequisites for art of the Northwest Coast are, in summary:

1. The artist must have an intimate, personal, and kinesthetic knowledge of the craft that is the foundation of the art. He must have a hand-eye knowledge of how to hold and apply the various tools—the adzes, knife, chisel, and maul. He must know, in terms of his own bodily responses, what each tool will do when applied to a particular piece of wood. From his apprenticeship and subsequent experience he must have evolved a series of bodily patterns that give rhythm, symmetry, tension, and relaxation, which will be reflected in the carved product.

2. The craftsman must be familiar with the potentialities of his materials. The forests yielded red cedar, yellow cedar, maple, alder, and yew among the usable woods. Each has a different grain, texture, and pliability and offers advantages for specific uses. The craftsman learned to recognize and work with these, from the selection of the log or living tree to the completion of the finished surface.

3. He must be familiar with the forms that are to be produced. The culture required the production of a great variety of forms for specific uses: boxes, dishes, masks, and musical instruments, to name a few. Each product was made in a unique way. Some craftsmen became specialists in the making of one particular type of object, such as a house or a canoe.

4. The form must be made within the traditional patterns that allowed the society to recognize and accept it. It had symbolic and emotional meaning, both implicit and explicit, which were emphasized by the craftsman in ways that fell within the conventions. These traditions prescribed identification features, elements of design and ornament, X-ray painting, and bisymmetrical split representation. From these and other elements the craftsman could select, recombine, and re-form to make a new statement. Thus he made a new work that still fitted into the frame of values and ceremonial art.

A craftsman who had successfully met all these conditions had become a master craftsman. He had been through a consciously guided apprenticeship, taken on by arrangement with a master employer. Only after this stage had been reached could he become an artist. Only then was his mind raised above concern with routine problems so that he was capable of conceiving and creating a product that could be called a work of art. His imagination and his ability to achieve had come together.

The woodcarver of the Northwest Coast held a central position in the society, and his work was related to all of its values. He was ordinarily a person of higher rank, who created the forms necessary for the expression of the society's beliefs and values. The Tsetseka season, the period of initiation, and the related forms of entertainment and hospitality were all affirmations that were given their material form in carved and painted figures. The artist was fundamental to all the purposes of the season, and his work was correspondingly recognized and prized.

It was this key role of the art and the artist that supported the vitality so evident in the collections of Northwest Coast material culture even as they have been preserved in museums. Every object reiterates the fundamental relationship of tradition, society, and the artist, and the training that enabled the craftsman to rise above his craft and become an artist.

Conventions of Carving and Painting

Very little of Northwest Coast art was representational in the sense that the image was meant to reflect the object as it appeared in nature. Objects that had a concrete existence were carved and painted within a cultural emphasis and a number of conventions that modified them in the portrayal by the artist.

The purpose of carving and painting lay in the culture itself. In the Northwest Coast it was the crest or the visible form of the mythic being that was the content of a work of art. The beings were the icons of Kwakiutl culture, the images that were symbolic of the emotion-laden content. The carver created in wood the images of the beings of supernatural power, including human ancestors. Totem poles, masks, houses, house furniture, and other distinctive lineage belongings were manifestations of the Kwakiutl's knowledge of their world.

World knowledge and outlook ran parallel to the canons of art, which prescribed the repeated use of certain forms, while the employment of the art itself was prescribed within closely defined contexts. The forms were depicted not only with their primary cultural image but in a manner that disclosed their symbolic associations. Clues provided in related design patterns showed links with other images and meanings.

The visitor to a museum or the guest at a traditional Kwakiutl ceremony will soon see that certain subjects were carved and painted again and again: human faces and bodies, birds, animals, and other heads and bodies were arranged on surfaces in clear and repetitive forms. Associated with these were recognizable smaller representations of eyes, claws, feathers, and the like, which were repeated on the surfaces of the carved and painted materials in definite ways. Boxes, chests, dishes, masks, and textiles were decorated with these recognizable elements, carved and painted in distinctive configurations that have been labeled the Northwest Coast style.

Further investigation reveals that the style was based on a number of conventions. The first was that of the choice of objects to be carved. These were the crest figures and other beings from the world of Kwakiutl belief. The second convention determined how the object was to be set out, how its symbolic association was to be confirmed and emphasized. Finally, the cultural purpose, the selection of the crest being and its associated symbolic clues, determined the distribution of decorative elements, which varied according to the ceremonial object to be decorated.

For the Northwest Coast artist, carving was the process of modifying the material of the basic wooden form by the use of tools which removed successive layers to fashion the crest image in three dimensions. To this basic task was added that of creating the object so that it served its purpose as a dish, a pole, or a mask. The dish would be hollowed to provide a receptacle for food, the pole carved to reveal a series of crest figures, the mask shaped to project the external image of the crest as an extension of the human head behind it. The client's commission set a three-fold challenge for the carver, based on the nature of the wood, the utilitarian function of the object, and the ways in which the crest images could be modified to accommodate these.

Painted decoration was applied by the carver as an embellishment of the crest image and an emphasis of purpose. It might be subsidiary, as in the wolf feast dish (Fig. 344), which has a painted eye socket and a small feature symbolic of a family image, or it might be conceived as essential to the form, as in the pair of eagle crest dishes (Pl. XIV), in which the form is deeply carved and painted in head, feathers, feet, and tail.

Flat decorated surfaces were another matter. Only the surface of the wood needed to be modified to establish the pattern of the crest image, in a form suitable to its size, shape, and purpose. Painted house fronts, house screens, and box fronts, as well as Chilkat and button blankets, were decorated with the crest being together with its associated clues, either as central themes or in a pattern that covered the whole surface. Smaller objects, such as silver bracelets, whistles, and rattles obeyed the same conventions, with two-dimensional designs incised or painted according to similar criteria.

Kwakiutl tradition offered many examples of ways in which three-dimensional modification of wood by carving was customary: totem poles, crest poles, feast dishes, and masks all had characteristic modes of carving. It offered other ways in which flat surfaces were modified, usually by painting only, sometimes with subsidiary slightly carved or incised lines as an emphasis.

The Clues within the Conventions

The formline, as defined by Bill Holm, established the outline, overall shape, and pattern of the carved or painted figure (see Holm 1965:19-29, 35). Holm identified black as the primary color for Northwest Coast art in general, and this was also true for Kwakiutl painting on flat surfaces, such as house fronts, painted curtains, and box fronts.

Of the various shapes that were used both for their symbolic value and as decorative devices, the first that should be mentioned is the ovoid and all its variations, ranging from a circle to an elongated rectangle with rounded corners (Holm 1965:31-34, 37-38, and Fig. 39). Sometimes purely decorative within the overall pattern, the ovoid can be a clue to the identification of the carved or painted figure. The circle, representing the blowhole or nostril of the killer whale, could serve to identify it in the absence of a full portrayal, either alone or, as it most often occurs, in association with the characteristic upright dorsal fin. The circle might also be the iris of the eye of other beings, such as fish. It was also used to represent limb joints or sockets, appearing on the shoulder, knee, elbow, end of spine, wrist, and ankle, as in Mungo Martin's paintings of a Merman and of a sea otter with a sea urchin, which illustrate various uses of the ovoid (Figs. 24, 25).

The ovoid was also used as the outline of a face, as in the pattern board shown in Figure 294. This one has readily recognizable eyes and eyebrows, as well as a minimal depiction of nose and mouth. The ovoid may indicate vitality, a human or living quality, but it most often serves as a space filler within the overall design. The "salmon-trout's-head" is a variation of the ovoid that has been analyzed in detail by Holm as a unit of decoration within the design (Holm 1965: Fig. 39).

As used for the eye of the crest figure, the ovoid had different forms for some of the different beings. The basic form had two opposing curves to give the outline, with a tension point at each corner (Holm 1965: Fig. 28A). Boas (1927:203 and Fig. 191) shows variations that are characteristic of some animal beings. A circular iris completed the eye.

The ovoid might be a separate element in the pattern accompanied by an abstraction of another anatomical feature, such as a feathered wing, a claw, a hand, or a tail. These designs might be supplemented by another, which Holm calls the U form, with its variation the split U (Holm 1965: 41-43, Fig. 32). This provided the possibility of decorative variation as well as allowing for recognition of the killer whale by its bifurcated tail.

Another variation of the ovoid was used to denote the eyebrow, which could be modified for purposes of both recognition and design (Holm 1965: Fig. 35). As an elongated rectangle, it could be used to outline the shape of other features of the body, or the body itself, in three-dimensional carving as well as in painting. Finally, the ovoid was used as a decorative device, a space filler which, properly employed, added to the dynamic tension of the pattern.

Another recurring form was the bracket line, often used in different combinations to denote scales or gills, identifying a sea being, as in Mungo Martin's drawing of a sculpin (Fig. 26). Additional conventions offered still further choices to the artist. Textural patterns for fur or feathers (Figs. 25, 28), or as in the crosshatching often used for the beaver's tail, were commonly used. The use of visual "punning," or "kenning," has already been mentioned.

Using these elements, both decorative and symbolic, set by tradition yet flexible, the artist found ways, often new and distinctive, to present the crest images to fit the space before him and to express his own genius. The conventions related to the identity of the crest beings allowed endless innovation through the disposition of the lines and surfaces of the portrayal.

In addition to the selection and combination of these design units, there were two conventions that involved an analytical approach to the anatomy of the beings portrayed. What has been called X-ray presentation, as mentioned above, allowed the artist to regard the internal, skeletal anatomy of the body as a decorative feature. The internal structure of the being, including the spinal cord and bones with joints and sockets, were shown either as formlines or as secondary colored lines and ovoids, completing the main form. The pattern was figurative, with no attempt at literal anatomical accuracy, and the rib cage and pelvic structure were seldom indicated.

The second convention was split representation, through a bisymmetrical opening up of the body form into two halves, which solved the difficulty presented by arrangement of the design on a conical surface, such as that of a woven hat. The two halves might be anchored by a central form such as the head of the crest figure. This arrangement and

the X-ray presentation were often used together. Examples of split representation are seen in Figures 89 and 498.

With such a large number of conventions for the presenting of crest figures, the artist could regard each new commission as a challenge calling for an original and creative approach to the image to be carved, the object to be decorated, and the surface material and space to be altered. Certain generally acceptable solutions to the challenges of size, material, and shape served as a springboard for creativity.

The flat, rectangular surfaces of house fronts, wooden and muslin screens, box fronts, wooden box drums, and blankets made either of twined fibers or of cloth were given cultural meaning by applied decoration. On wooden surfaces, paint was used to outline the design, usually in one color, and bisymmetrical and X-ray arrangements were often employed. Crest patterns were cut out of red flannel and applied to blankets, or were sewn on as lines of pearl buttons. Muslin screens were painted in rather more complex patterns. Designs were also adapted to three-dimensional forms, such as hats.

It has been said that the Northwest Coast artist abhorred an empty space (Adam 1949:160) and felt a compulsion to use overall patterns in order to avoid such spaces. Although it is possible to find examples of totally decorated surfaces, particularly in box fronts and Chilkat blankets, it is more common to find a deliberate and skillful use of spaces left unfilled (see Pls. XXII and XXVIII B). In these instances it is clear that the artist was aware of the enhancement of the form by the lack of adornment. Thus it was a matter of the artist's decision and judgment whether or not he chose to make use of overall patterning in depicting the crest figures.

The Nature of a Masterpiece

A Kwakiutl ceremonial object, made within traditional purposes and conventions, which is perfect in its whole and in its component details can be called a masterpiece of the art. It has been produced by a professional craftsman versed in knowledge of the medium in which he works, in the best use of tools, in knowledge of the traditional units of design and their depiction of the forms of the crest figures, and in knowledge of the range of ways in which these have been used to adapt to the shape and nature of the object. The true artist is the craftsman who can draw on all that knowledge and add his personal conception of it in a final, creative image based on the way he sees the object

as a whole. The end product, whether stated in carving or in painting, has the excellence of perfect craftsmanship combined with his conceptual power. It appears to have its own vitality and to be a statement of complete authority. The whole and the components are fused in a dynamic and almost living product. Such masterpieces recur throughout the collections of Kwakiutl ceremonial art made in varying places and periods.

The visual definition of a major work of Kwakiutl art is cohesive, taut, and dynamic. Within the work each unit or component design can be appraised. Circle, oval, U, split U, and bracket elements are perfectly delineated by brush or knife. Parallel lines are precise, their tension points perfectly joined. In a work of art these forms are exactly and completely made, and their relationship to the whole is perfectly chosen.

The Kwakiutl thought about the nature of their world, as symbolized in their carvings and paintings. The conventions of selecting the shape and form of the objects, and the traditional experience in which the artist was trained, worked through him, to be expressed newly and creatively and to emerge as a work of art. The good carvers were known and remembered. Their works were identified by someone's recalling the making of a particular object or series, or noting details of style, as when another carver would say, for example, "This is the way he made an eye." Such artists were commissioned to carve objects that served when a family established its claims at a special ceremony.

But not all objects made by Kwakiutl craftsmen were works of art. Some appear to have been produced in haste, or by an incompetent craftsman. They reveal themselves at once by rough and crude carving, imperfect decorative and symbolic elements, and failure to consider each unit in relation to the whole form. Their quality does not reflect the clear definition of material culture by the Kwakiutl, and the high value placed on it. The craftsman who made them may have had an interest in his work, but lacked the thorough training needed for a specialist or master.

Nevertheless, such roughly fashioned objects had their place in Kwakiutl life. The main thrust of ceremonial display was through the theatrical staging of events with dance and pageantry. Many items were needed for display in the room, and these would be provided by whoever could make them if the services of a major carver could not be procured. Thus, side by side with the art of talented and trained carvers there existed a pragmatic practice that made use of the less accomplished artisans. Their work would certainly be im-

perfect, their craftsmanship varying with the level of their competence. Yet frequently even these objects reflect a vitality of individual conception that illustrates the Kwakiutl emphasis on fitting the arts into their life.

The masterpieces of Kwakiutl craftsmanship and imagination can be seen in museum and private collections, in published works, and in contemporary use. The endless array of other objects devoted to establishing crest forms in many ways can be seen in all collections. Together, the fine works and those of ordinary craftsmanship give evidence of marvelous cultural cohesiveness, and a dynamic picture of human effort directed toward achieving a major goal of the culture, the establishment of a human claim to the strength and power of the universe.

We are in the presence of a vital culture, in its manifestations of a world view. Its art is a statement that the Kwakiutl live in a world where their ancestors can gather and hand their powers on to those who have followed them.

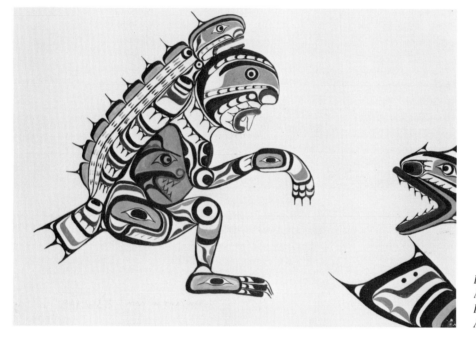

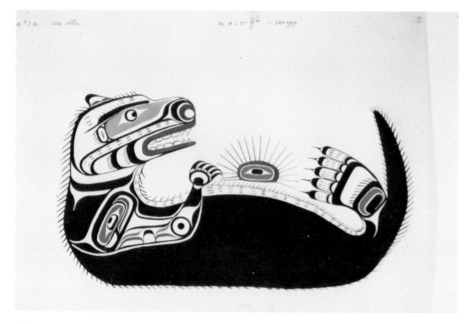

Fig. 24. Pugwís (Merman), painting by Mungo Martin. Watercolor on paper. Length: 16 in. Museum Purchase 1950. A9050

Fig. 25. Sea otter and sea urchin, painting by Mungo Martin. Watercolor on paper. Width: 16½ in. Museum Purchase 1950. A9056

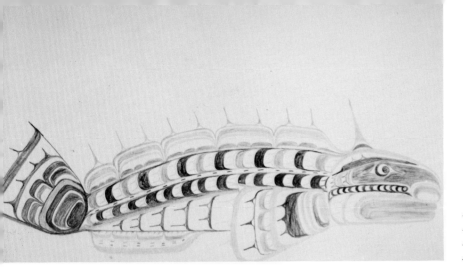

Fig. 26. Sculpin, drawing by Mungo Martin. Pencil and crayon on paper. Length: 18 in. Museum Purchase 1950. A9053

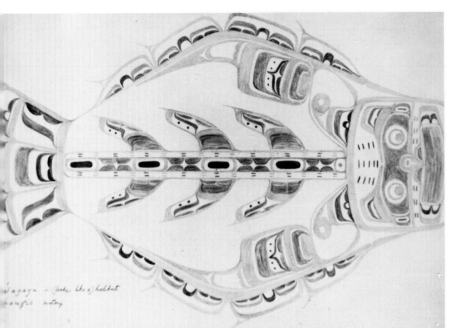

Fig. 27. Sea monster with body of a halibut, drawing by Mungo Martin. Pencil and crayon on paper. Length: 17¼ in. Museum Purchase 1950. A9052

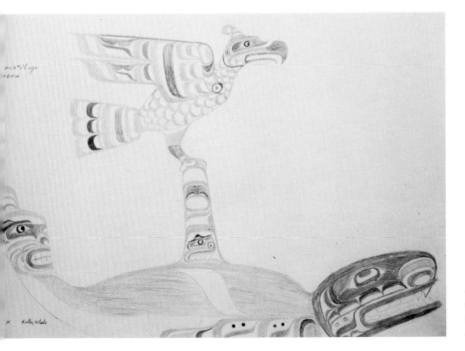

Fig. 28. Killer whale and Thunderbird, drawing by Mungo Martin. Pencil and crayon on paper. Length: 18 in. Museum Purchase 1950. A9057

Kwakiutl Mythology and Iconography

In the early days of the ancestral people of the myths, birds, men, animals, and fish lived in their own worlds, occasionally entering those of the others. Differing from each other only in covering, they could, and did, doff at will their cloaks of skin, feathers, or fur.

The earth with its familiar mountains, forests, local villages, and landmarks was inhabited by the myth people: Raven, Bear, Tsonokwa, Sisiutl, and many others. In the sky another area was inhabited by beings who lived in great houses and occasionally descended to earth on stairways. In this world lived Thunderbird and his younger brothers.

Under the sea lived another set of supernatural beings—not only fish and sea mammals, but a range of animals and birds who were the counterparts of the earth people: Sea Raven, Tsonokwa of the Sea, Sea Bear, and others. All of these were ruled over by Komokwa, chief of the undersea people, who lived in a great and wealthy house guarded by sea monsters. And there were others, some of them so huge that, when they rose up from the sea, the waters became shallow and swirled in tidal races.

There was also an underworld of ghost people living the same lives as those above earth, except that their night was day and their summer the winter above. These people were not tangible or substantial, but their lives were the same as those of humans.

Local groups and families traced descent to an ancestor among the myth people who in the early days had received special powers and privileges from a supernatural bird, animal, or other being. Such powers and privileges—including songs, dances, and the right to wear certain crests—were perpetuated from generation to generation. These crest forms are the main subject of carving, painting, and decoration, and much of Kwakiutl ceremony is based on these legendary inheritances.

Sky Beings

The complete representation of the bird form in carving and in painting always included head, wings, talons or claws, and feathers as the salient marks of its aerial nature. Other details—eyes, brows, beak, and nostrils—accompanied components in shapes specific to the particular being. In general, the bodies of sky beings, as carved on totem poles and house posts, followed the same configurations and proportions as those of human figures. They were portrayed seated, with head upright, beak thrust forward, wings the length of the body, knees bent, legs parallel and ending in talons. It should be noted, however, that the great beings of bird form that contained the force so influential in human life were depicted differently from the birds more familiar in the forest and on the shore.

Thunderbird (Pl. VII A; Figs. 48, 400, 401) was huge and powerful, able to catch and lift the killer whale. Lightning and thunder were the signs of his flight. He could lift the heavy frame of a dwelling and set it into position (field notes, Mungo Martin, UBC Museum 1950). The marks distinguishing Thunderbird from other sky beings are the supernatural horns that adorn his head, and the curved, humped, and massive upper beak over a curved lower one.* His talons and legs are emphasized to a greater degree than in other bird forms. His wings are not usually folded at the side, but are commonly shown outthrust, extended straight out from his side or even placed above his shoulders, a dramatic statement of his flying ability.

Kolus (Figs. 48, 49, 402, 403), the younger brother of Thunderbird, also lived high in the sky and was shown as a smaller version of his elder brother, but without the supernatural feathers or horns on his head. The myth of Kolus describes his covering as down rather than feathers, so that he was subject to profuse perspiration, but in carving he is shown as feathered. He is depicted, like Thunderbird, with outstretched wings, and was also credited with great strength. Mungo Martin

*This description and the ones that follow are intended to be helpful in the identification of particular figures, but it should be emphasized that there is considerable variation within each form.

cites Kolus, too, as lifting up the massive house frames for several Kwakiutl families and setting them in place for completion.

Raven (Figs. 78, 408-11) was a mythic being as well as a familiar habitant of forest and shore. In his supernatural character he was quick, curious, greedy, and mischievous. Various stories of episodes in his life recount how he benefited mankind by discovering fire, the rising and ebbing of the tides, and the alternations of day and night. He is identified by his massive, long, and sharply tapered beak, which may be an extension affixed to a totem pole, or may be depicted folded down along the front of his body. He is often painted black. As a lineage crest, Keso, the raven was commonly worn as a frontlet above the brow of the wearer. The long beak is similar to that of the supernatural raven. The bird-monster Hamatsa raven is described on pages 105-6.

Khenkho (Figs. 406, 407), one of the mythical birds, is characterized by a very long and narrow beak.

The eagle (Figs. 68, 404, 405) was recognized as the first among the familiar birds. His beak is shown as massive and outthrust, not as long as that of the raven, and not curved with the hump of Kolus or Thunderbird.

The hawk has a beak that is curved back to teeth shown between lips.

The beak of the owl (Fig. 412) is short and tapers to a V above lips. Owl was associated with darkness and the souls of the dead.

The loon (Figs. 369-71) was a crest frequently shown associated with the undersea king, Komokwa. The beak is pointed, sharp, and open, the upper beak separated from the lower. The usual presentation of the loon shows the whole upper body floating on the water, with head, neck, and flattish back seen as a total unit.

The heron (Pl. XIII), characterized by its long neck and long, sharp beak, is often represented seated on top of a mask. If the whole bird is presented, it is given the long legs of the shore bird.

The gull, shown either floating or flying, has a neck and beak shorter than those of the heron, with wings at the sides, painted white.

Other Sky Elements

The sun (Pl. XXIII; Figs. 425-28) is shown as a round, humanlike face, usually surrounded by a halo or a fringe of pointed pieces of wood denoting rays. A bird beak, usually like that of the hawk, juts from the face. Copper is often employed on the sun's face, which may be painted white, with orange or red rays.

The depiction of the moon (Pls. XXI, XXII; Fig. 429) varies. Sometimes it is carved as a serene, handsome, young male face. At other times a beak or wing feathers, like those of Raven, are added, following associations in the myth. In another convention, a disk representing the moon is shown with an added crescent form.

Echo (Pl. XXV; Figs. 434-36) is associated with speech and ventriloquism. All the outstanding echo masks have a number of mouthpieces, each of which can be inserted to cover the lips of the mask, and each belonging to a different being with its own distinctive voice.

Beings of the Forest and Mountain

These beings are marked by ears, muzzle, teeth, claws, and paws or hoofs. Sometimes the texture of fur is added.

The wolf (Pl. XVII; Figs. 392-95) was noted by the Kwakiutl as first in rank of the animals. In myth he was the first to initiate young humans into the winter dance ceremonial. The wolf's head is long, with a sharp muzzle and flat snout, usually slanted backward. The ears are narrow, either erect or flattened. Upper or lower teeth, or sometimes both rows, are shown, with two or four fangs as a rule. There may be a long tail.

The bear (Figs. 31, 32, 41, 44-46, 50, 69, 76, 378-91) was represented in myth as strong, aggressive, and fearless. He may symbolize the fierceness of the warrior and possess supernatural strength. The bear is distinguished by a massive, powerful muzzle, alert and aggressive rounded eyes, and wide, flaring nostrils. Fangs and claws are usually shown prominently and emphasized. Ears, if shown, are upright and blunt. The bear is differentiated from the wolf by a shorter muzzle, squared and more massive in form. Both upper and lower teeth and fangs are usually shown. Claws are long and pointed. The eye is rounded and fierce. Fur is often indicated. If paint is used, the color is black or dark brown.

The beaver (Figs. 47, 59 [bottom figure]), easily recognized in form, is not generally elaborated as a character in myth. Beaver may appear so frequently in carving because the form, with its distinctive and conventional marks, provides a useful variation on the animal forms. The characteristic features are two strong incisors, with a stick, sometimes held in upraised paws, raised to their tips, and a round, large, scaly tail, traditionally crosshatched. The tail is most often folded under the body and up over the front of the figure. Ears, if they appear, are upright, short, and rounded. The muzzle is flat, with round nostrils. If lips are shown, they are retroverted above the teeth.

The Sea and Its Beings

The massive killer whale is depicted again and again, shown in awesome form reflecting his natural presence. Killer whale masks are illustrated in Plates XV and XVI A; Figure 381. On totem poles or house posts, the carved body of the killer whale is not made to conform to the human canons applied to other beings, but is carved along the axis of the pole, with the long, blunt head disposed either up or down. Often the body is dispensed with, and only some of the distinctive features, such as the upright dorsal fin, frequently incorporating the blowhole, together with the bifurcated tail and the side flippers, are shown. The baleen whale, in contrast, has a short, curved dorsal fin, long pectoral fins, and round white spots on its body (Pl. XVI B).

Sea lions (Figs. 29, 30, 33-35, 37, 38) are prominent mainly as the living house posts of the treasure house of Komokwa, the guardian of the world under the sea. Like seals, they are shown with large joined flippers at the rear of the body, massive head and muzzle, round eyes, and the teeth, if any, large and blunt. They have pointed back-slanting ears, a short tail, and a yellow body.

Supernatural qualities of other sea beings are often represented by horns curving atop the head, like those of Thunderbird. These indicate that the fish form is that of the supernatural salmon, cod, or halibut (Figs. 376, 377, 378). All fish have rounded eyes in a socket which itself is rounded rather than rectangular. They have a muzzle or snout that may replace the human form of the nose of other beings, with the chin and brow slanted forward. Gill slits and scalloping to show scales are usually present. If tails are shown, they are distinctive of the particular fish, as are the fins.

Other marks of sea beings are forms abstracted from sea life. Concentric circles, like those of the octopus sucker, are used as adornment on the carved forms of other beings, as are rosettes, which may be an abstract representation of the sea anemone.

Komokwa, King or Guardian of the Undersea World, or Copper Maker, and his wife, Tlakwaki-layokwa, were two important beings who lived in a great house under the sea, which held ever full boxes of food, coppers, and other treasures. Myths recount how a young man seeks help and is met by an emissary of Komokwa in the form of a killer whale or a salmon which comes to the edge of the water and conducts the man to Komokwa's house, from which he is sent back, after a stay lasting years which appear to pass as days, in a canoe full of riches. He greets his relatives and founds a new lineage.

Komokwa is portrayed by a mask of predominantly human aspect, but with rounded eyes and the symbols of sea life on it (Pl. XVIII; Figs. 367-74). Brow and chin and cheeks have a structural visor or curtain, and perhaps the added representation of fins or gills. If the mask is painted, the colors black and dark green are included, indicative of the depths of the sea. Associated with Komokwa in the winter ceremonial and Klasila times are loons, killer whales, sculpins, and frogs, all of which have an affinity with copper and treasure.

Representations of Tlakwakilayokwa are less standardized and have not been clearly established. Her mask simply shows that she is associated with Komokwa. These masks were carved in pairs and show an affinity in style and colors.

Pugwís, or Merman, was an undersea spirit in human form. His face is fishlike, with two rounded brows above the rounded eyes and two prominent front incisors between his lips (Figs. 379, 380).

Other Major Beings

Often appearing in myth, Tsonokwa (Pls. XIX, XX; Figs. 253-65) had two forms, the most frequent a female member of a tribe of giants, shaggy forest inhabitants. She has a huge body and head, long pendulous breasts, and upthrust hands. Her rounded lips are pursed to utter the cry, "Hu hu!" She has an obsessive hunger for small children, whom she tries to lure to her house where she may devour them. The house contains fabulous treasures of boxes of forest foods and coppers. Tsonokwa is described as sleepy, with half-closed eyes; also vain, stupid, and clumsy. She may carry a basket on her back into which she intends to gather the children, but the bright and alert children of the Kwakiutl outwit her and snatch treasures, especially coppers, from her house.

The other form of Tsonokwa was a male giant of forest and high mountain, endowed with ferocity and great strength and a formidable alertness (Boas 1905:206). These male counterparts are represented by large heads whose style emphasizes force. Their eyes are open and alert, and they usually have locks of hair. It is a mask of the male form of Tsonokwa, the Geekumhl (Figs. 253-57), which is used in the important ceremony of the distribution of coppers by the chief, and this form is also present among the warrior-spirit characters and in the winter enactments of myth.

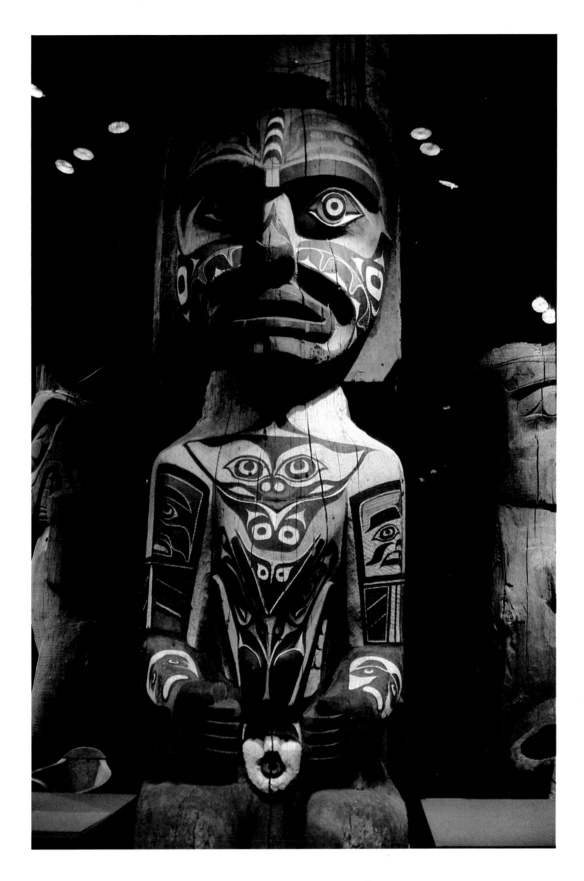

*Plate 1. Ancestor figure; interior house post from Quatsino,
carved in 1906 by George Nelson. Wood; black, white,
yellow. Height: 12 ft. 1957. A50009D*

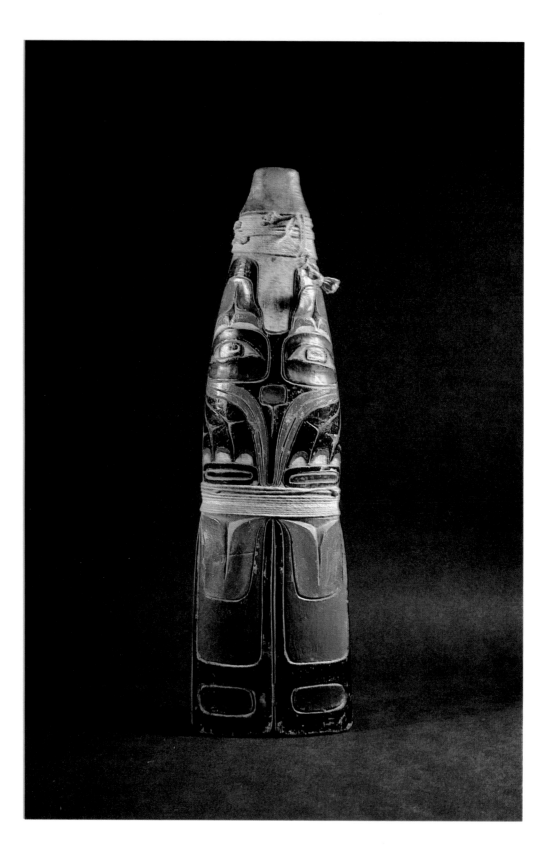

Plate II. Whistle with incised and painted eagle design.
Wood; black, white, red, blue. Length: 14 in. Walter and
Marianne Koerner Collection 1976. A2512

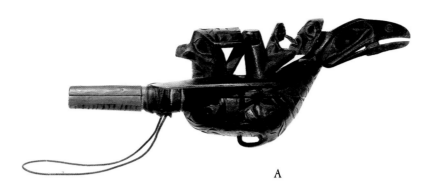

A

B

C

Plate III. A: Raven rattle from Sullivan Bay, of northern origin. Wood; black, red, blue. Height: 13 in. MacMillan Purchase 1952. A8333. B: Whistle with incised eagle design. Wood, varnished on bottom half. Length: 18½ in. Walter and Marianne Koerner Collection 1976. A5256. C: Whistle with incised killer whale motif. Unpainted wood. Length: 17½ in. Walter and Marianne Koerner Collection 1976. A5251

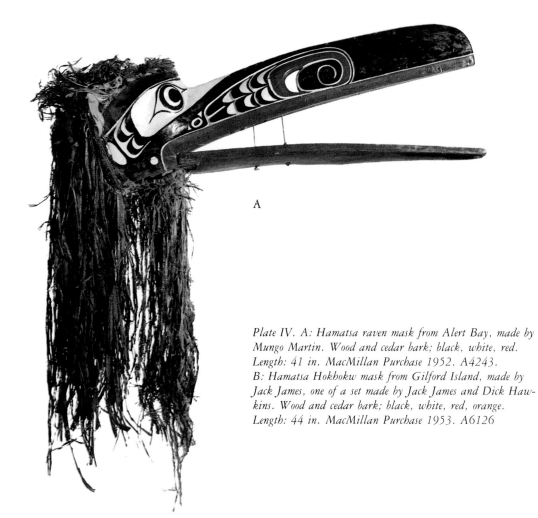

A

Plate IV. A: Hamatsa raven mask from Alert Bay, made by Mungo Martin. Wood and cedar bark; black, white, red. Length: 41 in. MacMillan Purchase 1952. A4243.
B: Hamatsa Hokhokw mask from Gilford Island, made by Jack James, one of a set made by Jack James and Dick Hawkins. Wood and cedar bark; black, white, red, orange. Length: 44 in. MacMillan Purchase 1953. A6126

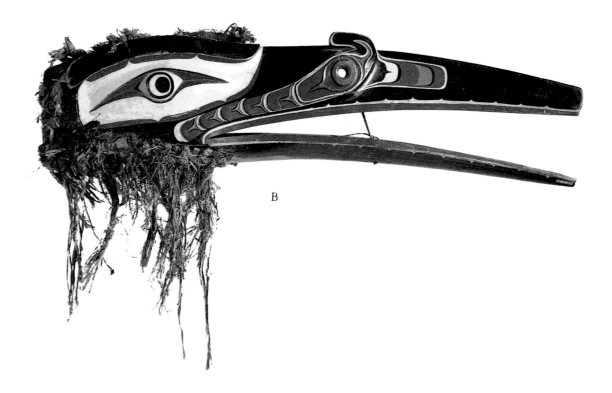

B

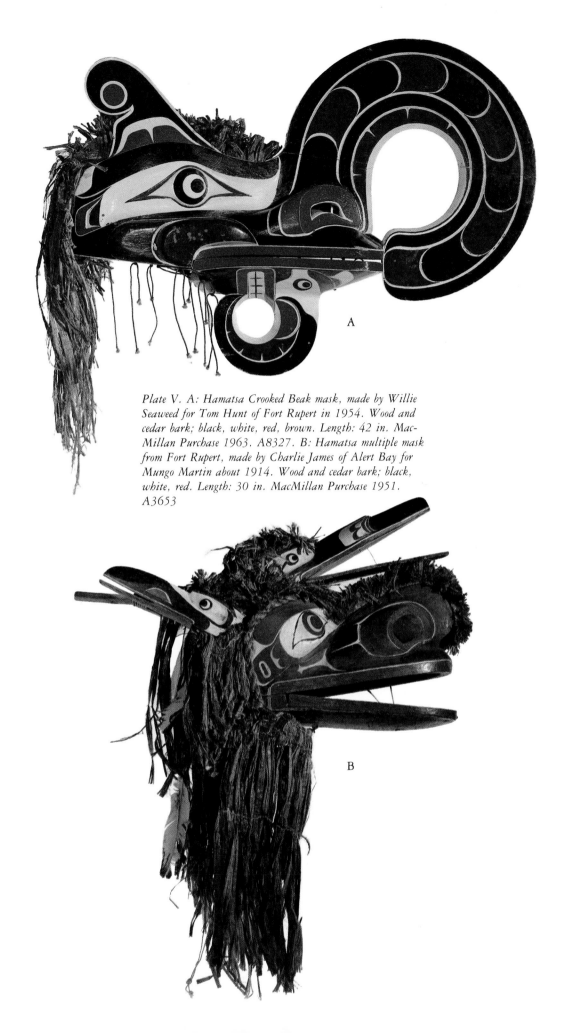

Plate V. A: Hamatsa Crooked Beak mask, made by Willie Seaweed for Tom Hunt of Fort Rupert in 1954. Wood and cedar bark; black, white, red, brown. Length: 42 in. Mac-Millan Purchase 1963. A8327. B: Hamatsa multiple mask from Fort Rupert, made by Charlie James of Alert Bay for Mungo Martin about 1914. Wood and cedar bark; black, white, red. Length: 30 in. MacMillan Purchase 1951. A3653

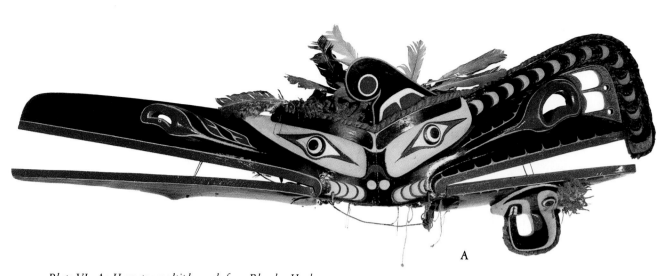

A

Plate VI. A: Hamatsa multiple mask from Blunden Harbour, made by Willie Seaweed about 1920. Wood and cedar bark; black, white, red. Length: 73 in. Walter C. Koerner Gift 1962. A7992. B: Hamatsa multiple mask from Village Island, said to have come from Owikeno and to be very old, also attributed to Dick Price. Wood and cedar bark; black, white, red. Length: 23 in. MacMillan Purchase 1952. A4169

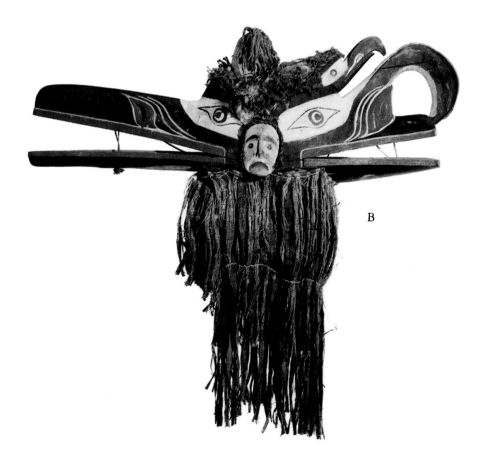

B

A

Plate VII. A: Supernatural Thunderbird mask. Wood; blue and red. Length: 27 in. Walter and Marianne Koerner Collection 1976. A5305. B: Button cloak from New Vancouver, with design of sun and small broken coppers in buttons and red appliqué on dark blue background. Width: 72 in. MacMillan Purchase 1961. A7490.

B

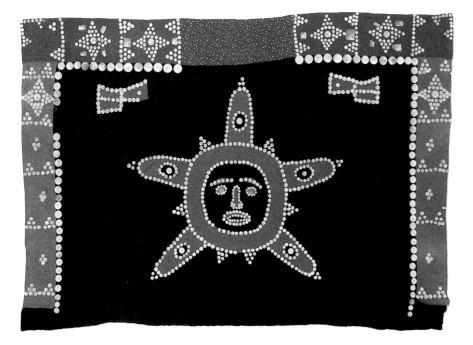

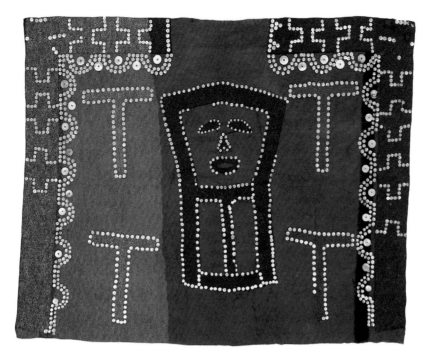

A

Plate VIII. A: *Button cloak from* Village Island, *with copper and* T *design in white buttons and* red appliqué *on green background. Width: 68 in. MacMillan Purchase 1952. A4171. B: Button cloak from* Village Island, *with tree design in white buttons and* red appliqué *on blue background. Width: 74 in. MacMillan Purchase 1951. A4251*

B

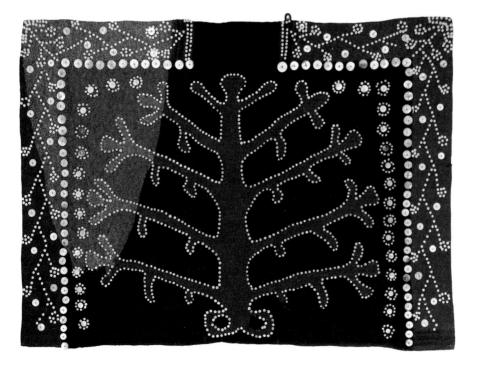

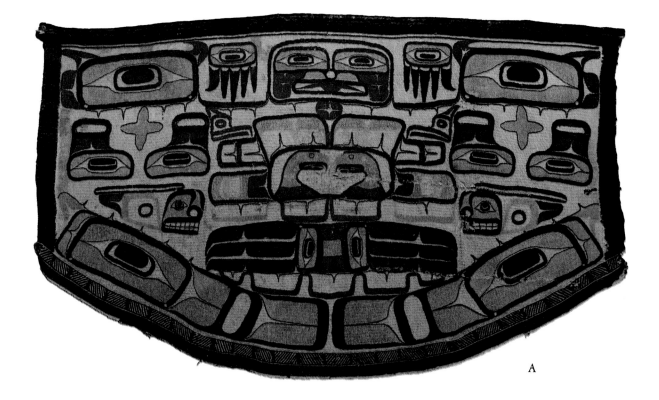

A

Plate IX. A: Chilkat cloak from Fort Rupert. Commercial
wool; black, red, green, yellow. Width: 60 in. MacMillan
Purchase 1962. A8041. B: Chilkat cloak woven by Mary
Ebbets Hunt, Fort Rupert. Wool; black, white, blue, yellow.
Width: 68 in. W. C. Koerner Purchase 1972. A17007

B

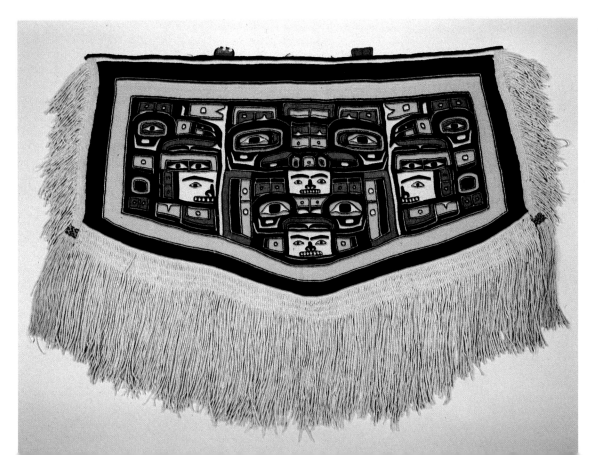

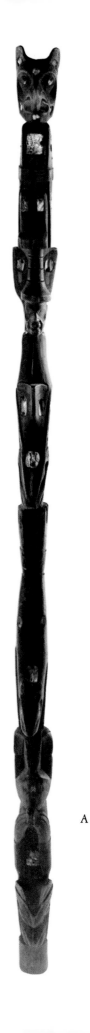

Plate X. A: Speaker's staff from Fort Rupert. Wood inlaid
with abalone; black, red. Length: 65½ in. Illustrated in
Curtis 1915: Pl. 333. MacMillan Purchase 1962. A8140.
B and C: Speaker's staff owned by James King of Kingcome
Inlet and representing the story of his ancestor, Copper Man.
Painted wood with copper, abalone shell, nails, rope. Height:
60 in. Museum Purchase 1968. A9181

B

A

C

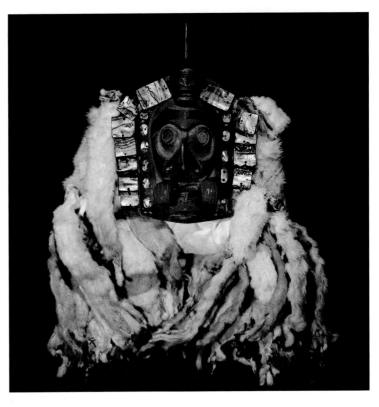

A

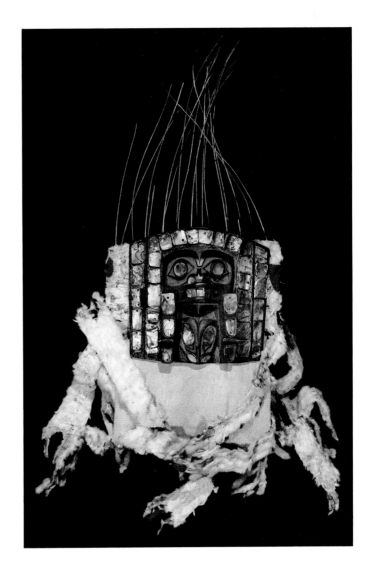

B

Plate XI. A: Chief's headdress from Village Island, hawk design. Wood, abalone shell, sea lion whiskers, ermine, cloth mantle; black, green, blue, red. Height of carving: 8½ in. MacMillan Purchase 1952. A4173. B: Chief's headdress collected at Fort Rupert, of Tlingit origin; bear design. Wood, abalone shell, sea lion whiskers, ermine, cloth mantle; black, red, blue. Height of carving: 8 in. MacMillan Purchase 1962. A8226

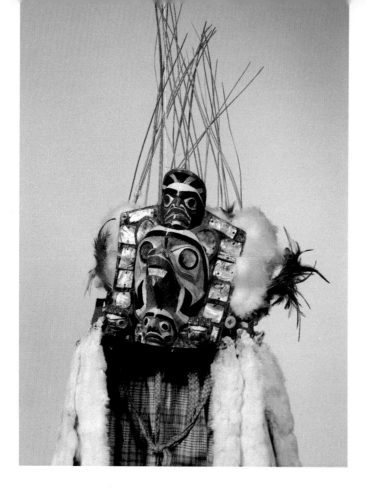

A

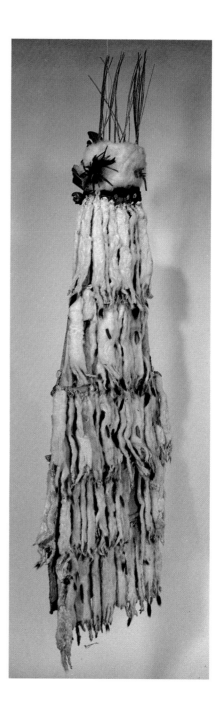

B

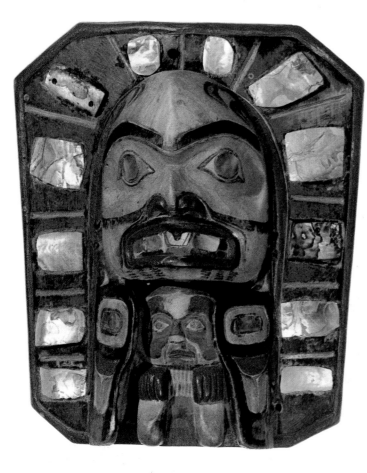

C

*Plate XII. A and B: Chief's headdress, possibly a bear
design. Wood, abalone shell, mirrors, sea lion whiskers, feath-
ers, down, mantle of ermine skins lined with cotton cloth;
black, white, red, pink. Height of headdress: 18 in.; length of
mantle: 52 in. Walter and Marianne Koerner Collection
1976. A5295. C: Chief's headdress from Fort Rupert, raven
design. Wood and abalone shell; blue, red, black. Height of
carving: 7½ in. MacMillan Purchase 1951. A3605*

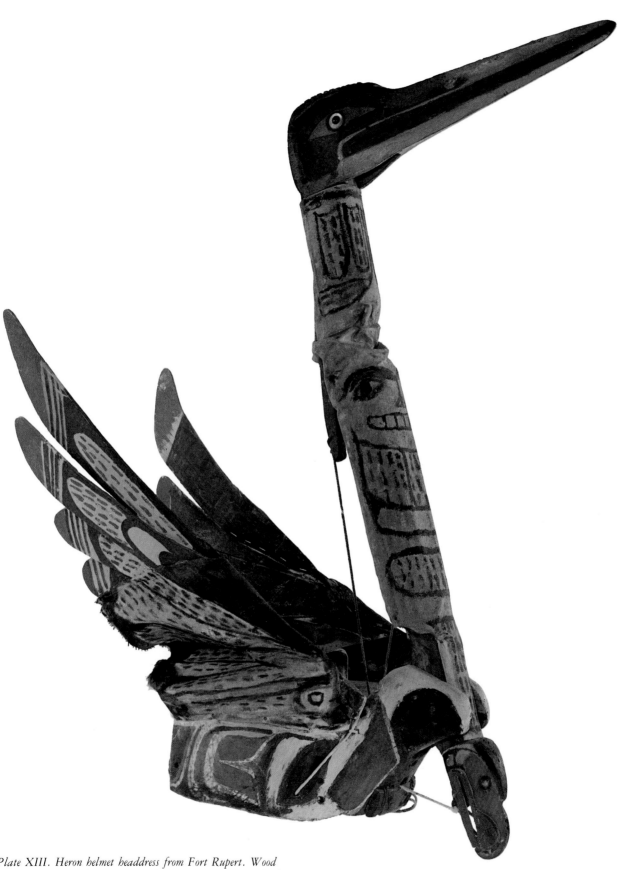

Plate XIII. Heron helmet headdress from Fort Rupert. Wood and canvas; red, white, blue, black, green, yellow. Length of extended neck: 34 in. MacMillan Purchase 1951. A3633

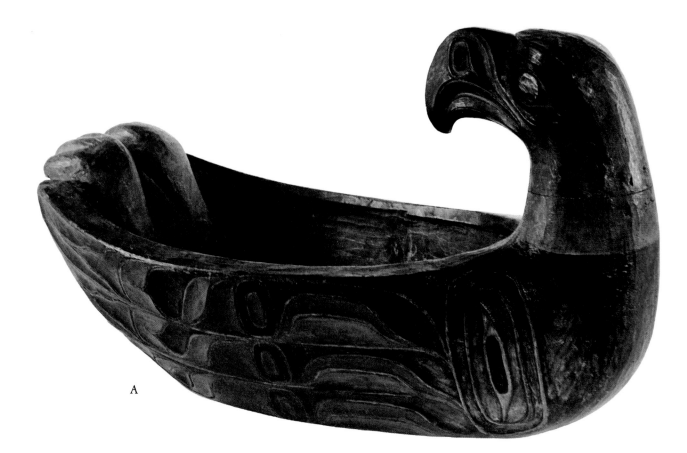

A

Plate XIV. A: Eagle feast dish from Hopetown. Wood; black,
green, red, yellow. Length: 30 in. MacMillan Purchase
1953. A6433. B: Eagle feast dish from Hopetown. Wood;
black, green, red, white. Length: 33 in. MacMillan Purchase
1953. A6432

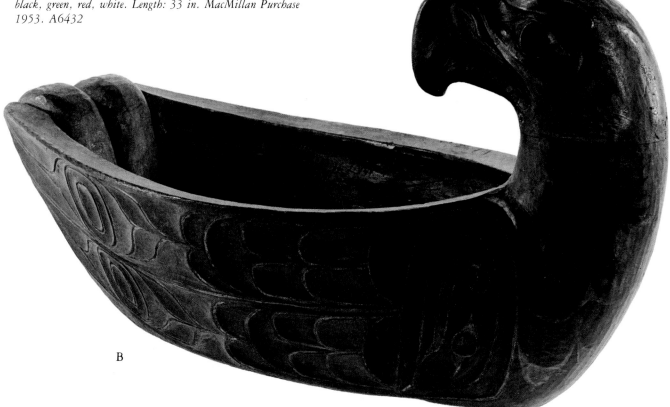

B

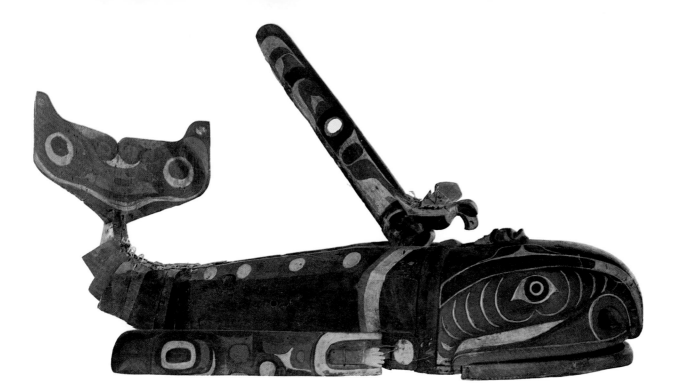

Plate XV. A: Killer whale mask from Sullivan Bay. Wood; black, white, red, green. Length: 65 in. MacMillan Purchase 1953. A6316. B: Killer whale mask from Alert Bay, with movable fins, tail, and jaw. Wood; black, white, red, blue, green. Length: 51 in. MacMillan Purchase 1960. A4506

A

B

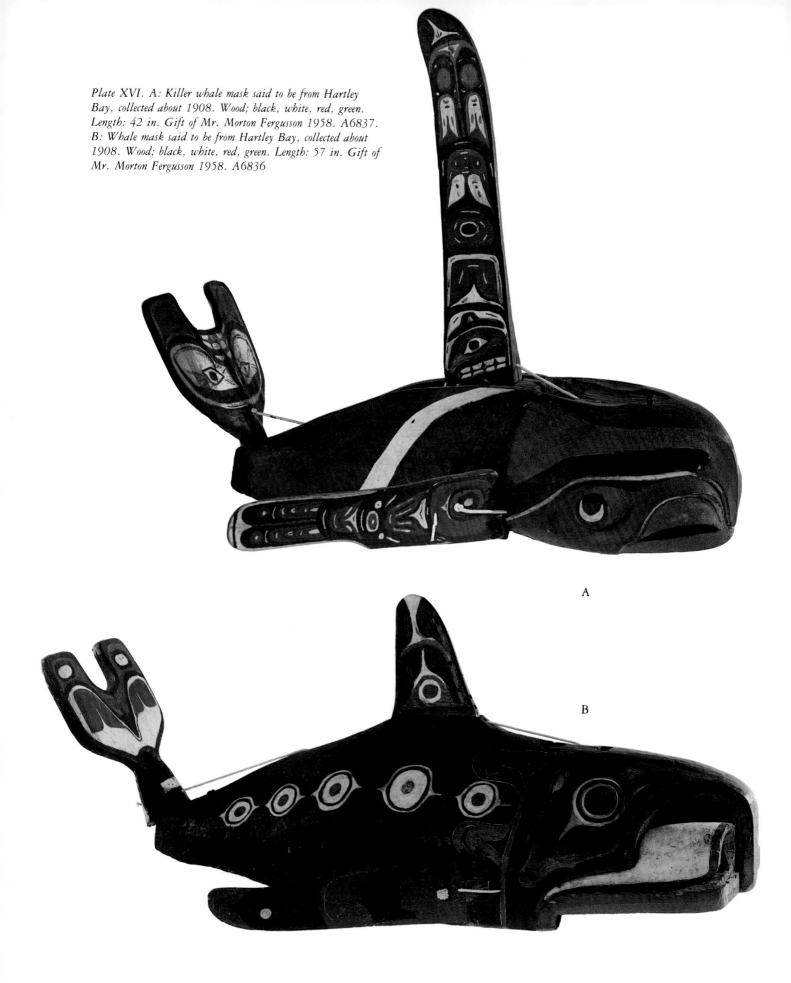

Plate XVI. A: Killer whale mask said to be from Hartley Bay, collected about 1908. Wood; black, white, red, green. Length: 42 in. Gift of Mr. Morton Fergusson 1958. A6837. B: Whale mask said to be from Hartley Bay, collected about 1908. Wood; black, white, red, green. Length: 57 in. Gift of Mr. Morton Fergusson 1958. A6836

A

B

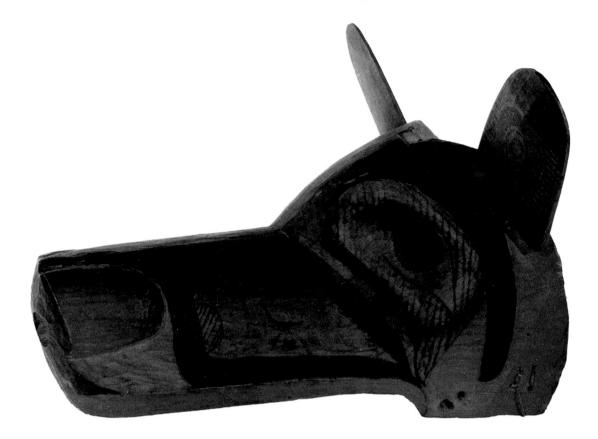

A

Plate XVII. A: Wolf mask from Kitlope. Wood; black, red.
Length: 15½ in. MacMillan Purchase 1948, Rev. G. H.
Raley Collection. A1744. B: Wolf mask from Sullivan Bay.
Wood with mirror eyes; orange, yellow, green, black. Length:
15 in. MacMillan Purchase 1951. A6552

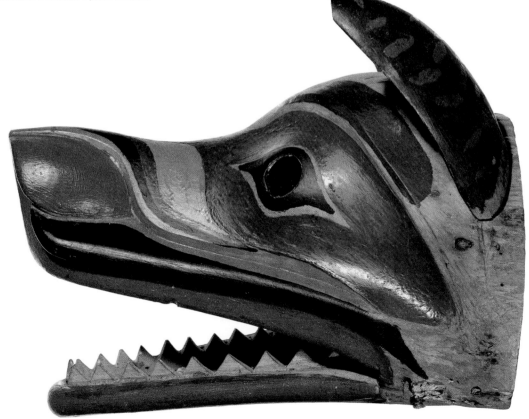

B

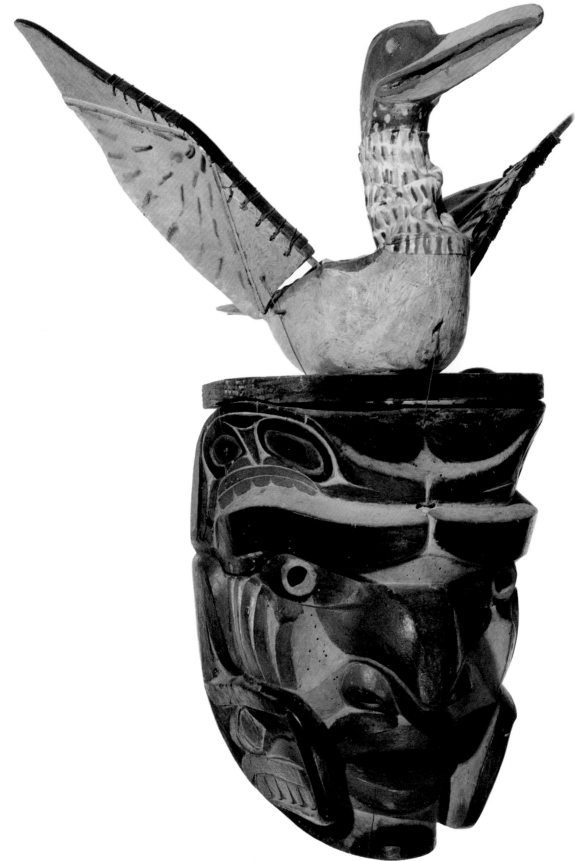

Plate XVIII. Komokwa mask from Village Island, of Bella Coola origin. Wood; wings and neck of duck, canvas; green, red, black, blue. Height: 31 in.; wingspan of duck: 32 in. MacMillan Purchase 1950. A3588

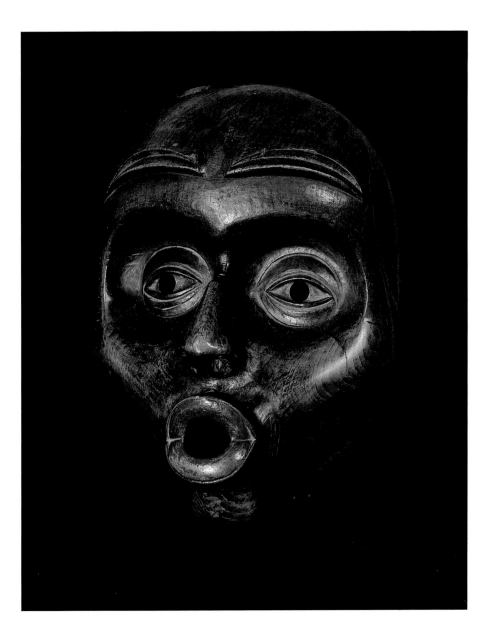

Plate XIX. Tsonokwa mask. Wood painted with graphite.
Height: 12 in. Walter and Marianne Koerner Collection
1976. A2601

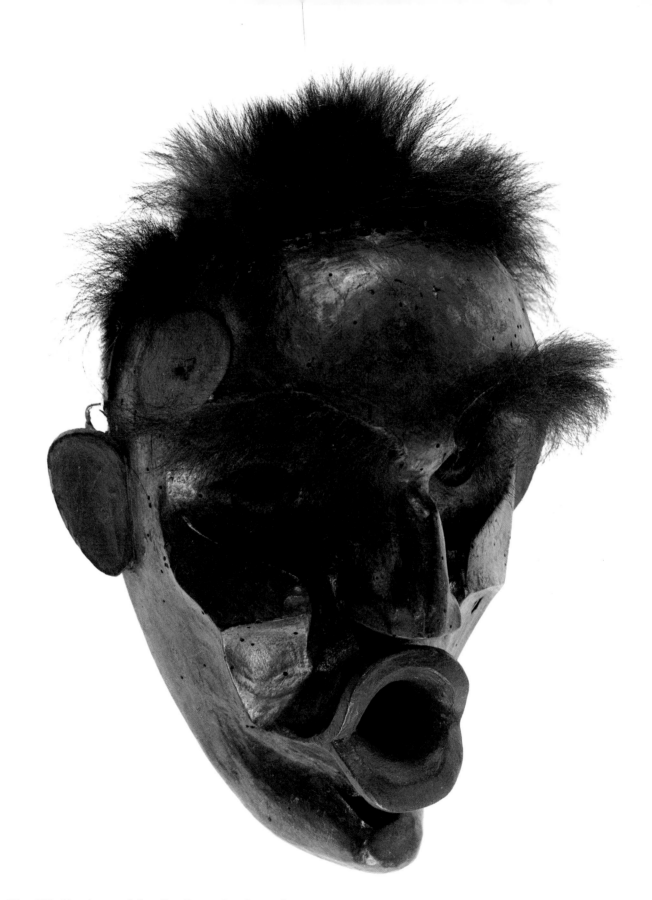

Plate XX. Tsonokwa mask from Fort Rupert. Wood painted with graphite and vermilion, bearhide eyebrows and hair; black, red. Height: 13 in. MacMillan Purchase 1951.
A3637

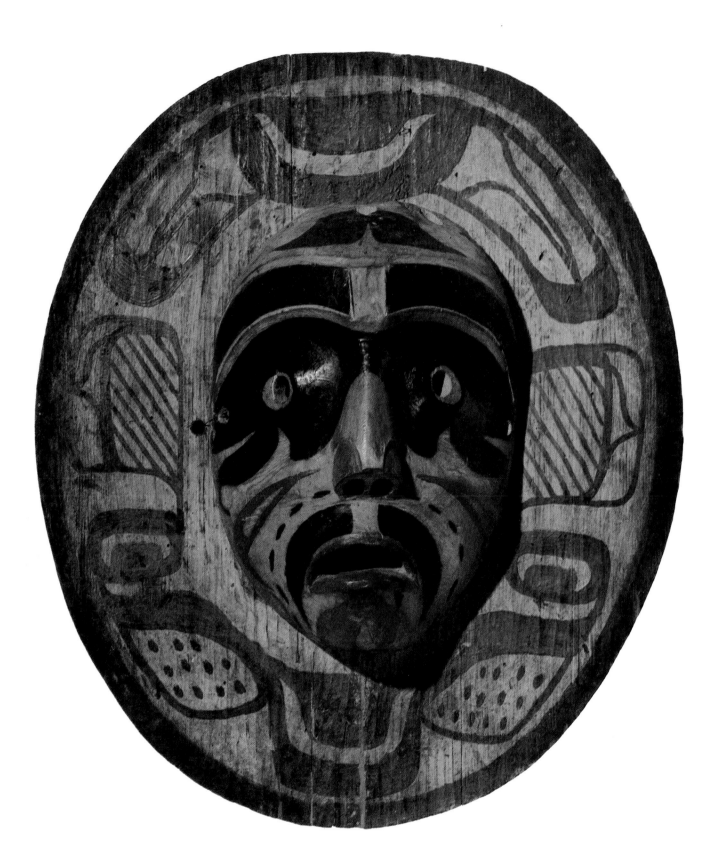

*Plate XXI. Moon mask from Kingcome Inlet, Bella Coola
style. Wood; orange, red, black, blue, green. Diameter of rim:
21 in. MacMillan Purchase 1952. A3770*

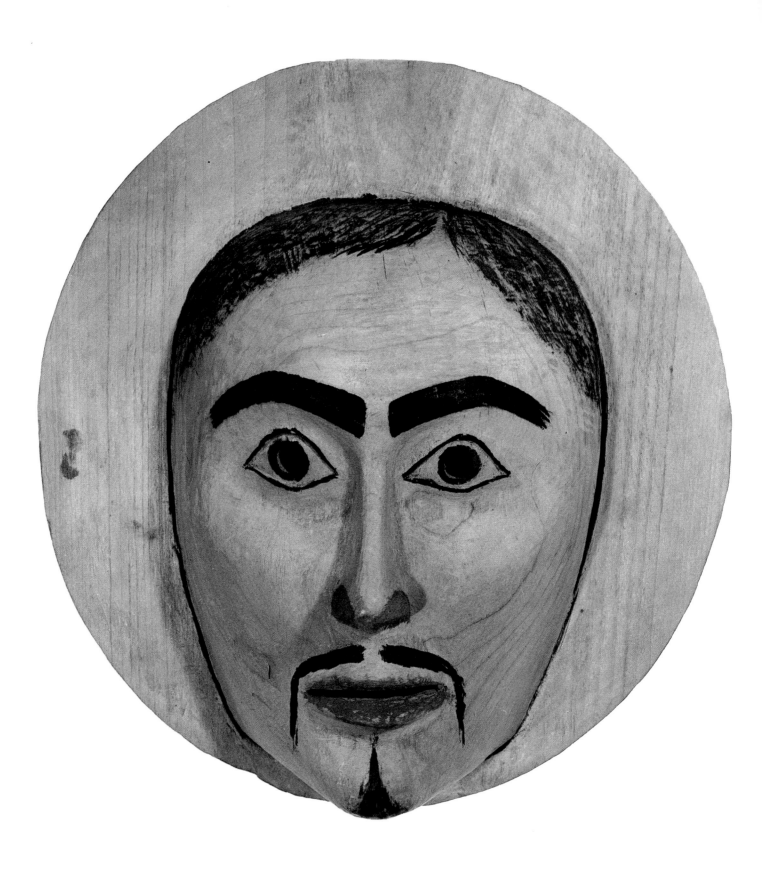

Plate XXII. Moon mask from Bella Bella, collected before 1945. Wood; black, red. Diameter: 12½ in. Museum Purchase 1949. A1797

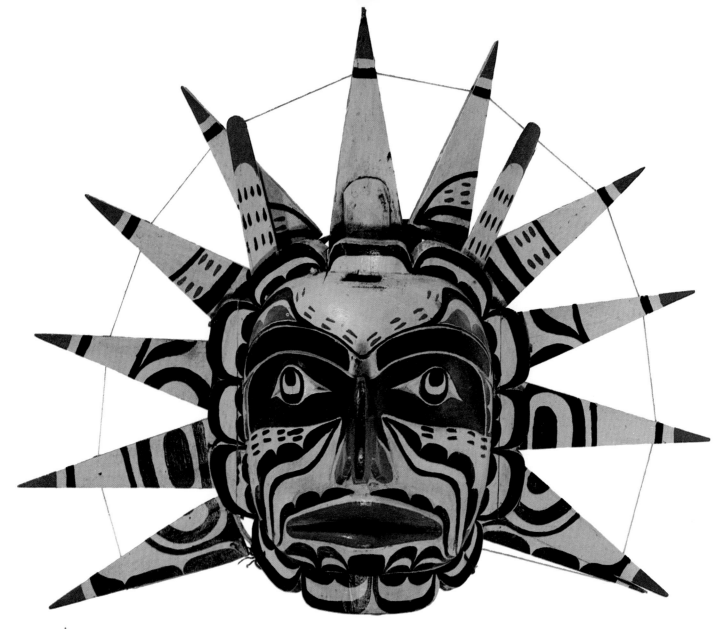

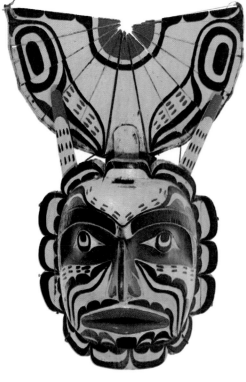

Plate XXIII. Sun mask from Kingcome Inlet, carved by Arthur Shaughnessy and used at Gilford Island in 1918. Wood; black, white, red, green. Diameter with rays open: 22 in. The rays, attached to a flexible band, are shown open (above) and closed (below). MacMillan Purchase 1951. A3553

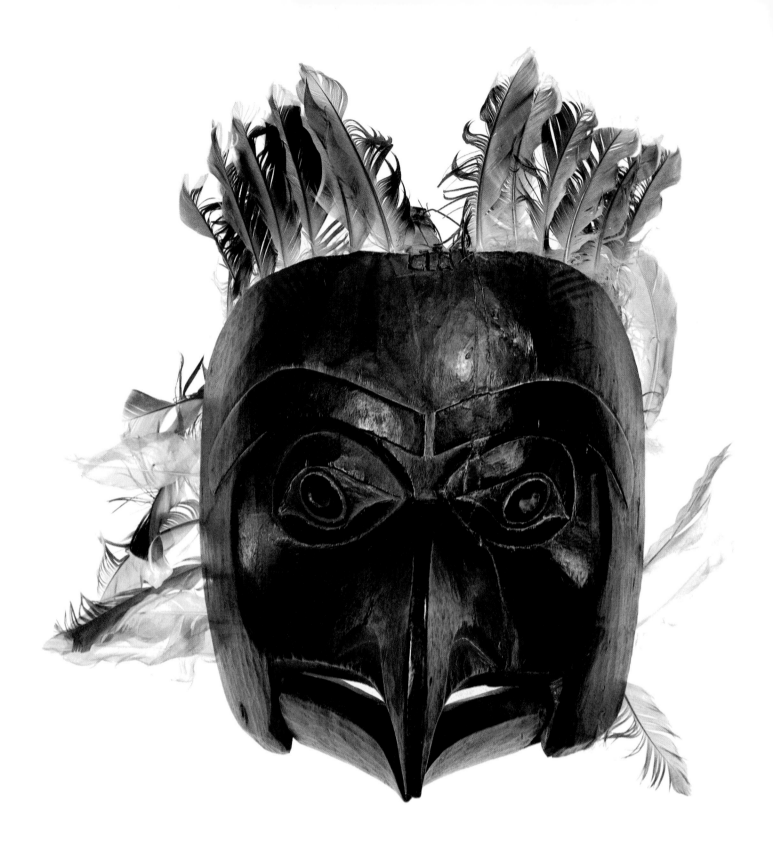

*Plate XXIV. Eagle mask from Kitamaat, said to have been
used by the Sonahed people up to 1884. Wood and feathers;
black, red. Height of carving: 11½ in. MacMillan Purchase
1948, Rev. G. H. Raley Collection. A1965*

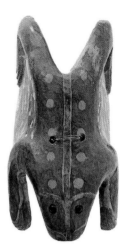

Plate XXV. Echo mask from Village Island, a complex mask with interchangeable mouthpieces. Originally from Owikeno, the mask passed to Blunden Harbour and then to Gilford Island through marriage. The mouthpieces represent (a) Bookwus, (b) bear, (c) unknown, (d) frog, (e) eagle, (f) unknown, (g) Tsonokwa, (h) killer whale. Wood; black, orange, blue, green. Height: 12½ in. MacMillan Purchase 1950. A3587

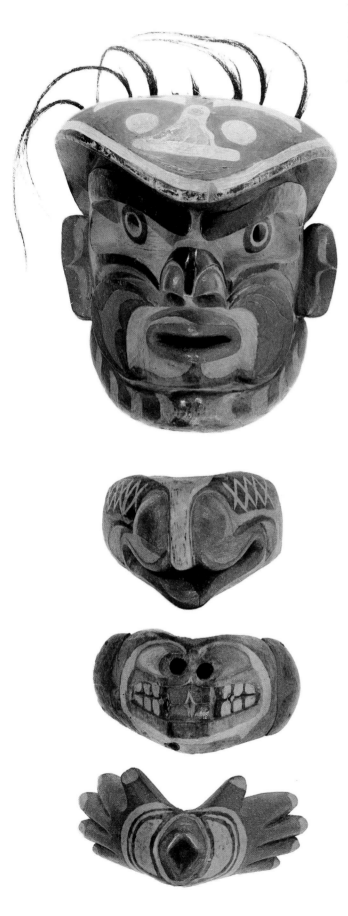

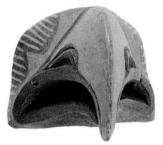

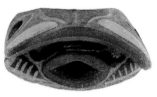

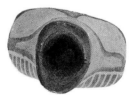

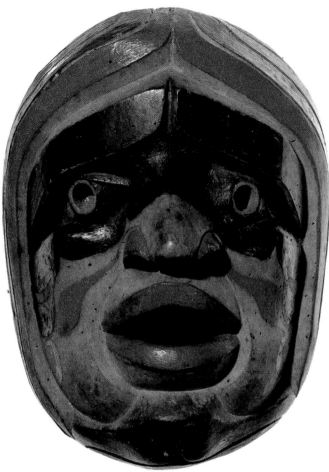

Plate XXVI. A: Mask of woman's face from Village Island, probably of Bella Coola origin. Wood; black, green, orange. Height: 12 in. MacMillan Purchase 1950. A3586. B: Fish mask from Gilford Island. Wood; black, red, white, green. Height: 13½ in. MacMillan Purchase 1952. A4094

A

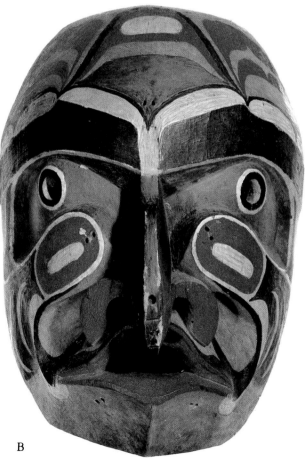

B

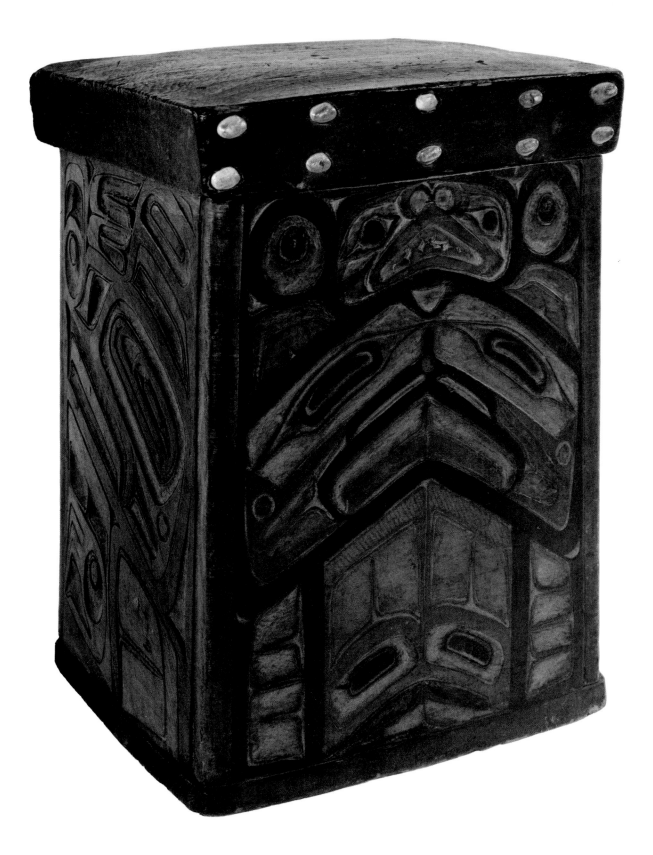

*Plate XXVII. Kerfed box with lid from Kitamaat, used by a
shaman to store his gear. Wood and shells; black, red.
Height: 13 in. MacMillan Purchase 1948, Rev. G. H.
Raley Collection. A1764*

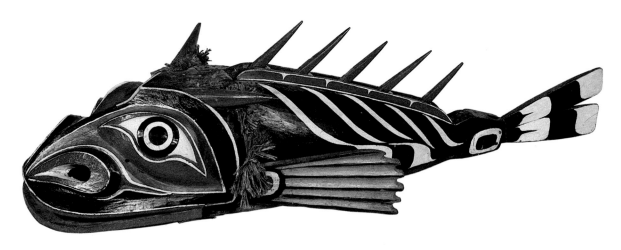

A

Plate XXVIII. A: Sculpin mask. Wood and leather; black, white, red, green, orange. Length: 60 in. Walter and Marianne Koerner Collection 1976. A5302. B: Loon helmet headdress from Alert Bay. Wood; gray, yellow, green, black, red. Length: 19 in. MacMillan Purchase 1951. A6102

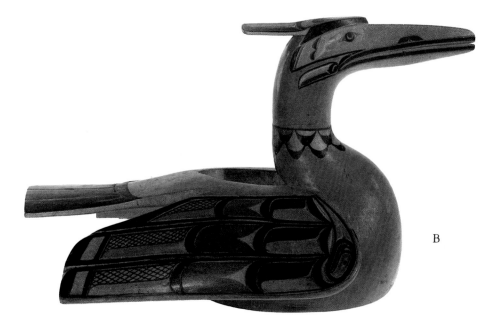

B

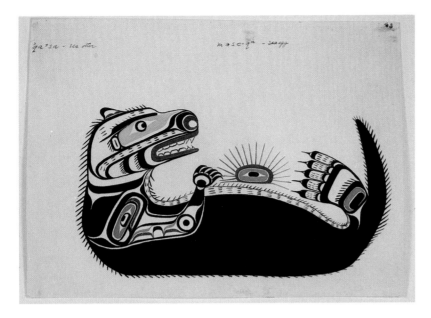

A

Plate XXIX. A: Sea otter and sea urchin, painting by
Mungo Martin. Watercolor on paper. Width: 16½ in.
Museum Purchase 1950. A9056. B: "Tsonokwis" (Tsonokwa
of the Sea) with octopus, painting by Mungo Martin. Water-
color on paper. Width: 18 in. Museum Purchase 1950.
A9045

B

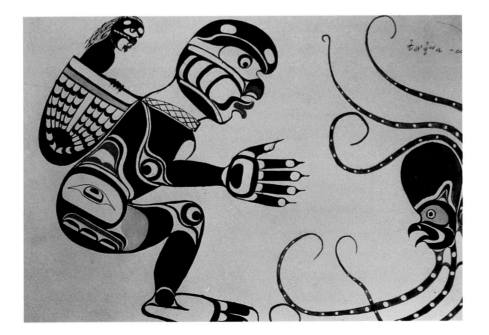

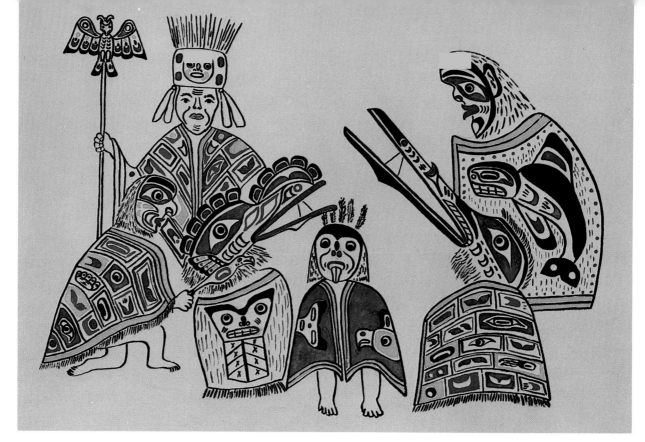

A

*Plate XXX. A: "Ceremonial Dance Masks," painting by
Lloyd Wadhams of Turnour Island. Watercolor on paper.
Width: 17 in. MacMillan Purchase 1962. A8004.
B: "Moonmask Dancers," painting by Henry Speck of Village
Island. Watercolor on paper. Width: 17 in. MacMillan Pur-
chase 1962. A8003*

B

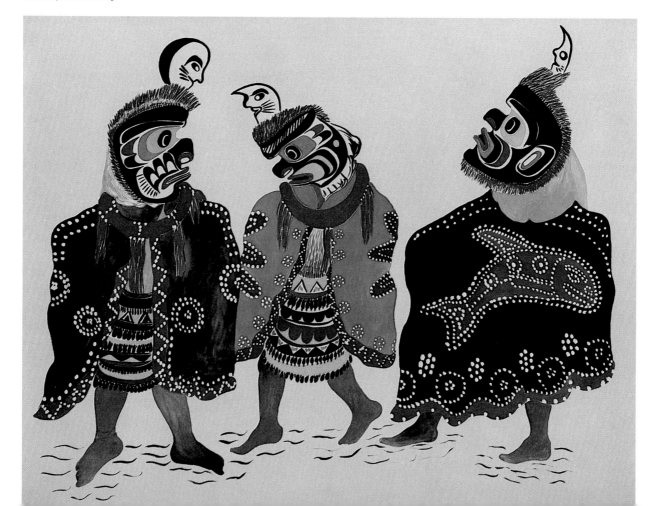

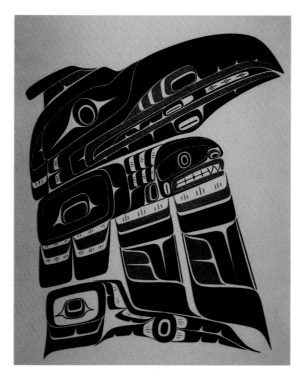

A

Plate XXXI. A: Raven painting by Roy Hanuse. Tempera on paper. Length: 12 in. Museum Purchase 1970. A9310. B: Killer whale painting by Roy Hanuse. Tempera and ink on cardboard. Width: 15 in. Walter C. Koerner Collection 1970. A9309

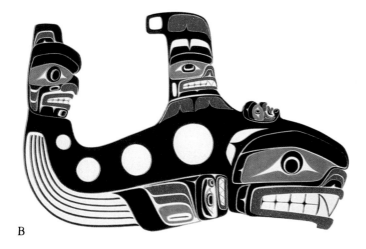

B

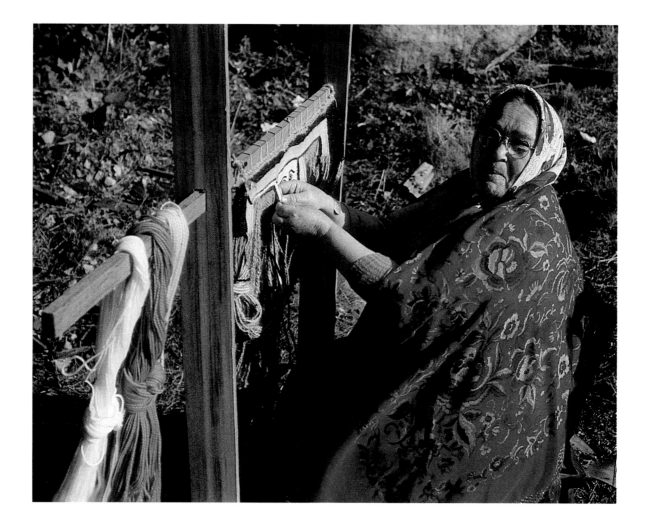

Plate XXXII. Mrs. Mungo Martin weaving a Chilkat blanket. University of British Columbia, 1951

The Sisiutl (Figs. 206-18), one of the most frequently depicted supernatural characters, was central to the themes of warrior power, strength, and invulnerability; the ability to cause death; and the contrasting theme of revival. In the myths, the Sisiutl guarded the house of the sky people. It was associated with the war dancer and with the Tokwit dancer, who performed magical tricks with figures that rose from the ground and flew from above. It was also associated with the *duntsik* or power boards (Figs. 219-30), abstracted forms of the Sisiutl itself, which appeared at the command of the Tokwit dancer and, when tapped by her magical wand, separated and glided from the room.

The form of the Sisiutl reflects its powers: it is double-headed, with serpentlike protruding and flickering tongues. The central portion is a face with stylized human features, surmounted by supernatural horns; another horn is seen on each serpent head.

The Sisiutl comes to the warrior at his command. Its body can act as a self-propelled canoe; its glare can cause a man to die, his joints turned backward. The blood of the Sisiutl, rubbed on the body of a warrior, makes him invulnerable. Warriors used the figure of the Sisiutl as a headband, a belt, and a bow. Among other beings associated with Sisiutl are Thrower, Flyer, and the quartz crystal that can be thrown to kill.

Bookwus (Figs. 437-48), the Wild Man of the Woods, was human in form and lurked on the edges of the forest and its streams, where he tried to persuade humans to eat food he offered them, after which they would become like him. He was associated with the spirits of people who had drowned and who hovered near him, and was also linked with the underworld of the dead from which ghosts returned during the season of the winter dance. Bookwus is represented as a shadowy human whose mask has attributes of a skull: deeply socketed round eyes, protuberant brow, and hollowed cheeks. At times the lips are drawn back over the prominent teeth.

Other Beings Shown in the Winter Dances

The beings associated with the winter dances are rarely portrayed outside of these dances and rarely, if ever, shown in representations of lineage myths, but are reserved for the most sacred parts of the winter ceremonies. Pre-eminent among them is the obsessive devourer of humans, Bakbakwalanooksiwae, and his servants, the bird-monster trio—Hamatsa Raven, Crooked Beak, and Hokhokw—and the female attendant. The bird-monster trio,

distinguished by their enormously flaring nostrils and long fringes of red cedar, are more fully described in the section on the Hamatsa ritual (pages 105-6). The female attendant wears no mask, but on her head is a distinctive helmet of red cedar bark (Fig. 174). Other attendants, called Solatlala, carry rattles (Figs. 140, 141, 146-49) that serve to pacify the monsters.

Another series of dancers who appeared in the initiation portion of the winter dance were the Atlakim dancers, those "bringing treasures from the forests" (Figs. 231-52). There were at least forty distinctive dancers, whose masks were made to be worn only for their brief four-day role and to be burned at the end of the season. (The fact that the masks in the museum collection had not been burned was explained by Kwakiutl informants by saying that the owners "didn't want to," or "wanted to save it." They may have felt that a new possibility had opened up, in that the opportunity to sell Atlakim masks to the outside, non-Kwakiutl world removed them as effectively as burning would do, and in addition had a financial benefit.)

The masks, in general, represent treasures of the forest and incorporate fresh spruce and hemlock twigs, clusters of bird feathers, and occasionally tree moss, ferns, and other forest tokens. Understandably in light of their brief use, some of them are rather crude. Mungo Martin reported starting to make a set at sunset and completing them by dawn. They are sometimes made of boards, roughly split or sawn and cut to size. Many are formed by simply nailing the two boards together at an obtuse angle. Little carving is attempted. Features are painted on a white background and are delineated in a quick and often caricatured fashion. Each mask has the features of a face that is only incidentally human. Extra features may be added to the flat surface by nailing them to the board. The effect is meant to be lively, humorous, and slapdash.

The museum collection does, however, contain some well-carved Atlakim masks, clearly identified by Mungo Martin and others as Atlakim. The departure from the usual style might be the result of a growing desire by the owners to retain masks for a longer period, as family possessions, or as a testimony to the desire of a new generation of carvers to affirm their skill.

In the same sequence in the winter dance were the ghost dancers, who were involved in the pageantry associated with death and revival (Goldman 1975:108). They wear wooden skulls as masks, carry wooden skulls, or wear red cedar bark costumes to which wooden skulls are attached as ornaments signifying the themes of death and revival (Figs. 198-203).

The Copper as an Icon

The copper is represented in its full form or in fragments—the T-shaped ridge or pieces broken or cut from it. These are sufficient to identify it (Figs. 266-70).

". . . The Kwakiutl themselves explicate the meaning of copper shields when they identify them as red, as salmon, as light, as capable of death and resurrection, as pertaining to the sky and to the sea, and so on" (Goldman: 1975:7). This statement gives the profound context that makes the copper so endless and strong a theme. In Kwakiutl art the copper is found on flat and carved wood, textiles, and metal surfaces, always in the same shield-shaped form. It is embroidered on dance aprons and blankets; painted on screens; carved or applied on staffs, rattles, headdresses, and totem poles; and recorded in special carvings to mark the special occasion of a chief's actions.

Special artifacts—harpoons, wedges, and cutting stands—were devised to establish the complex series of rituals in which the copper was ceremonially cut up or broken and distributed (Figs. 272-86). To officiate when dealing with a copper the chief donned a special mask of Tsonokwa, which was carved to depict the male qualities of the giant in warrior aspect, fierce, aggressive, and alert.

A Further Note on Identification

It was necessary that the members of the family that had commissioned the carving of a pole, or the masks belonging to the dances in which they took part, should recognize the icons of the carving or painting, and should know how they fitted into its history and its claims. It was also necessary that the guests who witnessed the inauguration of the pole or the use of the masks should recognize the legitimacy of the icons within the owner's claims. Consequently, the images portrayed by the carver had to follow conventions that enabled recognition by those who were present at the ceremony and heard the recital of family claims. Nevertheless, the artist's creativity had a great deal of leeway within the guiding conventions, and this was used to such an extent that persons who were not present cannot count on reading or deciphering the work of art as though it were the written account of the history or the myth, or even on identifying all the images unless they know in substance the family myths and claims.

The uncertainty resulting from creative individuality is greatest for certain items, such as boxes, gambling sticks, and Chilkat blankets. The naming of the elements of the decoration on many of these puzzled Swanton and Boas. A probable explanation for the greater obscurity of their decoration, which often appears to resemble common icons but fails to permit certain identification, was given by Wilson Duff (personal communication; see also Holm 1974:24), who pointed out the frequent change of ownership of such objects, through exchange, gift, sale, or gambling. Their utility for such exchanges would have been hindered if their decoration had such a clear crest identification that ownership would be limited to those possessing the particular crest.

The portrayal of individual claims on tribal crests was arranged by the carver and the persons who commissioned him. An outsider, asked the identity of the figures in their special combinations, might be able to give only the generalized account of the easily recognizable figures as they occur in the myth (Barbeau 1950:II, 762 ff.).

Inheritance

The Northwest Coast concept of property was basic to every action and purpose of life.

The chief of the lineage and those in his house shared the inherited material wealth of the family line, such as fishing grounds, berry fields, and hunting sites. These were well-defined places and rights. In addition, they amassed and created other material wealth: the large lineage house in which they lived, the totem poles that proclaimed their crests, and the boxes of preserved foodstuffs. The related intangible properties were fully as important. A series of rank names and positions were inherited and held by an incumbent until he retired or died, at which time his successor was installed. Inherited also were the series of ancestral myths and the right to recount these; the right to use certain crests, masks, and utensils; the right to use certain lineage names and to sing certain songs; the right to wear particular costumes and to perform the dramas of the family myths.

A recounting of a family myth—the legend of how crests, names, songs, and ceremonial privileges were obtained—is given by Curtis (1915:137). In an isolated place the individual encounters some supernatural beings, who grant these boons, as in the following legend of the gens Walas of the Lekwiltok sept Wiweakam:

Yakayálitnuhl was walking near Tēkya, when he saw sitting on a rock a very large bird covered with soft down of dazzling whiteness. The tip of its hooked beak could just be seen in the midst of the thick down. He cried out, "Whatever you are, I *tlúgwala* (to find a treasure; specifically, to obtain special powers and privileges from a spirit. [Curtis' note]) you!" The bird threw back the feathers and skin from its head, revealing the head of a man, and spoke: "I am *kólus*, yet I am a man. My name is Toqátlasaqiáq ('born to be admired')." His face was steaming with heat, because of the thick covering of feathers. Soon the entire coat fell away and he stood forth with the full figure of a man.

The bird man accompanied Yakayálitnuhl to his home, and told him: "Give a winter dance, and you shall have these dances from me: *sŭnqŭnhulikiyŭ* (thunderbird), *hóhlŭq* (a fabulous bird), *nŭ'nálahl* ('embodiment of the personation of weather'), *há'maa* (a large,

fabulous bird), *hámasîlahl* ('wasp-embodiment'), and *kólus*." All these dances came from creatures of the sky.

Yakayálitnuhl founded the Walas gens, this word ("big") being another name of the bird *kólus*. It is believed that members of this gens are easily thrown into perspiration, as was the bird man by his feather garment.

Each person held a ranked position reckoned in relation to the lineage chief, who was also a household head. All clan prerogatives and privileges were personified in him.

Curtis (1915:139) lists various titles of address in use among the nobility:

Áte is a title of respect and reverence, and is best translated "sir" or "lord." *Tlŭwŭlkŭmi* ("eldest son of a chief") is equivalent to "prince," and the corresponding feminine title is *ḳítihl*. In many cases the chief of a gens refers to his eldest son by a special hereditary epithet, such as *tlúgwi* ("treasure"). *Kii* is a term of endearment applied to the eldest child by the parents and the other children, as well as by one lover to another. Any one of noble rank is *gýikŭmi* ("chief"), and the head chief of a tribe or a sept is *hámakŭmi gýikŭmi* ("leader chief"). . . . A person of humble birth, or one who wishes to humble himself for the time being, addresses a noble with the deprecatory word *ḳáqiti* ("slave owner," that is, "I am your slave"), or *wáĩsiti* ("dog owner").

Title and privilege in one's family were strengthened and increased by marriage alliances with families that possessed other privileges; the children of such marriages would become doubly rich. Among the northern tribes—Tlingit, Tsimshian, and Haida—the maternal line was the important one for the transmission of family privileges.

Kwakiutl social organization was characterized by a paternal reckoning of lineage, except in the transfer of family prerogatives and privileges via marriage agreements. There was a special ceremony by which the inherited privileges of the wife's ancestors were transmitted to her husband by gift from her father. The transfer consisted of the legend, myth, dance, song, and crest form, represented by a special box containing masks, crest,

and whistles. These were given to the husband in potlatch, not for his own use but to be transmitted through him to his children or other heirs. The blowing of the whistle was the sign of transfer to take place during the initiation ceremonies in the Tsetseka season.

This double inheritance of family privilege with its associated crests, recitation, songs, dances, and apparel is the endless theme of Northwest Coast iconography.

Several other ways of acquiring family crest privileges were open to the people of the Northwest Coast. One was the acquisition of privilege by murder: killing the original owner allowed the victor to assume his privileges and material regalia. So important an institution as the whole Hamatsa dance complex, of primary rank among the dancing societies of the Kwakiutl everywhere, was obtained by the Fort Rupert Kwakiutl in 1835 by killing a group of Heiltsuk who were out in a canoe and seizing their regalia. A similar result could be achieved through taking a prisoner who became a slave, and thus lost his possessions and his position in the social group.

Another form of acquisition was by a gift, which could then be used by the new owner as one of his family privileges. According to a myth of the Kwakiutl, they were given the Kwekwe dance, mask, and rattles of the Comox by the latter after the Kwakiutl had gone over prepared for war to take it from them because "that's a very fine dance they have over there" (Boas 1905:236).

One other method was not formally acknowledged, but it is likely that there were a number of irregular borrowings in which the object was simply copied and a myth invented to justify it. If this myth was performed before the potlatch audience without public ridicule or challenge, then it could become an established part of the repertoire. This has been possible during the last eighty years because of the great loss of population that followed the invasions of new disease. There were many more family privileges available in many lineages than there were people to fill them (Codere 1950:97). A new condition arose, in which a person with social aggression but limited family privileges would pay an owner to recount the details to him. He then used these authenticating features so that he could publicly claim the privilege (Olson 1950).

Finally, there must have been some individual initiative and invention of prerogative. Curtis (1915:158-59) says that such an invention could be justified by its audacity, by the interest and charm of the new design, and by the failure of the audience or of a specific rival to challenge the invented myth.

32

The
Potlatch

The Kwakiutl individual of rank was concerned that others should recognize his claims and status. The same preoccupation was characteristic of the lineage group and of the villages in relation to each other. This concern was expressed in the institution of the potlatch, which provided a channel for claims to be made publicly, privileges to be displayed, and ceremonial hospitality to be offered. By accepting suitable gifts, guests in effect took payment as witnesses. The claims thus established by the host would be accepted at future potlatches.

The word "potlatch" comes from the Chinook Jargon, meaning "to give." Elaborate feasting and hospitality, accompanied by the bestowal of gifts, were the core of this ceremony, without which no important social event could take place and no claim could be made. All of the names, ranks, privileges, and honors of the lineage inheritance were meaningless without this formal ritual of hospitality and the acceptance of gifts by the guests.

The social occasions calling for validation by a potlatch were numerous: the transfer of marriage privileges, the assumption of a new name by a youth or the giving of a new rank, the new use of a family crest, the initiation of a new dancer into the dancing societies. Each of these was the occasion for a full-blown social effort, often involving intertribal invitations. Among the northern coastal tribes, the most important occasions were a series of mourning cycles and the raising of mortuary poles to a deceased chief; among the Haida, they were the raising of a new house and the introduction of a new lineage chief.

The basic procedure of the potlatch was always the same. The lineage chief would consult with the older members of his household group, for the potlatch effort involved the entire household or kin group. When it was agreed that the potlatch should be held, and the date had been set, preparations began. Food sufficient to feed guests over a period of time must be gathered, prepared, and stored. Enough gifts to give to all must be produced, and the needed goods bearing the family crest carvings must be amassed. The carver of the chief often lived in the chief's house (as did the speaker of the chief, who acted as official orator on ceremonial occasions), and since he knew all of the

inheritances he could carve any item with its appropriate designs.

In order to make ample gifts available, outstanding loans were called in as of a certain date. A system of loans and interest, indebtedness and reckoning, was an elaborate aspect of Kwakiutl life. Most public actions were financed by loans of white wool blankets, valued at one dollar each, which had been brought in by the Hudson's Bay Company early in the nineteenth century. These rapidly became a standard unit of value, and the other goods were appraised in terms of their value in blankets. The rate of repayment, which was agreed on at the time of the loan, varied according to the period involved; 100 per cent interest for a year's loan was standard.

New wealth was created by labor. Mats, baskets and boxes, furs, canoes, jewelry, and dishes were made for the gift-giving. After the arrival of trade goods, new items such as sewing machines, china dishes, and crates of oranges were purchased with the family's monetary earnings and given away. The essence of wealth was that it be distributed ceremonially.

Emissaries of the chief set off to invite the guests. When the time came for the event, these same emissaries, wearing formal costumes, went back to act as guides for the visitors.

The family of the host with the song leader and the speaker, in their finest robes and headdresses, stood upon the beach singing and dancing to greet the visitors as they approached by canoe. Sometimes large figures carved of wood were placed facing the sea to reinforce the welcome. Visitors were announced by the speaker and were seated according to their rank, in a traditional seating arrangement.

For the feasting, food dishes of varying sizes were brought in and passed around according to proper ritual as the herald explained the ancestral names of the food dishes and their history. The speaker also urged the different chiefs by name to eat and enjoy themselves, in the name of the host.

Since the potlatch was tied in with many social occasions great and small, it varied in length. Many family members offered minor episodes, such as the naming of a small child, as part of the major event.

One or more major events would be offered as a feature of each day. Family dances and dramas were enacted by dancers in masks and costumes to the accompaniment of songs and explanations by the speaker. Even more dramatic were the days when members of the family were introduced into the dancing societies. Each occasion was followed by feasting, oratory, and some gift distribution. Usually there was a climax of one form or another—a dance, a drama, or a copper-selling ceremony—then the final feast and speeches, during which the finest gifts were given away.

Potlatch gifts were bestowed as free donations by the host and his household. They were distributed in order according to the rank and position of the tribal lineage heads. Correct precedence was maintained by an official who called out the names as the gifts were given out. This was in itself a public recognition of the ranking positions of the lineage. The most important chiefs received the important and generous gifts, while people of little rank received token gifts. Extratribal visitors were also presented with gifts. Gifts, as payment, were made to the carvers and others who had served in preparing the potlatch.

If the potlatch was successful, all of the family group shared in the glory and pleasure of the social effort. Such an event might be spoken of up and down the coast with approbation and appreciation.

The immediate effect of the coming of the white man was to increase the variety of goods available to the Indians, who proceeded to trade with him for copper sheeting, muskets, brass and copper wire, and blankets. With the founding of Hudson's Bay Company trading posts at Fort Langley in 1827, Fort Simpson in 1831, Fort McLoughlin in 1833, Fort Victoria in 1843, and Fort Rupert in 1849, these materials became even more generally available, and the cultures reached a high point of activity in potlatching and carving (Codere 1950; Duff 1964:53 ff.).

Disease devastated the tribes, beginning in 1838 and reaching a peak in 1862, leaving 20,000 people dead, villages decimated and sometimes deserted, and much of the social system changed (Codere 1950:97; Duff 1964:42). In spite of disease, the reserve system, and the pressures on the Indians to become converted and assimilated into the white culture, lineage inheritance and the potlatch continued, and the southern Kwakiutl continued to borrow and adapt the ceremonial patterns of other tribes, particularly the dancing complex of the northern Kwakiutl.

In 1884, as a result of the disapproval of missionaries and government officials, the potlatch was made illegal. In spite of the prohibition, however, the potlatch was so interwoven with the purpose and meaning of Kwakiutl life that it continued, al-

though away from the main centers. In 1921, acting on secret information given by an Indian, the police sent a contingent to interrupt the potlatch of Daniel Cranmer of Alert Bay. Several of the participants were imprisoned, and the masks and coppers of the host and his guests were taken to the National Museum.

Since potlatching was an inherent sanction of so many important transfers and relationships, its discontinuance made coherent tribal life impossible. In 1951 the ban on potlatching was repealed, and the institution, which had operated under cover but in a diminished way, took on new vigor.

The potlatch made possible a wide distribution of vast amounts of goods and kept them moving as various forms of wealth, both material and nonmaterial, circulated among groups and individuals. It has been described as life insurance for the successor to a chief's position, for the new chief would receive all of the returns and interest for loans out in his predecessor's name, although against this he also owed to others the loans they had made. It was a socially integrating force for households, all of whose members benefited from the public recognition of their cooperative social effort. It was also integrative as a face-saving device for restoring the social equilibrium of an individual or group. If a mistake had been made publicly in ritual or etiquette, a potlatch could be given for the purpose of wiping out the incident, and those who received gifts would not refer to it again.

One type of potlatch that has received a great deal of attention is the rivalry potlatch. After the devastating effects of disease had decimated the Kwakiutl tribes, there were a number of positions and names open in the various lineages. Originally there were 658 positions in the social ranking system of the Kwakiutl. By 1898, of 1,597 people surviving only 637 were men of 16 years or more—not even enough to fill these positions (Codere 1950:97). A number of *nouveau riche* individuals asserted their claims to vacant positions, and the possibility of giving away great wealth aroused other rivals to compete for the same places with more and more lavish ceremonies, characterized by conspicuous waste.

There had always been a formal rivalry between the heads of various lineages. This, of course, heightened the suspense of ritual demonstrations, as first one chief and then the other gained apparent precedence. Actual practice was usually characterized by mutual agreement and coexistence. With the intensified struggle of rivalry for places that became open because of the shrinking of the population, the destruction of property by flamboyant gestures became more frequent, and quantities of food and property were destroyed by the aggressive contenders for supremacy.

The Copper Complex

The copper was an item of essential importance in the potlatch economy of the Kwakiutl, as well as among the Haida, Tsimshian, and Tlingit. These decorated sheets of beaten copper, a symbol of prestige and of surplus wealth, appeared in the same form among all these people (Figs. 266-70).

All known coppers were made of rolled sheet copper, which became an item much desired in trade soon after the first contact with the white man at the end of the eighteenth century. There is a tradition that earlier coppers were made of the naturally occurring metal traded down from the Coppermine River area, although there are apparently none of these now in existence.

Each copper had a name that boasted of its value: "all other coppers are ashamed to look at it," for which 7,500 blankets were paid; and "making the house empty of blankets," for which 5,000 blankets were paid. Each represented the number of blankets paid to obtain it, and had no function except to serve as an index of wealth.

The copper among the Kwakiutl was valued at the actual price of its last purchase. New purchasers vied to invest more property in it than the previous owner had been able to do. Thus a copper that was bought at the climax of a potlatch represented the triumph of the wealth of the host and his kin group, since it made it clear that he retained a surplus even after the extensive feasting, gifts, and ceremonial payments. Such an "auction" was a focal point of drama and excitement, as rival chiefs bid higher and higher for the copper. To purchase it was to win ceremonial distinction.

The ritual involving the purchase of the copper is described in detail by Boas (1897:345):

The trade is discussed and arranged long beforehand. When the buyer is ready, he gives to the owner of the copper blankets about one-sixth of the total value of the copper. This is called "making a pillow" for the copper . . . or "making a feather bed" . . . or "the harpoon line at which game is hanging" . . . meaning that in the same manner the copper is attached to the long line of blankets; or "taken in the hand, in order to lift the copper." . . . The owner of the copper loans these blankets out, and when he has called them in again, he repays the total amount received, with 100 per cent interest, to the purchaser. On the following day the tribes assemble for the sale of the copper. The prescribed proceeding is as follows: The buyer offers first the lowest prices at which the copper was sold. The owner declares that he is satisfied, but his friends demand by degrees higher and higher prices, according to all the previous sales of the copper. . . . Finally, the amount offered is deemed satisfactory. Then the owner asks for boxes to carry away the blankets. These are counted five pairs a box, and are also paid in blankets or other objects. After these have been paid, the owner of the copper calls his friends—members of his own tribe—to rise, and asks for a belt, which he values at several hundred blankets. While these are being brought, he and his tribe generally repair to their house, where they paint their faces and dress in new blankets. When they have finished, drums are beaten in the house, they all shout "hī!" and go out again, the speaker of the seller first. As soon as the latter has left the house, he turns and calls his chief to come down, who goes back to where the sale is going on, followed by his tribe. They all stand in a row and the buyer puts down the blankets which were demanded as a belt, "to adorn the owner of the copper." This whole purchase is called "putting the copper under the name of the buyer." . . . On the following day all the blankets which have been paid for the copper must be distributed by the owner among his own tribe, paying to them his old debts first, and, if the amount is sufficient, giving new presents. This is called "doing a great thing." . . .

When rivalry was fierce, the aggressor might "break" his copper. In this case, the copper was literally cut up, and the pieces, representing deliberately shattered wealth, were handed to the rival chief. The latter then had to destroy wealth of equivalent value or suffer shame. The broken copper could be riveted together and reused, but its value had to be re-established. As an ultimate gesture of magnificent waste, the whole copper could be thrown into the water and "drowned."

The copper as a symbol of conspicuous and surplus wealth was an endless theme among the Kwakiutl. Names of high-ranking people often contained a "copper" word: "Born to be Copper Maker Woman" was the important name of the wife of Komokwa, "The Wealthy One," who also had the name of "Copper Maker," and so on. Copper was also conceived of as a material of magical properties affecting human health. Indeed, the copper symbolizes light, salmon, and other elements basic to life (Goldman 1975:7).

The Ceremonial Year

The active working months of a successful spring and summer led to the accumulation of vast preserves of smoked and sun-cured fish and oil stocks. Summertime was the Bakoos time, the nonceremonial, secular part of the year, a time for travel, family camping, and the gathering of food.

With the onset of the rainy winter months, the Kwakiutl retired to their home villages and into their large cedar plank houses. These wet, cold winter months were a time of elaborate theatrical performances and ceremonies. This was the climax of the year, the Tsetseka, the ceremonial or supernatural season.

The name Tsetseka was taken from the Heiltsuk word for "shaman," the magician of the northern peoples who dazzled his audience with his demonstration of tricks. Along with the word were borrowed the supernatural and even sacred overtones of secret and magical tricks. This was the time when the supernatural spirits came for the purpose of initiating the young into the dancing societies. Everything during this season was different from the rest of the year—names were changed, and there were penalties for those who forgot the new ones; songs were changed, and the ways of singing them were changed. Everything directed attention to the special nature of the Tsetseka season.

At this time a new social order came into force. Clan, rank, and Bakoos names were replaced by a system according to which individuals were related to the spirits. Those of high secular rank had claim to the highest ranking spirit dances, but each person had to be formally initiated into the society his inheritance entitled him to join.

The change-over from the Bakoos season to the Tsetseka season was marked by a four-day carnival interlude devoted to celebration, joking, laughing, and feasting. Although this was essentially a time of pleasure and relaxation, it was introduced with a brief period of mourning songs commemorating those who had died since the last Tsetseka season. During the singing of each person's songs, members of his family lineage wore mourning masks (see Figs. 153-55).

After this memorial service, the masks were put away and the new order of merriment and revelry began. Boas and Curtis mention a special display of family masks that took place at this time. This is described by Curtis (1915:171):

A peculiar pantomime in which none of the regular dancers appears . . . is conducted as follows: On the first night the giver of the ceremony announces . . . [that he will show] . . . all the masks owned by his family, which have been arranged in rows behind a curtain stretched across the rear of the room. While the people strike with their batons without singing, the curtain is raised with three ropes passing over a roof-beam, and every mask suddenly rises and moves about in its place. In a few minutes the curtain is lowered, and with brief intervals the spectacle is repeated three times more. The maskers are supposed to be carried away by the spirits which they represent, and hence they remain hidden during the next three days. On the second and the third night there is no dancing, but a feast is given, and on the fourth night the dancing with masks is repeated in order to recover the maskers from the spirits that have captured them.

Feasting, oratory, and the display of family privileges in drama and dancing were all part of the proceedings. The description that follows is a summary of the details of the ceremony practiced by the southern Kwakiutl, in particular those of Alert Bay and the adjacent islands. This account differs in its elaboration from that given for the northern Kwakiutl by Olson (1954 and 1955) and Drucker (1940).

During the time of these dances, whistles were heard in the woods and the novices disappeared one by one. On the fourth night, following the performance of a dance calculated to excite the Hamatsa, he returned from the house of Bakbakwala-nooksiwae where he had been for some time, traditionally four months. The Hamatsa dropped down through the roof of the house, rushed wildly about surrounded by his attendants, and suddenly disappeared. Then the people went home, bathed ritually, and completed the preparations for the days to come—the days in which the spirits would

return and initiate the descendants into the secrets of their dancing orders. The next morning whistles were heard again in the woods. The people went out and "captured" the novices and the Hamatsa and brought them into the dance house. This was the start of the true Tsetseka season.

The Tsetseka Season

The essential element of the Tsetseka season was the initiation of the novices. The day after the whistles of the spirits were blown, the novices disappeared, supposedly taken away by the appropriate spirit to be inspired. During the time of their absence they were prepared for their role. Each dancing society initiated its novices secretly, closing its house to all noninitiates, each night being devoted to feasting for the members of the dancing house.

On the fourth night, after the novice's return, the whole village, and even outsiders, were invited to see a dramatic performance showing how the novice had been seized by the spirits, how he had acted while under their power, and how he had once again become human. On cue, the novice made a dramatic entrance, gave his cries, danced, and showed by convincing behavior that he was in a state of spirit possession. In the course of his dancing he demonstrated his magical tricks.

In a series of ritualized acts the attendants and assistants to the novice helped to gentle him, to calm him. Eventually, when he had been tamed, he returned to human society and danced more quietly. The length of this performance varied, the more elaborate ceremonies taking several days.

At the end of each stage of initiation, gifts were distributed and payments were made to those who were to be indemnified and to those who had assisted the novice. With each day's performance a feast was held.

In each village there were two groups: the uninitiated, who acted as an audience for the novices, and the initiated. The initiated were divided into two orders: the Seals—the Hamatsa and the war spirit dancers who were the high-ranking dancers; and the Sparrows, who included all the others, from children to old men and women. Those who had been initiated into the Seals but who wished to retire went into the Sparrow group. They were still high-ranking elders, who continued to direct events but were no longer under the influence of the supernatural spirit. The Sparrows comprised a series of age-grade groups: the youngest boys, called Sea Parrots; boys from thirteen to fifteen, called Mallards; the strong young men, called

Killer Whales; the oldest men, called Whales. Girls and women had equivalent names; the oldest group of women were called Cows (see Curtis 1915:164 for a complete list).

In some northern Kwakiutl tribes there was a separate dancing order, Mitla, whose novices were initiated by the spirits. In other dances Mitla was the name of a character who danced with supernatural tricks among those initiated by the war spirit. Another supernaturally inspired dancing order, Noontlem, or "Dog-Eaters," was common in the north, but among the southern Kwakiutl this word was used for dances not supernaturally inspired.

The Sparrows acted as jeering, mocking teasers of their high-ranking rivals, the Seals. This made for a comic interplay. Curtis (1915:205) reported this dialogue when the Tokwit, the female war spirit dancer, was looking for a box large enough to climb into so that she could (apparently) burn herself up:

At the end of the song she stood beside the fire, unwilling to leave. Now and then she cried ep ep, ep, ep ep! or, op op, op op!
The sparrows, who sat squatting about the room now began to call: "Well, ask her what she is going to do. If she is going to do anything, hurry and have it over! If she wants us to do something for her, say so and let us get about it!"
Some little distance from the singers sat . . . "Quick hearer," who holds his position by inheritance. The winter-dance speaker rose, saying, "I will ask what she wants." He went to the woman and appeared to whisper to her, but she made no reply. . . . "Quick hearer" in his place bent forward as if listening intently, and exclaimed: "I know what she wants! She says she wishes to be burned in the fire!"
The sparrows at once began to shout their willingness to perform whatever duties were necessary in carrying out the torture, but the woman turned and walked characteristically here and there in the space between the people and the fire, with gestures indicative of throwing magic power from her palms into the floor, and constantly crying op op, op op! Each utterance was accompanied by soft beating of the batons. Then she went to the fire and repeated her cry. Immediately the sparrows set up a babble of shouts: "She wants to go into the fire! Build up the fire! Push her into the fire, friends!" She moved round the fire, which was at the rear and somewhat to the left of the room, and the sparrows continued to make disparaging remarks about her: "Ha! Dancers of that kind are full of lies! They pretend to have been around the world!" The woman stood there for a while, then started again turning around and around and going over the entire floor, putting magic into it. Some of the sparrows followed her, imitating her motions and cries, and saying, "I can do the same thing!" Their leader . . . was particularly active. He

now called to some of his companions, "Come, stand close to me and burn me up, instead of this liar!"

After the woman had encircled the fire the second time and stood at the rear of the room, the . . . [leader] went to her, broke off a few twigs from her kirtle, and put them on his head, saying to his men, "How do I look?" The sparrows gathered round him in the right rear corner of the house, while the *tokwit* went to the left rear and on round the fire for a third time. At once . . . [the leader] started after her, imitating her. After the third circuit, some of the sparrows cried to the speaker . . . : "Well, are we going to stay here all night watching this woman go round the fire? Ask her what she is going to do!"

The Sparrows tried to provoke the other group into violent behavior, especially to prevent the retirement of the Seals from active dancing.

Associated with each of the winter dancing societies in its own dance house was the order of seating, with a place for the song leader, the drum beater, and the heralds who directed the events, and specially ordered places where the singers sat. Each society followed its own order and ritual. All the societies used certain outward signs taught to them by their supernatural ancestors: red cedar bark to be worn on the head and neck; eagle-down to float on the people softly, as a sign of peace; red or black paint to adorn the face.

After all who claimed membership in the societies had been initiated, food supplies in the houses were low, and each host prepared a special farewell feast. When the final gifts and payments had been made, the speaker warned that soon the season would change again. Everyone sang the last Tsetseka songs, danced, and used the Tsetseka names. The red cedar bark was burned; the face paint was removed. Then a summer song was sung; the people turned and addressed each other by their secular, nonceremonial names; and the Tsetseka season was over for another year.

Staging the Tsetseka

In a sense, the whole of the Tsetseka season was staged. Each portion of it was under the guidance of the heads of the dancing societies and was carried out under their instructions by a group of officials—speakers, heralds, and hereditary officials with specialized duties. These controlled the time of beginning, agreed on the sponsor's dancing houses, and helped arrange for the spiriting away of the novices. Within the dancing society, the initiated ones participated in planning the proceedings, with the proper ways of appearing, dancing, uttering the special cries, and staging the dramatic tricks. The intention was always to convince the village of the real presence of spirits and the supernatural.

The house itself was a stage, with seating arranged so that the wall next to the curtain was shielded, and the dancers could come and go unseen. The central fireplace was the focus of attention. Dancing took place around the fireplace—the dancers moved four times around, counterclockwise, pivoting at the front and the back of the house, then disappeared. The performers entered suddenly through the front door, while others left unnoticed.

Illusion was managed in many ways. "Prop" men hidden above the beams of the house manipulated the strings that helped the dancers to control their magic tricks. Supernatural birds or other creatures, announced by thunderous noise on the roof, flew down through the air, appeared to pick up a person, and then flew up again. Underground passages increased the repertoire of magical tricks; such illusion gave credence to the presence of spirits. Curtis noted that some people even stayed home in the deserted village during the summer berrying and fishing times in order to prepare the tunnels under the floor of the Ghost Dancers' House.

Staging was always deliberate. Even the apparently spontaneous destructive frenzy of the Hamatsa was subject to planning (Curtis 1915:179): "He advances on certain lines which have been secretly marked out on the floor, and those who have been previously warned by the initiator that hamatsa will bite them sit where these lines touch the edge of the open space, so that hamatsa can easily reach them."

During the winter dance season the whole village, not only within the houses but also outside, becomes the scene of the pageant. A novice was sought after and captured on the edge of the woods. Another novice—balanced on boards over a low-slung canoe—arrived apparently dancing on the water. The use of illusion was an important element: one novice was seen arriving by canoe with his sponsor when there was a sudden accident, the canoe overturned, and the novice was drowned. He was later revived and danced amid general rejoicing. Actually the drowning figure was a cedar carving which was weighted down and sunk. In another example of illusion the Hamatsa novice, fleeing to the woods, apparently disappeared in mid-flight. The Hamatsas, wearing red cedar bark head and neck rings, went into the woods to capture the novice. On the way they were handed hemlock boughs, which they donned. They advanced toward the Hamatsa novice, who, in order to mystify the village spectators, quickly substituted red cedar bark ornaments for his green hemlock rings. When the crowd opened, he had apparently disappeared, quickly to reappear at a considerable distance in the person of a second substitute dressed exactly like him. This one was then surrounded and "lost" in the same manner (Curtis 1915:174).

In one part of the drama, the Hamatsa novice rushed out from the house with everyone else in pursuit. The Killer Whales, who had been teasing him, ran to take refuge in the water, where they were cornered by the novice. He was afraid to go into salt water, and they were afraid to come close to him for fear of being bitten. Several novices of the sea-creature spirits appeared for initiation at the edge of the ocean as though they had just come up from its depths.

Terror, drama, and comedy were balanced to produce good theater:

During the feast the grizzly bear may become aroused, growl and roar, and try to get out of the room.

The people scramble back to their seats along the walls, while attendants rush over to restrain the beast. After a terrific struggle, despite their efforts, a board will be torn loose, and they will all be sent sprawling, but instead of a grizzly bear the figure of a decrepit old man will totter forth [Drucker 1940:207].

Some dancers acted as buffoons and created a disturbance. Some were clumsy; some were mimics who staggered around imitating the actions of others.

While the real dancers are making their secret preparations behind the screen, the jesters amuse the audience. They dodge behind the screen, parody the coming performance. Or one may accuse the other of lying, then peek behind the screen and come out to report "the real truth" to a convulsed audience [Olson 1940:A:5, 175].

Meticulous attention to the details of theatrical illusion and dramatic impact characterized the productions of the ceremonies.

Within the large plank house, the central fire cast lights and shadows. At the far end opposite the entrance door was a theatrical curtain made of wooden planks or muslin with the crest of the initiating spirit of the dancing house painted on it (see Figs. 89, 90). Behind the curtain, awaiting their cues, were the dancers in costume. At one side was a small hidden cubicle to which the novice retreated. There were several such small rooms for the various dancers.

The dancing house in which the Tokwit dancers were going to perform was vacated and carefully guarded several days before the initiation. Underground passageways were dug, down which the dancer could disappear. A system of kelp speaking tubes was installed. Elaborate gear was brought to the house, such as false-bottomed chests in which the dancer would be concealed while apparently being consumed by fire.

Every opportunity to create drama was exploited. Various tricks were employed to create convincing illusions. An apparent beheading used portrait carvings and bladders filled with seal blood. The fire thrower handled burning embers in leather gloves with wooden palms skillfully put on by his attendants. He walked on the fire over wooden boulders wearing protective footgear. The Tokwit dancer climbed into a wooden box, was consumed by fire, and in due course was reconstituted.

Curtis (1915:212-13) described two other examples of illusion, summarized as follows:

Kinkalatlala walks about the house, making her cries. A noise is heard, and a wooden kingfisher appears. The bird descends to the dancer and follows him, darts at him and spears him with its long beak. It then flies up to the roof. The dancer has strings which raise and lower the bird, and there is a man above on the roof who also controls the strings.

The female Mitla spirit produces salmonberries out of season. Four masked female attendants dance around her. Salmonberry shoots are let down from the roof. The berries are pebbles covered with resin gum dyed with iron oxide. The people eat them and pretend to fall dead, but are then revived.

A simple device was the use of the dancer's blanket to aid in concealment. A gesture of a blanket-covered arm would make a screen behind which one mask could be changed for another, or a whistle held under the blanket could be blown secretly.

Hereditary Officials and Their Ceremonial Roles

Each functionary among the Kwakiutl had a specific job to perform during the winter ceremonials. Most of these jobs were hereditary, passed on from father to son. The speaker (Alkw) was a hereditary official who acted as spokesman for the chief on all public and ceremonial occasions. He had a badge of office, the speaker's staff, which he held at all times while addressing the crowd. This official, who usually lived in the household of the lineage chief whose spokesman he was, also acted as "taster" for the chief, helping to divert the immense amounts of food that were served out at ceremonial feasts.

Each society had a song master who invented, and then memorized, every song belonging to every member of the society. This office was not hereditary; the song master was appointed because he was very quick at making up and learning songs. Most members had four songs for each of their names. When a novice was to be initiated, the song master was called in by the sponsor and paid to invent the songs. He and his assistants retired to the woods, while the novice hid nearby, and after some experimentation devised a song which they and the novice memorized. These songs were subsequently brought out whenever needed as the theme of the dancer. During the dance the song master and his assistants sang the song while the people beat time with sticks as they danced around the room.

The baton master split the batons or music sticks for all the guests present and passed them out to the visitors to the house. He also brought in the long planks on which the sticks were struck. Later the sticks of the visitors, which were temporary, were collected and disposed of. Those of the leaders were carved and were permanent.

The senior members of the dancing societies who had retired from active service comprised a body of elders who directed proceedings to see that ritual and protocol were observed. Some of these kept watch during each dance and announced publicly when a mistake had been made in the dancing or behavior of the members. Those who had erred were publicly rebuked and might have to give a potlatch or gifts in restitution.

Other officials connected with the ceremonial organization included the following:

Four messengers for each sponsor of a dancing series, who invited the villagers. These messengers carried staffs of office. Other messengers invited other tribes and conducted them back to their villages.

The "Quick Hearer," who listened at dances and interpreted the movements of the dancers, calling out their wishes to the crowd.

The eagle-down gatherer and dispenser.

The cedar bark distributor of head rings for visitors and guests.

The Takiumi, or special distributor of gifts, also called "Holding the Upper Part," who was in charge of the distribution of gifts at the potlatch. He held up each gift as he called out the name of the recipient. This was a very responsible position, for the Takiumi had to remember the proper order of precedence since any violation of this might give rise to new struggles between rivals. His assistants handed out the gifts as he called them.

Four copper holders, including two to hold the copper, one to cut it, and one to hold the pieces.

The "Word Passer," whose position depended on musical talent and the ability to memorize. He assisted the song master and acted as a prompter, having memorized the songs made by the maker for each new dancer.

The distributor of tallow and paint for facial painting.

The drum beater.

"Hotluliti," or "Obeyed by All," a director of ceremonies for each dancing society.

Various attendants at each dance society who interpreted, ran errands, built up suspense, and so forth.

Various police officers or monitors who kept order. These helped the elders keep "score" of mistakes made by people during the ceremonies and called out errors at the end of the day.

In addition to these, as further examples of the detailed allotment of chores, for the final purifying ceremonies of the Hamatsa there were a stone picker, a wedge splitter, a tong splitter, a cedar bark shaper, a cutter, a dish carrier, and a water carrier. All of these were engaged in the tasks connected with the making of a cedar bark figure which was elaborately constructed at the end of the Hamatsa sequence and then purified by smoke and embers, thus releasing the Hamatsa novice from his involvement with the spirits.

Other societies had less complex, but similar, sets of chores and officials.

Dancing
Societies

In 1895, Boas listed fifty-three different characters who had roles in the dancing societies of the southern Kwakiutl. By 1913, when Curtis listed those he found at Fort Rupert, there were sixty-three such dancing roles (Curtis 1913:156-58). Of these it appears that some had proliferated, such as Mitla, and had been divided between a man and a woman. In general a role assigned to a man was danced by a man, but if there was no male descendant to inherit the dance, a woman could be eligible for it.

The investigations by Drucker, in 1938, of the dancing roles that had survived among the Kwakiutl showed that a number of both major and minor roles were still inherited and danced, at least until recent times, in a series of two or three dancing orders (Drucker 1940:228).

The dancing societies of the Kwakiutl consisted of four main groups. Of these the most important and the most complex was the Hamatsa society under the supernatural inspiration of Bakbakwalanooksiwae, a powerful man-eating spirit, represented in the dance by the cannibal dancer or Hamatsa, in human form. The second group was under the inspiration of Winalagilis, the war spirit initiator. The third group, the Atlakim dance series, could be used either for Klasila or for Tsetseka displays by changing the symbolic decorations. The fourth group was made up of the Dluwalakha or Klasila dancers (meaning "Once more from Heaven")—those who had been given supernatural treasures or *dloogwi*, which were passed on to the novice, but who were not, as a group, involved in the convincing and terrifying displays of supernatural seizure.

Among the northern peoples, the Tsetseka society comprised all those who acted as shamans, with the shamans' hereditary rights to supernatural healing powers and secrets.

A dinner attended by all the members of the dancing societies and given on the evening after the Hamatsa novice was tamed was described by Curtis (1915:231 ff.). A summary of his account follows.

At dusk, they began to assemble at the Hamatsa dancing house. The Sparrows, in their varied costumes representing animals, fish, and birds, filed in and were seated in their traditional seating places in the house. The guests from other villages, also in their costumes, were shown to their seats. Rushing in and shouting, two Fool dancers, tattered and unkempt, came carrying baskets of stones. They clumsily ran to their places, one to the left of the house, one to the right.

Two Hamatsa grizzly bears lurched in, their faces painted black, with great teeth. They growled, and sauntered to their positions. Thunderbird came in, with a flying motion.

The Hokhokws picked their way, stiff-legged like herons, as though looking downward into the water.

The War Dancers, with painted faces, carried lengths of rope. They looked up at the beams as though ready to swing from the rafters. All called out, "Don't do it, don't do it!" for these fierce warriors like to do violence. Tsonokwa, great and shaggy, stumbled in the wrong way round the fire, tripping over people as she went. Attendants guided her to her seat, where she subsided and fell asleep.

The Mitla, or "Thrower" dancer, appeared in the doorway, glowering and clapping his sharp clapper. He glowered fiercely, reaching for his magic weapon. Everyone cried out, "Don't throw it, don't throw it!"

Then silence descended on all. This was "the weight of the winter dance pressing on the people."

The baton keepers handed around the music sticks. The dance leader held his rattle high. A long pause: then it fell. The batons crashed! Vibrated louder! He raised his rattle again. Silence. Then he shook it; it fell. He raised it; four times it fell. The batons drummed a rapid crescendo. Then the singing began. The song leader led: all sang the songs of the Tsetseka season. Three songs were sung in succession by all.

Then the house attendants brought dishes and feast spoons, first to each of the four Hamatsas in whose honor this dinner was held. The Sparrows reached for the spoons and dishes, crying "Give it to me! Me first!" Their dishes were placed before them, and other dishes in turn were placed before the other guests.

Boas (1897:545-46) describes the conversation at a similar dinner. He is reporting the conversation of the age grades of the Sparrows:

While the people were eating, the different societies uttered their cries:
 "The hens are pecking!"
 "The great seals keep on chewing."
 "The food of the great killer whales is sweet."
 "The great rock cods are trying to get food."
 "The great sea lions throw their heads downwards."
. . .
 When uttering these cries, the members of the societies lifted their spoons and seemed to enjoy the fun. . . . Then they ate as quickly as they could, and all the different [sparrow] societies vied with each other, singing all at the same time.

Other Northwest Coast tribes had similar dancing societies. The Bella Coola had two: the Koosioot, a winter dancing society comparable to the Kwakiutl Tsetseka, in which supernatural spirits initiated the novices with tricks and violence; and the Sisauk, the equivalent of Klasila or Dluwalakha, in which family and clan crests representing natural elements, flowers, and birds were given in connection with major intergroup potlatches.

The focal point of Haida society was the building and validation of a new lineage house and the installation of a chief. The potlatches for this occasion were accompanied by the initiation of members into a shamans' society in which the members learned and presented various tricks, usually violent.

The Tsimshian had four societies and four kinds of dances. These centered about the commemorative mourning cycle after a chief died, and the installation of his successor. Of the four societies, there were three in which the novices who were initiated learned tricks simulating states of supernatural possession.

The main dance of the Nootka was the wolf dance, in which the novice was initiated by wolves. Family crest masks might be shown.

The Salish had a series of "spirit quest" dances during the winter months. They had only one masked dance, an inherited dance representing the mythical being Kwekwe.

Hamatsa
Ritual

The most important winter dance among the Kwakiutl was that of the Hamatsa society. The Hamatsa complex originated among the Haisla, the northern Kwakiutl group at Kitlope, which was apparently the center for the dissemination of this dramatic dance complex. In recent times it was borrowed by the Tsimshian and the Haida of Skidegate. The Nootka and Tlingit alone are not recorded as having adopted it.

The Hamatsa dance was acquired by the Fort Rupert Kwakiutl in 1835 when they attacked a Heiltsuk canoe, several of whose occupants had Hamatsa whistles and masks in their possession. This acquisition was then distributed by marriage transfer.

To become a full-fledged Hamatsa one must have danced a cycle of twelve years, four years through each of three grades. When the novice was ready to begin the series, the Hamatsa senior of his family line would retire in his favor. Usually the novice had already completed several other seasons of dancing in lower ranking societies. All of these stages involved feasting, gifts, payments, and ceremonial costs, and only people of wealth could afford them.

The popularity of this performance resulted from its complex cast of characters and the dramatic ritual, which took at least four days to complete. It was based upon legends of the bird-monsters who inhabited the sky-world and were eaters of human flesh, terrifying apparitions that searched for human bodies to consume. The horror they inspired was heightened by the drama unfolded before the audience. Their behavior could not be accounted for in human terms, and thus it proved to the uninitiated the validity of spirit possession. Most early missionaries were certainly convinced of the literalness of the flesh-eating cannibalistic monsters, but the two most thorough students of the subject, Drucker and Curtis, have concluded that the apparent cannibalism was a carefully planned stage effect, involving effigies, sleight-of-hand, and other well-known theatrical devices much used by the Kwakiutl (Drucker 1965:165; Curtis 1915: 221).

The performance consisted of the dramatic seizure of the novice by the Hamatsa initiating spirit, his disappearance into the woods, his four-day frenzy, and his ritual taming to the point where he became human again and a full-fledged member of the dancing society.

The chief cannibal spirit was Bakbakwalanooksiwae, whose spirit dominated the Hamatsa novice and all his assistants. He was invisible, but his presence was made known through a weird whistling sound—the winds blowing through millions of mouths in his body. Bakbakwalanooksiwae controlled a large household in the sky, whose members were portrayed in the dances of the Hamatsa society. These included the Hamatsa, an obsessive cannibal in human form, the representative cannibal spirit of Bakbakwalanooksiwae; the Noonsistalahl or fire thrower, a being obsessed with fire; the Hamatsa's two attendants, who always danced with him—Komunokas, the rich woman, and Kinkalatlala, a female slave, both danced by women; Kwakwakwalanooksiwae, the cannibal raven; the Hokhokw, a fabulous long-beaked bird-monster; Galokwudzuwis, the "crooked beak" bird-monster; Nanes Bakbakwalanooksiwae, the cannibal grizzly bear; Hamshamtsus, a less violent cannibal; and Noohlmahl, the fool dancer.

When the Hamatsa whistles sounded in the woods, the novice disappeared and remained invisible for a period of time during which it was said he was being initiated into the ways of Bakbakwalanooksiwae. With him were his two invariable companions, Komunokas and Kinkalatlala, each with four attendants of her own. (For examples of Hamatsa whistles, see Figs. 113, 115, and 117.)

When the formal initiation was to begin, the novice appeared wearing hemlock branches in his hair and around his waist, over his shoulders, and around his wrists and ankles. He was in a state of animal-like ferocity, uttering cries of *"haap"* (eat), trying to bite people, and frequently breaking away from his captors, members of the society who were trying to soothe him. In his frenzy he ran into the

woods, was brought back, and jumped down from the roof back into the room. At first he danced with a crouching step, very low, hands and arms akimbo, trembling, eyes starting, his head turning sharply this way and that, agitated by his spirit. At times he was completely overcome by his madness. Key words such as "body" and "eat," uttered by the audience or helpers, and their actions, goaded him into frenzied fits, and from time to time he disappeared into the closet at the rear of the house behind the *mawihl* (screen). When he reappeared he was wearing cedar bark ornaments. While he was absent, senior members of the Hamatsa society representing the various bird-monsters performed their dances in turn, wearing masks with a red cedar bark fringe, and long cedar fringes partially concealing their bodies and legs; each uttered his characteristic cries. All those who had "gone into the House of Bakbakwalanook-siwae" to be initiated directly by him or his spirits were thought to have "learned his secrets." Such people were *lakhsa*. All others were *wikhsa*, "those who have leaned against his walls."

Each character danced four times around the central fire while the audience beat time for his dance and song. At the back of the house, a great cannibal tethering pole (*hamspek*) was put up. This was loosely fastened, so that it seemed to give way when the novice was tied to it, and it swayed and teetered, moved by his supernatural strength. From outside, the pole could be seen swaying above the housetop.

After four days and four nights of frenzy, during which he was subjected to various soothing practices—being offered "human" flesh to eat and ducked in sea water, having fish oil poured on him and ritual fire and smoke directed at him—the novice finally became calmed. Wearing his cedar bark head ring and neck rings and a button blanket, he danced as a full-fledged Hamatsa and received a new Hamatsa name. Last of all, four officials performed a series of purifying tasks. They constructed a ring of red cedar bark, which was passed over the new Hamatsa's body and then burned in a cloud of smoke to complete the purifying process. On the final night there was great feasting and recounting of the legend, and payment was made to all those who had taken part in the ceremonies and to the others for any damage incurred through the violence of the novice. All the initiates gave Hamatsa dances and songs. Once the novice had been initiated, he danced with others of the society while new novices were brought along. An eyewitness account of the Hamatsa ritual is given in Appendix II.

The bird-monsters and the Noohlmahl wore masks. The other characters wore black face paint, and they all wore distinctive red cedar bark neck rings, skirts, capes, wrist rings, and sometimes cedar bark headdresses. The Hamatsa himself had a different set of head and neck rings at each stage of his initiation.

Ritual of Winalagilis, the War Spirit

The second high-ranking dancing order was made up of those who were inspired by the war spirit, Winalagilis. Characterized as brutal, violent, and impervious to pain, they possessed very dramatic tricks. Boas pointed out that these dancers may have represented the warriors of an earlier day, and they retained many of the warrior attributes such as fierce appearance, unkempt hair, and an aggressive demeanor.

The mythological basis of their performance was the possession of various magical gifts and powers: a quartz crystal that could cause death when it was thrown; the ability to fly, to become invisible, to control fire, and to touch it without harm; the use of "the water of life" to revive the dead; and a supernatural healing ritual. All of these were represented in a repertoire of tricks and demonstrations by the dancers.

Most of these dancers wore no costume except ordinary cedar bark skirts or kilts. They used hemlock boughs rather than cedar bark for head and neck rings. Their faces and frequently their bodies were painted with black pigment. They wore no masks, except those in the ghost dance, who sometimes wore masks representing skulls (Figs. 201, 203). The warrior dancers often wore headdresses in the form of the Sisiutl, the double-headed serpent which was a recurring theme of this series of dances.

The chief dancers of the Winalagilis ritual were the following:

The Mamaka (thrower) entered fiercely, looking about alertly for his "secret," a small tube that could expand to become quite long. This was his "disease," which he pretended to throw into the crowd while they ducked their heads and covered them with their blankets. By telescoping his tube, the Mamaka seemed to catch it again magically. Finally he appeared to drive it into himself and fell dead, after which he withdrew the disease, arose, and danced off. The Mamaka carried a Sisiutl staff and bow.

The Noonsistalahl (fire thrower) was obsessed by fire and could not be kept away from it by his attendants. Wearing shoes and gloves of wood and leather, made to be inconspicuous as possible, he seemed to walk across the fire, pick up embers, and throw the fire about without being harmed by it.

The Hayleekilahl (healer dancer) had the power to heal any of the effects of violence done to themselves by the warrior characters, who skewered themselves, swung from hooks, and by using seal bladders filled with blood appeared to inflict grave harm upon themselves.

The Matum (flyer) wore the magic quartz crystal on his head and flew from the roof into the room. Mitla was another war dancer, who wore a belt and carried a bow bearing the Sisiutl crest.

The most dramatic dancer of this group was the Tokwit, a female war dancer, who performed many magical tricks, using false-bottomed boxes, carved portrait heads, and kelp speaking tubes. Some of her tricks were having herself put into a box and apparently burned to death, having her head cut off or a sword run through her, and speaking from the underworld through the kelp tubes. At the beginning of the dance, the Tokwit, with her hands held palms up, singing her song, conjured the Sisiutl spirit up from the ground. The undulating, swaying, glittering *duntsik* ("power board"; see Figs. 220-30) rose up. When she struck it, it separated into two Sisiutl forms.

The ghost dancer was another character associated with the war dancers. Ghosts had the treasure or secret of being able to return the dead to life, and this was the theme of their performance. Their tricks all pertained to the underworld. During their dance they used underground tunnels to drag other dancers to the underworld and back. Each dancer in turn gave his dance and his cry ("hamamamama") and disappeared. This cry caused the Hamatsa, the war dancers, and the Sparrows to become excited. As each of them went toward the back of the room to see what was happening, he fell down as though stricken dead. The ghost dancers brought up the chief dancers from below, and revived the others. All then danced and sang together.

Atlakim
Dancing

Another important dance was the Atlakim ("taken far away into the woods" or "taken back into the woods"). The Atlakim was an inspired dancer who received and displayed a forest treasure or gift.

The southern Kwákiutl made this into a large-scale dance, including twenty-six young men and fourteen young women. On the whole, they were considered to be amusing. Their special sacred room was decorated with hemlock boughs instead of cedar bark. They wore masks (Figs. 231-52), each clearly recognizable as the character portrayed, and their head and neck rings were woven of hemlock and balsam, intertwined with strips of red cedar, salal branches, fern fronds, and moss—unusual materials for a Tsetseka dance. They also wore aprons of these same materials, hanging down in draperylike fashion.

There was only one song among them, repeated over and over as each dancer was called forth in turn. Each performed his dance and showed his treasure—usually the mask. Then a female dancer came out, danced, retired, and returned wearing red and white cedar bark neck and head rings, and finally a small group returned and performed a magical restoration of one of the dancers, who had been struck dead by supernatural power.

Dluwalakha Dancing and Masks

The fourth group among the dancing societies of the Kwakiutl were the Dluwalakha, or Noontlem—words used by Boas (1897) to mean "nonsacred." Klasila was another term for Dluwalakha (Boas 1935a:88). Dluwalakha dancers wore masks representing the family crest myth and family *dloogwi*, which were supernatural in origin, but the dancers were not supernaturally possessed in the same way as the Hamatsa, Winalagilis, and Atlakim dancers. The supernatural gift passed on to the novice was of a simpler sort, often being the dance or other mimetic action, and the novice did not have a lengthy disappearance or an elaborate seizure. Holm (1972:30) has given a description of a Dluwalakha, or Klasila, dance:

The approach of the supernatural power motivating the Tlásulá dance is represented by the sound of cedar whistles or horns which differ from those of the Tséyka in that the sound is produced when the thin sides of the mouthpiece vibrate together. The sound resembles that of a reed horn or klaxon. The new dancer who is about to be initiated (that is, for whom the Tlásulá mask is to be shown) enters, wearing the dancing headdress. His song commences, and he begins to dance. At this point he is considered to be very susceptible to spirit possession, and his attendants, instead of guarding against his losing self-control, tease and torment him. They mimic his dancing or dance along behind him under the ermine trailer of the headdress. The new dancer can tolerate these annoyances for only a short time before he loses control and rushes out of the door of the house with his attendants in pursuit. Very soon they reappear, carrying the headdress and blanket of the missing dancer. A lively discussion ensues, with much conjecturing as to the whereabouts of the dancer. The attendants sometimes try, ineptly, to carry on in the dance. Today the whole atmosphere during this byplay is lighthearted and even comic, although it may have been more serious in other times.

At this point masked figures called Gakhula, or Intruders, may enter the house (see Figs. 156-58). They are dressed outlandishly, and they interrupt the proceedings in a boisterous way. The attendants finally eject them from the house after a mock struggle.

Suddenly the horns are heard from outside the house, signaling the return of the novice dancer in the form of a supernatural being. The attendants fearfully and very reluctantly investigate. Finally they bring in a masked dancer, impersonating the creature who figures in the origin myths of the dancer's family.

The Dluwalakha dancing masks represented such mythological ancestors as Komokwa, Thunderbird, Kolus, and others. They also illustrated legends involving such characters as the sun, the moon, echo, and other elements of nature. A great number of them referred to the animals, birds, and local features of the landscape that played a role in the recounting and re-enactment of family myth.

In the darkened house against the fire's flickering, these masks were powerfully evocative manifestations of the spirit world, with a compelling fascination. The high point in the evening's performance was often marked by the use of a transformation mask. The dancer drew attention to an approaching change by the rhythm of his dance and by the centrally prominent place he chose to stand, as the beat of the song sticks intensified. Slowly the mask opened, revealing within it another being who also belonged in the myth of the dance.

Wigs of shredded cedar bark, fur, feathers, or even burlap were worn with the masks, and the costumes were very cleverly devised to give the illusion of furred, feathered, or other nonhuman beings. Many of these can be seen in the photographs taken by Edward S. Curtis between 1912 and 1915 (Curtis 1915). In later years these elaborate costumes were often replaced by button cloaks (see Pl. VIII; Figs. 298-300).

The rich and intense emotional experience of these dances, shared by the whole village, provided the major purpose and reward for the craftsman of the Northwest Coast. His audience, sophisticated in a tradition of masks and carvings, appreciated his ingenuity and virtuosity. They were interested in new theatrical invention. For a skillful and inventive craftsman there must once have been a nearly inexhaustible market for all the new carvings

he could produce. This demand and the high standards of the audience were responsible for the great volume and high quality of the work of these tribal craftsmen.

Most family crest masks were shells of wood, hollowed out to fit over the face of the wearer. To support those of ordinary dimensions, light harnesses of wood around the head were sufficient. Larger ones were often supported by a stick extending downward from the back of the mask framework to the wearer's waist and there tied to a belt. Still others were held in place by the dancer's hands. Some, made and supported in the same manner, were worn on the head, resting on the forehead.

It will be noted that these masks are not by any means all of equal artistic or technological quality. Some were simply and quickly hacked out for one occasion only, while others that show great dramatic and inventive power were meant to be a permanent part of a man's wealth. Some masks are crudely shaped and unfinished in surface and in treatment of detail and are painted in the same way, with carelessness and indifference. Moreover, there is an apparent relationship between crudity of workmanship and the choice of nontraditional colors, although this is not invariable. The Thunderbird mask in Figure 400, painted an unusual pale blue, is very well carved, but the color is probably the result of repainting by someone of a later generation than the carver.

Well-carved masks exhibit the following characteristics:

1. Treatment of the wood is not rigid but plastic; parallel curved lines follow each other with ease and then diminish to a gently tapered and clean-cut finishing point.

2. Details of features show a certain technological virtuosity, an obvious enjoyment by the artist of his ability to elaborate the flare of a nostril, the curve of an eye, or the ridge of a cheek within the distinctive features of the mask.

3. The different parts or features are developed in a balanced relation to one another, and as a total form give an appearance of unity and strength.

The serious artist also accepted the limitations of traditional colors as part of the challenge and usually felt no necessity to introduce others.

These differences in craftsmanship have been interestingly reflected in the comments of Kwakiutl visitors to the museum. Some have noted the crudity of carving and painting of certain masks and showed some indignation and contempt for poor craftsmen. They seemed to feel that it was a reflection on the seriousness of the occasion for which the masks had been made. They appreciated the better pieces and were frequently able to identify the carvers. Not all Kwakiutl have been artists, however, nor are they all art critics. Some were apparently indifferent to the esthetic qualities of the masks, being concerned only with the questions of who had owned them and when they had been worn.

It is not easy to ascertain the age of some of the older masks, and it is impossible to give a date for the beginning of their use in the general region. Ethnographers in the second half of the nineteenth century noted an abundance of masks and a variety of uses. Masks from the Nootka were collected by Cook in 1778, and we know that the complex organization of the dancing societies and potlatching and the technology and style of the masks must have taken a long period of time to develop. So far archeology has not been able to throw direct light on the topic, and the problem is complicated by the fact that wooden objects in this moist region do not easily survive over a long period of time if subjected to ordinary weathering.

If there is any substance in the conjecture of Lieutenant T. Dix Bolles (1893:221-22) that the mask he illustrates was two hundred years old in 1892, this is one dating point, for this mask is well within the typological framework of those with which we are concerned. The three Tanis society masks shown in Figures 190-93, collected by G. H. Raley in Kitlope in 1897, were found in a burial cave, and Raley reported that they were considered "very old" at that time. However, since the possessions of one's grandparents can seem "very old," this cannot be taken as a reliable indication. The information that has been gathered about the museum collection offers little on this subject, although it is helpful in coming to some conclusions about the development of masks the past hundred years or so.

In respect to standards of workmanship, it cannot be assumed that a well-made mask is old, and a poorly made one is modern. Some fine pieces and some poor pieces date, as nearly as can be determined, over the whole range of time during which these masks were made. Nor are depth of carving and detail accurate criteria of the age of a carving: some artists, both recent and of older times, have worked with great success with bold, high planes and strong features, without any extraneous detail, while some of the crudest and most inept items, new and old, are characterized by much nonessential detail, which serves only to emphasize the clumsiness of the whole.

Three outstanding characteristics emerge from an examination of the following carvings of the northern region, around Kitamaat and Kitlope: house posts (Figs. 42-46), Tanis masks (Figs. 190-93), soul catcher (Fig. 499), grave effigy (Fig. 73), and

wolf mask (Pl. XVII A). They are mostly black, with little or no other color. They are rather massive and forceful in concept, if not in actual size. They are finished in an extremely fine and polished manner. If this northern boundary is extended to the Xaihais, we may add the totem pole (Fig. 62), several ladles, and twin masks (Figs. 472, 473), which exhibit the same qualities. It would seem, then, that the masks that should be considered early ones are those with dark color and rather simple, massive, but well-finished forms.

Two other pieces that are known to be comparatively old should be noted. Plate XXIV shows an eagle mask from Kitamaat, worn by the Eagle people (called "Sonahed" up to 1884, according to Raley's notes). This mask is also seen on top of the middle Tanis mask in the old photograph reproduced in Figure 190. It is an extremely fine, beautifully finished and polished piece, with symbolic facial painting in very delicate red and black lines for which old paint was used. The wolf mask from Kitlope (Pl. XVII A) has the same qualities.

PART II
Ceremonial Art

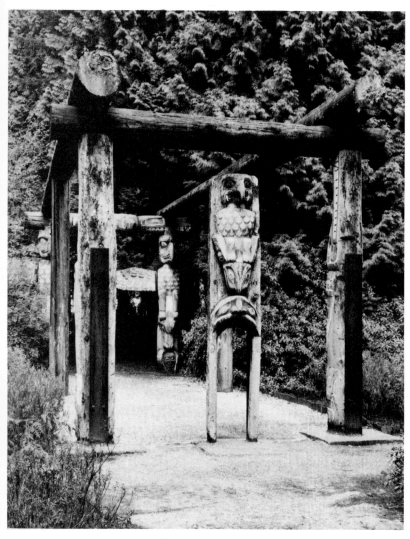

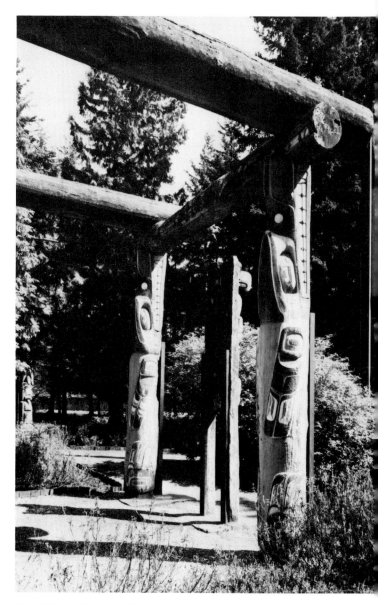

Fig. 29. Fort Rupert house frame, carved in 1900 for the dowry of Mrs. Spruce Martin. House frame consists of eleven pieces: two rear Thunderbird posts, height: 14 ft.; rear Sisiutl crossbeam, length: 30 ft.; two frontal sea lion posts, height: 14 ft.; two crossbeams fluted by adzing, length: 30 ft.; one frontal entrance post with two birds, height: 12 ft. Purchased by Marius Barbeau 1947. A50039

Fig. 30. Sea lion posts from house shown in Figure 29. A50039

The
Lineage
House

The lineage house was central in Kwakiutl thought, and its physical structure symbolized the people in it as truly as did their myths and crests. The house was regarded as "the sacred container of the lineage," its very structure a crest (Goldman 1975:47, 63). It bore the crest painting on its front, was given a ceremonial name, and was itself an entity within the social organization.

In the myth time, the beings of sky and sea and forest also lived in houses in their proper domains. Thunderbird, Kolus, and the other associated beings had their house in the sky, as did Bakbakwalanooksiwae and his Hamatsa servants, Raven, Crooked Beak, and Hokhokw, in their own domain (Boas and Hunt 1905:186). Komokwa's house was under the ocean waters, Tsonokwa's was in the forest, and even the mountain goats lived together in a house amid the peaks (Boas 1935b: 129, 1910:385).

A house of the village was indissolubly related to the life of its chief and head. When the chief died, the house was "empty," "broken" (Goldman 1975:64). The death of a lineage head prompted a related family to reform its grouping under a new head, and to build a new house. The actual house of a lineage head was associated with marriage and the gifts of the bride's father to the groom (Goldman 1975:75), and was often one of the "treasures" brought to him by the bride. The house posts and the speaker's post were major gifts.

The construction of a house was commissioned to specialists who were skilled in directing the work. They and their laborers chose the cedar from which the house was to be built, felled the trees and directed the hauling of the logs to the site, prepared the posts and planks, and saw to the completion of the house in all its physical details. The size was proportionate to the wealth of the family. The building itself, the appropriate carving and painting that defined it, and the ceremonial opening that marked its completion all had to be paid for.

When the house was officially opened, the head of the new lineage assumed his ceremonial names, as did others living with him. The house was also given its formal ceremonial identity, referring to the family's crests. Guests witnessed the description of the house posts, their carved forms, and their names and meaning. A new bride would bring furnishings and supplies, including feast dishes and boxes of food. A totem pole might be officially recognized or inaugurated at this time, its crests recounted to define the lineage names and powers, or the carving and installation of the pole might take place at a later time.

At the end of the recitation of names and descriptions of the house, its posts, and its furniture, goods were distributed to the guests. The lineage members performed the dances and sang the songs they owned, not only for entertainment but also as continuing announcements of ownership and ties. Gifts were distributed in the manner dictated by the ceremony, one kind from the family of the host and another from the family of the bride (Goldman 1975:69 ff.). Guests of high rank received correspondingly greater gifts in quantity and quality.

After the entertainments had been given and the claims recognized, the guests departed for their villages. The house now became the core of the life of the lineage. Families lived in their allotted spaces, carried out their daily chores and activities, and centered their social life in the house. At ceremonial times it assumed a new identity as the base of Tsetseka preparation and performance, and the *mawihl*, the painted muslin curtain, was used to mark off the space in which the dancers could get ready.

The houses of a Northwest Coast village formed a row parallel to the water in a cleared space on the beach, facing the sea. They were rectangular in plan, with an entry through the front and a gabled roof. Four upright posts embedded in the earth supported two cross beams, and these in turn supported the two longitudinal beams on which the frame and planks of the roof rested (Fig. 29; see also Spradley 1972, photographs showing the beams for a community house being raised and in place). Plank walls were held to a frame of upright posts by horizontal boards of sill and ceiling.

The cross beams were carefully completed by the carver. The surface of the cedar was adzed in parallel rows, resulting in a fluted pattern. The cross beams, like the house posts, might also be carved with crest figures, and these carvings often show Kwakiutl art at its most vigorous, as in the powerful grizzly bear posts (Figs. 31, 32) and the painted sea lion posts (Figs. 37, 38). The Koskimo sea lion house posts and ancestor figure shown in Plate I and Figures 33-36 are part of a magnificent set of carvings photographed by Edward S. Curtis in 1910, shortly after the house was completed (Curtis 1915: Pl. 1). The representation of an ancestor stands behind the seat of honor—a plank supported by two kneeling figures—which was to be occupied by a senior member of the family. The ancestor figure is carved in the same stark manner as the sea lion posts, producing a powerful effect, taut and vigorous. Painting is used to enhance the face of the figure, the wolf crests on his arms, and the copper on his chest.

A study of house posts contributes to an understanding of the historical development of Kwakiutl art. Earlier traditions and conventions, as shown in the house posts from Kitamaat (Figs. 42-47), foreshadow the characteristics noted in the Xumtaspe and Koskimo carvings. Reduced to basic lines and forms, these were the foundation for later and more florid styles.

In addition to totem poles, which are discussed in the following section, there were other carvings associated with the lineage house.

Speakers' posts or poles were carvings in which the open mouth of a figure on the hollowed post allowed an orator to speak the ceremonial words of welcome to the audience as if they were emerging from the mouth of the ancestor himself (Figs. 51, 52). Usually the post was placed inside the house. The memorial pole in Figure 57 was an external pole in front of the house, in which the bottom figure represents a speaker.

The frontal pole was a variation of the crest pole that emphasized the entrance to the house as a great mouth, "swallowing" those who entered (Goldman 1975:64). The opening of the doorway was carved or painted as an oval or circle through which people had to stoop as they entered (Fig. 48). Other crest poles showed a single crest figure at or near eye level. Some were raised by the use of a standard; others sat on the ground. Usually they were placed outside the house (Fig. 49). Occasionally large human figures called welcome figures were carved and set outside the house, facing the sea, to express a welcome to visitors arriving by canoe from another village. Curtis (1915:141) describes a post at Nimpkish, carved before 1865,

which represented the chief's scout gazing out over the water to watch for canoes arriving with wedding proposals for him.

Family carvings were sometimes commissioned by a chief to represent events of importance to lineage history, especially ones that occurred in his own time. Two figures from the Koerner collection illustrate this category. Figure 53 represents a lineage head at a moment of importance during the copper ceremony. The carving is an excellent example of the human figure in a comparatively representational style. The T shape of a copper can be seen on his shoulders and neck, and it is possible that originally a copper shield was clasped to his chest, while his free arm was extended in a gesture appropriate to public oratory. The copper would have been an important one, bearing a name, and the incident commemorated in the carving was undoubtedly a significant one. Within the Kwakiutl canons of carving, the figure is strong, taut, and confined to essentials. Rounded limbs and body include nothing to detract from the positive figure depicted at an instant worthy of record. It is unusual, within the conventions of portrayal, in that the chief is shown with no ceremonial or crest emphasis, no cedar bark ring on his head or chest, no crest symbol on his face. Evidently his individual power and achievement were selected for emphasis. The carving was probably intended to be kept inside the house, mounted on a base designed for the purpose.

Figure 54, a crouching slave bearing a chief on his back, is not a realistic portrayal of the way the slave would actually be employed, but it is an artistic device intended to show high rank, stressing the prestige of a chief who is able to command others. Other carvings, such as the ridicule figures described on page 80, are mentioned in the literature of the Northwest Coast as commissioned for special purposes and placed outside the houses. Many collections include carvings of great skill, identifiable as Kwakiutl, which have been separated from any record of the occasion and the purpose for which they were produced.

Important feast dishes and ceremonial boxes, which were among the treasures brought by a bride as part of the marriage arrangement, must also be considered within the context of the lineage house. Carved by specialists and their assistants, they were commissioned by a lineage head and his family to mark milestones of family affirmation at events that publicly recognized their claims.

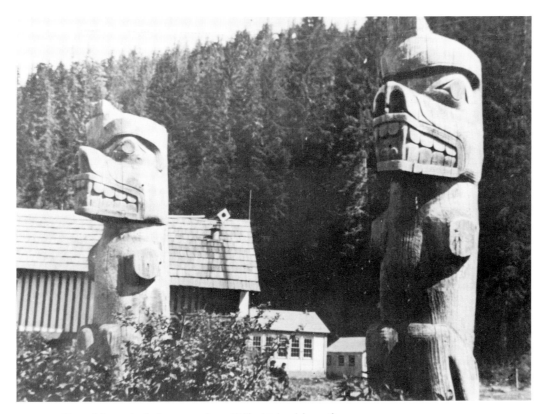

Fig. 31. *Two of four grizzly bear posts from Gilford Island house frame, carved by Awalaskinis for Chief Kiwidi, photographed* in situ. *Height: 12 ft. Collected by BCTPPC 1956. A50010 AB*

Fig. 32. *Two grizzly bear posts, photographed* in situ, *from house described in Figure 31, caption. A50010 CD*

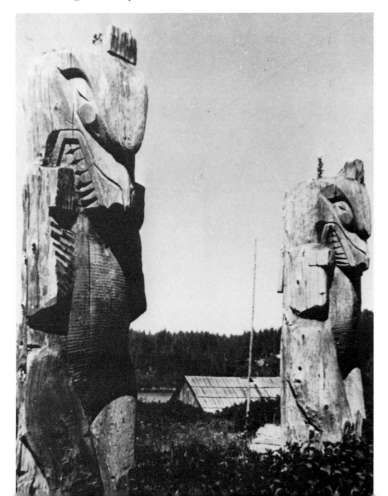

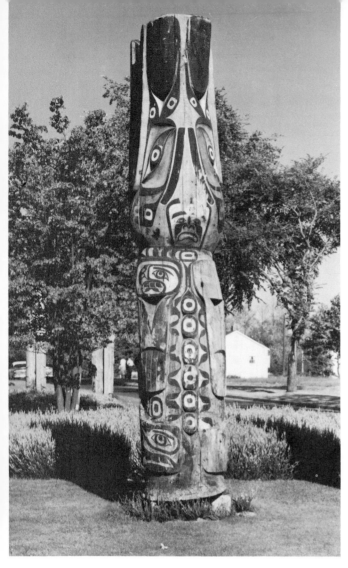

Fig. 33. Sea lion post from Quatsino house frame, carved by George Nelson (DEF) and Quatsino Hansen (ABCGH) in 1906. House frame consists of eight pieces: four upright sea lion posts (ABGH), height: 12 ft.; Sisiutl crossbeam (C), length: 18 ft.; human ancestor figure post (D; see Plate 1), height: 12 ft., before which is placed a platform (F) supported by two kneeling figures (E). Collected by BCTPPC 1956. A50009

Fig. 34. Sea lion posts and Sisiutl crossbeam, photographed in situ, from house described in Figure 33, caption. A50009 ABC

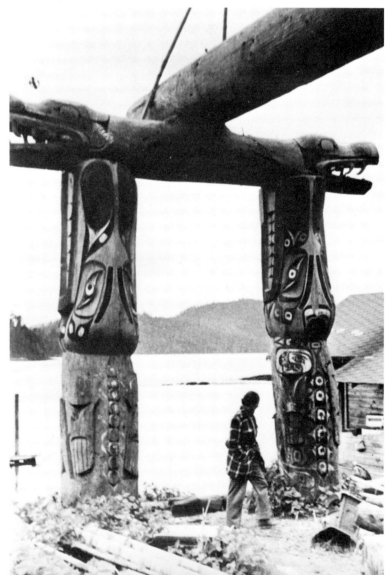

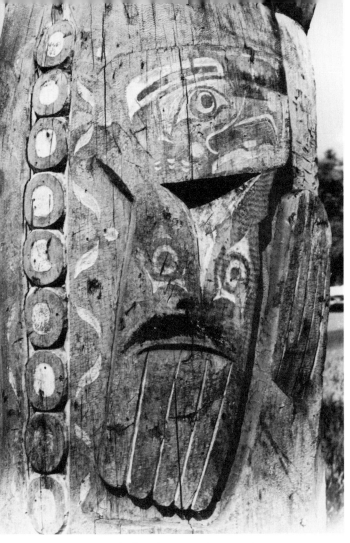

Fig. 35. Detail of sea lion post. A50009 A

Fig. 36. Human ancestor figure with platform and kneeling figures, photographed in situ by Helen Codere in 1955, from house described in Figure 33, caption (see also Plate I). A50009 DEF

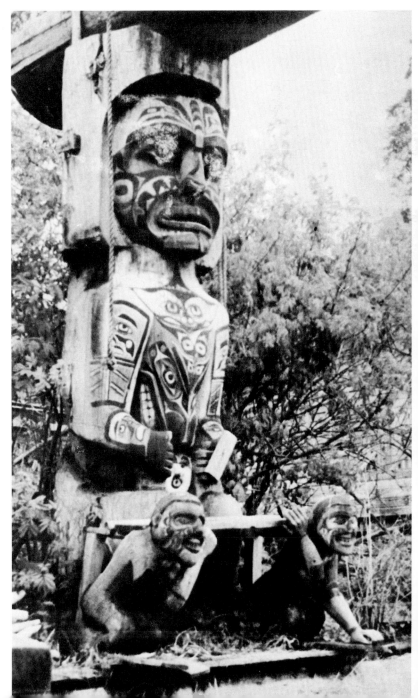

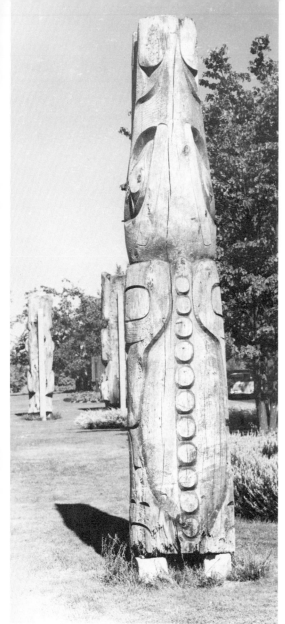

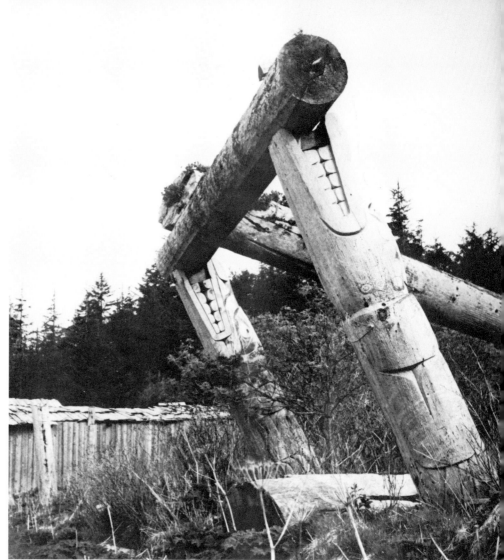

Fig. 37. Sea lion post from Hope Island house frame, carved in 1900. Height: 13 ft. See Figure 38. Collected by BCTPPC 1956. A50008 B

Fig. 38. Sea lion posts and crossbeam from Hope Island house, photographed in situ by Helen Codere in 1955. Height of sea lion posts: 13 ft.; length of crossbeam: 19 ft. See Figure 37. A50008 ABC

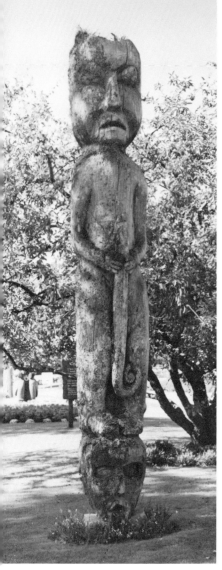

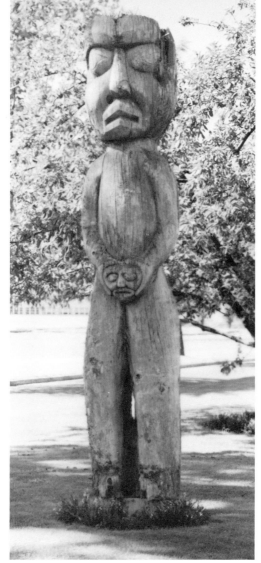

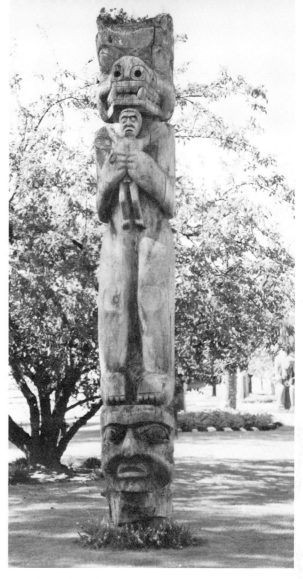

Fig. 39. Human ancestor figure from Hope Island, wearing Sisiutl belt. Height: 14 ft. Collected by BCTPPC 1956. A50007 A

Fig. 40. Human ancestor figure from Hope Island. Height: 12 ft. Collected by BCTPPC 1956. A50007 B

Fig. 41. Grizzly bear ancestor figure from Hope Island. Height: 14 ft. Collected by BCTPPC 1956. A50007 C

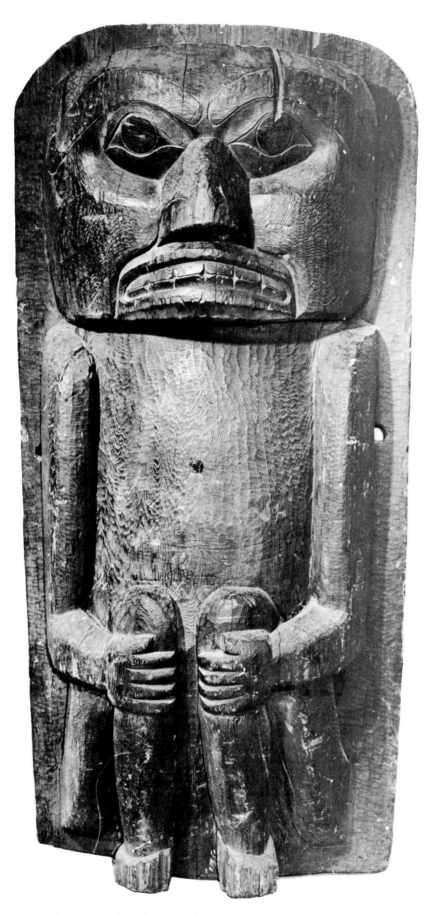

Fig. 42. Human figure house post from Kitamaat. Height: 69 in. MacMillan Purchase 1948, Rev. G. H. Raley Collection. A1779

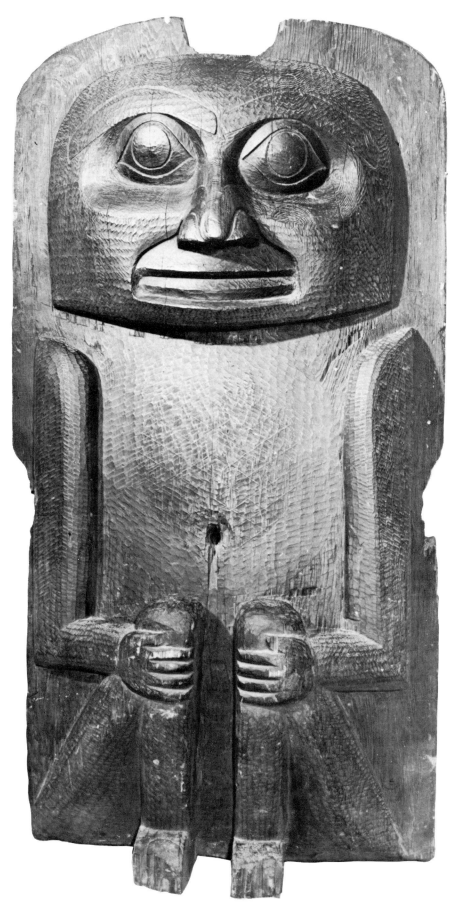

Fig. 43. Human figure house post from Kitamaat. Height: 63½ in. MacMillan Purchase 1948, Rev. G. H. Raley Collection. A1778

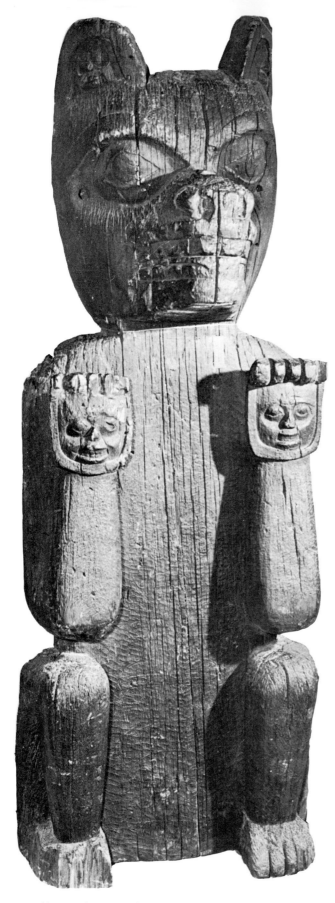

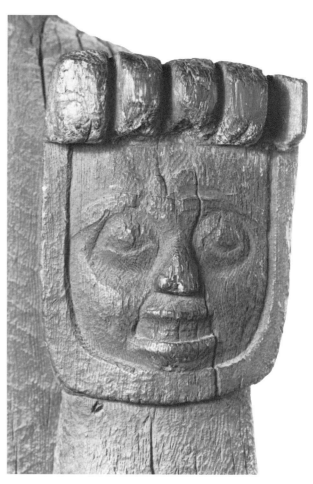

Fig. 45. Detail of paw of bear house post. A1790

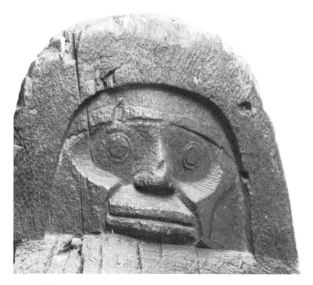

Fig. 46. Detail of ear of bear house post. A1790

Fig. 44. Bear house post from Kitamaat. Height: 75 in.
MacMillan Purchase 1948, Rev. G. H. Raley Collection.
A1790

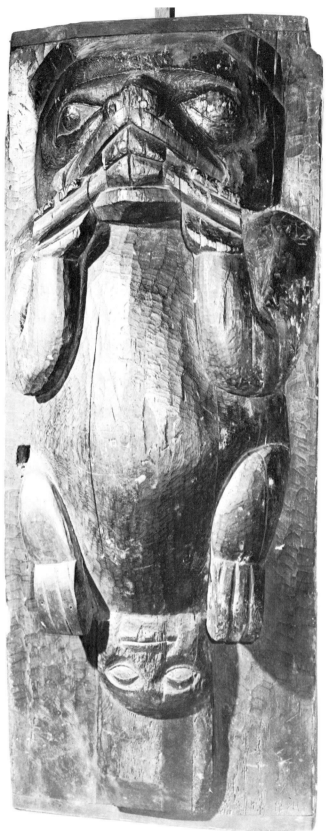

Fig. 47. Beaver house post from Kitamaat. Height: 63 in. MacMillan Purchase 1948. Rev. G. H. Raley Collection. A1789

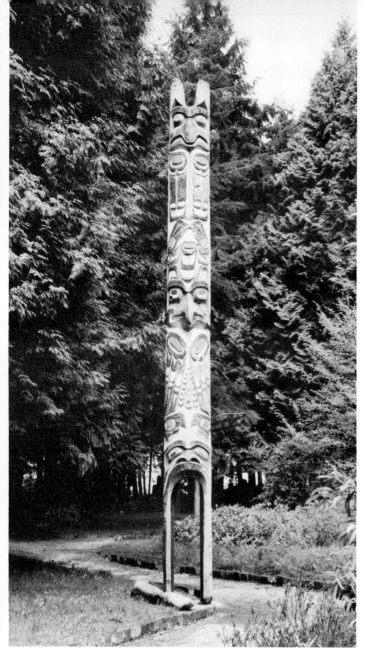

Fig. 48. Kolus and Thunderbird frontal pole with entrance, from Fort Rupert, carved by George Hunt about 1895. Height: 15 ft. Purchased by Marius Barbeau with Kolus crest pole (A50042) 1947. A50041

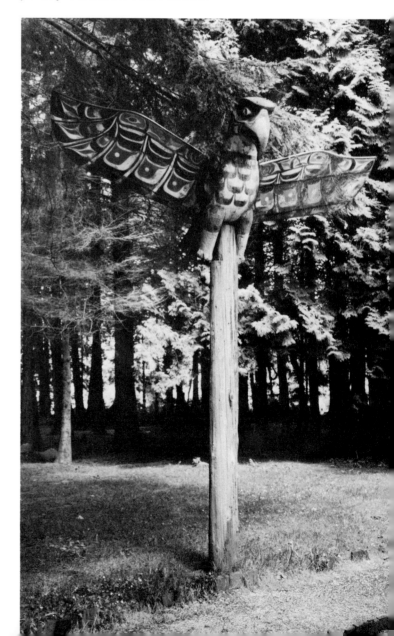

Fig. 49. Kolus crest pole from Fort Rupert. Height: 11 ft. Purchased by Marius Barbeau with Kolus and Thunderbird frontal pole (A50041) 1947. A50042

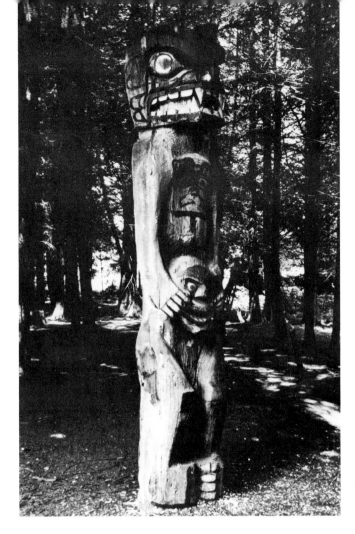

*Fig. 50. Bear figure from Fort Rupert. Height: 12 ft. 6 in.
Collected by Marius Barbeau 1947. A50036*

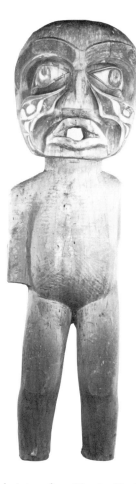

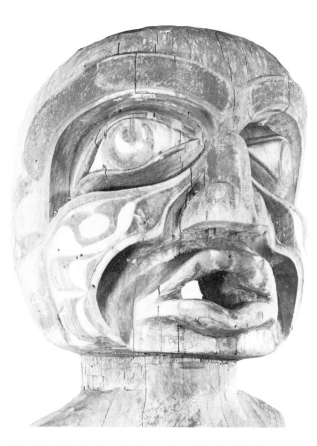

Fig. 51. *Speaker's post from Blunden Harbour. Wood; white, green, black. Height: 92 in. Gift of Sidney Gerber 1954. A50043*

Fig. 52. *Detail of speaker's post from Blunden Harbour. A50043*

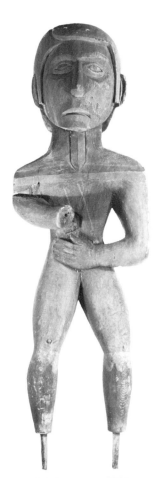

Fig. 53. *Human figure that may have originally held a copper. Height: 41½ in. Walter and Marianne Koerner Collection 1973. A17148*

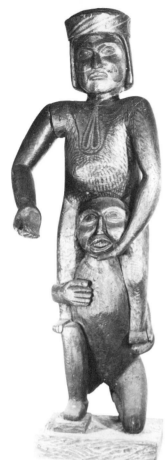

Fig. 54. Chief carried on the back of a slave. Wood; black, red. Height: 51½ in. Walter and Marianne Koerner Collection 1973. A17154

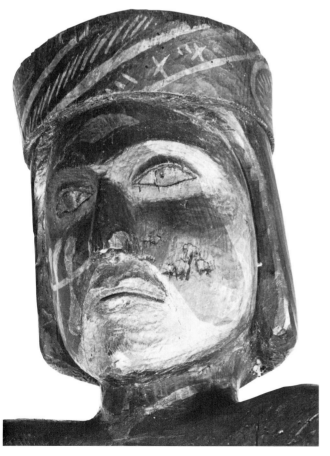

Fig. 55. Detail of chief. A17154

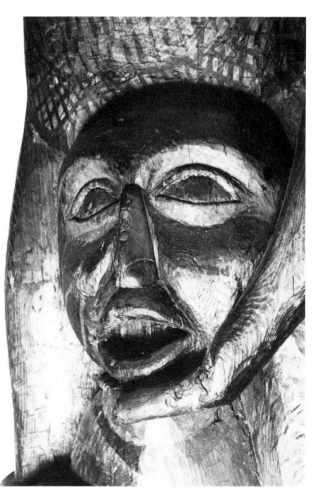

Fig. 56. Detail of slave. A17154

Totem Poles

Standing in front of the lineage house, the totem pole was the tallest and usually the most complex crest carving made by the Kwakiutl artist. The pride and wealth of the family were closely tied to it, as was the reputation of the carver. Eighteenth-century European explorers described and sketched the large wooden images standing inside Northwest Coast houses and the others, now universally recognized as totem poles, that stood outside. The totem pole has become a symbol of the geographic and political entity which is the present Northwest Coast. It is an art form unique to the region, characterized by its tall, columnar form bearing images of humans, birds, and other animals of the sea and forest. The column may be solid or partly hollowed, some of its features may be extended beyond the pole, and it may be either painted or bare.

The totem pole is a precise art form embodying a statement of beliefs about important social realities—descent, inheritance, power, privilege, and social worth—of the people who inhabited the Northwest Coast before the advent of European explorers and settlers. The figures on the pole were an affirmation of the strength of the living family, deeply entwined with emotional response, though they were never idols nor were they worshiped. They were, however, forms of deep meaning within the complexities of social life.

This meaning had a threefold context. First, it was the chosen visible expression of family history—the descent from remembered ancestors and the possession of powers derived from them. Furthermore, the history had to be publicly recounted and witnessed. At the time of the gathering when the pole was officially proclaimed, an orator employed ceremonial language to trace the names of the family and give details of the generations and events embodied in the carved images. Finally, the erection of the pole was surrounded by appropriate rituals. Guests received hospitality and gifts, attesting by their acceptance the legitimacy of the event and of the symbols on the pole.

In their earlier forms, totem poles were smaller and simpler than they later became. The advent of steel tools—adze blades and axes, the chisel and the curved knife—made it possible for the carver

to work with greater efficiency and elaboration, and throughout the past century to the present time poles have soared in height (Barbeau 1950:I, 5).* The efflorescence of totem pole carving was supported by increased wealth through trade, and the ceremonies associated with the carving and erection of a new pole were enriched with copper, blankets, and glassware, Marius Barbeau, the most eminent student of the totem pole and its significance, states that it was elaborated first among the Haida and the Tlingit, both of whom adapted it in form and meaning from the Tsimshian (Barbeau 1950:I, 9). It was later modified by the Bella Coola and the Kwakiutl to fit their aesthetics and social life, and still later the Nootka began to work in their preferred style, while the Salish continued to confine their major carving to house boards and ancestor and grave figures.

The threefold ceremonial association of carved form, spoken word, and social validation was inseparable. But the words were transient, and the guests departed. Only the carved pole remained visible. Thus it is not possible for an outsider who is ignorant of the ceremonial context to "read" the pole as if it were a glyphic or pictographic presentation of myth or history. It is the carved and silent remnant, an array of symbols of the family history which was replayed at its inauguration. Moreover, it should not be assumed that all of the images are clearly identifiable. Many figures represent people, objects, animals, or events named in the legend that is told when the pole is erected.

Bill Holm (1972:83) points out that we "tend to simplify the number of different beings represented in the art to a few crest animals." He summarizes the findings of Swanton (1909), who gives a list of sixty-two Haida crests "including such unlikely creatures as rainbow, cirrus cloud, drying frame, and cedar limb." Holm also notes that Boas listed ninety-nine Tsimshian crests, "in-

* In 1957 Mungo Martin carved a totem pole 100 feet high to present to Queen Elizabeth II in honor of the British Columbia Centennial. This pole now stands in Windsor Park. Later he made a similar one that stands in front of the Maritime Museum at the Vancouver City Museum and Planetarium. An even taller pole, 127 feet high, is in Beacon Hill Park, Victoria.

cluding victorious arrow, burning ground, sliding people and food of copper beaver. . . . All these could be represented in the art often in a form which could easily be misinterpreted as some very ordinary bird or animal."

The Kwakiutl artist also created images whose interpretation was given in the recital of family history but was closed to a viewer not familiar with it. On a pole carved by Mungo Martin, for example (Fig. 59), there is a human figure representing his father's maternal grandfather, whose wealth enabled him to support five full-time carvers and their whole families for two years while they worked on commissions for him. The house that was built during this time was said to have been so enormous that the roof beams were too heavy to be raised by humans. The great Thunderbird came down, took up the roof beams in his talons, and placed them in position. To the uninformed viewer, this interesting ancestor appears as merely another character.

Nevertheless, while an outsider cannot read the family history in the details of the totem pole, and while, indeed, the pole has no independent meaning of its own, many of the crests can be identified, and the ways in which they are presented can be understood in the general context of Kwakiutl life and appreciated as aesthetic achievements.

The cedar trunk provided the surface of the pole on which the crest figures were carved and painted. Its height varied but was usually between fifteen and fifty feet, taller than any other representations of the crest figures. Figures were arranged on it from top to bottom, but their sequence was not a measure of importance. "Low man on the totem pole" is an outsider's interpretation; position did not indicate rank.

The figures were those of the family's crests, and the carver might choose to portray them elaborately or simply and to combine their forms as he saw the opportunity to create the most satisfactory composition. They were presented so that the center front, which faced the sea and guests as they arrived by sea, was the visual center of interest. The back was left uncarved, relatively rough and plain, although paint might be applied to the unfinished figures.

The theme that ran through the myths and lineage recitations of the Kwakiutl, and was reflected in the figures on the totem pole, was that of a world in which beings of the sky, the forest, the mountain, and the sea had a deep relationship with the humans in a world which they shared on equal terms. These beings were represented in Kwakiutl art by their external coverings of fur, feathers, scales, and other features which could be divested at will, revealing a human form under their animal outer form.

Schematically, the human figure was usually the one that established the proportion to which the other figures were sculpturally related. On Kwakiutl poles it was typically portrayed in a compressed or seated position, usually with head, features, torso, arms, and legs represented. The torso was upright, the knees were drawn up, the arms fell straight from the shoulders to the elbows, and the forearms were extended from the elbows or crossed the chest at right angles.

The head was usually one-third of the total height of the figure. The face had eyebrows, eyes, nose, and mouth, each represented in conventional manner. The eyes, each set within a softly rectangular socket, showed the characteristic form of Northwest carving, in which two opposed curves, with tension lines at each corner, contained a round iris. Eyes, sockets, cheeks, chin, and lips were nearly always carved, and eyebrows, eye lines, pupils, nostrils, and lips were always painted. The face might be left as a natural, unpainted surface, with only the features painted on it. The hair of the head was painted black.

The face and figure were usually male, since the ancestral powers generally resided in the male head of the family. He might be shown without adornment, or the face might have crest symbols that referred to the nature of the powers. The human figure in its seated form was sometimes adorned with a cloak falling from shoulders to feet, sometimes showing a design. A ceremonial head or neck ring might be added, and sometimes a potlatch hat was shown on the head (Figs. 58, 62, 63). The figure was a generalized human form, without musculature or sexual organs. Hands and fingers, feet and toes were usually completed by carving and were seldom painted.

Animals of forest and mountain were usually shown in the same seated or compressed form as humans, with the forelegs from elbows to paws at right angles to the upright torso, knees drawn up to the thighs in front. Claws were depicted on all paws. Animals also usually faced outward from the center front. Above the brow were upright ears which were rounded, squared, or pointed, modified according to the vision of the carver. They had eyebrows, eyes, muzzles, nostrils, and teeth, all carved and emphasized by painting. The bodies, following convention, were painted overall, usually brown or black. Sometimes tails were shown, particularly for the wolf, who had a long tail, and the beaver, whose round, broad tail was always crosshatched. A painstaking carver would carve out the crosshatching in addition to painting it (see the bottom figure in Mungo Martin's pole, Figure 59). Frequently the head was carved bending forward

and biting a smaller form, or the paws shown holding such a form. This represented a mythic episode in which a smaller figure was incorporated or overcome by a larger.

Birds were shown in the same seated position as humans, facing center front, "shoulders" to "hips" upright, knees drawn up, legs ending in talons. Wings and beak were essential features. The wings, usually painted white, were either folded, reaching from shoulders to hips in a cloaklike fashion, or extended from the surface of the column by added pieces of wood that emphasized flight. Feathers were indicated by conventional texturing in contrasting colors. The beak was always shown, long and sharp or short and curved, according to the characteristics of each bird being. See, for example, the pole from Rivers Inlet illustrated in Figure 60, which depicts a fifteen-foot Hokhokw with an extended beak thirteen feet long. If the beak was not extended forward, it still had to be shown. Raven's head might be bent downward, with the beak in front of the body. The bird was given nostrils, ears, and usually eyebrows. Thighs, lower legs, and talons might be extended beyond the column of the pole, showing the moment of landing after flight. These extensions were fastened to the pole by mortise and tenon, doweling, or nailing, and might be given extra support with a brace or from the ground.

In the portrayal of sea beings, conventions allowed the figure to depart from the upright seated pattern. The killer whale and the sea lion were usually given long bodies, which might be exaggerated in length for emphasis. They were usually carved with the head downward and the tail curved forward to form a platform for the figure above. The killer whale was marked by an upright dorsal fin, single blowhole, side fins, and bifurcated tail. If all of these were present, the body might be omitted, but the figure would have ears, eyebrows, eyes, nostrils, and teeth. The sea lion was distinguished by flippers joined at their ends. A marine origin was indicated by rows of semicircles used as gills, eyes, finlike frills, or octopus tentacles. The eyebrows of sea beings were often sharply arched above the eye.

The face of a human peering out from under a beak or muzzle indicated that the ancestor had been transformed from a being of sky, sea, or forest to a human form.

The copper was the most common symbol shown on a Kwakiutl pole. Its shape varied little, but its symbolic association differed in the context of the recited myth, showing power, life, strength, and wealth. It might be clasped like a shield; shown as a crest decoration on body, head, or clothing; or a decorative form painted without reference to any other figure.

The conventions of painting varied with time and locality, and artists established individual styles within them. The earlier traditions common to the Northwest Coast emphasized details through the use of natural pigments found locally, such as clamshells, earth ochers, and charcoal, with salmon egg or other oil used as a binding medium. The poles carved by Mungo Martin at the university in 1950 and 1951 were painted in this early style, although with paints prepared for him by a commercial company, leaving the wood exposed for the main body of the figures. In the twentieth century, when commercial paints became readily accessible, the Kwakiutl began to use color lavishly. The bodies of the crest figures were blocked in with black or dark brown, with white for the extended wings, eyes, and decorative outlines. Additional colors—red, orange, blue-green, and gray—were used for detail. The elaborate extensions of wings, beaks, horns, fins, and hands offered new surfaces for flamboyant treatment. Color came to rank with form, texture, and pattern as an important element in the aesthetic statement of the totem pole.

Although there were differences in the carving style of the various regions of the Northwest Coast, these do not obscure the significance of the pole as the most important work of art, displaying the figures of family history and myth and the wealth that supported the artist who carved it. In his representations of the figures on the pole, the artist followed the traditional local taste as reflected by his own inventive genius. In general, Kwakiutl poles included more figures that extended beyond the cedar column than did those of the northern traditions. Wings jutted and flared; legs were outthrust; horns, representing supernatural origin, curled from the surface. Usually the pole tapered to the top, and the finial might be carved in such a way as to emphasize the taper. A small top figure would give the illusion of greater height. The overall use of emphatic dark colors contrasted with the white used for detail, texture, and pattern. Kwakiutl poles were generally distinguished by the emphasis on more realistic forms, one above the other. The overall impression produced is one of activity, motion, and interrelated total form.

The totem poles shown in Figures 64-66 are examples of model poles, which were first created in response to a demand by the tourist trade for a portable product of this region during the last decades of the nineteenth century. Because they were made by fine carvers, these models are worthy of the traditions that went into the development of this unique art form.

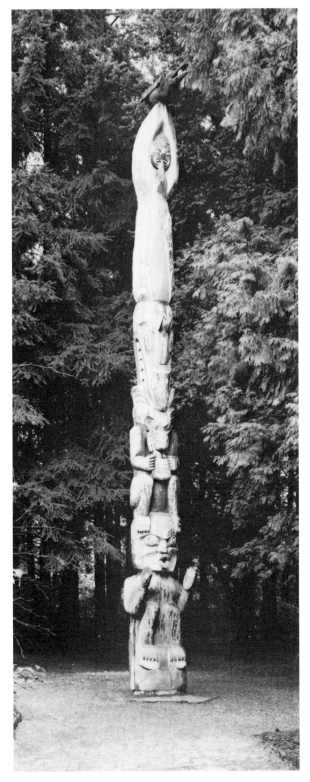

Fig. 57. Raven-of-the-Sea pole from Alert Bay, carved by Mungo Martin in 1902. Height: 40 ft. Purchased by Marius Barbeau 1947. A50037

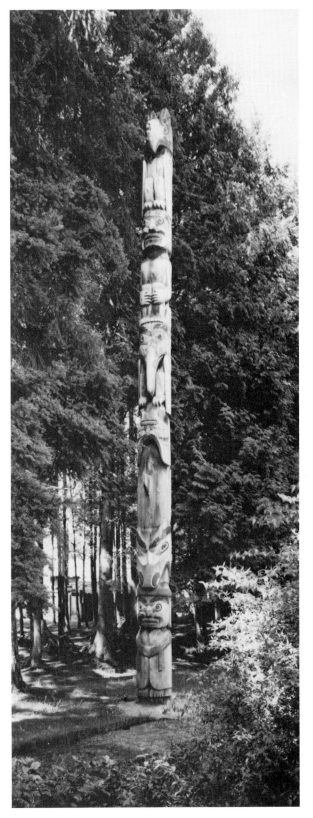

Fig. 58. Totem pole of Chief Kalilix, carved by Mungo Martin at the University of British Columbia in 1951, commemorating the head of his family line, who obtained the privilege of being served first at potlatch feasts. Height: 50 ft. A50040

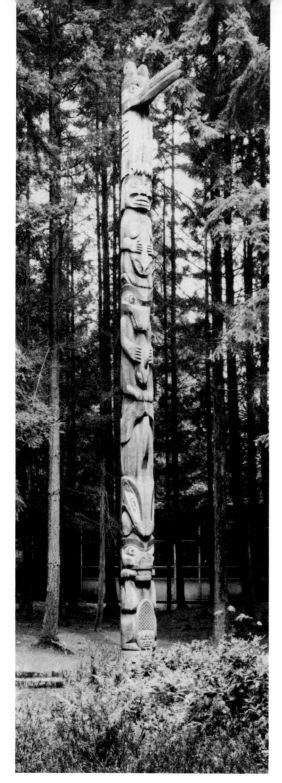

Fig. 59. Totem pole of Chief Kwekwelis, carved by Mungo Martin at the University of British Columbia in 1951, honoring his father's maternal grandfather, who was noted for having given the largest potlatch of his time, at Fort Rupert. Height: 50 ft. A50035

Fig. 60. Hokhokw portal pole from Rivers Inlet, carved before 1900 for Chief Walkus, photographed in situ. Height: 15 ft. BCTPPC Purchase 1956. A50006

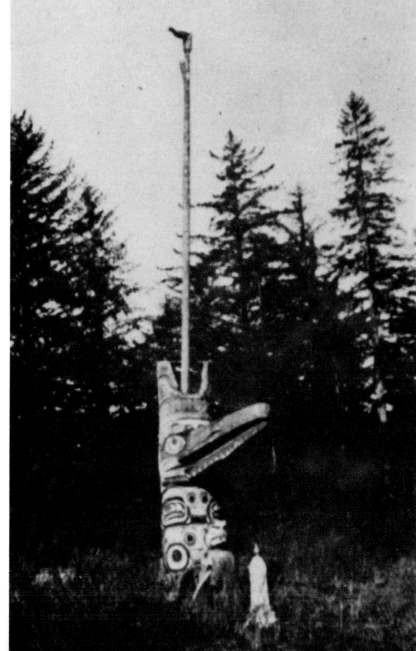

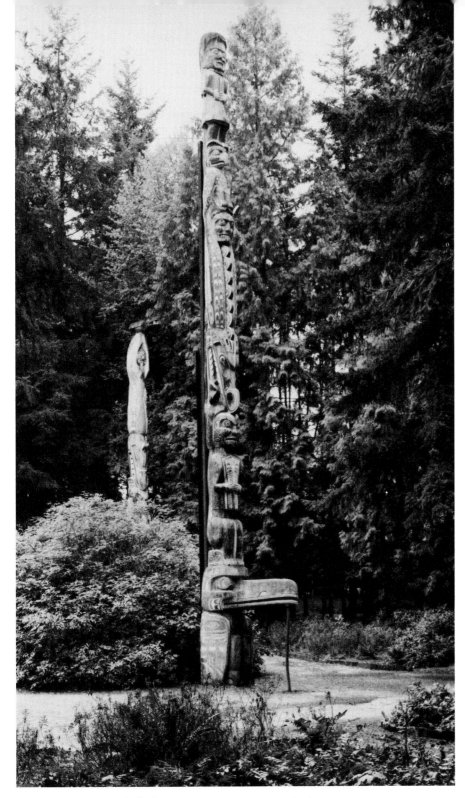

Fig. 61. Totem pole of Chief Tatensit, Fort Rupert, carved by Charlie James c. 1900. Height: 40 ft. Collected by Marius Barbeau 1947. A50038

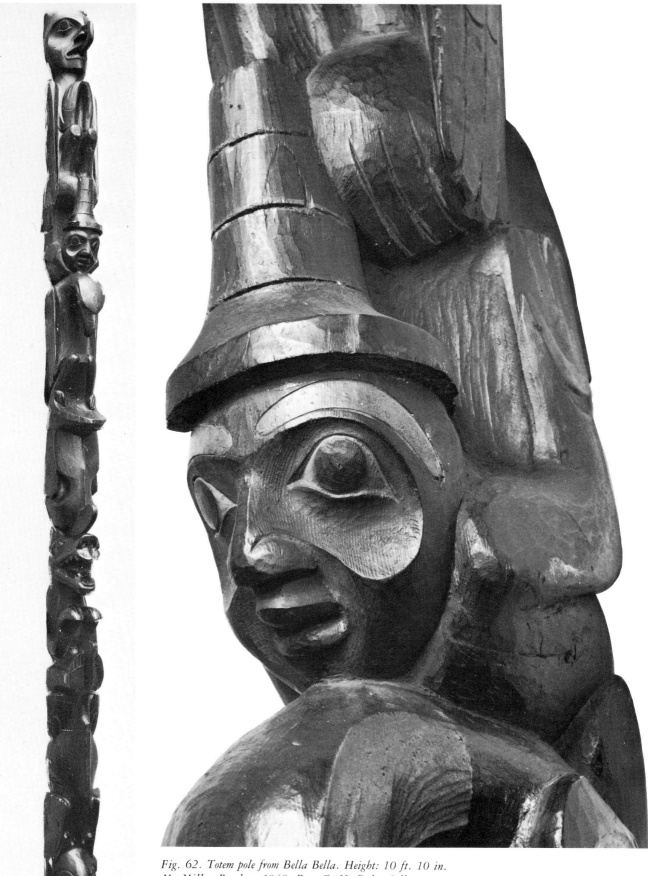

Fig. 62. Totem pole from Bella Bella. Height: 10 ft. 10 in.
MacMillan Purchase 1948, Rev. G. H. Raley Collection.
A6543

Fig. 63. Detail of totem pole from Bella Bella. A6543

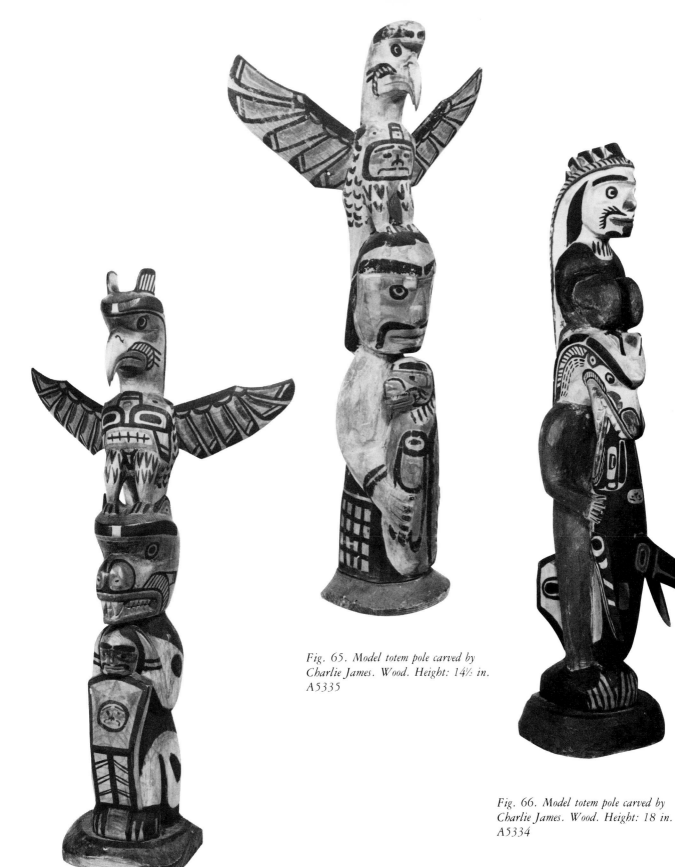

Fig. 64. Model totem pole carved by
Charlie James. Wood. Height: 15½ in.
A5329

Fig. 65. Model totem pole carved by
Charlie James. Wood. Height: 14½ in.
A5335

Fig. 66. Model totem pole carved by
Charlie James. Wood. Height: 18 in.
A5334

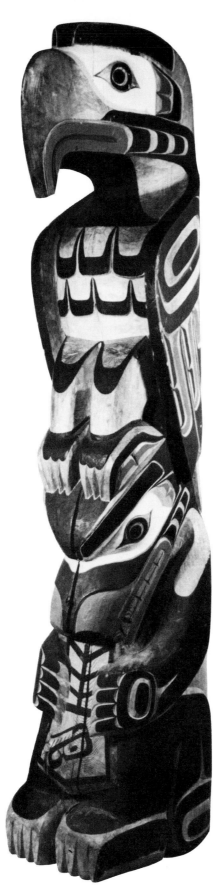

Fig. 67. Totem pole carved by Doug Cranmer. Wood; black, red, green. Height: 72½ in. A8381

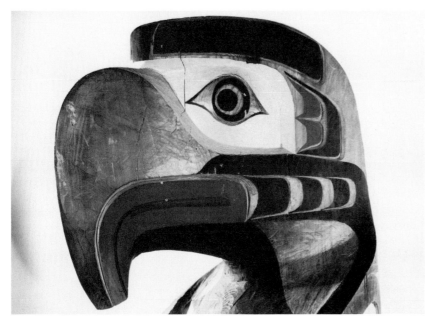

Fig. 68. Detail of eagle from Doug Cranmer totem pole.
A8381

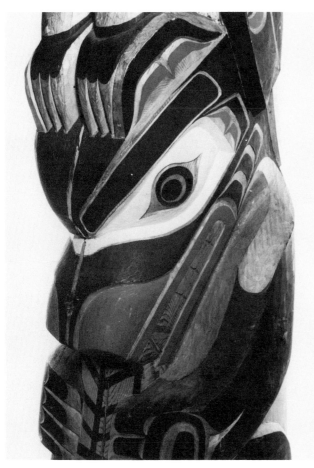

Fig. 69. Detail of bear from Doug Cranmer totem pole.
A8381

79

Other Human and Animal Carvings

A number of other types of carvings were made by the Kwakiutl and by other peoples of the Northwest Coast. Portraits of chiefs were sometimes carved as commemorative figures in recognition of an outstanding potlatch or some great deed. Such a carving might be placed on a tall pole, on the front roof gable or in front of the chief's house on a special occasion. Among the Kwakiutl, portraiture was often used more directly for illusion. A substitute head, for example, might serve to illustrate magical decapitation.

Ridicule figures were carved for the purpose of shaming a rival who had failed in boastful claims or had fallen short of meeting a social challenge. Such figures were often represented as emaciated beggars, and were sometimes seated at the fireside at a potlatch. Emmons (1914:64) recounts the revenge of an Indian chief of Graham Island who, after being fined by the court, had a portrait figure made of the judge and argued with it. Boas (1895: 366) recounts a quarrel between a man and his father-in-law. When the marriage exchange gifts failed to follow the expected satisfactory agreement, the young man showed his contempt for his father-in-law by having a carving of his wife made, a chain put around the neck of the effigy, and the figure "drowned" with all due ceremony. This reflected adversely on her family's ability to meet their commitments.

As we have already seen, the Kwakiutl often used carvings to create an illusion, as in the case of the novice arriving in a canoe who apparently drowned when the canoe overturned (Curtis 1915: 161). Swanton (1905:160) mentions a black whale built by the Haida which was large enough to hold ten novices inside.

Examples of some of these human figures are shown in Figures 70-73.

Some miscellaneous animal carvings, and implements decorated with crest designs, are illustrated in Figures 74-88. It should be noted that many tools and implements of domestic use were made in a decorative form which had no relation to ceremony or ritual. The craftsman probably put in the extra work for his own pleasure.

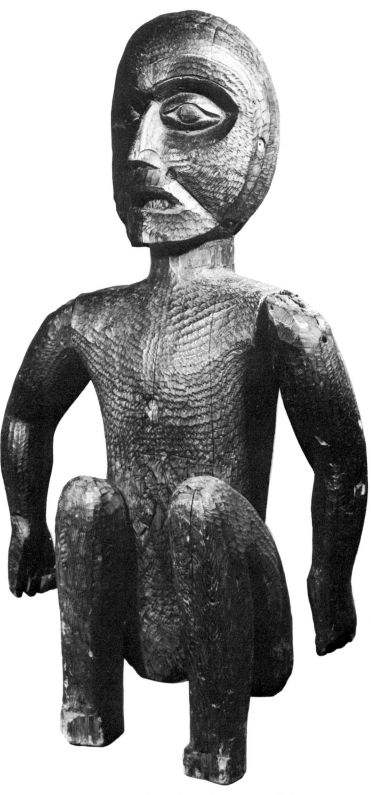

Fig. 70. Ancestor figure from Alert Bay. Wood; brown, black, red. Height: 58 in. MacMillan Purchase 1948, Rev. G. H. Raley Collection. A1800

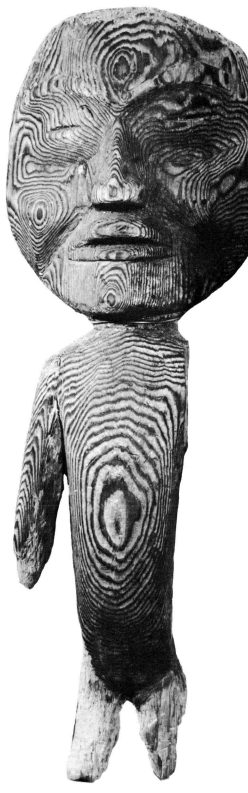

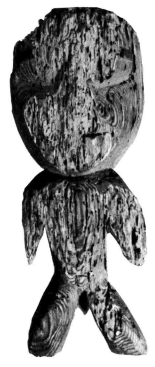

Fig. 72. *Grave effigy from Kitamaat. Unpainted wood.*
Height: 11 in. MacMillan Purchase 1948, Rev. G. H.
Raley Collection. A3688

Fig. 71. *Grave effigy from old village near Kitamaat. Un-*
painted wood. Height: 23 in. MacMillan Purchase 1948,
Rev. G. H. Raley Collection. A1799

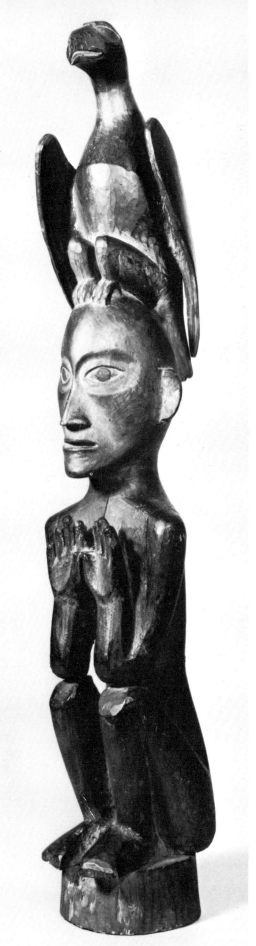

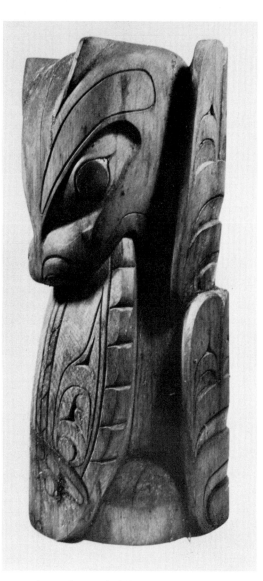

Fig. 74. Sea lion with fish in its mouth, carved by Mungo
Martin. Wood. Height: 14½ in. Walter and Marianne
Koerner Collection 1973. A17149

Fig. 73. Effigy from the grave of a chief at Kitamaat.
Wood; brown, black. Height: 33½ in. MacMillan Purchase
1948, Rev. G. H. Raley Collection. A2197

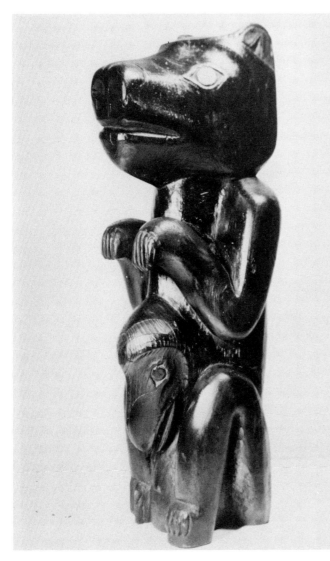

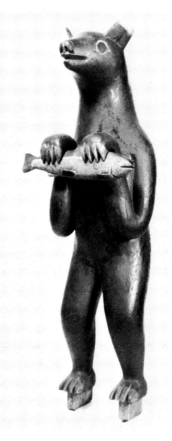

Fig. 75. Bear with raven. Oiled cedar. Height: 20¼ in.
Walter and Marianne Koerner Collection 1973. A17150

Fig. 76. Bear with a fish in its paws. Wood; black. Height:
37½ in. Museum Gift 1950. A2192

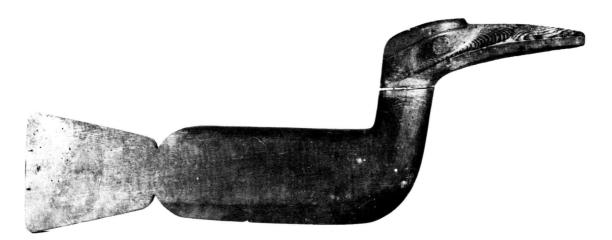

Fig. 77. Loon plaque. Wood. Length: 27 in. Walter and
Marianne Koerner Collection 1970. A5264

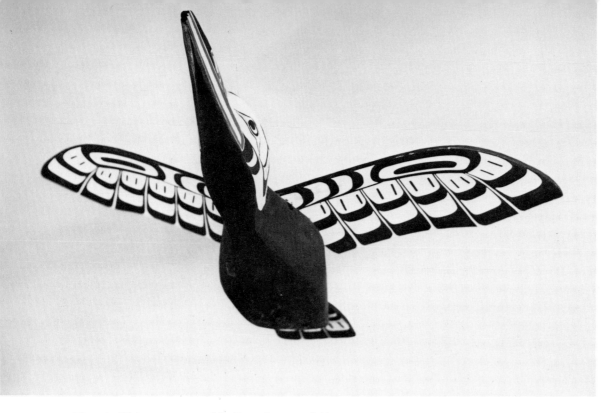

Fig. 78. Flying raven, carved by Doug Cranmer of Alert
Bay. Wood; black, white, red. Length: 42 in.; wingspan:
48¼ in. Walter and Marianne Koerner Collection 1973.
A17153

Fig. 79. Fish-man charm from Kitamaat. Wood; black.
Height: 8 in. MacMillan Purchase 1948, Rev. G. H. Raley
Collection. A3439

Fig. 80. Another view of fish-man charm. A3439

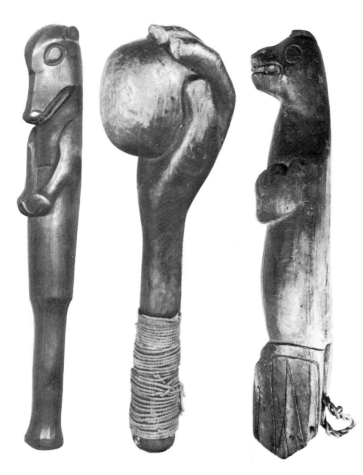

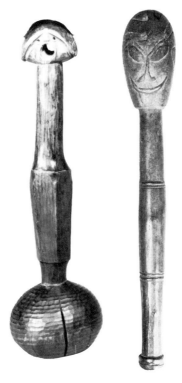

Fig. 81. Wolf-shaped club from Kitamaat. Wood. Length: 12 in. MacMillan Purchase 1962. A7958

Fig. 82. Club from Kingcome Inlet, carved in the shape of a hand holding a stone. Wood. Length: 14½ in. MacMillan Purchase 1952. A4115

Fig. 83. Net float in the shape of a sea otter. Unpainted wood. Length: 18½ in. MacMillan Purchase 1948, Rev. G. H. Raley Collection. A3437

Fig. 84. Club. Wood. Length: 12 in. MacMillan Special Grant 1962. A8076

Fig. 85. Fish club from Bella Bella. Wood. Length: 16 in. MacMillan Purchase 1948, Rev. G. H. Raley Collection. A1481

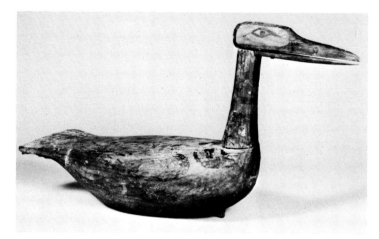

Fig. 86. Duck-shaped net float from Kingcome Inlet. Wood; black, white. Length: 20 in. MacMillan Purchase 1953. A6198

Fig. 87. Carving of man and animal from Bella Bella, probably the handle of an implement. Wood; red, black. Length: 7½ in. Frank Burnett Collection 1927. A131

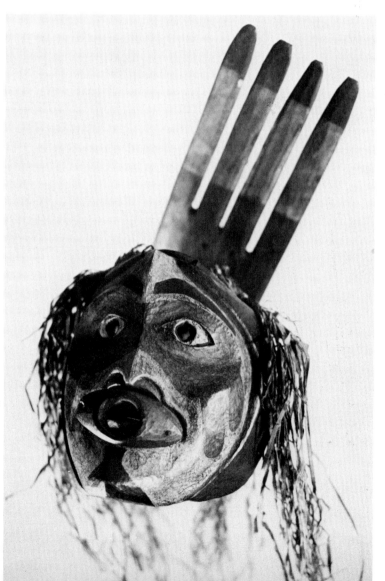

Fig. 88. Maskette with rotating handlike carving, probably intended to whirl around at the top of a mask or headdress. Wood and cedar bark; black, white, red. Height: 11½ in. Walter and Marianne Koerner Collection. A5301

Ceremonial Curtains

The light from the fire in the center of the dancing house accentuated the dramatic effects of the performance. At the rear there was a dressing room, to which the dancers retired in order to don their masks and change their costumes, and into which they could disappear. Here, too, there was a space where the novice could hide. To look into this territory was strictly forbidden to those who had not been initiated.

In the old days this room was a closet constructed of cedar plank walls, which were painted with the design of the tutelary spirit of the house. Later large cotton sheets were painted with the Tsetseka spirit of the dancing house and used as curtains. Each dancing house had its own spirit-painted curtain, called a *mawihl*.

By tradition the *mawihl* was ceremonially burned at the end of each winter dance season. Several informants reported, however, that because of the expense of commissioning a new curtain every year, the *mawihl* was often saved and used in the following season.

Examples of these curtains are shown in Figures 88 and 89. They were painted in black—either water pigment, mud and charcoal, or oil paint. The examples shown include in their designs the figure of the Sisiutl, the two-headed snake whose body is a human face (see also Figs. 206-30). Combined with the Sisiutl in Figure 90 is the T-shaped form of the copper (see also Figs. 266-70).

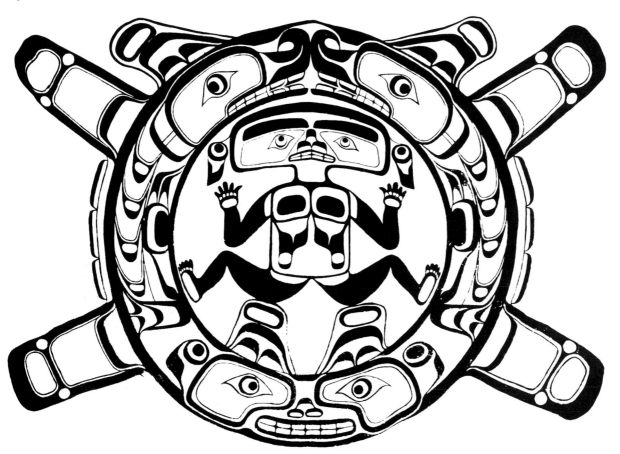

Fig. 89. Ceremonial curtain from Kingcome Inlet, attributed to Arthur Shaughnessy. Muslin with black painted design of Sisiutl and human figure. Width: 10 ft. MacMillan Purchase 1953. A4363

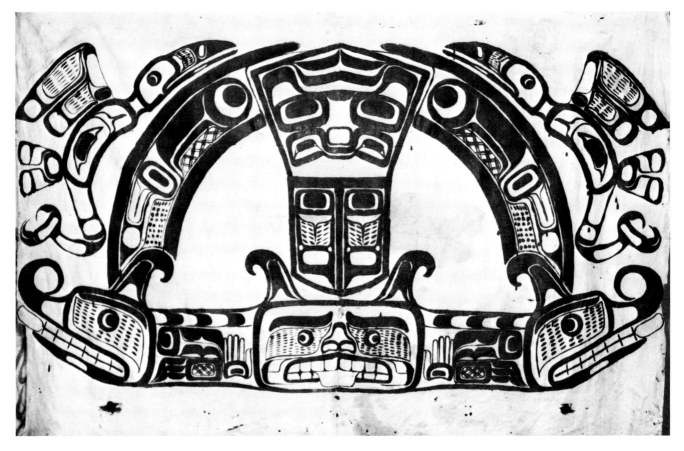

Fig. 90. Ceremonial curtain from Hope Island or Kingcome Inlet. Cotton with black painted design of Sisiutl, ravens, rainbow, and copper. Width: 13 ft. 1 in. MacMillan Purchase 1953. A6270

Supernatural Treasures

The *dloogwi*, or supernatural treasures, often consisted of small puppets or animal figures, sometimes in special boxes or cradles, which had supernatural significance. One way in which they were used is described by Drucker (1940:215):

On the appointed day the guests arrive. As they draw up in line before the beach, the villagers clap hands and sing while the host chief dances in honor of his guests. Then the chief stops suddenly and produces a "spirit doll" (a wooden figurine representing a nawaluk*w*) from beneath his robe. He whirls it about his head four times, then pretends to throw it to the head chief of the guests. The latter "catches" it (really displaying one of his own). If he intends to dance himself, he keeps the spirit; if not, he returns it. If several tribes are invited, the spirit is "thrown" to the head chief of each. This transforms the guests from the secular to the ritual state, so they may enter the dance house.

The puppets shown in Figures 95 and 96, from Bella Bella, are of this type. They are very light, with bodies made of cloth stuffed with grass. The others are made of wood. The puppets in Figures 91 and 92, representing Noontlemgeela, were conjured up out of the floor by the Tokwit dancer.

Figures 93 and 94 show two puppets that were lowered by strings from the beams of the dancing house. Although they appear to be Christian angels, this is not necessarily their only inspiration, for the concept of magical flying with or without wings was a supernatural gift theme of several winter dances embodied in myth. All the wooden puppet figures have mica flakes or silver paint on some portion of them to enhance the glittering effect of their arrival.

Figure 97 shows a Tokwit box with a figure that was conjured up by the Tokwit dancer. The box was buried in a trench nearby, and when an assistant pulled the strings, which were attached to spools, the small puppet rose above the ground, its arms outspread. The puppet in the cradle shown in Figure 98 was covered with a crest-painted sheet (now in fragments). It sat up as the strings were pulled and appeared to be watching a spinning ball (now missing) that whirled around on the shaft in the front of the cradle.

The "supernatural crabs" (Figs. 102, 103) were made on spool rollers, so that they scuttled along the floor sideways when pulled. Each leg was attached very lightly to a piece of cloth along the edge of the crab, and the effect of the wooden pieces striking each other produced the dry, rustling sound of a crab scuttling on a rock.

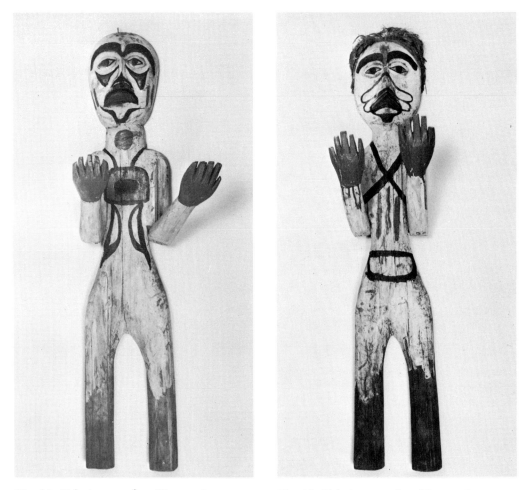

*Fig. 91. Tokwit puppet from Kingcome In-
let. Wood; black, white, red. Height: 33
in. MacMillan Purchase 1951. A4514*

*Fig. 92. Tokwit puppet from Kingcome In-
let. Wood; black, white, red. Height: 33
in. MacMillan Purchase 1951. A4515*

*Fig. 93. Tokwit puppet from Kingcome Inlet, about 35 years old.
Wood. Height: 26 in. MacMillan Purchase 1951. A4516*

*Fig. 94. Tokwit puppet from Kingcome Inlet, about 35 years old.
Wood. Height: 26 in. MacMillan Purchase 1951. A4517*

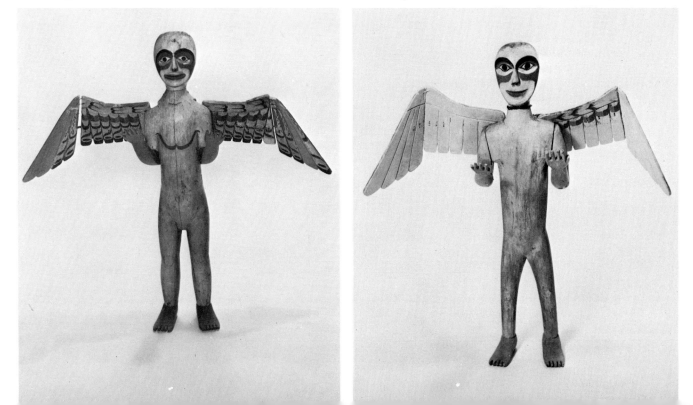

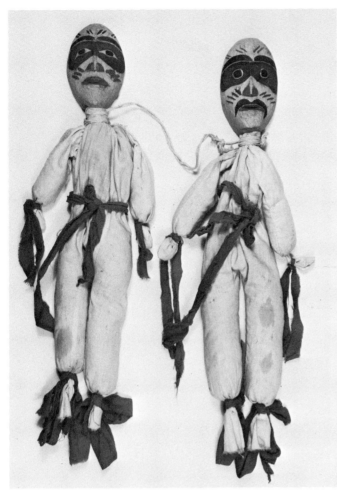

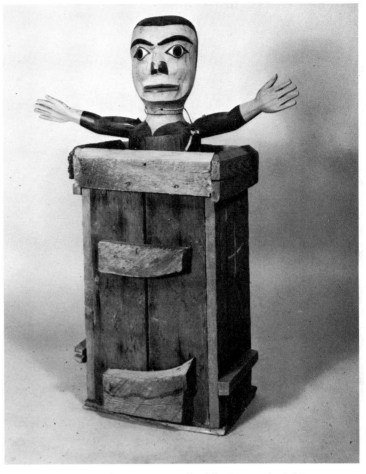

Figs. 95, 96. Tokwit puppets from Bella Bella. Wood with cloth bodies. Height: 22 in. Dr. and Mrs. G. E. Darby Valedictory Gift 1931. A3411

Fig. 97. Tokwit box from Kingcome Inlet. The box was buried in the dirt floor, and the figure appeared in the course of the dance. Wood; red, white, black. Height with figure extended: 35 in. Leon and Thea Koerner Foundation Purchase 1958. A6891

Fig. 98. Puppet cradle from Village Island. Wood; red, black, green. Length: 45 in. MacMillan Purchase 1961. A7877

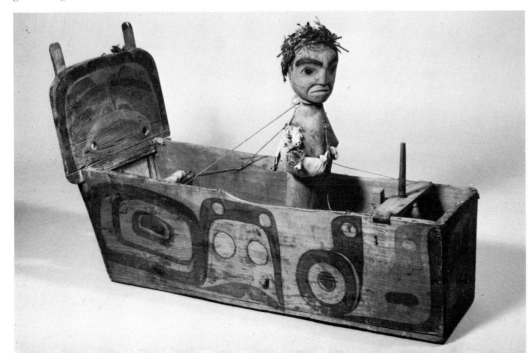

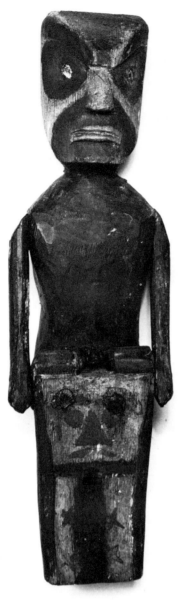

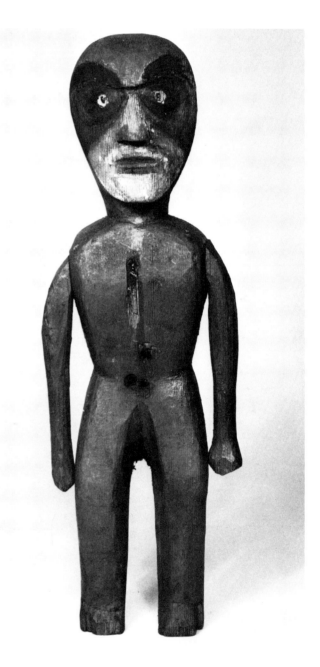

Fig. 99. Human figure with copper, possibly Tokwit. Wood; black, white, green, brown. Height: 13½ in. Walter and Marianne Koerner Collection 1970. A5280

Fig. 100. Human figure, possibly Tokwit. Wood; black, white, red, green; copper at bottom. Height: 14½ in. Walter and Marianne Koerner Collection 1970. A5260

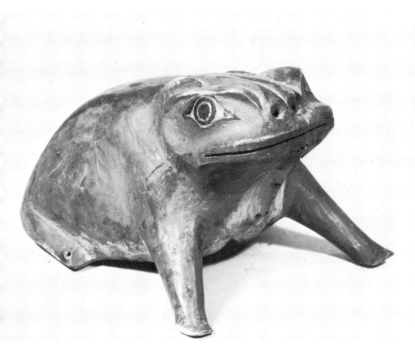

Fig. 101. Tokwit frog from Kingcome Inlet. Wood; green, black, red. Length: 11½ in. MacMillan Purchase 1953. A6200

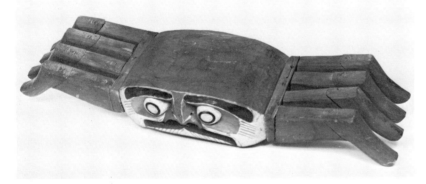

Fig. 102. Tokwit crab from Port Hardy. Wood and nails; red, orange, black, white. Width: 26½ in. MacMillan Purchase 1954. A6362

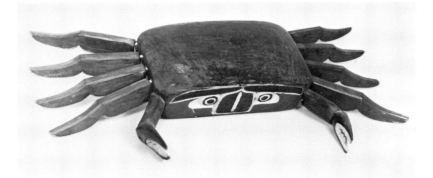

Fig. 103. Tokwit crab from Kingcome Inlet. Underneath the crab is a spool roller. Wood; brown, white, black. Width: 29 in. MacMillan Purchase 1952. A4104

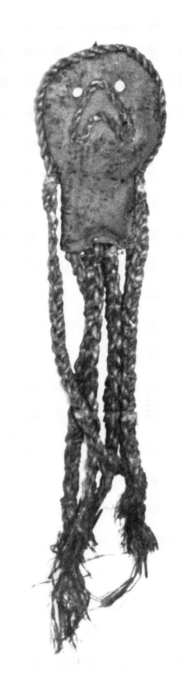

Fig. 104. Octopus puppet. Cloth body with filler material; red cedar bark tentacles; cedar bark mouth; button eyes. Height: 11 in. Walter and Marianne Koerner Collection 1976. A5296

Batons,
Whistles, Clappers,
and Rattles

Songs and dances were part of all ceremony and ritual, a fundamental element of the inherited privilege. Equally important were the many whistles and other musical instruments that were specifically designated for most dances.

The transfer of the whistles and the box holding the gear for the dance was an important part of the transfer of privileges from father to son-in-law. Members of the society witnessed the transfer, meanwhile giving the ceremonial cry belonging to the Tsetseka season, even though the actual ritual might take place in the Bakoos time. The use of sound to characterize the ever present supernatural spirits among humans was a very important part of the winter society dances.

All performances for public or dancing society gatherings involved the use of long planks, placed near the seats of the dance house, on which wooden batons were beaten in time for the singers and dancers. To obtain and to pass out these batons was the inherited job of an official. Drumming to accent the beat was also basic to all performances, the most widespread drum form being a rectangular box suspended from a rafter by a rope and beaten with a leather-covered stick.

A round drum of hide stretched over a wooden frame and grasped from behind was another form frequently used, especially in the south. The drum and drummer had a designated place in each dance house arrangement.

The whistles blown in the woods to introduce the ceremonial season—usually four times for each of four nights—caused commotion and excitement in the village as the people prepared for the new season. There were several types of whistles, each with its characteristic sound, and a vast number were made. Of the 150 in the collection at the museum, a selection has been made to illustrate the main types. Wooden whistles of one, two, or three shafts, each with several holes and reeds, produced a strong, clear, rather eerie note, whose effect increased with the number of shafts. These were made of thin, hollowed shells of wood, glued with pitch and bound together. Whistles with reeds, which were bound together and fastened in-

side, were especially associated with the Klasila, and their tone was easily recognized. Bellows whistles like those in Figures 128-30, bound under the arm by a strap and completely covered by the wearer's costume, produced their sound from concealment. Other magical whistles were so small that they could be held inside the mouth and blown without revealing the source of the sound, or blown secretly when a hand or the corner of a blanket momentarily concealed the mouth in the course of the dance. Figures 113, 115, and 117 illustrate examples of Hamatsa whistles, which were of great importance as part of the spirit manifestations. The dramatic importance is indicated by the variety of specialized whistles, each of which was carefully made to produce specific tones. Every whistle was the object of time, skill, and concern, and was considered by those who owned it as a necessary part of the whole family collection.

Clappers were fashioned of a piece of wood cut, squared or rounded, hollowed out, and wrapped together with cedar withes or other vegetable fibers. The clapper was hinged flexibly on one side and produced a percussive noise when shaken. The sudden and loud noise was part of the drama. Thus the war spirit dancer, the male form of Mitla, came in balefully and sounded his clapper before he used his magical weapon. A clapper said to have been "carried by Mitla while he was disrupting the singers" is shown in Figure 152.

Rattles, like whistles, were an essential part of all inheritances. Their forms varied with their purpose. The complex chief's rattle, or bird rattle (Figs. 131-35), which was one of the outstanding art forms of the region, was a hollowed shell of wood, usually carefully carved and fitted, extremely light and finely finished in the form of a bird. Some adaptation of this form extended from the northern Tlingit down to the southern Kwakiutl and Nootka. Undoubtedly first borrowed by the southern groups from the northern tribes, it was used everywhere by high-ranking officials as an accessory to complete their costumes. It was employed only during the Klasila, not in Tsetseka

times, when the round rattle was used. The chief, while he was making a speech, shook the rattle to emphasize what he was saying. The chief's rattle was held always pointed downward. Bill Holm (1972:30) mentions that this is because of a myth in which a bird rattle, once held pointed upward, came to life and flew away.

Originally this was probably a healing rattle used by shamans, its use symbolized by the protruding tongue of a recumbent figure identified as an otter, an animal associated with the shaman. The general form of the rattle was that of a bird, the handle being the tail, the back of the bird a platform on which assorted small figures were carved, and the belly emphasized by a bird's face and beak. In nearly every case the animal and human figures were exquisitely carved, detailed, and painted. Colors, usually limited to touches of red and black, were employed sparingly and softly.

The rough shape was cut from yellow cedar or alder and split in two. With a curved knife, the block was then hollowed to a shell with walls as thin as one-sixteenth of an inch. The shell was then carved carefully with a knife blade and finished smooth by the use of an abrasive such as sharkskin. Small stones or shot were put in, and the rattle was sewn together by a withe through small holes bored in the side—one, two, or three stitches at each side. The two halves of the handle were then bound by withes.

Shamans' rattles were generally round, hollowed shells made with the same care and finished but unadorned. The rattles associated with the Tsetseka season were of this hollowed form, and many of them, particularly those used by the Hamatsa, were carved to imitate a skull. The Solatlala, attendants of the Hamatsa, carried rattles, sometimes in the form of human heads, which were used to pacify the cannibal dancer and help to calm him down as he became tamed (Figs. 136, 140, 141, 146-49). Rattles made of copper, or of wood in the shape of copper, were associated with the important copper, symbol of surplus wealth (Figs. 142-45).

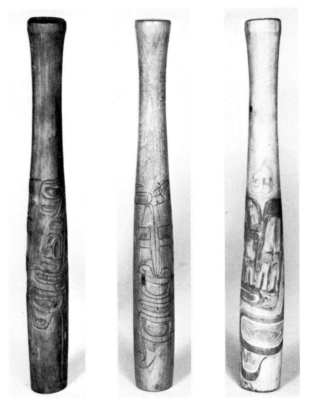

Fig. 105. Baton from New Vancouver. Wood. Length: 13 in. MacMillan Purchase 1952. A4377

Fig. 106. Baton from New Vancouver, with Thunderbird design. Wood. Length: 13½ in. MacMillan Purchase 1953. A6439

Fig. 107. Baton from New Vancouver. Wood; blue, red, orange. Length: 13½ in. MacMillan Purchase 1953. A4291

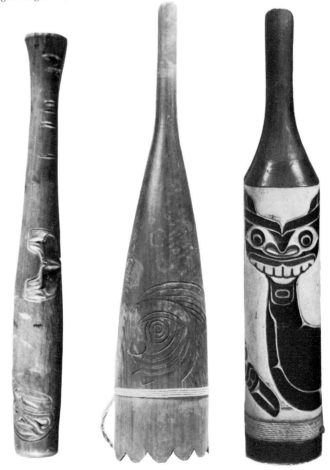

Fig. 108. Baton with killer whale design. Wood. Length: 12½ in. Walter and Marianne Koerner Collection 1976. A2591

Fig. 109. Klasila whistle, probably Kwakiutl. Wood. Length: 19½ in. Gift of Walter C. Koerner 1962. A8325

Fig. 110. Klasila whistle from Kingcome Inlet, with killer whale design. Wood; white, black, red, blue. Length: 15 in. MacMillan Purchase 1951. A3660

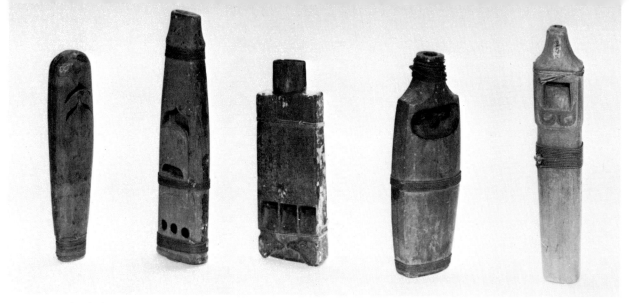

Fig. 111. *Whistle from Village Island. 2 pieces of wood bound with cord, with 2 carved slits, some red paint; 1 tone. Length: 9½ in. MacMillan Purchase 1953. A4222*

Fig. 112. *Whistle from Village Island. 2 pieces of wood bound with string, with 3 holes and 2 carved slits; 2 tones. Length: 11¼ in. MacMillan Purchase 1953. A4207*

Fig. 113. *Hamatsa whistle from Fort Rupert. 2 pieces of wood bound with string, with 2 carved bird figures; 3 tones. Length: 9 in. MacMillan Purchase 1951. A3620*

Fig. 114. *"Owl whistle" from Hope Island. 2 pieces of wood bound with cord; 1 tone. Length: 9¾ in. MacMillan Purchase 1953. A6263*

Fig. 115. *Hamatsa whistle from Blunden Harbour. 3 pieces of wood bound with string; 2 tones. Length: 11 in. MacMillan Purchase 1953. A6330*

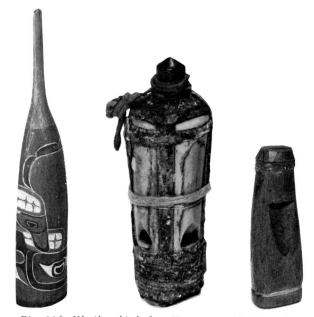

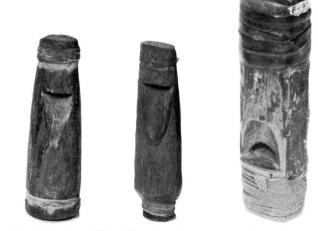

Fig. 116. *Klasila whistle from Hopetown, with killer whale design; ½ missing. Wood; blue, green, black, red, white. Length: 16 in. MacMillan Purchase 1953. A4339*

Fig. 117. *Hamatsa whistle from Alert Bay. Wood and bone bound with cord and sealed with resin gum; 4 tones. Height: 4¼ in. MacMillan Purchase 1962. A7973*

Fig. 118. *"Invisible" whistle from Fort Rupert, collected in 1885. Wood. Length: 3⅛ in. MacMillan Purchase 1963, Cadwallader Collection. A8401*

Fig. 119. *"Invisible" whistle from Fort Rupert, collected in 1885. Wood. Length: 3¾ in. MacMillan Purchase 1963, Cadwallader Collection. A8403*

Fig. 120. *"Invisible" whistle from Fort Rupert, collected in 1885. Wood. Length: 3½ in. MacMillan Purchase 1963, Cadwallader Collection. A8404*

Fig. 121. *"Raven whistle" from Village Island. 2 pieces of wood bound with string and carved with a crude human face; 2 tones. Length: 11¼ in. MacMillan Purchase 1953. A4188*

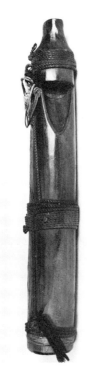

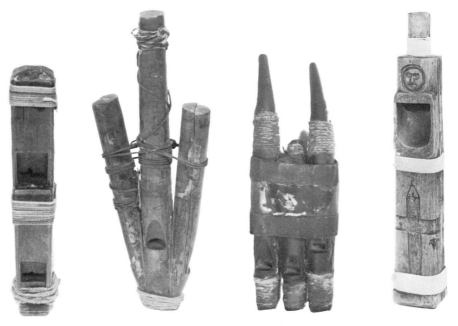

Fig. 122. Hamatsa whistle. Wood bound with cord; 2 tones. Length: 11½ in. Walter and Marianne Koerner Collection 1970. A5258

Fig. 123. "Eagle whistle" from Village Island. 5 pieces of wood bound with string; 4 tones. Length: 6½ in. MacMillan Purchase 1953. A4225

Fig. 124. Whistle from New Vancouver. 3 wooden pipes bound with string and tied together; 4 tones. Length of middle pipe: 10½ in. MacMillan Purchase 1954. A6372

Fig. 125. Whistle from Kitlope. 3 horn tubes bound together with paper, tape, and cord; 3 tones. Length: 5¼ in. MacMillan Purchase 1948, Rev. G. H. Raley Collection. A1758

Fig. 126. Whistle from Gilford Island. 2 pieces of wood bound with twine, carved with a Tsonokwa head; 1 tone. Length: 13⅛ in. MacMillan Purchase 1952. A3828

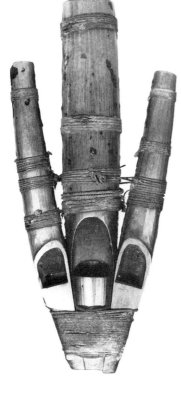

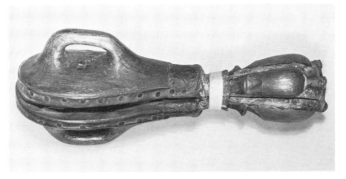

Fig. 128. Bellows whistle from Kitamaat. Wood and leather; 4 tones. Length: 13½ in. MacMillan Purchase 1948, Rev. G. H. Raley Collection. A2183

Fig. 127. Whistle. Wood bound with cord; 3 tones. Length: 13 in. Walter and Marianne Koerner Collection 1970. A5255

Fig. 129. Bellows whistle from Fort Rupert, collected in 1885. Wood and deerhide. Length: 9 in. MacMillan Purchase 1963, Cadwallader Collection. A8399

Fig. 130. Bellows whistle from New Vancouver Village. Wood and leather with nails; 2 tones. Length: 6¾ in. MacMillan Purchase 1961. A7486

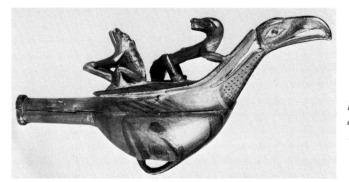

Fig. 131. Rattle from Bella Bella, with raven, frog, and sea otter design. Wood; black, red. Length: 13 in. MacMillan Purchase 1948, Rev. G. H. Raley Collection. A1760

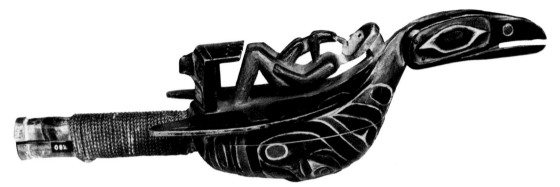

Fig. 132. Raven rattle. Wood; black, red, green. Length: 13¼ in. Walter and Marianne Koerner Collection 1970. A5253

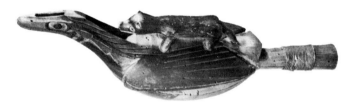

Fig. 133. Rattle with bird and bear design. Wood; black, red, green. Length: 16 in. MacMillan Purchase 1962. A8284

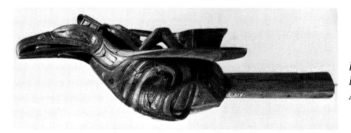

Fig. 134. Raven rattle from Village Island. Wood; black, green, red. Length: 12 in. Leon and Thea Koerner Foundation Gift 1957. A6634

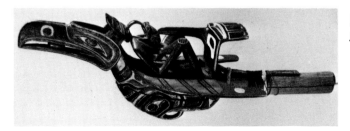

Fig. 135. Raven rattle from Gilford Island. Wood; red, black, green, white. Length: 12½ in. MacMillan Purchase 1953. A6308

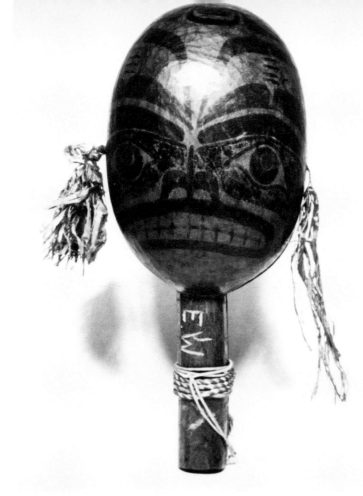

Fig. 136. Solatlala rattle. Wood and cedar bark;
green, black, blue. Length: 11 in. Walter and
Marianne Koerner Collection 1970. A5263

Fig. 137. Rattle. 2 pieces of hammered copper
riveted to a wooden handle; sea bear design; black,
red, green. Length: 9⁹⁄₁₆ in. Walter and Marianne
Koerner Collection 1970. A5259

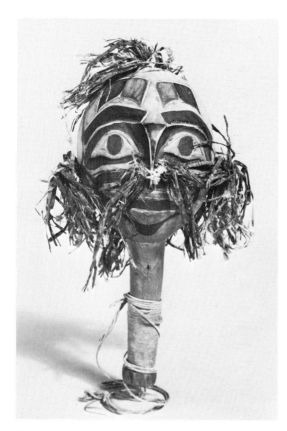

Fig. 138. Rattle from Smith Inlet, with hawk de-
sign. Wood and cedar bark; red, black. Length: 11
in. MacMillan Purchase 1951. A4027

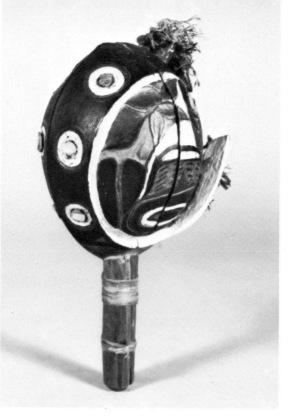

Fig. 139. Rattle from Blunden Harbour, with
whale design. Wood, cedar bark, and abalone shell;
white, black, green, red. Length: 11½ in. MacMil-
lan Purchase 1951. A3656

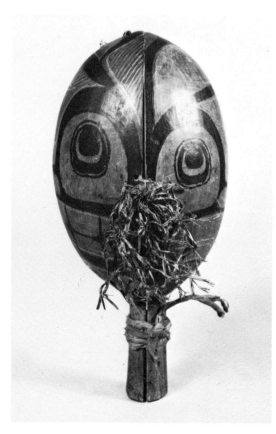

Fig. 140. Solatlala rattle from Gilford Island.
Wood and cedar bark; red, black. Length: 11 in.
MacMillan Purchase 1962. A8046

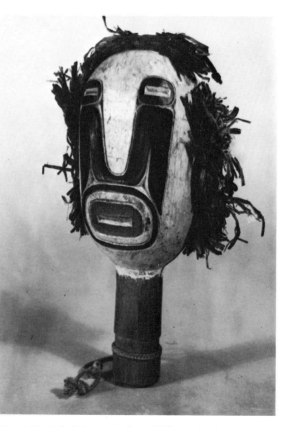

Fig. 141. Solatlala rattle from Gilford Island.
Wood and cedar bark; white, black, red. Length:
13 in. MacMillan Purchase 1953. A6296

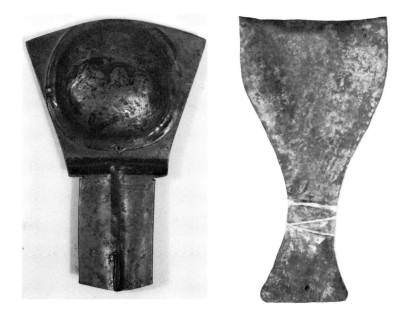

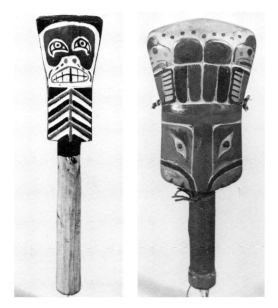

Fig. 142. *Rattle from Village Island. Copper; green, red, black. Length: 7 in. MacMillan Purchase 1953. A4254*

Fig. 143. *Rattle from Bella Bella. Copper. Length: 5¼ in. Dr. G. E. Darby, 1931 Valedictory Gift. A1111*

Fig. 144. *Modern ceremonial rattle from Village Island. Wood, shaped in the form of a copper; black, green, red. Length: 10½ in. MacMillan Purchase 1951. A6099*

Fig. 145. *Rattle from Village Island. Wood, shaped in the form of a copper; green, red, blue. Length: 9½ in. MacMillan Purchase 1953. A4031*

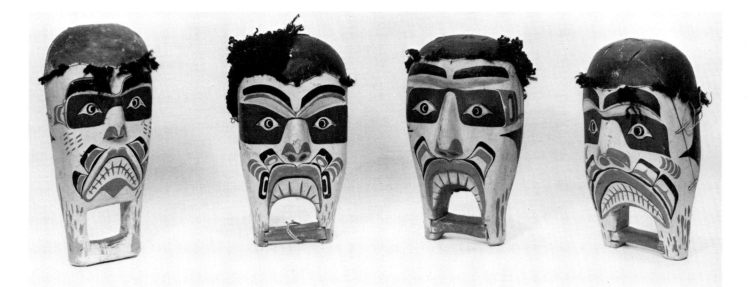

Figs. 146-49. *4 Solatlala rattles from Fort Rupert, made by Dick Price in 1940 and depicting severed heads. Wood with woolen hair; white, green, black, orange. Height: 13 in. MacMillan Purchase 1952. A3793, A3794, A3795, A3796*

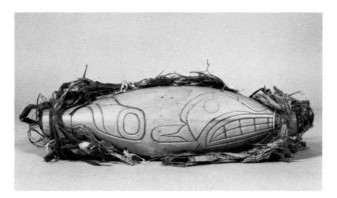

Fig. 150. Rattle from Kingcome Inlet, with killer whale design. Wood and cedar bark; yellow. Length: 17½ in. MacMillan Purchase 1961. A7316

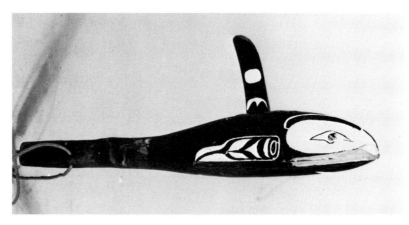

Fig. 151. Rattle from Port Hardy, with killer whale design. Wood; black, white, red. Length: 9½ in. Mac-Millan Purchase 1954. A6363

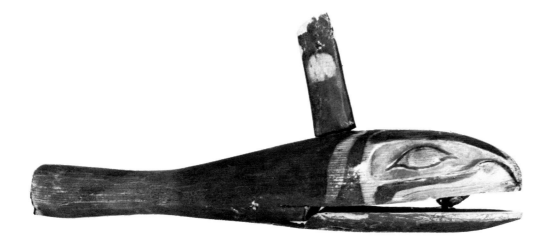

Fig. 152. Clapper from New Vancouver, with killer whale design. Wood; black, green, red. Length: 11¼ in. MacMillan Purchase 1954. A6368

Mourning
Masks

The brief mourning period that introduced the winter ceremonials was marked by the singing of the songs of those who had died since the last Tsetseka season. Members of the family lineage of the deceased wore mourning masks like those shown in Figures 153-55. Figure 153 depicts a woman of the Koskimo, who practiced head-shaping, as shown by the sloping forehead. The lines painted on the mask represent furrows made by deliberate self-abrasion of the skin, a stylized form of grief demonstration. Figures 154 and 155 have lines of copper, representing tears streaming down each cheek.

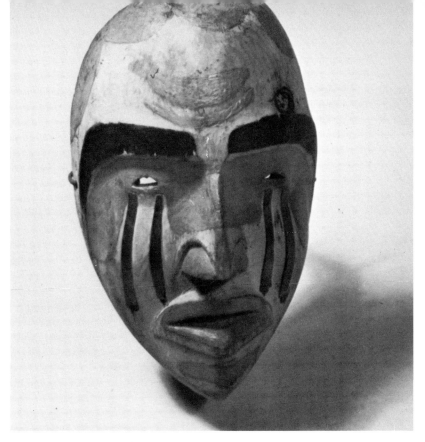

Fig. 154. Mourning mask from Village Island. Wood; orange, black. Height: 10¼ in. MacMillan Purchase 1952. A4176

Fig. 155. Mourning mask. Wood; black, orange, blue. Height: 10¼ in. MacMillan Purchase 1948. A6544

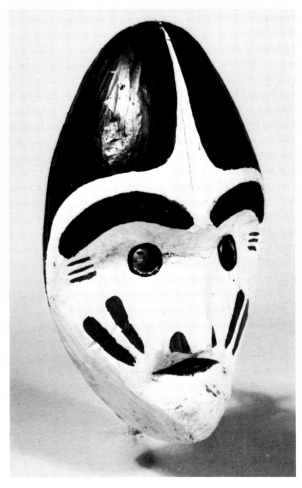

Fig. 153. Mourning mask from Smith Inlet. Wood; red, white, black. Height: 13 in. MacMillan Purchase 1953. A6352

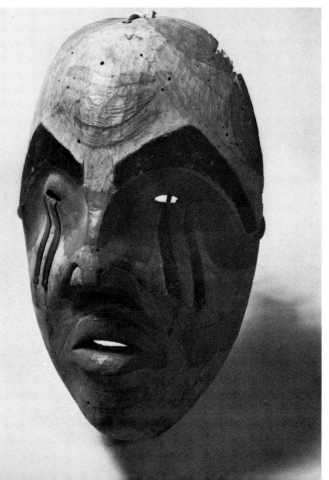

Masks of Gakhula, the Intruder

The masks shown in Figures 156-58 represent Gakhula, the Intruder, whose entrance interrupted the proceedings of the Klasila. These characters engaged in a mock struggle with the attendants and were finally subdued and ejected from the house. Gakhula is associated particularly with the southern Kwakiutl.

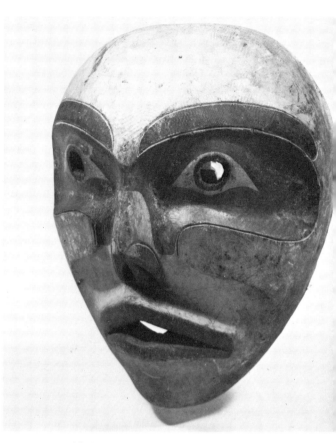

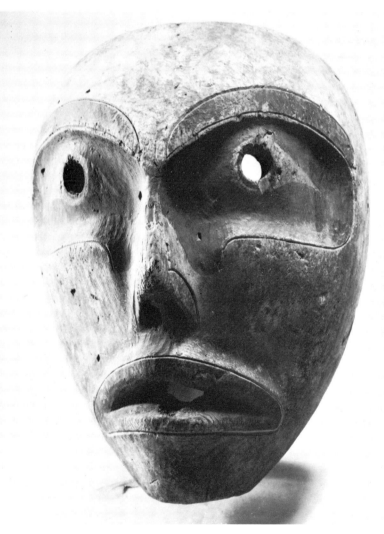

Fig. 156. Gakhula (Intruder) mask from Gilford Island. Wood; green, red, black, white. Height: 12 in. MacMillan Purchase 1952. A3816

Fig. 157. Gakhula (Intruder) mask from Kingcome Inlet. Wood; green, black, red, white. Height: 12¼ in. MacMillan Purchase 1953. A6274

Fig. 158. Gakhula (Intruder) mask from Kingcome Inlet. Wood; yellow, black, red. Height: 10 in. MacMillan Purchase 1953. A6211

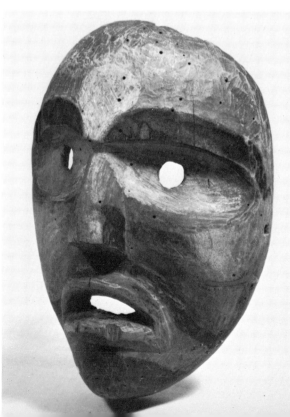

Hamatsa Bird-Monster Masks

Hamatsa bird-monster masks were worn with cedar bark fringes hanging from the back of the mask down over the shoulders, effectively concealing the dancer, who was further covered by a long cape of shredded cedar bark that fell to the ankles. The lower beak of the mask was jointed, so that when the proper string was pulled it shut with a clap. At one point in the dance a number of bird-monsters, dancing with a springy bird step in unison with the sharp beat of the batons, turned their heads in various directions and clapped their beaks to the beat. At moments of high drama they clapped their beaks in fast vibration, while the beat of the batons and the dance steps increased rapidly.

The bird-monster masks were constructed to be worn on the forehead, with the cedar bark fringe concealing the face and shoulders. They varied in length from less than two feet to more than eight feet, and in weight from two to sixteen pounds. Considerable strength, not only of the neck and shoulder muscles, but especially of the legs, was required in order to wear these masks and dance with them in the difficult squatting position.

The masks were secured in two ways. In some, a strong stick fastened at the top and back of the mask went straight down the spine to mid-shoulders or waist. there it was fastened by a rope (originally of cedar bark, later of twine) around the waist or chest. The other method used was a rope harness going from the top back of the mask down around both armpits and tied around the chest or waist. Both methods held the mask securely and left the hands of the dancer free for manipulating the beak or for dancing gestures.

The traditional color of all these masks was black, with details of white paint, and red added to the nostril or beak. Most of them were both carved and painted, and they were made with great care. A few had small wooden skulls added to the cedar bark fringe. These skulls were characteristic motifs of the whole Hamatsa drama (see Figs. 197, 204, 205).

The Hamatsa Complex

Because of the importance of the Hamatsa winter dancing society among the Kwakiutl, the Hamatsa masks were always carefully carved, representing the finest efforts of the carvers commissioned to make them for a new member. These masks have been sought by collectors as one of the most dramatic and imaginative examples of the art forms produced by Kwakiutl carvers.

Hamatsa masks portrayed the fabulous bird-monsters, Kwakwakwalanooksiwae ("Raven-at-the-mouth-of-the-river"), Hokhokw, and Galokwudzuwis (Crooked Beak). The Hamatsa masks in the museum were acquired by purchase from their Indian owners, over a period from 1948 to 1965, along with other ceremonial dancing society properties. They are uniformly of high quality in craftsmanship and imagination, carved and painted in a long line of tradition. During this period, twenty-nine Hamatsa raven masks were collected, seven of Hokhokw, thirty of Crooked Beak, and three of multiple characters. Although no attempt was made to obtain representative proportions of the four types of masks, it is possible that the acquisitions did in fact reflect the proportion actually produced. Several examples of each of the four types of Hamatsa masks have been selected to illustrate the essential characteristics of each of the bird-monsters.

Hamatsa ravens are seen in masks carved by Mungo Martin (Pl. IV A), attributed to Dick Hawkins (Fig. 160), carved by Joe Seaweed (Fig. 159), and attributed to Willie Seaweed (Fig. 161). See also Mungo Martin's painting (Fig. 501). These masks are distinguished from non-Hamatsa raven masks (Figs. 408-11) by the cedar bark fringe covering the face and extending down to the shoulders. The Hamatsa raven has a long, heavy beak, with the emphasis on a firm curve near the end of the upper beak, over the nostrils, and toward the tip. The massive nostril is characterized

by a marked flare, achieved by an elaboration of carved-out lines, brackets, and parallel curves. The nostril is always further emphasized by red paint. The eye socket area, which occupies one-fourth to one-third of the head, is emphasized by the characteristically curved open eye form, deeply carved. The raven head is painted in black as the primary color, with white the secondary color used for detail, and red for emphasis on the flared nostril and "lips" of the beak. Sometimes orange is used as a subsidiary fourth color for details of the nostril.

Hokhokw masks are shown in Plate IV B, made by Jack James; Figure 162, made by Willie Seaweed; and Figure 163, made by Charlie George, Sr. This bird is characterized by a long, narrow bill, longer and narrower than that of the raven, with the upper beak squared off at the tip. The beak is about three times the length of the eye form. The nostril is emphasized with flared carving and red paint. Black is the primary color, with white used as a secondary color to emphasize the eye socket and nostril details, and red the third color to elaborate the nostril and "lips" of the beak. The small curved beak face on the underside of the bottom beak in Figure 162 appears to be a symbol of the initiating overall spirit, and probably represents Bakbakwalanooksiwae.

Plate V A, carved by Willie Seaweed for Tom Hunt, and Figures 164-70 illustrate Crooked Beak masks. These provided the greatest range for individual variation by the artist because of the elaborate curve, arching above the short, squat beak, that characterized this remarkable bird. This curved wooden arch, which might be either solid or cut out, comprises half of the mass of the mask. It is emphasized by the use of paint in details of curved lines and brackets. The nostrils within the mask muzzle are flared, and the emphasis of the nostrils with the curved beak arching above them gives to the whole mask a character both aggressive and massive. The eye form in its socket is tapered at both ends, with a round, alert, open pupil.

The mask shown in Plate V A is decorated on the underside of the lower beak with a small carving that probably represents the Hamatsa spirit master Bakbakwalanooksiwae. The incorporation of this symbol was apparently dictated by the carver's design scheme, and even without it the conventions of the carving as a whole express the Hamatsa nature of the mask. Another feature of this mask that was included by the carver's choice is the ear form above the eye ridge, representing the supernatural sky-spirit ear of the bird.

The painting of the Crooked Beak masks follows the tradition of using black as the primary color; white as the secondary color, for emphasis; and red as the third color, used to mark the nostrils and beak "lips." In the mask in Plate V A, Willie Seaweed, a gifted master carver, has chosen to use brown paint in addition to the traditional black, white, and red.

Multiple Hamatsa masks were made up of the three bird-monsters, in various combinations, representing the successive stages of the initiation. The mask illustrated in Plate V B, made by Charlie James for Mungo Martin about 1914, consists of two small raven beaks and a small Hokhokw beak on top of a massive Crooked Beak, which supports them. All four beaks are open and can be made to "clack" at appropriate moments in the dance by the use of concealed strings. The alert, carefully carved heads convey a strong sense of vitality.

The mask in Plate VI A, made by Willie Seaweed about 1920, has the Hamatsa raven on the left and Crooked Beak on the right. The ears adorning Crooked Beak, which were added later, are supernatural ears, such as were often placed on the heads of mythical birds, animals, and fish. Plate VI B, a mask attributed to Dick Price, includes a raven on the left with Crooked Beak on the right and a small curved beak and head on top. The curve of this top beak is not a true "crooked beak," but is aberrant in the Hamatsa mask tradition. See also Mungo Martin's painting of a multiple mask (Fig. 500).

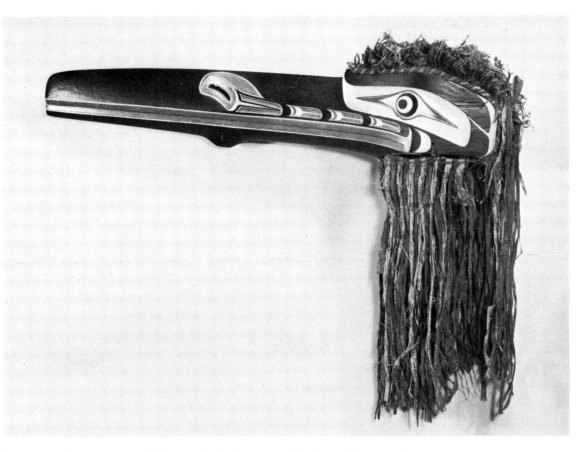

Fig. 159. *Hamatsa raven mask from Village Island, made by Joe Seaweed. Wood and cedar bark; black, white, red. Length: 51 in. MacMillan Purchase 1954. A6121*

Fig. 160. *Hamatsa raven mask from Kingcome Inlet, attributed to Dick Hawkins. Wood and cedar bark; black, white, red. Length: 53 in. MacMillan Purchase 1952. A3815*

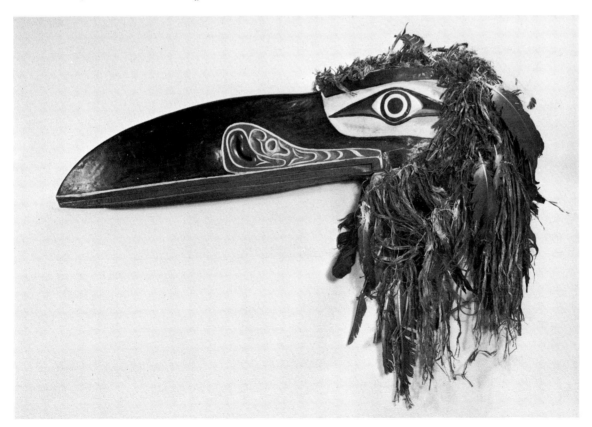

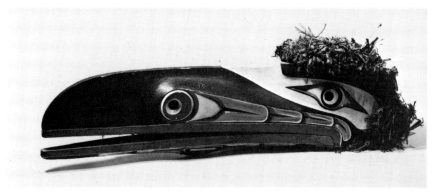

Fig. 161. *Hamatsa raven mask from Kingcome Inlet, attributed to Willie Seaweed. Wood and cedar bark; black, red, orange, white. Length: 34 in. MacMillan Purchase 1953. A4249*

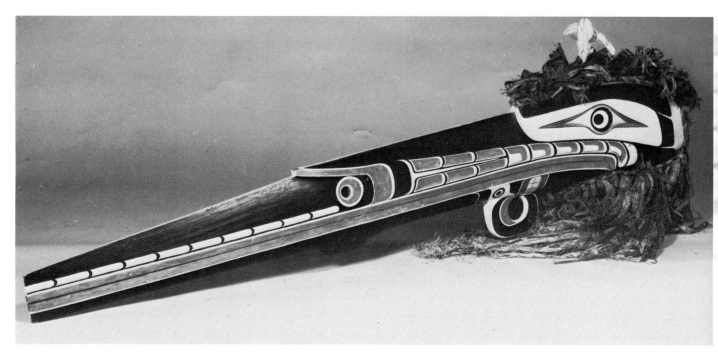

Fig. 162. *Hokhokw mask from Village Island, made by Willie Seaweed. Wood and cedar bark; black, white, red. Length: 72 in. MacMillan Purchase 1954. A6120*

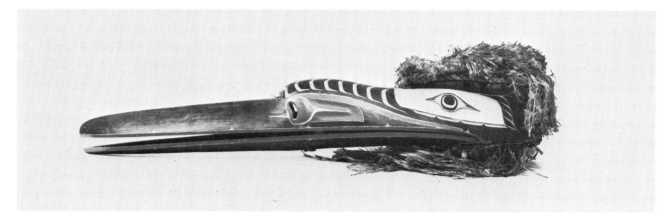

Fig. 163. *Hokhokw mask from Kingcome Inlet, made by Charlie George, Sr. Wood and cedar bark; black, white, red. Length: 65 in. MacMillan Purchase 1960. A4493*

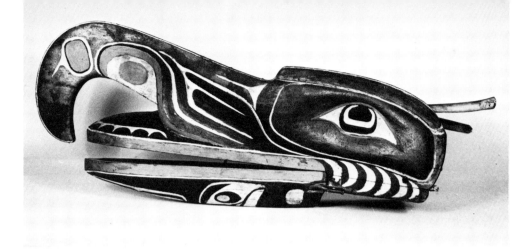

Fig. 164. Crooked Beak mask. Wood; black, white, red, green, blue. Length: 31 in.
Walter and Marianne Koerner Collection 1970. A5304

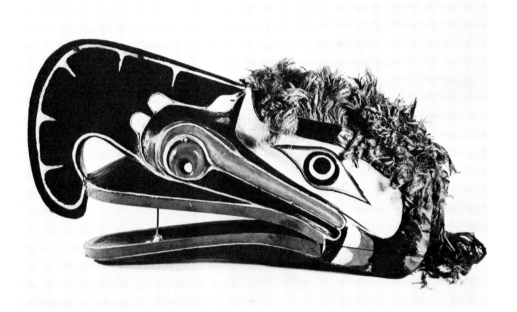

Fig. 165. Crooked Beak mask. Wood and cedar bark; black, white, red. Length: 28½ in.
Walter and Marianne Koerner Collection 1970. A5299

Fig. 166. Crooked Beak mask. Wood and cedar bark; black, white, red. Length: 20½ in.
Walter and Marianne Koerner Collection 1970. A5303

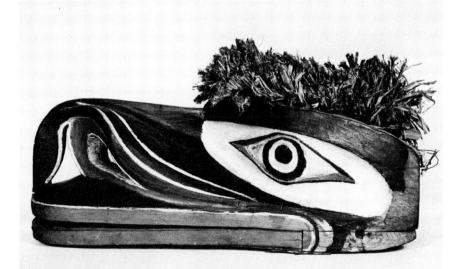

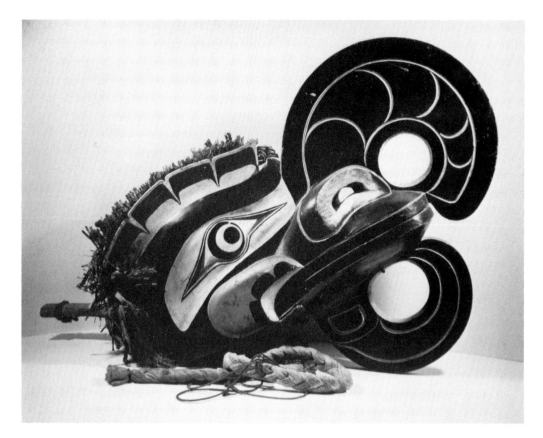

Fig. 167. *Crooked Beak mask, made by Willie Seaweed. Wood and cedar bark; black, white, red, maroon, gray. Length: 30 in. Walter and Marianne Koerner Collection 1973. A17152*

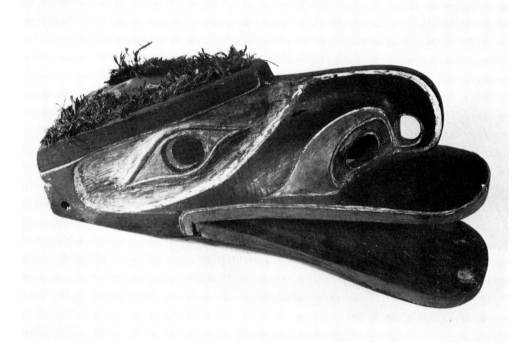

Fig. 168. *Crooked Beak mask. Wood and cedar bark; black, white, red. Length: 19½ in. Walter and Marianne Koerner Collection 1973. A17138*

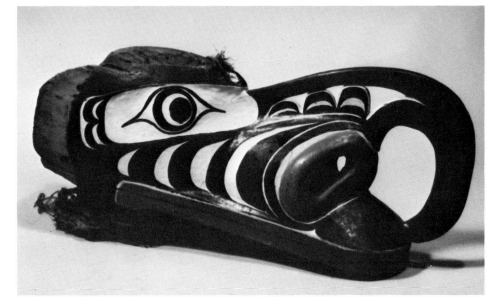

Fig. 169. Crooked Beak mask from Village Island. Wood and cedar bark; black, white, red. Length: 34 in. MacMillan Purchase 1952. A4158

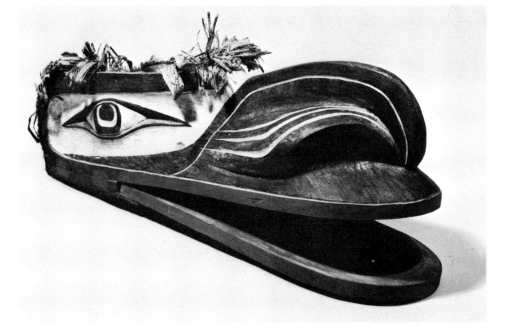

Fig. 170. Crooked Beak mask from Smith Inlet. Wood and cedar bark; black, white, red. Length: 30½ in. MacMillan Purchase 1953. A6151

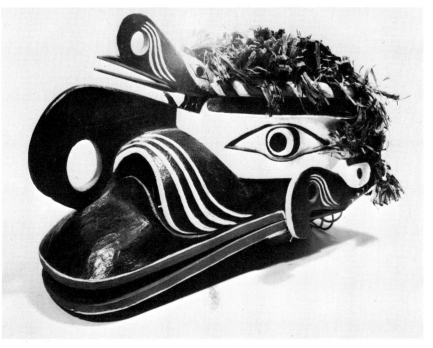

Fig. 171. Hamatsa multiple mask from Hopetown, attributed to Jim Howard of Blunden Harbour. Wood and cedar bark; black, white, red. Length: 25 in. MacMillan Purchase 1952. A4133

Hamatsa
Cedar Bark Head
and Neck Rings

Other headdresses representing bird forms were traditionally made of red-dyed cedar bark and were much lighter than the wooden ones. These were worn by the two women attendants in the dance, Kinkalatlala and Komunokas. Kinkalatlala wore a forehead mask called a *hetliwey* (Fig. 174). Komunokas wore another shape of red cedar bark helmet headdress.

Red cedar bark was an integral symbol of the Tsetseka dance series. Some Tsetseka dances used red and white cedar bark mixed. In the Bakoos, or nonsupernatural, season, white cedar bark and often feathers were used.

The headdresses worn by the Hamatsa dancers were particularly elaborate and specialized. The Hamatsa novice wore a different set of head, neck, and wrist rings every night of his performance. Each of these was elaborately plaited, twisted, and stiffened, and to the initiates each was a specific badge of identification.

The head rings of the Hamatsa (Figs. 172-81) had elaborate crosspieces and other details symbolizing the Milky Way, which was the tethering pole of Bakbakwalanooksiwae, or other associated themes. The amount of energy expended by the women who dyed the cedar bark red by steeping it in alder bark juice and then plaited, knotted, and decorated these items must have been considerable. When yarn, which is less fragile than cedar bark, became available, it was treated in the same fashion as cedar bark—dyed red, plaited, and knotted.

Figures 183-85 illustrate the neck rings worn by all those eligible to wear them, and of the many in the collection these show the basic form. Figure 185, intricately plaited, is a variation.

Cedar bark ornaments similar to these, worn by other dancers, are illustrated in Figures 287-93. It is possible that Figure 176 should be included among these.

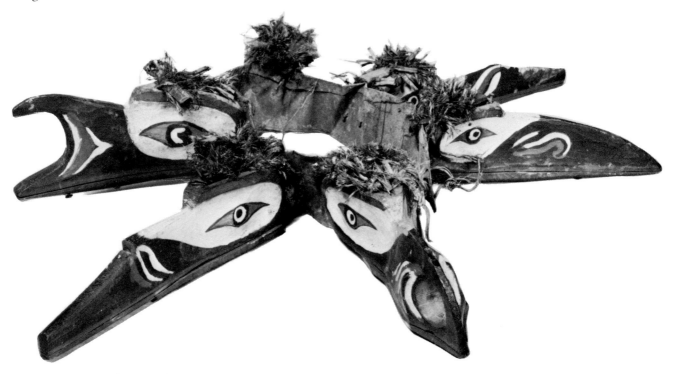

Fig. 172. Hamatsa head ring from Kingcome Inlet, attributed to Jim Howard. Metal stovepipe with birds made of wood and cedar bark; black, white, red. Diameter of stovepipe: 8 in.; length of birds: 10 in. MacMillan Purchase 1954. A6377

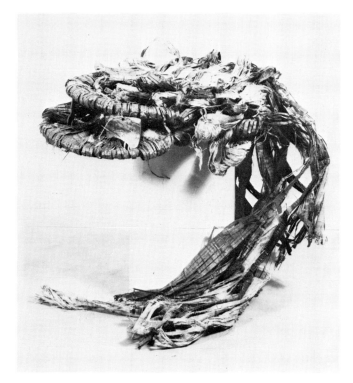

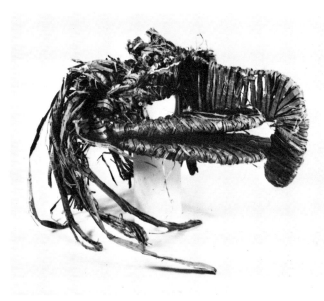

Fig. 174. *Crooked Beak headpiece from Gilford Island, attributed to Jim Howard, about 1935. Cedar bark. Length: 17 in. MacMillan Purchase 1951. A3664*

Fig. 173. *Hamatsa head ring from Blunden Harbour, said to have been 1 of a pair. Red cedar bark with 2 abalone shells attached. Length: 38 in. MacMillan Purchase 1951. A4021*

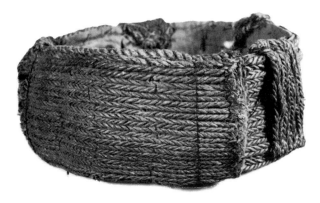

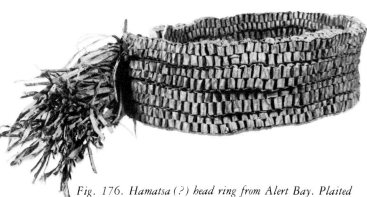

Fig. 175. *Hamatsa head ring from Fort Rupert. Red cedar bark mounted on cloth. Diameter: 7½ in. MacMillan Purchase 1948, Rev. G. H. Raley Collection. A1467*

Fig. 176. *Hamatsa (?) head ring from Alert Bay. Plaited natural cedar bark. Diameter: 8 in. MacMillan Purchase 1962. A7952*

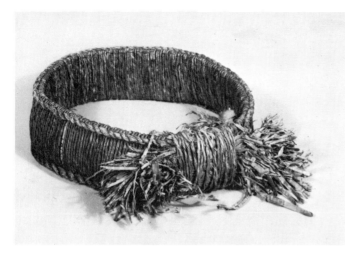

Fig. 177. *Hamatsa head ring. Red cedar bark. Diameter: 8 in. MacMillan Purchase 1948, Rev. G. H. Raley Collection. A1747*

Fig. 178. *Hamatsa head ring from Blunden Harbour. Red cedar bark. Diameter: 7½ in. MacMillan Purchase 1953. A6136*

Fig. 179. *Hamatsa head ring from Kingcome Inlet. Red cedar bark. Diameter: 8½ in. MacMillan Purchase 1952. A3842*

Fig. 180. *Hamatsa head ring from Kingcome Inlet. Red cedar bark and red cotton knitting. Diameter: 7 in. MacMillan Purchase 1951. A6083*

Fig. 181. *Hamatsa head ring from Alert Bay. Natural cedar bark and cotton coiling. Diameter: 8 in. MacMillan Purchase 1960. A4522*

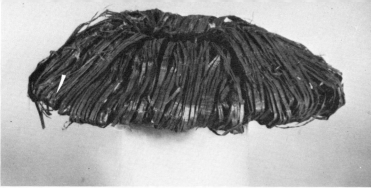

Fig. 182. Hamatsa headpiece from Alert Bay. Diameter: 17 in. Deep red cedar bark. MacMillan Purchase. A8331

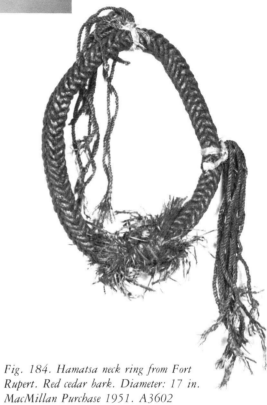

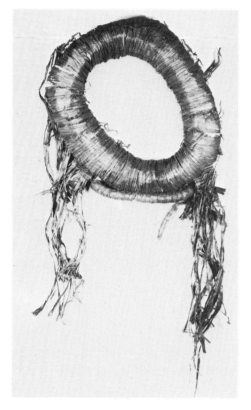

Fig. 184. Hamatsa neck ring from Fort Rupert. Red cedar bark. Diameter: 17 in. MacMillan Purchase 1951. A3602

Fig. 183. Hamatsa neck ring from Village Island. Red cedar bark. Diameter: 26 in. MacMillan Purchase 1951. A4518

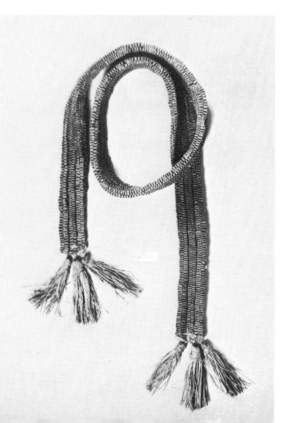

Fig. 185. Hamatsa neck ring from Alert Bay. Plaited red cedar bark. Length: 96 in. MacMillan Purchase 1962. A7950

Noohlmahl Masks

The Noohlmahl or "fool" dancers were messengers for the Hamatsa, ran errands for them, and acted as a sort of police during the Hamatsa series. They were violent, foolish, and nonhuman. They kept a kind of order by loudly threatening people, pushing back crowds, glaring at anyone who laughed, and throwing rocks and clubs. They were said to be under the control of the Ahlasimk spirits, who lived on a remote inland lake and hated everything calm, clean, or attractive.

Boisterous and unruly, the Noohlmahl buffoons were also filthy. Their garments were in dirty tatters, their hair unkempt and matted, and their repulsive, twisted masks matched the rest of their horrid appearance (Figs. 186-89). The chief feature of the Noohlmahl mask was an exaggerated, huge nose, and this aspect was emphasized in the pageant. Words referring to nose, smell, or mucus sent these creatures into a towering rage.

Their furious reaction caused them to strike out with their clubs and demolish any property in the way. For this reason no property of value was left in the dancing house, since the possessor would have to be indemnified by the sponsor of the dance for any damage done. Sometimes, however, the destruction was deliberately arranged, in order that the owner would receive a gift in payment afterward.

The Noohlmahl dancers were assisted in their enforcement of the ritual by the Hamatsa grizzly bears (Nanes Bakbakwalanooksiwae). These dancers, clad in bearskins and with long wooden claws, had faces painted red to represent an immense bear's mouth. Angry and menacing, they threatened anyone in the audience who moved or laughed, rattled the walls of the houses, and smashed any property placed in their way. The owner of such property, or anyone scratched by one of these bears, was later compensated by a potlatch gift.

Fig. 186. Noohlmahl mask from Gilford Island, attributed to Willie Seaweed. Wood; black, red. Height: 11 in. MacMillan Purchase 1953. A4305

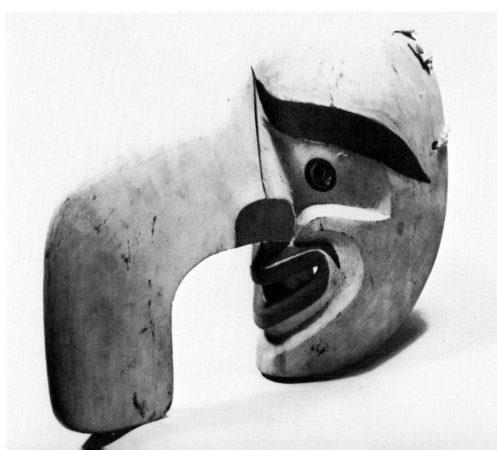

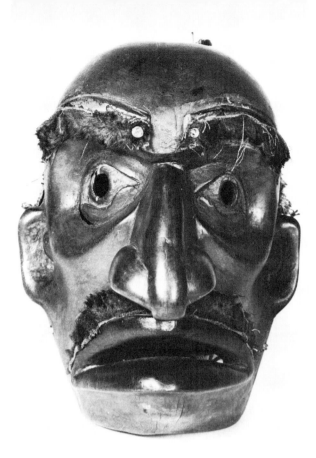

Fig. 187. Noohlmahl mask. Wood, hide, fur. Height: 11¼ in. Walter and Marianne Koerner Collection 1970. A5267

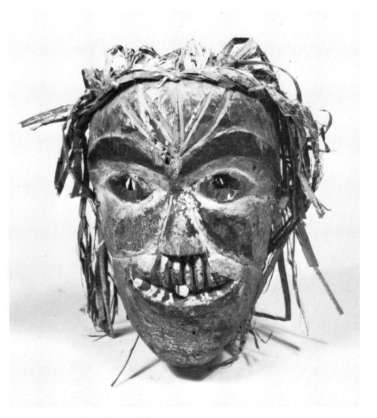

Fig. 189. Noohlmahl mask from New Vancouver. Wood and cedar bark; green, white, black. Height: 9¼ in. MacMillan Purchase 1951. A6094

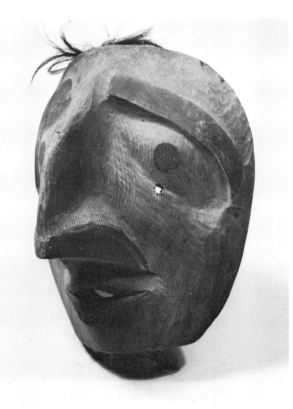

Fig. 188. Noohlmahl mask from Kingcome Inlet. Wood and hair; black, red. Height: 10¼ in. Mac-Millan Purchase 1952. A3821

Tanis
Masks

The masks shown in Figures 190-93 are from Kitlope, at the center of origin of the Hamatsa dance complex. In this nothern Kwakiutl area, the "house name" or "initiated" term for Hamatsa was "Tanis" (cf. Olson 1940:176; Olson 1954:243; Drucker 1940:208, 211, 216).

According to the accounts, there were four chiefs eligible to wear these masks. One may be missing from this set collected by G. H. Raley from the burial cave of a former Kitamaat chief. These were said by Raley to have been considered "very old" in 1897, when he collected them.

Since these masks are so different in representation from the bird-monster complex, they pose an interesting problem in the transmutation of form and perhaps of meaning when the ritual was adopted by the southern Kwakiutl. The masks are

Fig. 190. Photograph found in Rev. G. H. Raley's notes showing Tanis masks collected in 1897. The eagle mask on top of the middle figure is the one illustrated in Pl. XXIV. (Left to right) A1784, A1783, A1782

powerfully carved and very solid; although the blocks of wood are hollowed out behind, the walls are thicker than is usual with masks. All three are painted with black graphite. Figure 192 has a touch of red ocher on the lips, and a sheet of mica used for the eyes. The masks are flat on the bottom jaw, as though made to sit upright on a flat surface.

The photograph reproduced in Figure 190 was found in Raley's notes. It clearly shows the same set of masks, but includes appendages that were not there when the masks arrived in the museum in November 1948. The mask on the left (cf. Fig. 191) has two small hands or paws beside the lower jaw, and a series of what appear to be spruce or cedar twigs above the two heads. The one in the center (Fig. 193) is shown with the eagle mask illustrated in Plate XXIV sitting on top of it. An ermine back covering shows at the right. The mask at the right (Fig. 192) also has small paws just over the brow of the bottom head.

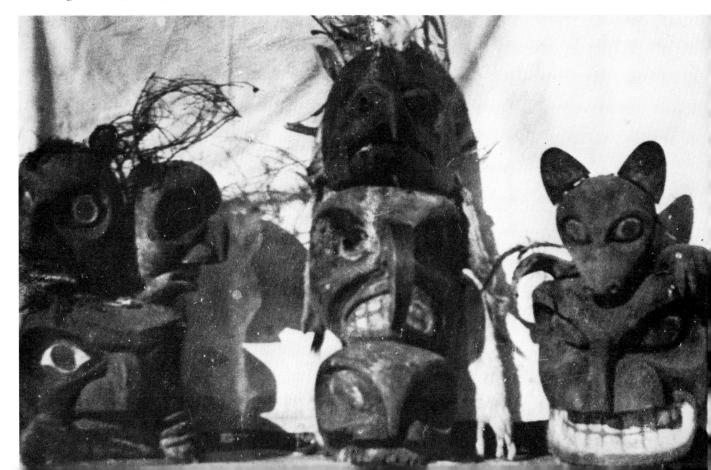

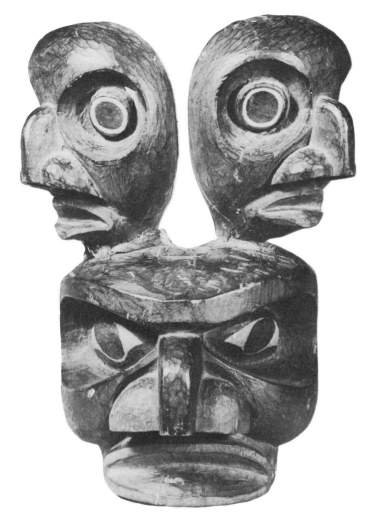

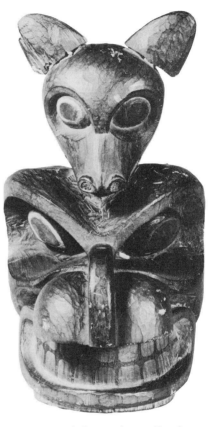

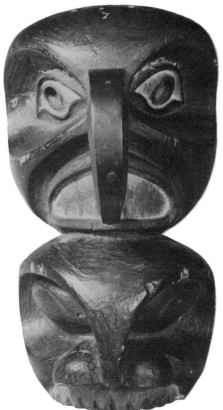

Fig. 191. Tanis mask from Kitlope, collected 1897. Wood; black, red. Height: 17½ in. MacMillan Purchase 1948, Rev. G. H. Raley Collection. A1784

Fig. 192. Tanis mask from Kitlope, collected 1897. Wood; black, red. Height: 16 in. MacMillan Purchase 1948, Rev. G. H. Raley Collection. A1782

Fig. 193. Tanis mask from Kitlope, collected 1897. Wood; black, red. Height: 17 in. MacMillan Purchase 1948, Rev. G. H. Raley Collection. A1783

Ceremonial Skulls

Figure 205 is an example of a blanket worn by an initiated Hamatsa as the ritual covering of his dance costume. The small wooden skulls affixed to it are indicative of the number of times he had danced as Hamatsa. Skulls were a symbol of the Hamatsa's grisly concern. Wooden skulls were often used to adorn headdresses, masks, and head rings; and rattles (Fig. 194) were often carved in this form. Those illustrated in Figures 198-200 were small ones sewn to clothing at one time. Figure 200 was probably carried on a board by the Kinkalatlala attendant in her dance placating the Hamatsa.

The ghost dancers associated with the Winalagalis war spirit ritual also wore head and neck rings adorned with wooden skulls (Fig. 202), and sometimes a mask representing a skull (Figs. 201, 203).

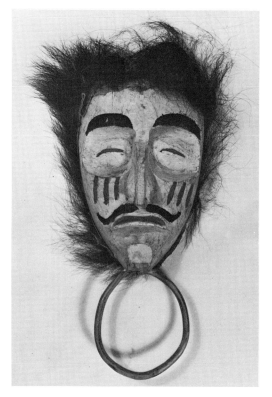

Fig. 194. Hamatsa rattle from Kingcome Inlet in the form of a ceremonial skull. Wood and bearskin. Height: 13 in. Mac-Millan Purchase 1953. A6183

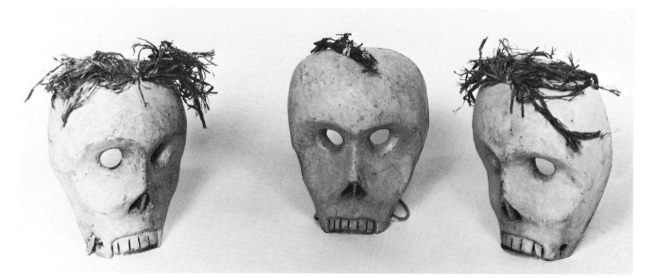

Figs. 195, 196, 197. 3 Kwakiutl ceremonial skulls from Village Island. Wood painted white with cedar bark decoration. Height: 7½ in. MacMillan Purchase 1952. A4166

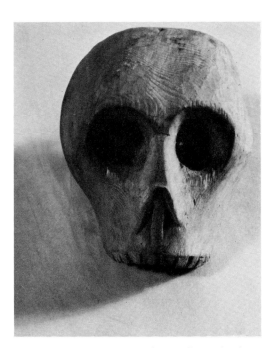

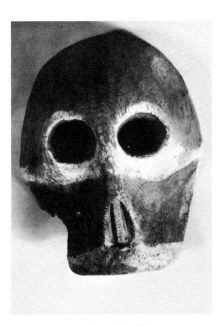

Fig. 199. *Ceremonial skull from Kingcome Inlet, attributed to Dick Hawkins. Wood; green, purple, red, white. Height: 5¼ in. MacMillan Purchase 1953. A6160*

Fig. 198. *Ceremonial skull from Village Island. Unpainted wood. Height: 4½ in. MacMillan Purchase 1953. A6344*

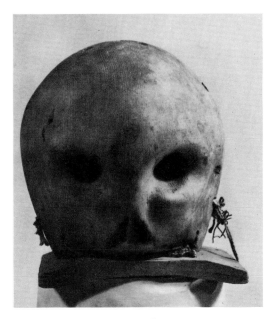

Fig. 200. *Ceremonial skull from Kingcome Inlet. Unpainted wood. Height: 8½ in. MacMillan Purchase 1952. A3823*

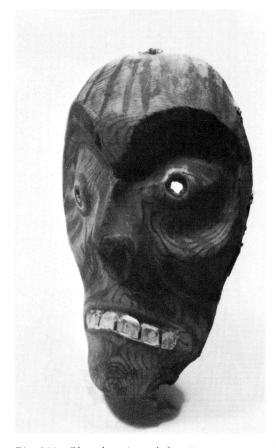

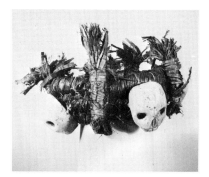

Fig. 202. Ghost dancer's headdress from Hope Island, said to be over 100 years old. Natural cedar bark with 4 wooden skulls painted white. Diameter: 15 in. MacMillan Purchase 1953. A6267

Fig. 201. Ghost dancer's mask from Fort Rupert, also said to be the Wild Man of the Woods. Wood; black, white, red. Height: 12½ in. MacMillan Purchase 1951. A3613

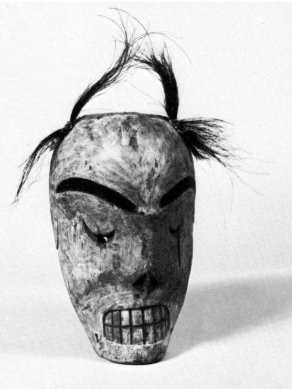

Fig. 203. Ghost dancer's mask from New Vancouver Village. Wood and horsehair; white, black, red. Height: 9 in. MacMillan Purchase 1961. A7488

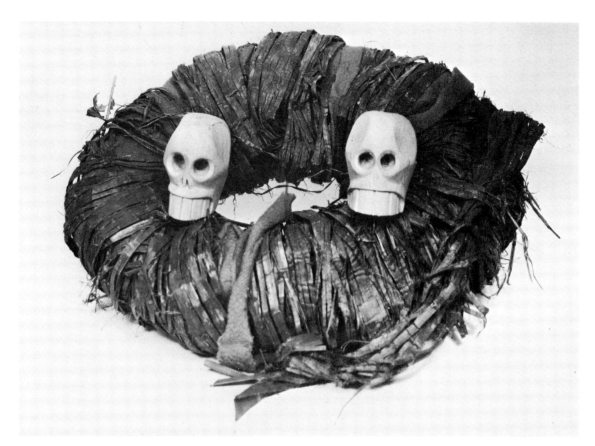

Fig. 204. Hamatsa head ring from Kingcome Inlet. Deep red cedar bark with 2 unpainted wooden skulls. Diameter: 14 in. MacMillan Purchase 1951. A6082

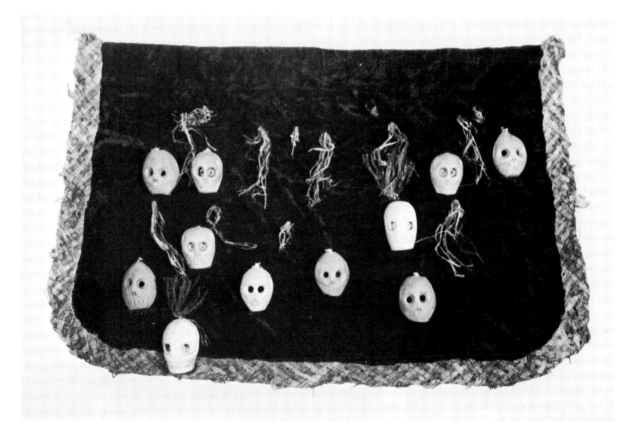

Fig. 205. Hamatsa robe from Kingcome Inlet. Black velvet robe decorated with 9 wooden skulls and woven fringe of red and brown cedar bark. Length: 61 in. MacMillan Purchase 1951. A6080

Sisiutl Headdresses and Ceremonial Objects

The Sisiutl, the double-headed serpent whose body was a face, played an important part in the ritual of Winalagilis, the war spirit. This mythological creature was the warrior's assistant. It could be ridden and rowed like a canoe; its flesh was impervious to any spear; it could inflict instant death by its glance; and it could cause any enemy who looked upon it to be turned to stone, with all his joints turned backward. The Sisiutl was a frequently used design on the headdresses of the warrior dancers (Figs. 206-9), on ceremonial belts (Figs. 211-13), on cloaks and aprons (Figs. 302, 303, 305, 309), on batons (Fig. 214), knives (Figs. 215, 216), clubs (Figs. 217, 218), feast dishes (Figs. 341, 342), power boards (*duntsiks*, Figs. 219-30), and other ceremonial objects.

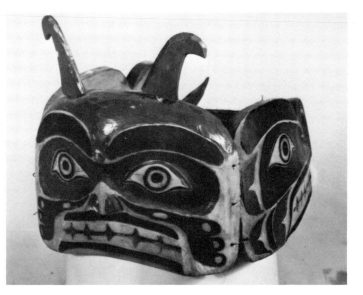

Fig. 207. Sisiutl headdress from Fort Rupert. Wood on leather base; black, red, green. Height: 10 in. MacMillan Purchase 1951. A3639

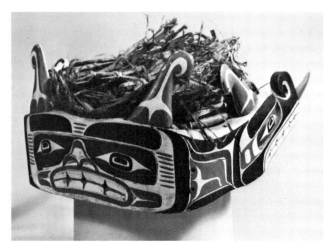

Fig. 208. Sisiutl headdress from Fort Rupert, made by Dick Price in 1940 and worn with small replicas around the wrists and ankles. Wood and cedar bark; white, black, red, green. Length: 15 in. MacMillan Purchase 1952. A3790

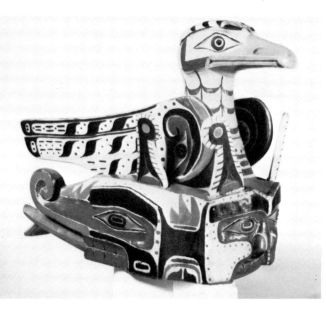

Fig. 206. Sisiutl and loon headdress from Alert Bay. Wood; green, red, black, yellow. Height: 16 in. MacMillan Purchase 1953. A4036

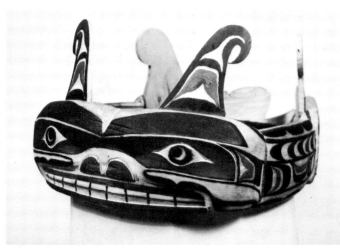

Fig. 209. Sisiutl headdress from Fort Rupert, attributed to Dick Hawkins. Wood and leather; black, green, red. Length: 12 in. MacMillan Purchase 1951. A3604

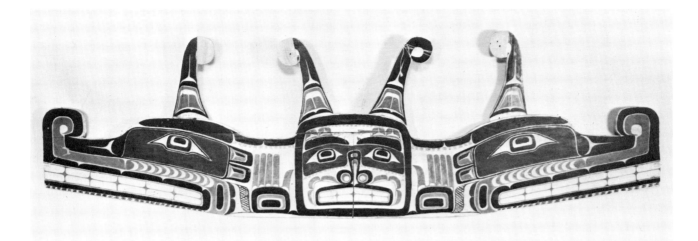

Fig. 210. Sisiutl ceremonial board from Fort Rupert. Wood; red, green, black, white. Length: 11 ft. 6 in. MacMillan Purchase 1951. A3636

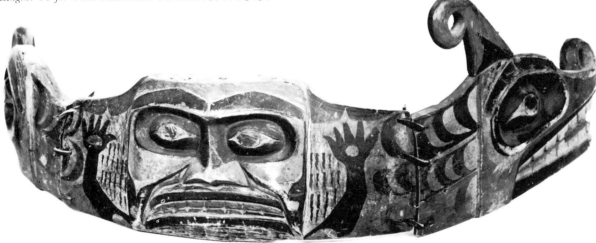

Fig. 211. Ceremonial belt with Sisiutl design from Village Island. Wood; red, black, green, blue. Length: 39 in. MacMillan Purchase 1961. A7472

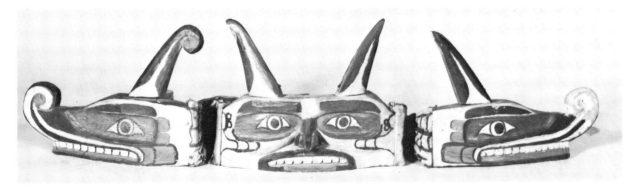

Fig. 212. Ceremonial belt with Sisiutl design from Village Island. Wood and cotton; white, green, black, red. Length: 60½ in. MacMillan Purchase 1952. A4263

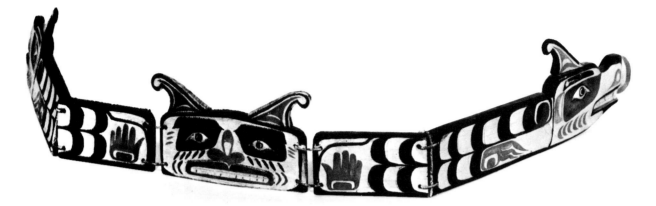

Fig. 213. *Ceremonial belt with Sisiutl design from Fort Rupert. Wood and cord; white, black, orange, green. Length: 50 in. MacMillan Purchase 1952. A3791*

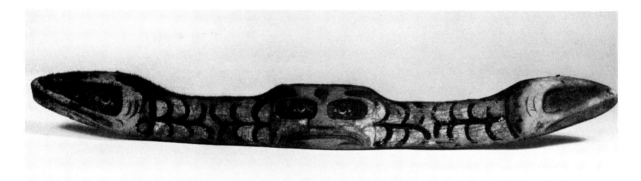

Fig. 214. *Sisiutl baton. Wood; black, white, red, green. Length: 28¼ in. Walter and Marianne Koerner Collection 1970. A5265*

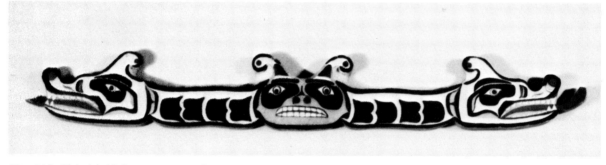

Fig. 215. *Sisiutl knife from Kingcome Inlet. Wood; black, white, green, red. Length: 27 in. MacMillan Purchase 1952. A3804*

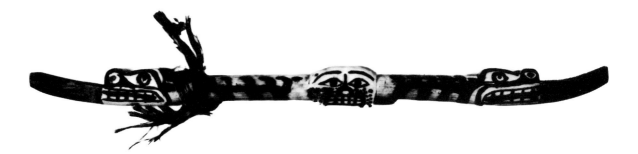

Fig. 216. Sisiutl knife from Kingcome Inlet. Wood; red, black. Length: 37 in. MacMillan Purchase 1952. A3800

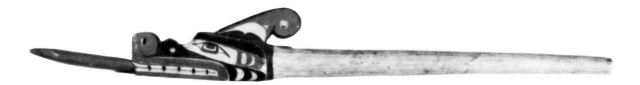

Fig. 217. Sisiutl club from Fort Rupert. Wood; red, black. Length: 39 in. MacMillan Purchase 1951. A3632

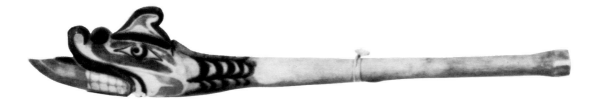

Fig. 218. Sisiutl club from Kingcome Inlet. Wood; black, green, red. Length: 28 in. MacMillan Purchase 1952. A3799

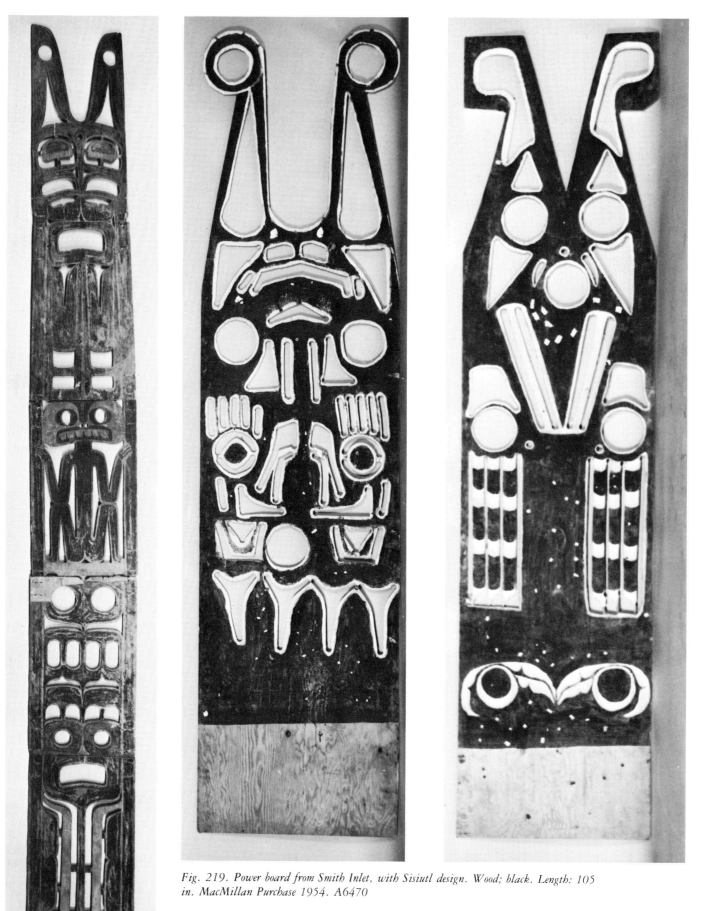

Fig. 219. *Power board from Smith Inlet, with Sisiutl design. Wood; black. Length: 105 in. MacMillan Purchase 1954. A6470*

Figs. 220, 221. *Pair of power boards from Fort Rupert, with Sisiutl design, attributed to Frank Walker. Wood; black, white. Length: 25 in. MacMillan Purchase 1952. A3797, A3798*

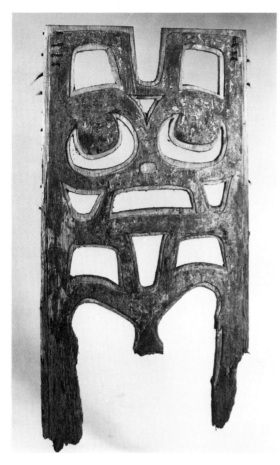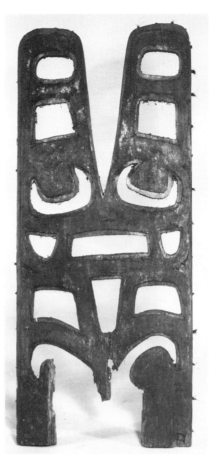

Fig. 222. Power board fragment from
Loughborough Inlet, with Sisiutl design.
Wood; black. Length: 28 in. W. C.
Koerner Purchase. 1969. A9082

Fig. 223. Power board fragment from
Loughborough Inlet, with Sisiutl design.
Wood; black. Length: 28½ in. W. C.
Koerner Purchase 1969. A9081

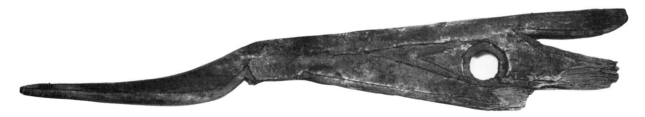

Fig. 224. Power board fragment from Loughborough Inlet. Wood; red, black.
Length: 21½ in. W. C. Koerner Purchase 1969. A9084

Fig. 225. Power board fragment from Loughborough Inlet. Wood; red, black.
Length: 17¼ in. W. C. Koerner Purchase 1969. A9083

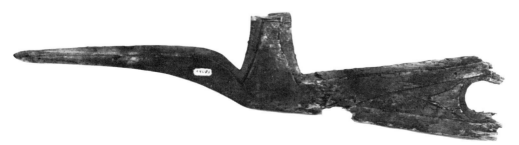

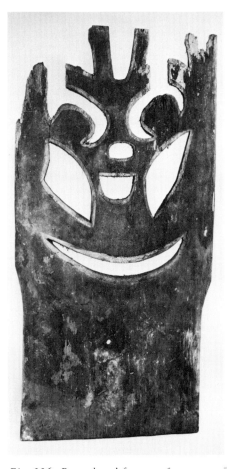

Fig. 226. Power board fragment from Loughborough Inlet, with Sisiutl design. Wood; black. Length: 30½ in. W. C. Koerner Purchase 1969. A9079

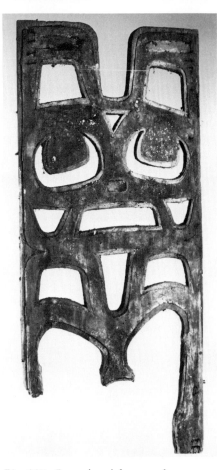

Fig. 227. Power board fragment from Loughborough Inlet, with Sisiutl design. Wood; black. Length: 30 in. W. C. Koerner Purchase 1969. A9077

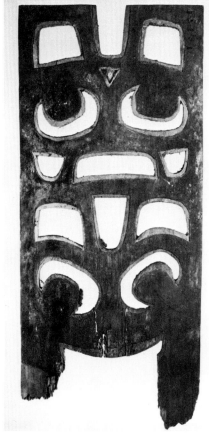

Fig. 228. Power board fragment from Loughborough Inlet, with Sisiutl design and some mica inlay. Wood; black. Length: 28 in. W. C. Koerner Purchase 1969. A9080

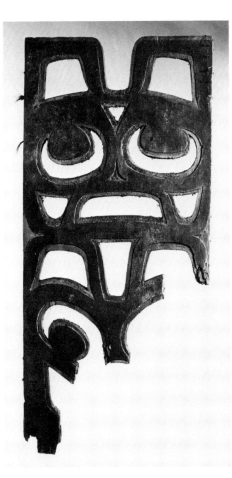

Fig. 229. Power board fragment from
Loughborough Inlet, with Sisiutl design
and possibly some mica overlay on the eyes.
Wood; black. Length: 28 in. W. C.
Koerner Purchase 1969. A9078

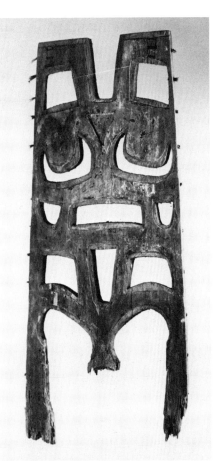

Fig. 230. Power board fragment from
Loughborough Inlet, with Sisiutl design.
Wood; black. Length: 28 in. W. C.
Koerner Purchase 1969. A9076

Atlakim Masks

The masks in this series represent a variety of different characters from a possible array of forty. Thus each mask represents a different emphasis, and as a class they do not share the distinctive overall form of masks that portray a single mythological character. Moreover, since the masks were made by different carvers in sets of four, five, or more, the sets owned by various families and used as part of their series vary greatly in the style of carving.

Boas (1921:1193) gives the following list of dancers for the Atlakim dance:

1. "Calls Others into House" [Fig. 237, "Grouse"]
2. "The Caller" [Fig. 235]
3. "Stump of the Woods" [Fig. 233]
4. "Laughing Woman of the Woods" [Fig. 231]
5. "Cannibal of the Woods"
6. "Dancer of the House"
7. "Raven of the Woods"
8. "Long Life Maker"
9. "Heat of House Woman"
10. "One Side Moss in Woods" [Fig. 247]
11. "One Side Rock in Woods" (one man and one woman)
12. "Frog Woman"
13. "Crooked Beak of the Sky"
14. "Hokhokw of the Sky" [Figs. 241, 242]
15. "Rich Woman"
16. "Woman giving Birth" (pretends to give birth, and her child gets up wearing a mask) [Fig. 250, "Woman"; Figs. 251 and 253, "Children"]
17. "Midwife" (comes out and shakes hands, dancing around. Another child is born and gets up wearing a mask—one boy and one girl)
18. "Salmonberry Woman"
19. "Sparrow Woman"
20. "Salmon Spirit"
21. "Listener"
22. "Sprinkler"
23. "Mountain Goat Hunter"
24. "Tying Woman" (blue jay)
25. "Dust-in-House-Woman"
26. "Helper-in-the-House"
27. "Door Keeper of Woods" [Fig. 248]
28. "Partridge Woman"
29. "Thrush"
30. "Owl"
31. "Raindrop Maker"
32. "Answering Woman"
33. "Walking behind the Mountain Woman"
34. "Sneezer" [Fig. 249]

It will be noted that some of these characters duplicate those in other Tsetseka dances—Raven, Hokhokw, Crooked Beak, and Rich Woman—but most Atlakim masks, unlike the Hamatsa masks, were made roughly and hastily. Some were constructed of two boards fastened in a V form at the front of the face, not carved but rather crudely painted in white, orange, and black. They were meant to be worn in a dancing series for four years only and then burned. Those that are well finished, well carved, and carefully painted are a tribute to the carver, who refused to produce a rough, hastily made object even for temporary use.

Only a few of the masks shown have been identified by informants. This is not surprising since there was a considerable amount of local variation in the group of forty, and not all of the characters would necessarily be often used.

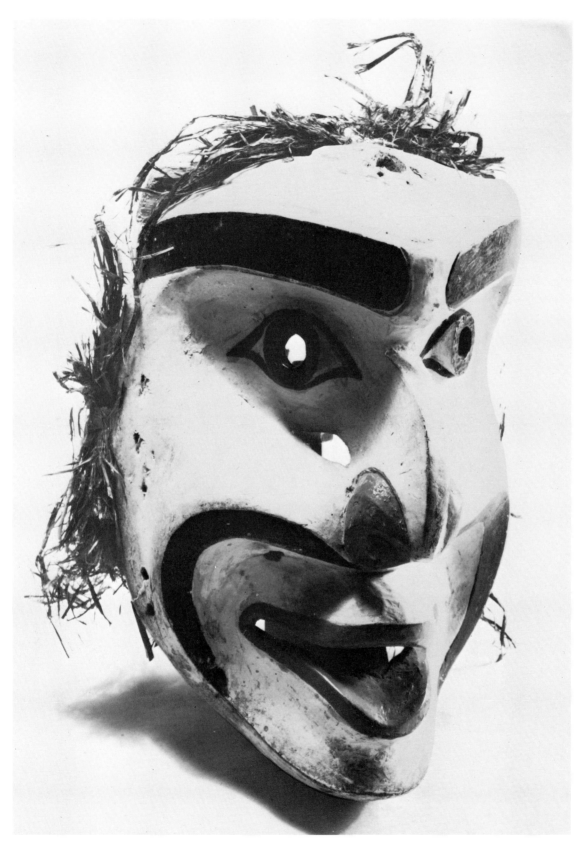

Fig. 231. Atlakim buffoon mask from Village Island. Wood and cedar bark; white, red, black. Height: 12 in. MacMillan Purchase 1952. A4159

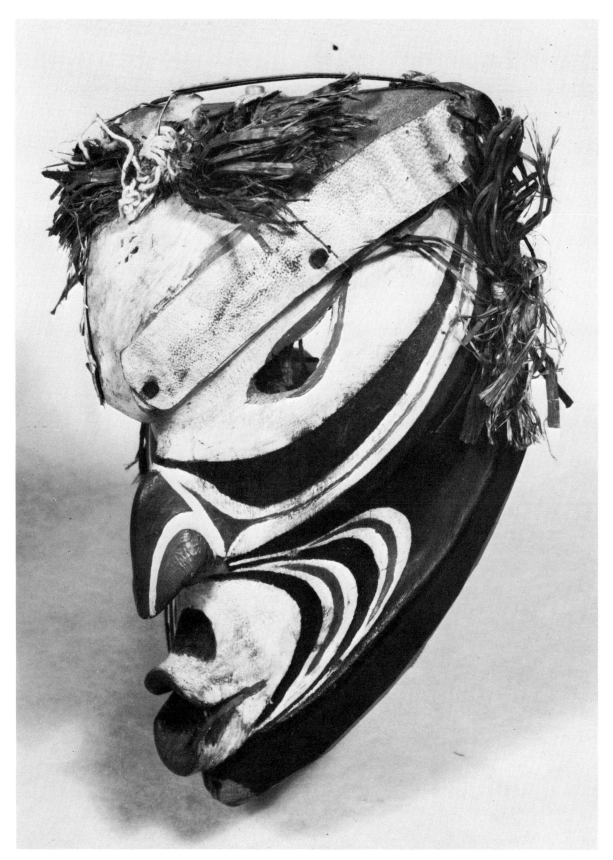

Fig. 232. Atlakim mask from Blunden Harbour. Wood, cedar bark, and hide; white, red, blue. Height: 11 in. MacMillan Purchase 1953. A6347

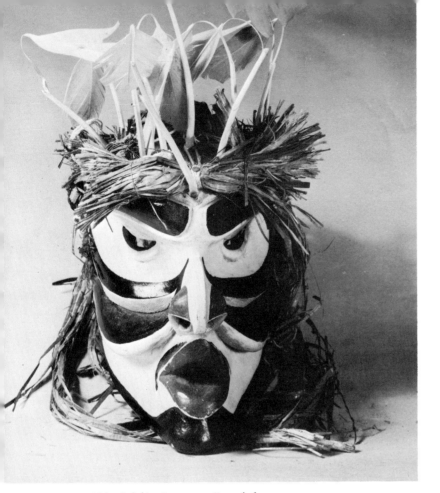

Fig. 233. Atlakim "tree stump" mask from Blunden Harbour, said to follow A6223 (Fig. 234). Wood, cedar bark, and feathers; white, red, black. Height: 10 in. MacMillan Purchase 1953. A6348

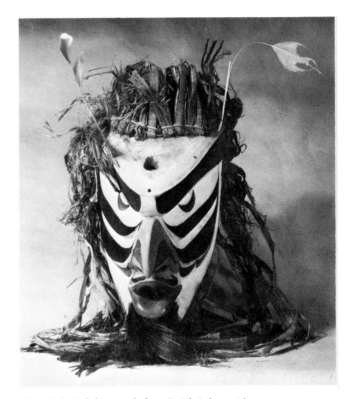

Fig. 234. Atlakim mask from Smith Inlet, said to follow A6088 (Fig. 237). The hole in the forehead was where a small branch was inserted. Wood, cedar bark, and horsehair; white, black, red, orange. Height: 10 in. MacMillan Purchase 1953. A6223

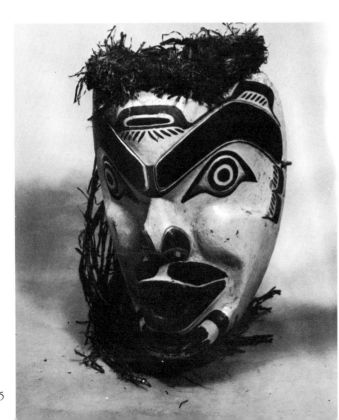

Fig. 235. Atlakim "caller" mask from Village Island, attributed to Willie Seaweed. Wood and cedar bark; white, red, black. Height: 12 in. MacMillan Purchase 1953. A6341

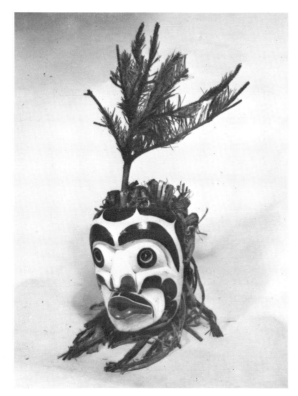

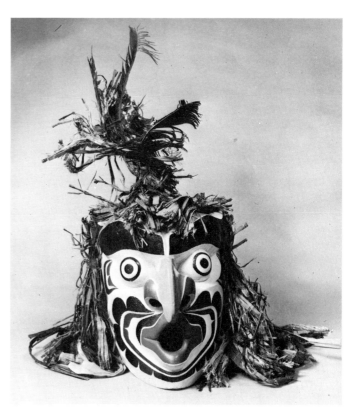

Fig. 236. Atlakim "spruce tree" mask from Blunden Harbour. Wood and cedar bark; white, red, black. Height: 9½ in. MacMillan Purchase 1953. A6221

Fig. 237. Atlakim grouse mask from Alert Bay, attributed to Willie Seaweed; said to be the first dancer to appear. Wood, cedar bark, and feathers; red, white, black, orange, brown. Height: 11 in. MacMillan Purchase 1951. A6088

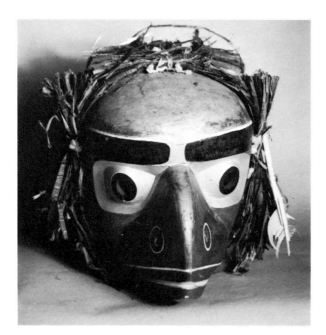

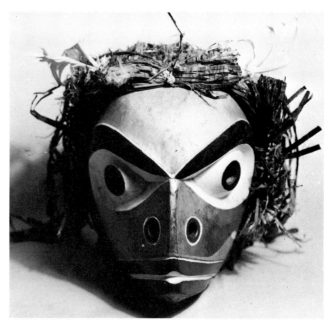

Fig. 238. Atlakim fish mask from Smith Inlet. Wood and cedar bark; black, gray, silver, red, white. Height: 9½ in. MacMillan Purchase 1953. A6235

Fig. 239. Atlakim fish mask from Smith Inlet. Wood and cedar bark; silver, black, red, orange. Height: 10 in. Mac-Millan Purchase 1953. A6215

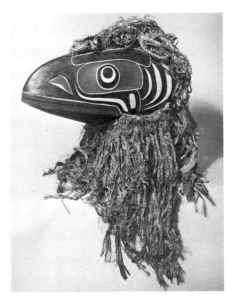

Fig. 240. Atlakim bullhead fish mask from Smith Inlet.
Wood and cedar bark; red, green, black. Length: 17 in.
MacMillan Purchase 1953. A6168

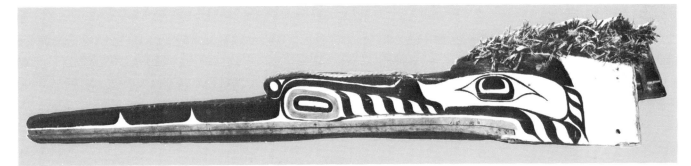

Fig. 241. Atlakim Hokhokw mask from Village Island, made by Mungo Martin.
Wood and cedar bark; black, white, red. Length: 89 in. MacMillan Purchase
1952. A4153

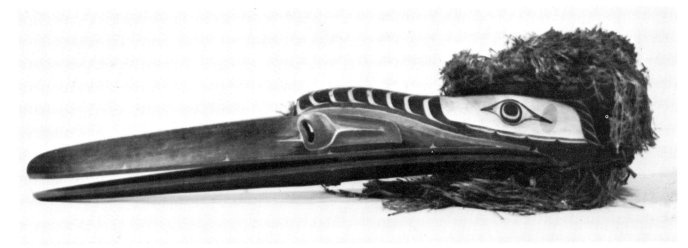

Fig. 242. Atlakim Hokhokw mask from Kingcome Inlet. Wood and cedar bark;
black, white, red. Length: 65 in. MacMillan Purchase 1960. A4493

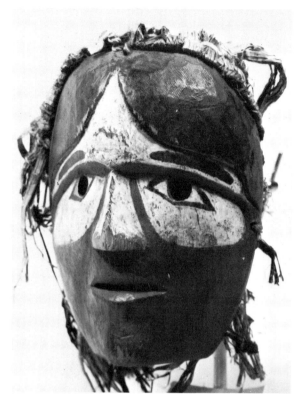

Fig. 243. Atlakim "mother" mask from Village Island.
Wood and cedar bark; red, black, white. Height: 7½ in.
MacMillan Purchase 1953. A6342

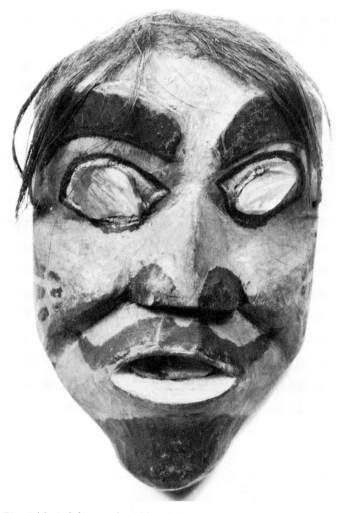

Fig. 244. Atlakim mask. Although it appears to represent a
man with a mustache, its small size may mean that it was
worn by a child and was intended to represent one of the chil-
dren of the mother dancer. Wood and horsehair; black, red.
Height: 5¼ in. Walter and Marianne Koerner Collection
1970. A5279

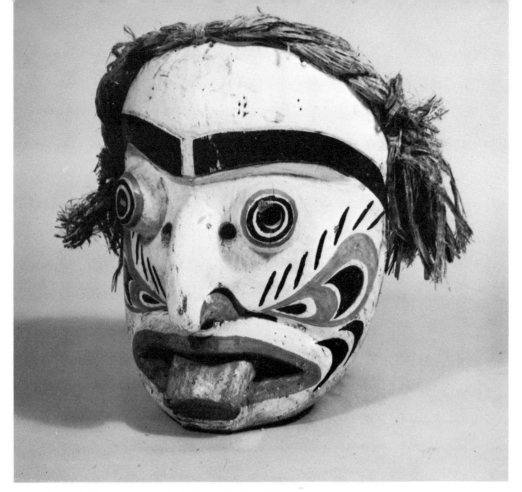

Fig. 245. Atlakim mask of a mimic (Nenolu), from Village Island, last used in a potlatch at Alert Bay about 50 years ago. Wood and cedar bark; white, orange, black. Height: 15 in. MacMillan Purchase 1952. A4156

Fig. 246. Atlakim mask from Village Island. Wood; red, white, black. Height: 11½ in. MacMillan Purchase 1951. A6107

Fig. 247. Atlakim "Moss Face" mask from Village Island. Wood and cedar bark; red, black, white. Height: 15 in. MacMillan Purchase 1952. A4157

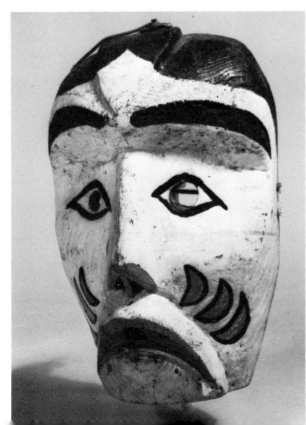

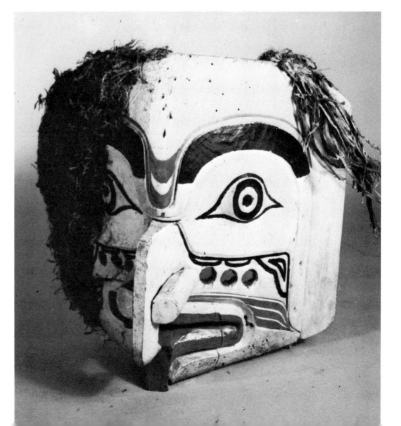

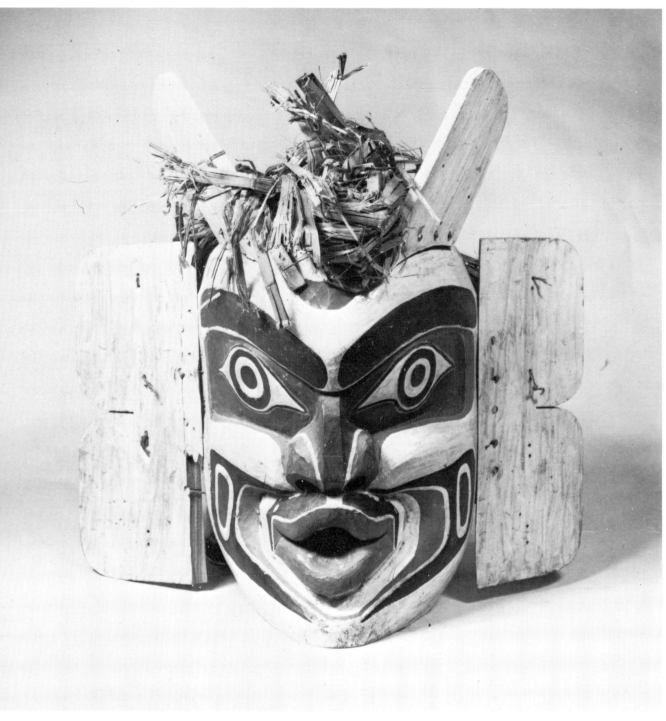

Fig. 248. Atlakim "door" mask from Blunden Harbour. Wood and cedar bark; white, green, red, black. Height: 16 in. MacMillan Purchase 1952. A4245

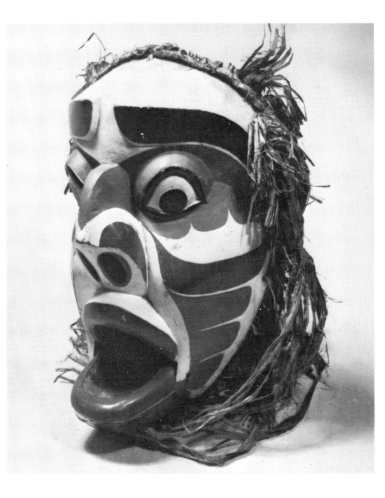

Fig. 249. Atlakim "Sneezer" mask from Smith Inlet, attributed to George Walkus. Wood and cedar bark; red, brown, white, black. Height: 13½ in. MacMillan Purchase 1953. A6214

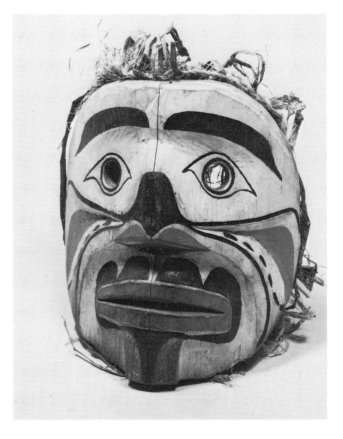

Fig. 250. Atlakim mask from Village Island, representing the mother of A4163a and A4163b (Figs. 251, 252). Wood and cedar bark; red, black. Height: 9 in. MacMillan Purchase 1952. A4163c

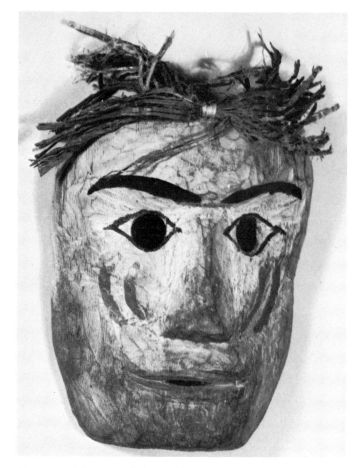

Fig. 251. *Atlakim mask from Village Island, representing the daughter of A4163c (Fig. 250). Wood and cedar bark; red, white, black. Height: 7¼ in. MacMillan Purchase 1952. A4163a*

Fig. 252. *Atlakim mask from Village Island, representing the daughter of A4163c (Fig. 250). Wood; red, white, black. Height: 9 in. MacMillan Purchase 1952. A4163b*

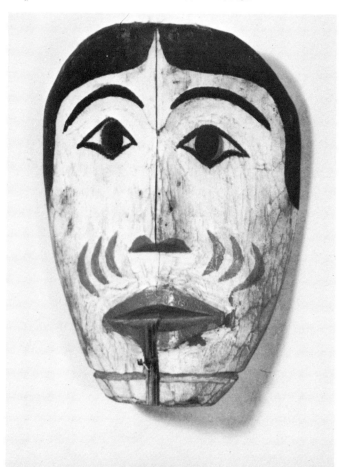

Tsonokwa Masks

A complex character in the dancing societies of the southern Kwakiutl was the giantess Tsonokwa, one of the large family of giants who lived in the faraway mountains and woods (Pls. XIX, XX; Figs. 253-65). Black in color, with bushy, unkempt hair and a pursed mouth through which she uttered the cry, *"Hu hu,"* she was a horrid and threatening figure. On her back she carried a basket in which she collected children, taking them home to eat. The children usually outwitted her, however, because she was vain, stupid, and clumsy. In another aspect, Tsonokwa controlled the magic "water of life," a gift she bestowed on a family that wrested her secrets from her. Her most important role was that of bringer of wealth and good fortune. In her house there were many boxes of treasure which were found by children who went to seek her, and there were also the magical Sisiutl house beams and posts, another indication of her treasure and her importance.

In the pageantry of the winter dances Tsonokwa appeared in two forms. As a dancer in the Tsetseka performance she was a shaggy, lumbering creature with half-closed eyes. She could not keep alert enough to dance the normal four circuits around the fire, but shambled in the wrong way and was guided to her seat, where she fell asleep. She kept falling asleep whenever anyone pointed a finger at her, and she did not participate in the events.

In the role of wealth-giver, so important a theme in the potlatch, Tsonokwa is depicted as a male. He carried a basket in which were stored coppers, which he handed to the chief who was selling or giving them away. At a moment of climax in the copper dispersal, the chief put on a family crest mask called a Geekumhl (Figs. 253-57), representing a male Tsonokwa, cited by Boas and Hunt as "a warrior [attendant] to his brother Man Eater" (Boas and Hunt 1905:209). This mask, characterized by a strong and vigorous face, usually had locks of human hair and was very carefully carved. As this creature, the chief "cut" the copper with a copper cutter, which often had the carved head of a Tsonokwa on its handle (Figs. 279-83).

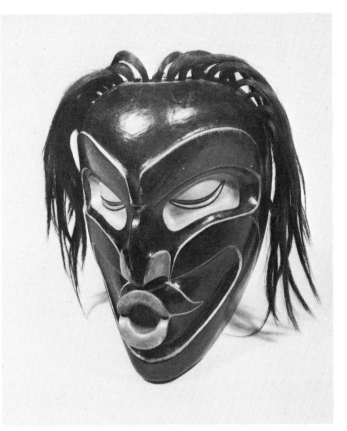

Fig. 253. Tsonokwa mask (Geekumhl) from Hope Island, made by Willie Seaweed. Wood and human hair; orange and black with red hair. Height: 10½ in. MacMillan Purchase 1953. A6271

Fig. 254. Tsonokwa mask (Geekumhl) from Gilford Island. Wood and horsehair; black, red, blue, white. Height: 18 in. MacMillan Purchase 1952. A3774

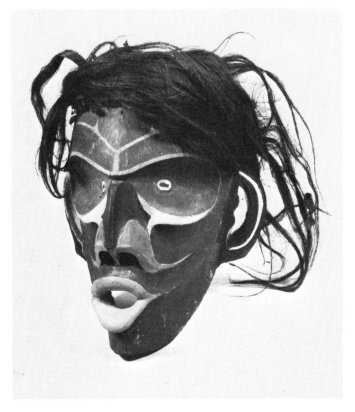

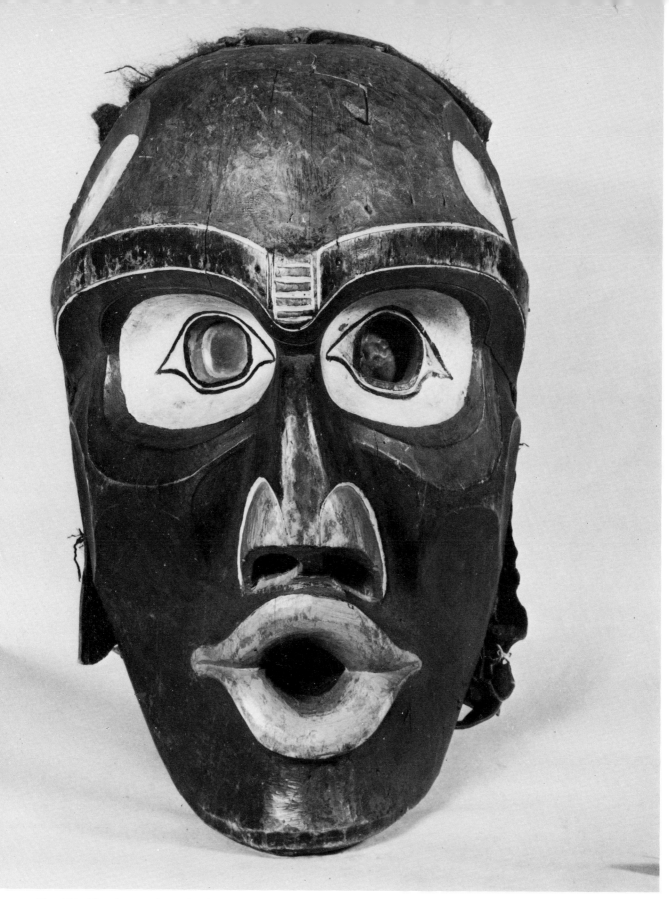

Fig. 255. *Tsonokwa mask (Geekumhl) from Turnour Island. Wood; black, white,*
red. Height: 19½ in. MacMillan Purchase 1961. A7491

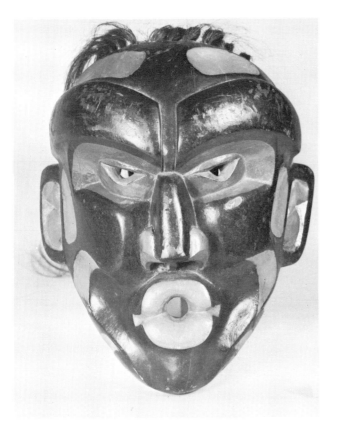

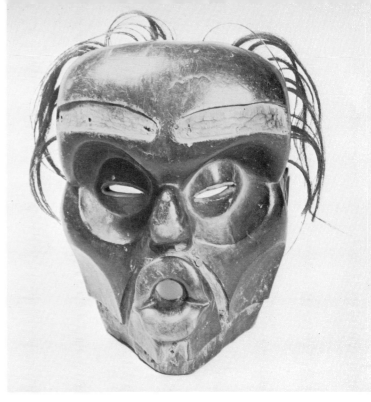

Fig. 258. *Tsonokwa mask from Fort Rupert. Wood; black, white, red enamel paint. Height: 11½ in. MacMillan Purchase 1952. A4179*

Fig. 256. *Tsonokwa mask (Geekumhl) from Village Island. Wood and human hair; red, green, black. Height: 11 in. MacMillan Purchase 1953. A4034*

Fig. 259. *Tsonokwa mask from Smith Inlet. Wood; red, black, white. Height: 16½ in. MacMillan Purchase 1953. A4286*

Fig. 257. *Tsonokwa mask (Geekumhl) from Gilford Island. Wood and human hair; black with reddish lips; eyebrows, chin, and area around mouth indented for inlay. Height: 11 in. MacMillan Purchase 1954. A6374*

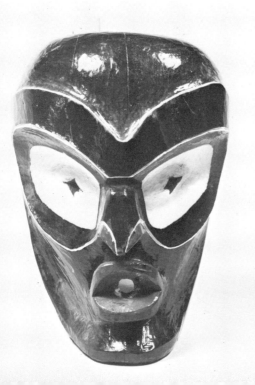

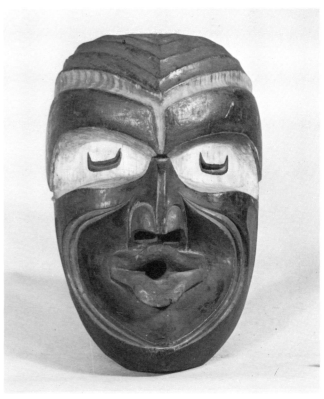

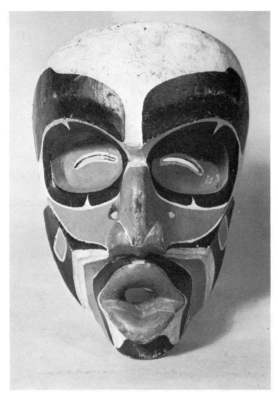

Fig. 260. Tsonokwa mask from Kingcome Inlet. Wood; white, gray, black, with faint red line. Height: 14 in. MacMillan Purchase 1952. A3787

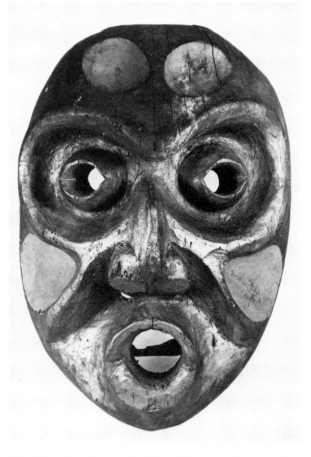

Fig. 261. Tsonokwa mask from New Vancouver. Wood and hair; black, red, gray, white. Height: 13 in. MacMillan Purchase 1954. A6369

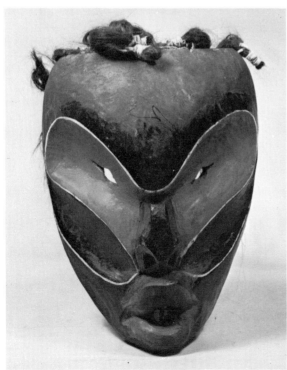

Fig. 262. Tsonokwa mask. Wood; black, red. Height: 15½ in. Walter and Marianne Koerner Collection 1973. A17143

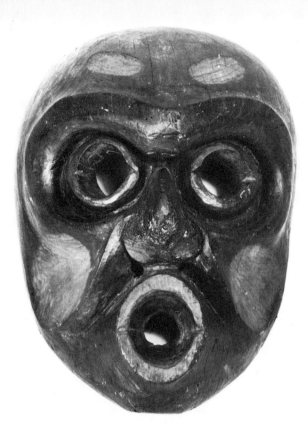

Fig. 263. Tsonokwa mask. Wood; black, red. Height: 15½
in. Walter and Marianne Koerner Collection 1973. A17142

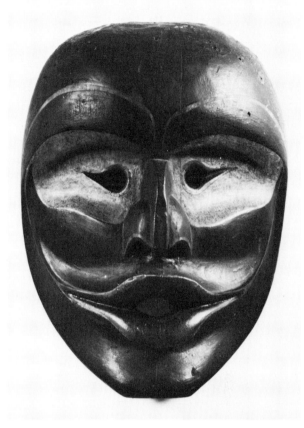

Fig. 264. Tsonokwa mask. Wood; black, white, red. Height:
13⅛ in. Walter and Marianne Koerner Collection 1976.
A2505

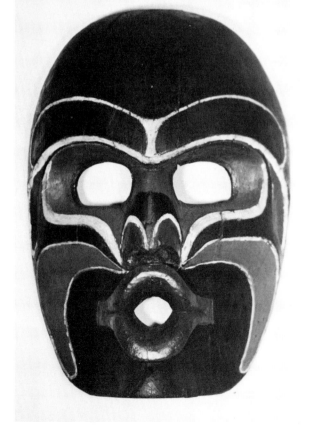

Fig. 265. Tsonokwa head, the cover of a large feast dish.
Wood; black, red, tan. Height: 35 in. Walter and Marianne
Koerner Collection 1976. A2522

Coppers

The copper was made of a large flat sheet of beaten copper cut in the shape of a shield with a T-shaped ridge imposed on it. It was painted with black lead, through which a crest design was incised. Coppers varied in height from six inches to two and a half feet. They were brought out as the climax of a potlatch, and were the preferred finish to the ceremony. They were particularly associated with the marriage transfer of privileges, with a wife's gift to her husband, and with naming ceremonies.

At naming ceremonies, a large ceremonial cradle (*yathla*) was constructed and hung from the beams at the front center of the house (Fig. 271). The copper was a "blanket" to keep the child warm. A herald or other official stood at each corner of the cradle and shook his rattle four times, pretending that there was a child in the cradle. A speech was then made naming the copper and the child. Rattles used in these ceremonies are shown in Figures 142-45. They were made either of copper or of wood in the shape of a copper.

Copper used as a decorative motif on garments (Pls. VII B, VIII A; Figs. 298-303, 305), staffs (Pl. X B, C; Figs. 338, 339), and crest carvings had the clear and unmistakable meaning of wealth, which itself was linked with health, brightness, and light. The staff illustrated in Plate X B and C represents the story of Copper Man, ancestor of James King of Kingcome Inlet. Walking on the sands beside the sea one day, he saw clams spurting liquid of many colors. When he dug to find them, instead of clams he found little bivalve coppers, which he collected and which eventually brought him much wealth. These copper clams were carved on his staff.

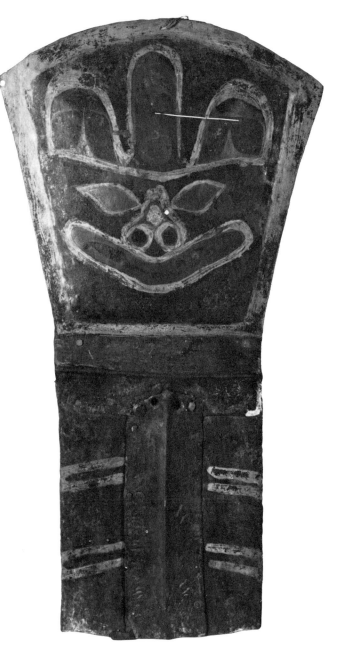

Fig. 266. Copper painted black, white, and red. Height: 22 in. Walter and Marianne Koerner Collection 1976. A17157

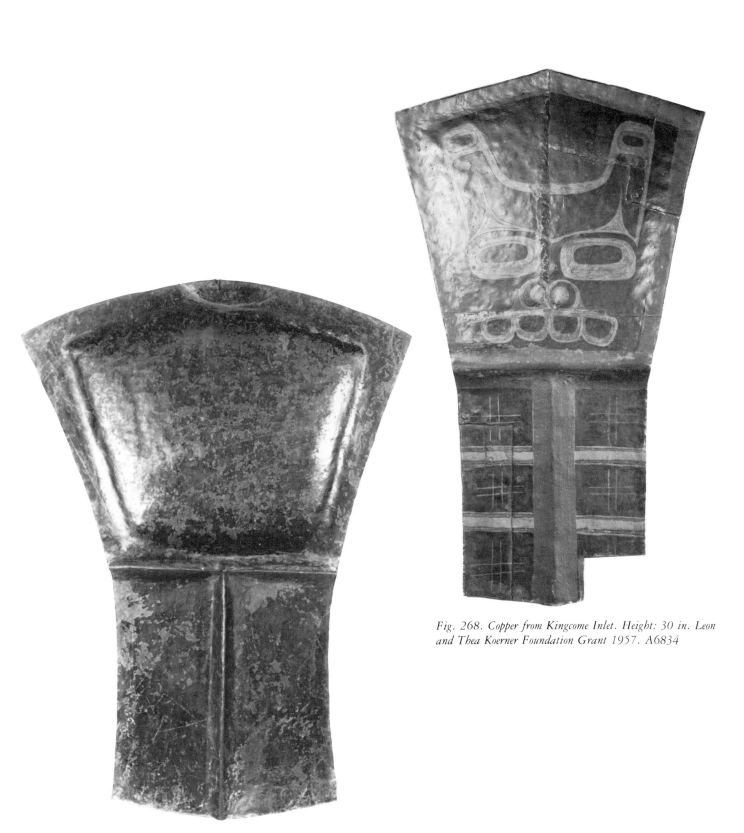

Fig. 268. Copper from Kingcome Inlet. Height: 30 in. Leon and Thea Koerner Foundation Grant 1957. A6834

Fig. 267. Copper showing classic form with convex shape and clearly raised T form. Height: 29 in. Walter and Marianne Koerner Collection 1976. A17156

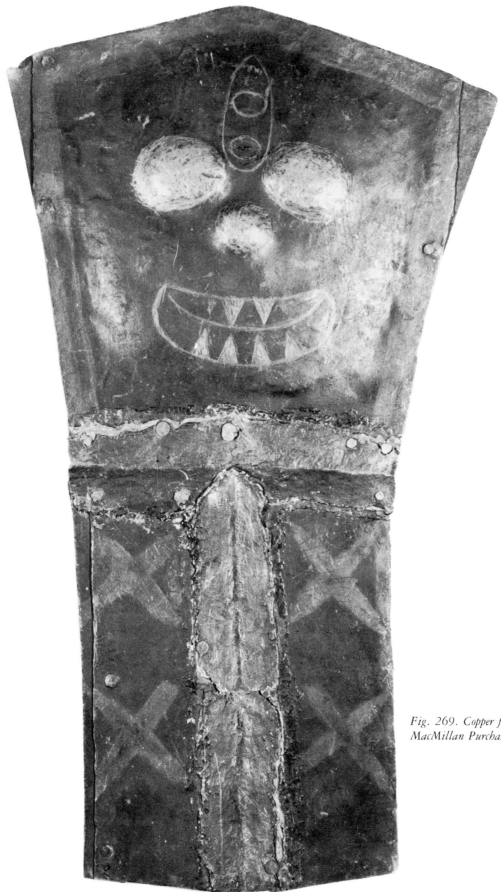

Fig. 269. Copper from Fort Rupert. Height: 21 in. MacMillan Purchase 1962. A8059

Fig. 270. Copper from Smith Inlet. Beaten copper riveted to-
gether at the ⊤ ridge. Height: 31 in. MacMillan Purchase
1953. A4343

Fig. 271. One side of a ceremonial cradle from Fort Rupert,
used in naming or copper ceremony; the other side is identical.
Wood covered with painted cloth. Length: 62 in. MacMillan
Purchase 1951. A3638

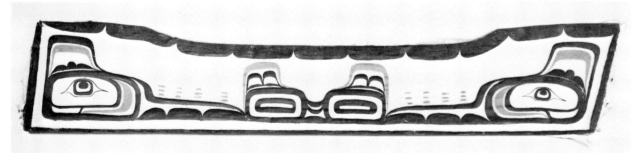

Ceremonial Weapons

Ceremonial weapons were associated particularly with the copper complex. The copper was sometimes "speared" with a harpoon (Figs. 272-78) or spear, in the ceremony associated with the transfer of privileges at the time of marriage. A wedge or "dagger" with a steel blade several inches wide was used to cut the copper. The copper shield was placed on a cutting platform (Fig. 286), and the wedge was hit so that the blade produced a rough, irregular cut in the copper. Often the wedges were symbolic daggers, carved of wood like the ones shown in Figures 279-85. In this case an additional cutting tool would be used. Daggers adorned with skulls were said to be used in the sense of "killing" the copper, that is, cutting it up with a wedge as a slave was killed with a stone dagger in the old days. They were also used in dances.

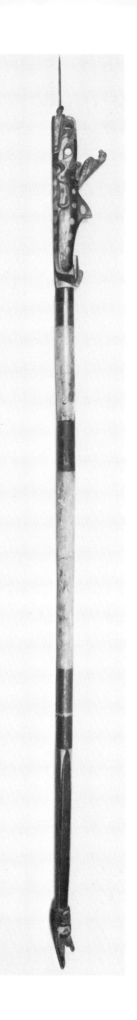

Figs. 272, 273, 274, 275. Ceremonial harpoon from Fort Rupert, used "to spear copper like a whale at marriage transfer ceremony." Wood with dagger point on end; black, red, white, with killer whale and eagle design at tip (Fig. 273) and face on other end (Figs. 274, 275). Length: 100 in. MacMillan Purchase 1951. A3630

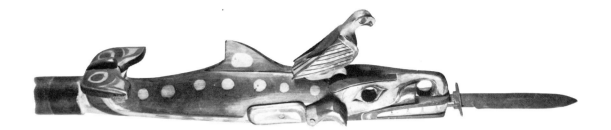

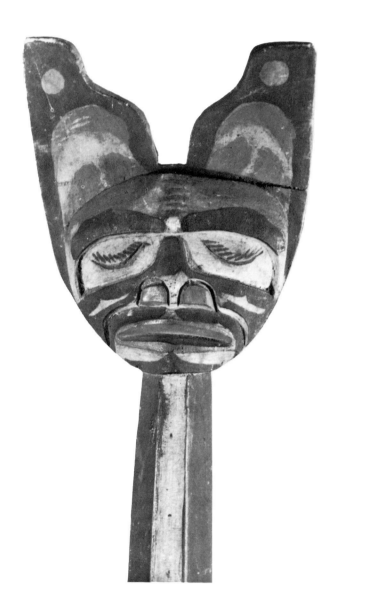

153

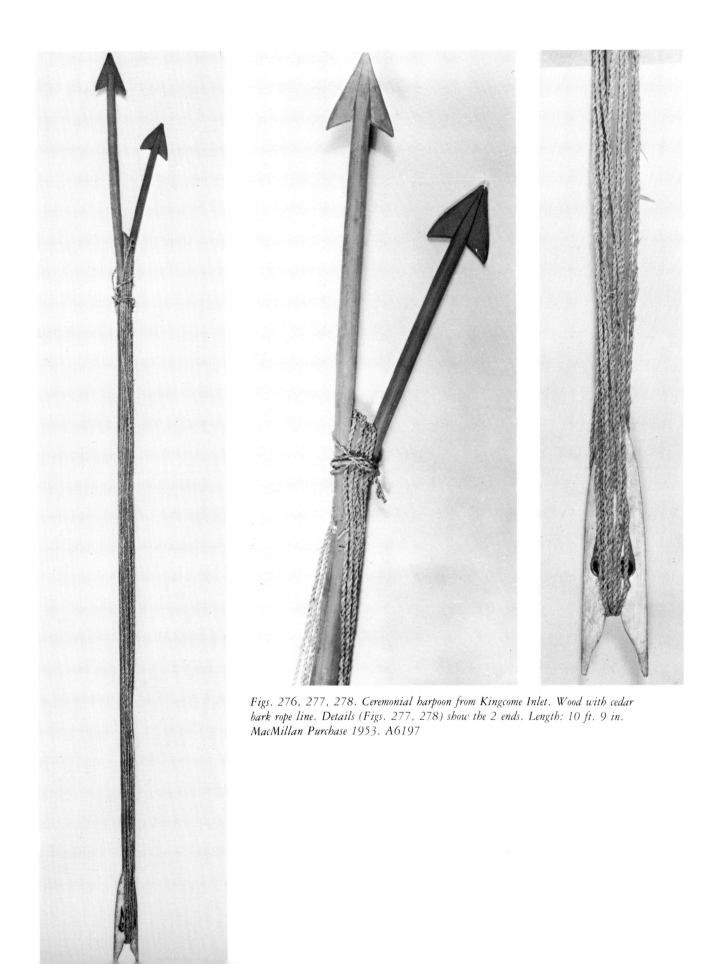

Figs. 276, 277, 278. Ceremonial harpoon from Kingcome Inlet. Wood with cedar bark rope line. Details (Figs. 277, 278) show the 2 ends. Length: 10 ft. 9 in. MacMillan Purchase 1953. A6197

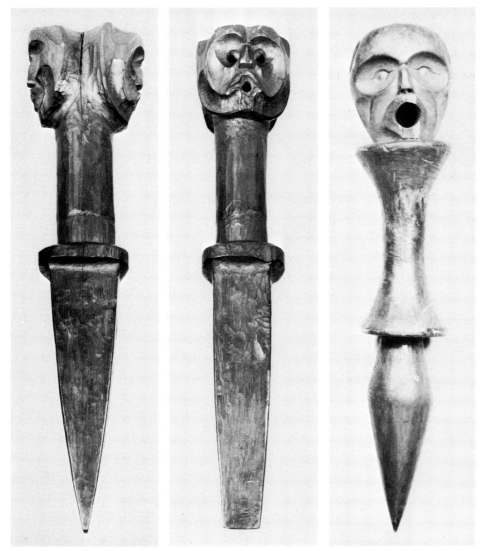

Figs. 279, 280. 2 views of
Tsonokwa ceremonial dagger from
Gilford Island, with 2 carved
Tsonokwa heads on the handle.
Unpainted wood. Length: 15 in.
MacMillan Purchase 1952.
A3824

Fig. 281. Tsonokwa ceremonial
dagger from New Vancouver Vil-
lage. Wood; black. Length: 18
in. MacMillan Purchase 1961.
A7474

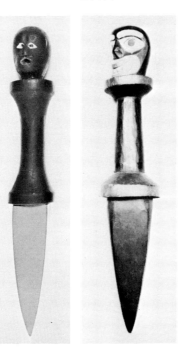

Fig. 282. Tsonokwa ceremonial
dagger from New Vancouver Vil-
lage. Wood; black, red, white.
Length: 18 in. MacMillan Pur-
chase 1961. A7487

Fig. 283. Tsonokwa ceremonial
dagger from New Vancouver.
Wood; black, red, white, yel-
low. Length: 17½ in. MacMil-
lan Purchase 1954. A6367

Fig. 284. Ceremonial dagger with human
face carved at end of handle. Wood. Length:
15½ in. Walter and Marianne Koerner Col-
lection 1970. A5262

Fig. 286. Copper-cutting stand from Gilford
Island, carved in the form of a bear. Wood
with an iron cutting platform on top of the
head. Height: 36 in. MacMillan Purchase
1961. A7878

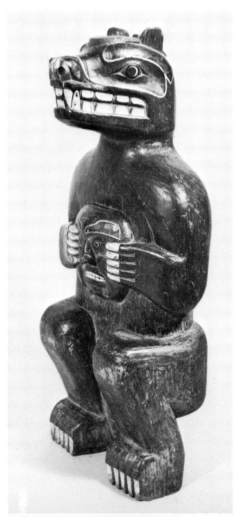

Fig. 285. Ceremonial dagger with human
face carved at end of handle. Wood. Length:
9¼ in. Walter and Marianne Koerner Collec-
tion 1973. A5316

Ceremonial
Cedar Bark

The red-dyed cedar bark head and neck rings worn by the Hamatsa dancers have been shown in Figures 172-85. During the Tsetseka season similar ornaments were worn by other dancers, although some, as we have seen in the Atlakim dance, used hemlock, salal, and ferns instead. Some red cedar bark head rings were trimmed with ermine and abalone shell to make a ceremonial headband of a more permanent sort (Fig. 288).

White, bleached cedar bark had a different function, indicating that the Klasila season was in force. In some cases a cape, skirt, or fringe was made of both red and white cedar bark.

Some cedar bark head and neck rings are shown in Figures 287-93. The three with the cardboard fish, shown in Figures 291-93, were said to have been used by twins because of the mythical association between salmon and twins.

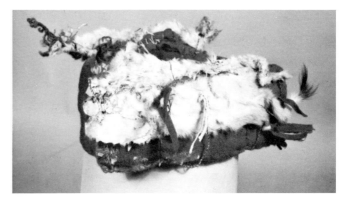

Fig. 287. Head ring from Alert Bay. Red Hudson's Bay blanket, ermine, and cedar bark. Diameter: 8 in. MacMillan Purchase 1960. A4523

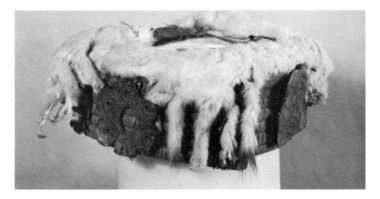

Fig. 288. Head ring from Gilford Island. Cedar bark with abalone shell, ermine tails, cotton cloth, and skins. Diameter: 9 in. MacMillan Purchase 1953. A6298

*Figs. 289, 290. 2 head rings from Blunden Harbour. Red cedar
bark. Diameter: 10 in. MacMillan Purchase 1952. A4228b*

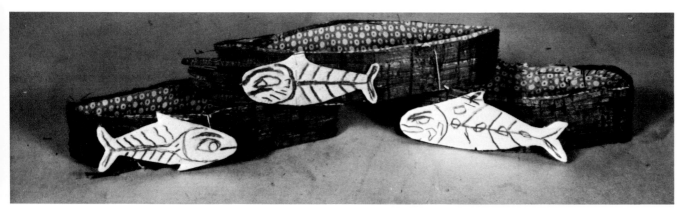

*Figs. 291, 292, 293. 3 head rings from Blunden Harbour. Red cedar bark with
cardboard fish. Diameter: 8 in. MacMillan Purchase 1952. A4240*

Ceremonial Clothing

The dress worn by Northwest Coast Indians for ceremonial occasions was as splendid and showy as human ingenuity could make it. Sea otter robes and fine furs were at first supplemented and later supplanted by the Chilkat blanket, a rectangular textile woven of mountain goats' wool and worn as a cloak. Such blankets, woven on a loom by Tsimshian and later Chilkat women, were composed of highly abstracted crest designs in blue, yellow, white, and black, with a long, heavy white fringe around the hem. (Pl. IX; Figs. 295-97). Each one took nearly a year to make and was highly valued up and down the coast among the other tribes, whose chiefs purchased one whenever possible. Among the Kwakiutl, only those with Tlingit forebears claimed the Chilkat blanket. For all Chilkat weaving the pattern of the crest design was painted by a man on a "pattern board" (Fig. 294) and then copied on the loom by a woman weaver.

An interesting development in the diffusion of Chilkat weaving took place when Mary Ebbets, a woman of the Tongass Tlingit, married a man in Fort Rupert, settled there for the rest of her lifetime, and continued to weave in the Chilkat style. She produced at least twelve blankets, now the heirlooms of her grandchildren, which were later copied in a new variation of weaving by Kwakiutl women. This episode has become significant for the history of museum collections. The following account of Mary Ebbets Hunt is based on notes written by Marius Barbeau (1950:II, 651).

Mary Ebbets was born in 1823 in southern Alaska. When she was about eighteen, she married an English Hudson's Bay factor, Robert Hunt, who was settled in Fort Rupert. They had eleven children, seven daughters and four sons, one of whom, George Hunt, was for many years an assistant and informant for both Franz Boas and Edward S. Curtis. A grandson, David, married Sarah, called Abayah, who later married Mungo Martin. A great-granddaughter married Dan Cranmer, a chief of the Nimpkish of Alert Bay. Mrs. Hunt died in 1919 at the age of ninety-six.

Mary Ebbets Hunt had learned traditional weaving in the North, and while she was at Fort Rupert she wove blankets of traditional style for each of her children (see Plate IX B). It was noted that she was reluctant to weave in front of the Kwakiutl women, who were eager to learn her technique and "broke in" to the room to watch her. Some of her blankets are still used as heirlooms in the Fort Rupert-Alert Bay area. It is these traditional blankets which were the source of the Kwakiutl weaving by Mrs. Mungo Martin, adapted from the Chilkat blankets in the museum collection.

A more common ceremonial costume was the "button blanket" or cloak (Pls. VII A, VIII; Figs. 298-300, 305-6). After trade blankets became available, a special kind of dark blue blanket was preferred for this special purpose. These were made into very brilliant cloaks decorated with red flannel appliqués of family crest motifs and with pearl shell buttons.

Other clothing worn at ceremonies included a variety of dance aprons and leggings of flannel or of woven Chilkat cloth. Dance aprons were decorated with small items that created pleasant sounds, such as thimbles, cartridges, small coppers, puffin beaks, deer hoofs, and the like (Figs. 301-4). A shirt of Chilkat textile trimmed with fur was sometimes worn and was, like the cloak, a very costly item.

Footgear was not worn in earlier times. Clothing for nonceremonial occasions was very simple—capes and skirts of woven or twined cedar bark for the women; cedar bark blankets or nothing for the men.

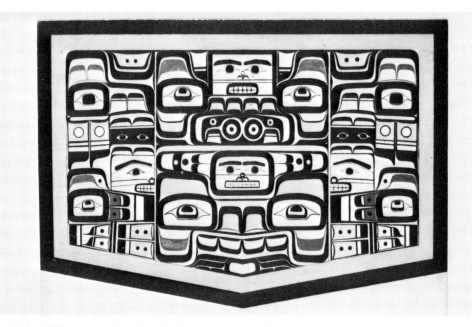

Fig. 294. *Chilkat pattern board, made by Mungo Martin for Mrs. Martin at UBC Museum 1951. Wood; white, green, yellow, black. Length: 48 in. MacMillan Purchase 1951. A3658*

Fig. 295. *Mrs. Mungo Martin completing the fringe on a Chilkat blanket, UBC Museum 1951*

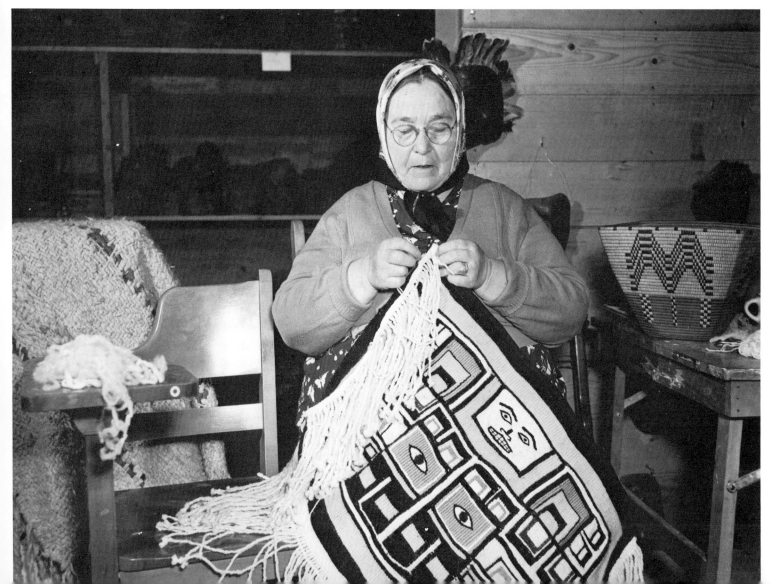

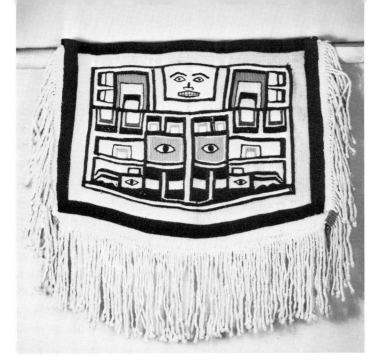

Fig. 296. Chilkat apron woven by Mrs. Mungo Martin at UBC Museum 1951. Commercial wool; black, white, yellow, blue, green, red. Length: 44 in. MacMillan Purchase 1951. A3654

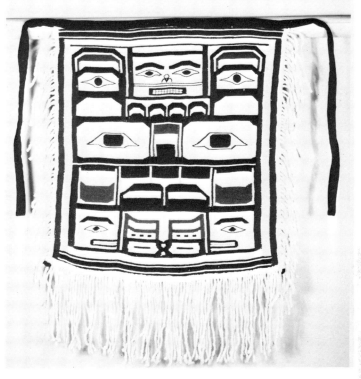

Fig. 297. Chilkat apron woven by Mrs. Mungo Martin at UBC Museum 1951. Commercial wool; white, yellow, green, black. Length: 34 in. MacMillan Purchase 1951. A4184

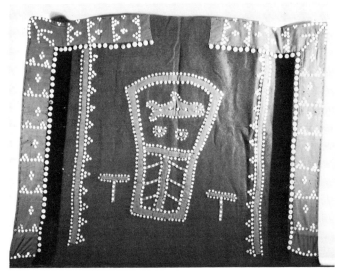

Fig. 298. Button cloak from Blunden Harbour. Blue textile with red appliqué and buttons; copper design with killer whale. Length: 56 in. MacMillan Purchase 1952. A4226

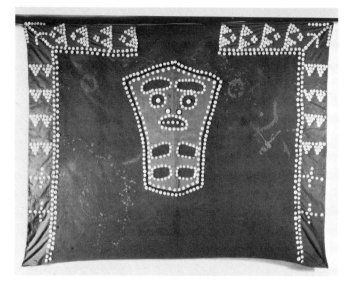

Fig. 299. Button cloak from Blunden Harbour. Green textile with copper design in red appliqué and buttons. Length: 51 in. MacMillan Purchase 1953. A6138

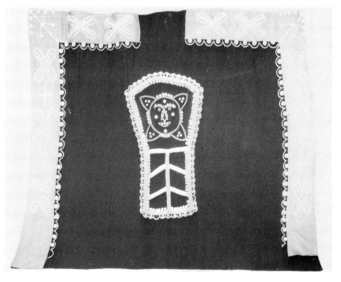

Fig. 300. Button cloak from Kingcome Inlet. Blue textile with red appliqué and buttons; copper design with sun. Length: 72 in. MacMillan Purchase 1953. A4326

Fig. 301. Dance apron from Blunden Harbour, said to have been made before 1880. Black cloth with yellow and red bead-work design of a copper and 2 ravens, and small copper dangles. Length: 18½ in. MacMillan Purchase 1953. A6245

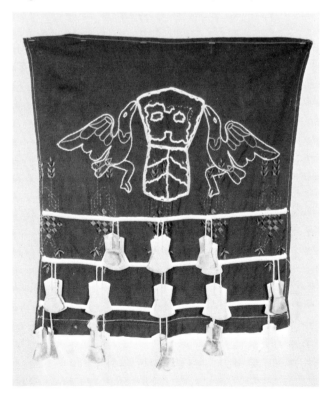

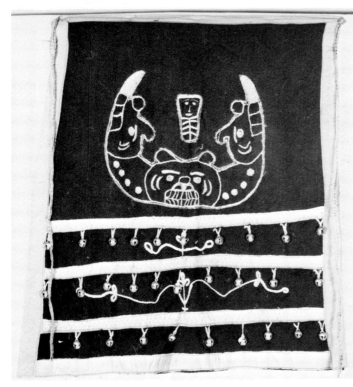

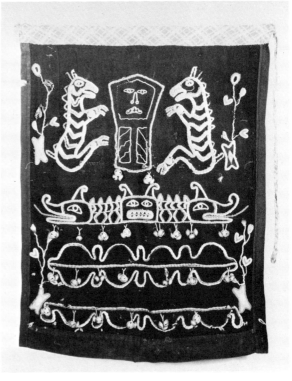

Fig. 302. Dance apron from Hopetown. Black wool with red cotton trim and chrome sleighbells on fringe; embroidered design of Sisiutl and copper. Length: 25½ in. MacMillan Purchase 1952. A4131

Fig. 303. Dance apron from Village Island. Black textile with bells attached; embroidered and beaded design showing a wolf on each side of a copper, and Sisiutl below; green, white, red, yellow, pink, blue. Length: 31 in. MacMillan Purchase 1952. A4172

Fig. 304. Dance apron from New Vancouver Village. Red textile with beaded design of a flowering plant with a wolf on each side; fringe of thimbles and bullet shells. Length: 30 in. MacMillan Purchase 1961. A7489

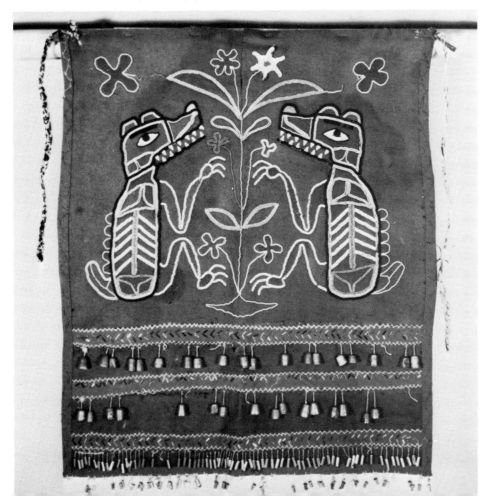

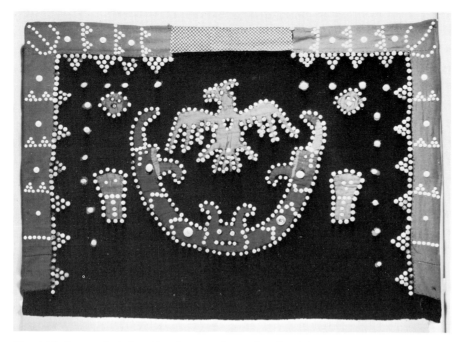

Fig. 305. Button cloak from Fort Rupert. Blue wool with red flannel appliqué of Sisiutl, coppers, and Thunderbird. Length: 52 in. MacMillan Purchase 1953. A4325

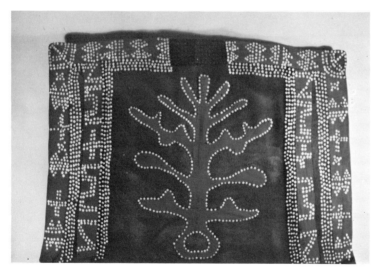

Fig. 306. Button cloak from Kingcome Inlet. Tree design in red appliqué and buttons on blue background. Length: 74 in. MacMillan Purchase 1953. A3730

Chiefs' Headdresses

Among the northern tribes, finely carved wooden crest badges attached to a head ring were traditional for all ceremonial Klasila wear. These *amhalayt*, as they were called by the Tsimshian, were copied by the Kwakiutl in the middle of the last century and constitute some of their finest crest carvings from then on. The Kwakiutl called them *yukweewae* (dancing forehead masks). The Kwakiutl also acquired and used many frontlets from the Bella Coola, Haida, and Tsimshian.

Fine carvers were employed for these headdresses (Pls. XI, XII, Figs. 307-17). A carved wooden frontal piece, inlaid with blue-green abalone shell glued with gum or pitch, was attached to a head ring of reinforced cedar bark and cloth. The rim of the cylindrical crown was lined with a row of sea-lion whiskers that stood stiffly upright. Sometimes feathers were also used as decoration. The stiff sea-lion whiskers held the eagle-down that floated out of the headdress during the dance. A cloth or deerskin panel that covered the head and descended to the waist or below was attached to this elaborate headdress and then covered with white ermine skins, making an impressive and dignified chiefly adornment. Traditions of painting and the colors used varied.

Fig. 307. Chief's headdress from Hopetown, with hawk design. Wood; green, black, red. Height: 5½ in. MacMillan Purchase 1952. A3839

Fig. 308. Chief's headdress from Fort Rupert, with sun design, collected in 1885. Wood, abalone shell, and cedar bark; green, black. Height: 10½ in. MacMillan Purchase 1963. A8391

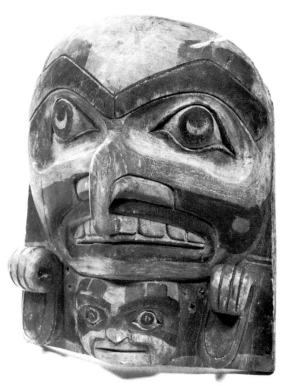

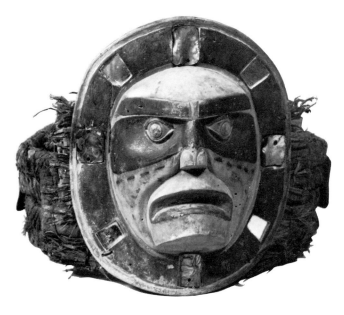

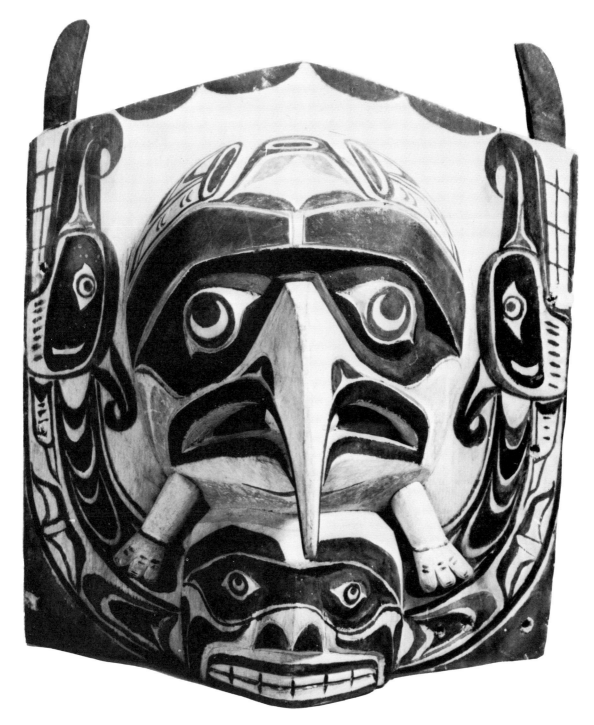

Fig. 309. Chief's headdress from Village Island, with Thunderbird and Sisiutl design. Wood; green, blue, black, yellow. Height: 8½ in. MacMillan Purchase 1953. A3731

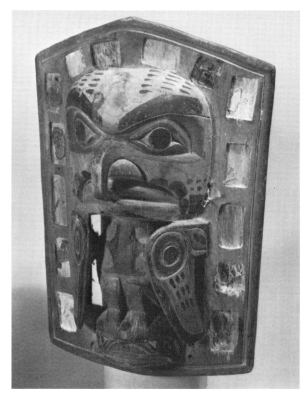

Fig. 310. Chief's headdress from Smith Inlet, with hawk design. Wood with abalone shell inlay missing; red, green, black. Height: 8½ in. MacMillan Purchase 1953. A6149

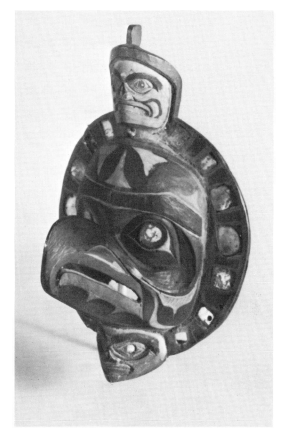

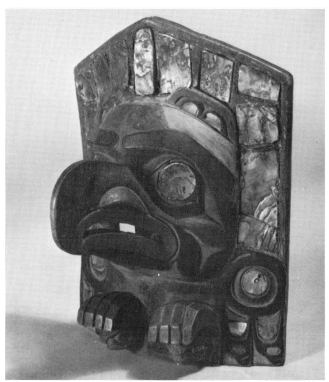

Fig. 311. Chief's headdress from Hope Island, of Bella Coola origin, with Thunderbird design. Wood and abalone shell; black, blue, red. Height: 8 in. MacMillan Purchase 1953. A6273

Fig. 312. Chief's headdress from Blunden Harbour, with Thunderbird design. Wood and abalone shell, with mirror eyes; black, green, blue, red. Height: 11 in. MacMillan Purchase 1953. A6322

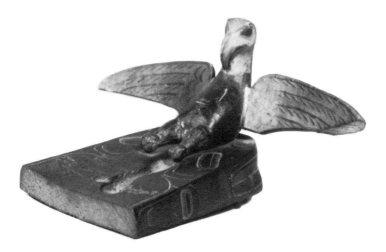

Fig. 313. *Chief's headdress from Kitamaat, with eagle design, used by Sonahed people up to 1888. Wood; brown, black, white. Length of plaque: 8¼ in.; wingspread of eagle: 12 in. MacMillan Purchase 1948, Rev. G. H. Raley Collection. A4456*

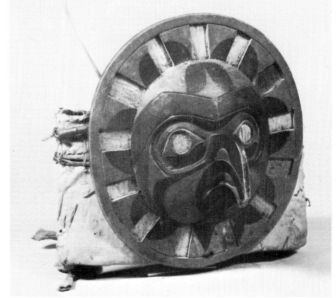

Fig. 314. *Chief's headdress from Alert Bay, with sun and raven design. Wood, cloth, and sea lion whiskers; red, green, black. Height: 8½ in. MacMillan Purchase 1951. A6096*

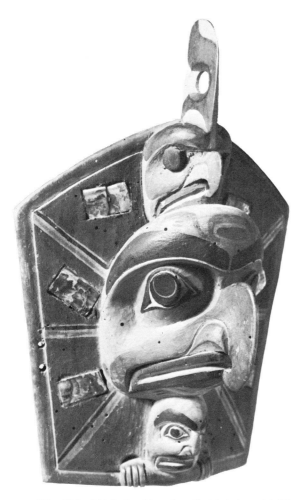

Fig. 315. *Chief's headdress from Smith Inlet, with Thunderbird design. Wood and abalone shell; green, red, black. MacMillan Purchase 1952. A4237*

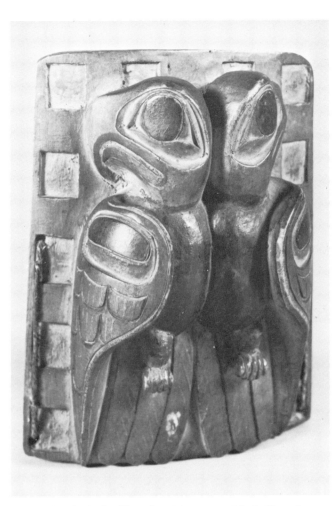

Fig. 316. *Chief's headdress from Kitamaat, with double eagle design. Wood; black, red. Height: 6¼ in. MacMillan Purchase 1948, Rev. G. H. Raley Collection. A2180*

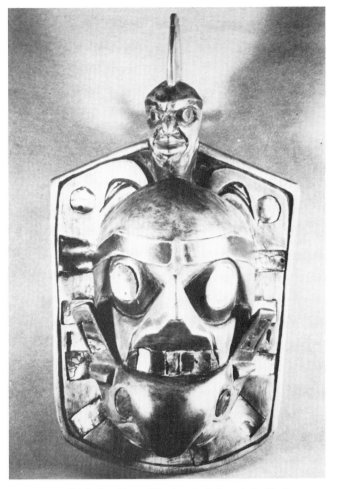

Fig. 317. *Chief's headdress. Wood and abalone shell; black, red. Height: 11½ in. Walter and Marianne Koerner Collection 1976. A2465*

Helmet
Headdresses

Headdresses of the "helmet" type, as distinguished from the chiefs' ceremonial dancing headdresses, were usually wood carvings representing family crest birds and worn on top of the head, with the button blanket completing the costume. The helmet headdresses were held firmly in place by a ribbon or string tied under the chin, and were worn by both men and women.

Most of these were carved of solid wood, with a shell-like form hollowed out to fit over the head (Pl. XIII; Figs. 318-23). In some of them the carvings were attached to rings fitting around the head. Sometimes these headdresses were spectacular; the neck and wings of the heron illustrated in Plate XIII, for example, could be raised and lowered by strings.

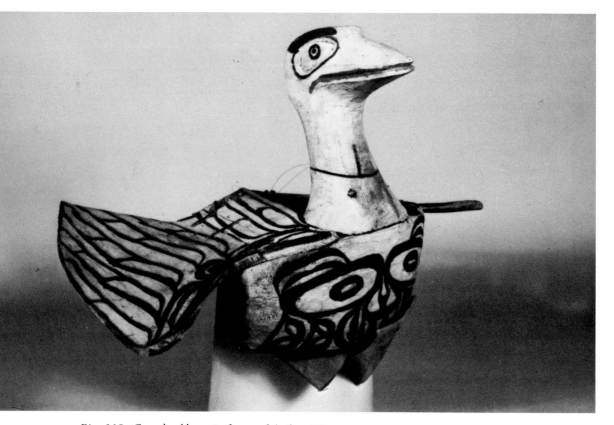

Fig. 318. Goose headdress, 1 of a set of 4, from Kingcome Inlet. Wood; black, white. Length: 20 in. MacMillan Purchase 1953. A6155

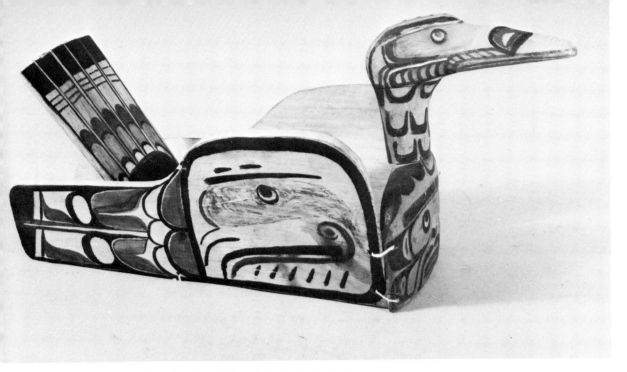

Fig. 319. Goose headdress from Village Island. Wood; black, red, green, yellow, purple. Length: 18½ in. MacMillan Purchase 1952. A4162

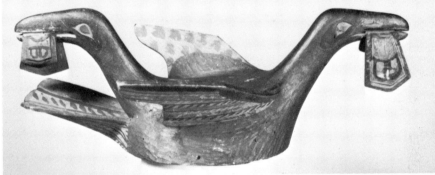

Fig. 320. Double raven headdress with coppers, from Blunden Harbour. Wood; black, green, red. Length: 19 in. MacMillan Purchase 1953. A6236

Fig. 321. Thunderbird headdress from Blunden Harbour, made by Willie Seaweed. Wood; red, orange, green, white, black. Length: 14 in. MacMillan Purchase 1951. A6090

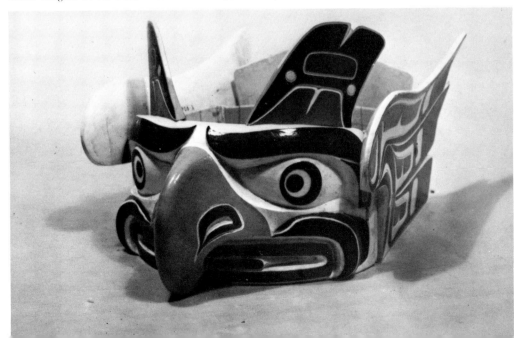

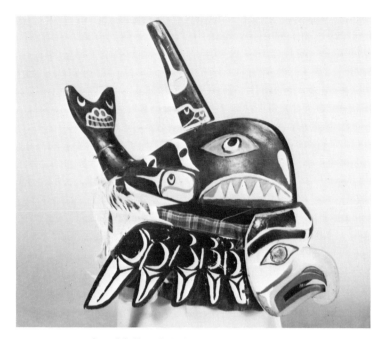

Fig. 322. Hawk and killer whale headdress from Fort Rupert. Wood decorated with plaid cotton and red feather; black, white, yellow. Length: 15 in. MacMillan Purchase 1952. A4183

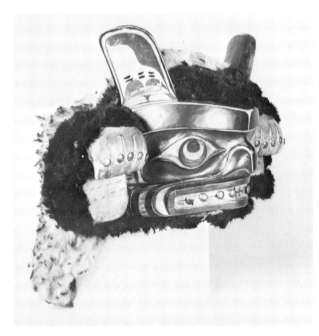

Fig. 323. Bear headdress from Alert Bay, made in 1900. Wood, sheep's wool, and abalone shell with brass studs. Width: 15 in. MacMillan Purchase 1963. A8416

Jewelry and Cosmetics

Early Northwest Coast jewelry consisted of dentalium shell necklaces; labrets of stone or ivory, which were inserted into the lower lips of women of rank in northern regions; pins of bone or ivory; and pendants and charms of carved ivory. With the advent of new trade goods new materials were adopted: brass and copper wire to be rolled into bracelet forms, and a variety of glass beads—red, dark blue, light blue, and brown, round or cylindrical, and in many sizes, which were bought from both Russian and European traders. These beads were combined with dentalium shells to make handsome necklaces. Figures 327-30 show some of these ornaments, which are typical of the Northwest Coast area generally.

Dark blue-green haliotis (abalone) shell, traded up from the Californian coast, was much favored. The contemporary generation of middle-aged people call the pieces about three inches square "the twenty-dollar" size, since they are said to have cost that amount of money. These squares of abalone shell were used to inlay masks, carvings, and headpieces. They were also sewn onto button blankets and cedar bark head rings.

Silver and gold coins were introduced by the Russians who settled in Alaska in 1798. Shortly afterward, the Indian craftsmen of the coast began to hammer the coins into flat bars that could be bent and incised with sharp lines in crest designs. Bracelets were worn by women of rank, usually several at a time, and the practice of incising crest designs on silver and gold bracelets drew the attention of some very skilled craftsmen. The finest bracelets have a slightly hollowed form, convex to the wrist (Figs. 324-26). Among the Haida, silver and gold bracelets owned by the wife were pledged to her husband for his amassing of wealth for a potlatch or purchase. These were brought out on sticks, usually ten to a stick.

Hair was dressed with combs of wood, bone, or stone, but combs were not worn for decoration. Instead, hairpins and other ornaments called *tchenes* by the Tlingit, made of iron and inlaid with shell, were popular with young girls, and women adorned their hair for festive occasions with pieces of red yarn and ribbon.

Some tattooing was done by most Northwest Coast groups, but the practice was common only among the Haida, whose high-ranking members wore black crest designs pricked into the chest, back, arms, and legs.

Face-painting for everyday wear was usually for cosmetic purposes, or as an overall protection against sun, wind, and cold. For ritual occasions, elaborate designs colored red or black were applied and sometimes powdered over with a layer of bird's down.

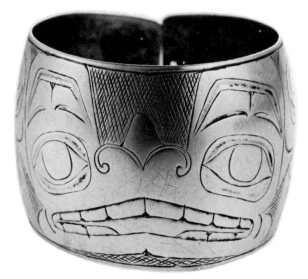

Fig. 324. Bracelet from Sullivan Bay, of Haida origin. Silver. Diameter: 2½ in. MacMillan Purchase 1955. A6172

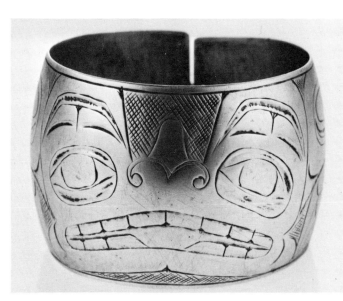

Fig. 325. Bracelet from Kingcome Inlet, of Haida origin. Silver. Diameter: 2 in. MacMillan Purchase 1952. A3847

Fig. 327. Glass trade beads, Russian type. A6140

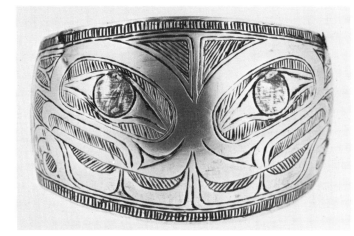

Fig. 326. Bracelet from Kingcome Inlet, with Thunderbird design. Silver. Diameter: 2¼ in. MacMillan Purchase 1952. A3848

Figs. 328, 329. "$20" size abalone shells backed by copper. A7881, A7880

Fig. 330. 5 vine maple hairpins. A3559

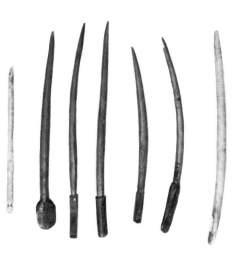

174

Ceremonial Staffs

The ceremonial staff, or "chief's talking stick" (Pl. X; Figs. 331-40), carved and ornamented, was the badge of office of the speaker, who stood by the chief and relayed his sentiments to the gathered visitors. Other staffs, such as the *gwispeck*, were carried by the heralds who went from house to house to invite people to various events. These staffs were not always carved.

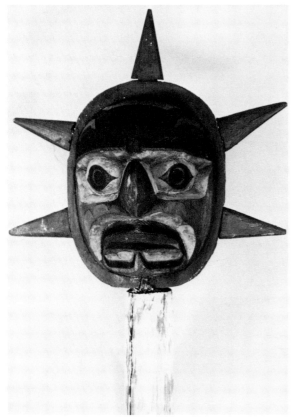

Fig. 331. Finial of speaker's staff, possibly representing the sun with its rays. Wood; black, red, light blue. Height: 8 in. Walter and Marianne Koerner Collection 1973. A17151

Fig. 332. Speaker's staff from Fort Rupert, illustrated in Curtis 1915:Pl. 333. Wood inlaid with abalone shell; black, red, green. Length: 65½ in. MacMillan Purchase 1962. A8140

Fig. 333. Speaker's staff from New Vancouver Village. Varnished fir wood with some traces of red paint. Length: 78 in. MacMillan Purchase 1961. A7473

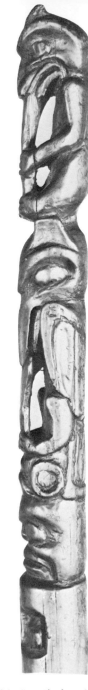

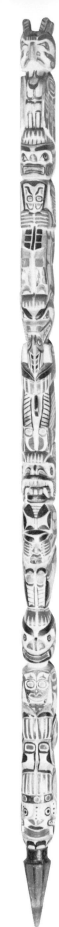

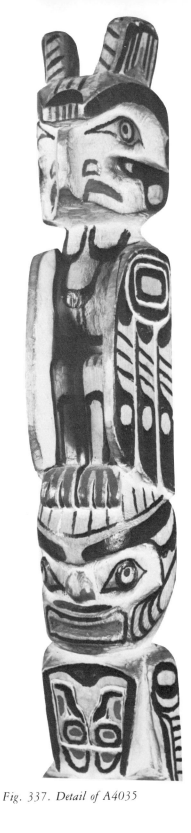

Fig. 335. Detail of A3655

Fig. 334. Speaker's staff from Blunden Harbour. Varnished wood, the lower part painted green. Length: 57 in. MacMillan Purchase 1951. A3655

Fig. 337. Detail of A4035

Fig. 336. Speaker's staff from Village Island. Wood; black, red. Length: 66 in. MacMillan Purchase 1953. A4035

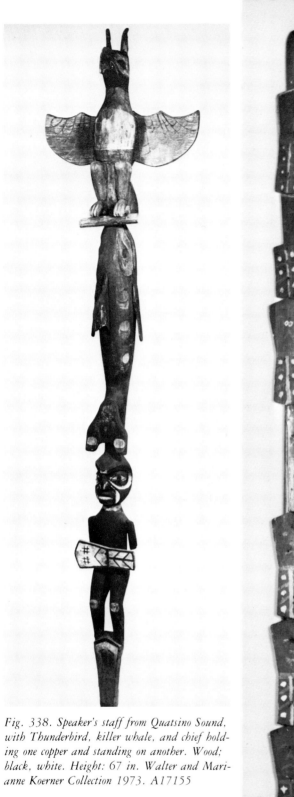

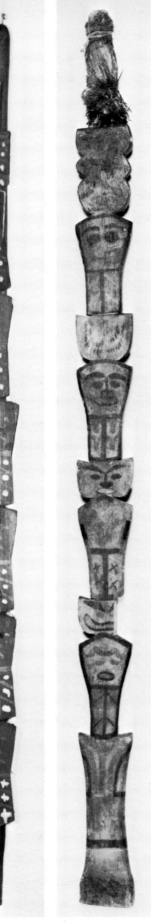

Fig. 338. Speaker's staff from Quatsino Sound, with Thunderbird, killer whale, and chief holding one copper and standing on another. Wood; black, white. Height: 67 in. Walter and Marianne Koerner Collection 1973. A17155

Fig. 339. Speaker's staff from Village Island. Wood; black, white, red, with copper motif. Length: 60 in. MacMillan Purchase 1953. A6029

Fig. 340. Speaker's staff from Turnour Island. Wood; black, red, with copper motif. Length: 50 in. MacMillan Purchase 1961. A8378

Feast
Dishes

The feast was an invariable accompaniment to social gatherings, large or small. On ceremonial occasions when guests were being entertained, the food was served in crest dishes by the household members and passed out in the correct order of rank for that particular feast. The order varied, as we have seen, for Tsetseka, clan, or intertribal gatherings. The speaker spoke for the host, urging everyone to eat as much as he could. Food served depended upon the occasion, but consisted mainly of dried salmon, dried halibut, and smoked shellfish, with fish oil used as a condiment.

Feast dishes were part of the household crest belongings, and important ones were named. They were among the treasures brought by a bride, and in sets of four they represented the divisions of the supernatural beings of the undersea, sky, land, and forest. They were also symbolic of the abundant resources of food indicated by their natural forms (Goldman 1975:76). They varied in size. The first one used in a feast was a very large one which might be the size of a canoe, such as the twenty-foot Sisiutl feast dish shown in Figure 341 (see also Figs. 343, 344, 350, 351). This contained generous portions of the food that was to be dispensed. Large ladles (Figs. 357-59, 362-65) were used to serve food into smaller containers, which were placed before every four or six people.

Members of the household ladled food from these into individual serving dishes with smaller spoons. Small dishes of oil, in which the dried fish was dipped, were placed near at hand.

Most of the dishes were made of wood, either shaped from a hollowed-out log or formed of kerfed boards with convex sides. Kerfed wooden food dishes, illustrated in Figure 494, were made by grooving a cedar board and then steaming it so that it could be bent at right angles (see pp. 8, 15).

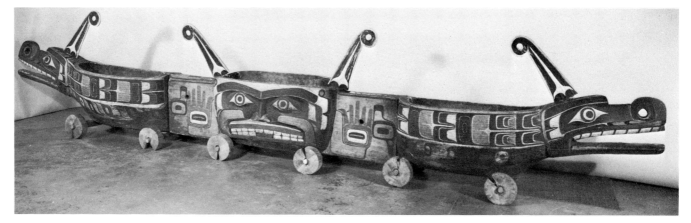

Fig. 341. Sisiutl feast dish from Turnour Island, attributed to Charlie James, 1907. Wood; green, black, red, white. Length: 20 ft. MacMillan Purchase 1950. A4147

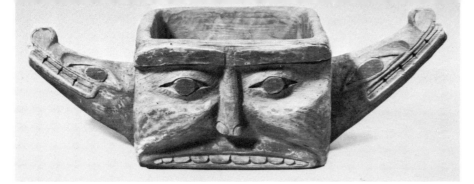

Fig. 342. *Sisiutl feast dish from Kingcome Inlet, 1 of a pair. Wood; green, blue, black. Width, including heads: 32¼ in. MacMillan Purchase 1954. A3414*

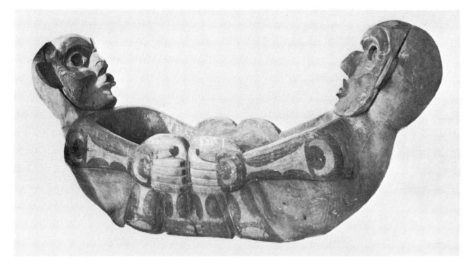

Fig. 343. *Feast dish from Kingcome Inlet in the shape of 2 Tsonokwa figures. Wood; some black and gray. Length: 89 in. MacMillan Purchase 1960. A4492*

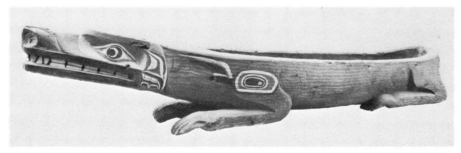

Fig. 344. *Wolf-shaped feast dish from Kingcome Inlet. Wood; black, white, green, red. Length: 10 ft. 3 in. MacMillan Purchase 1952. A6557*

Fig. 345. *Feast dish from Kingcome Inlet, in the shape of 2 beavers. Unpainted wood. Length: 24 in. MacMillan Purchase 1951. A3668*

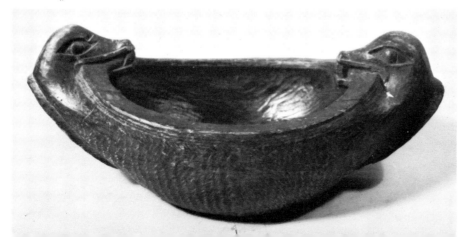

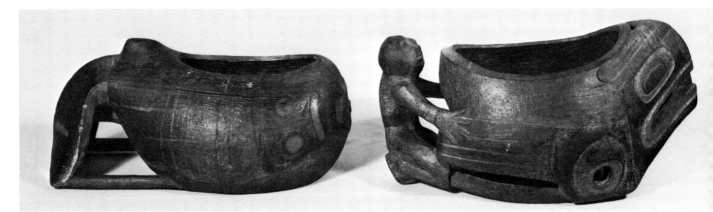

Figs. 346, 347. Pair of very old dishes from Quatsino, made in the shape of 2 halves of a whale and commemorating the capture of the first whale by the culture hero Kula. Wood; black, red. Length (left): 26 in.; (right): 27 in. MacMillan Purchase 1948, Rev. G. H. Raley Collection. A1786, A1785

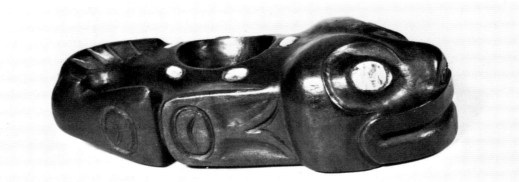

Fig. 348. Fish-shaped oil dish from Bella Bella. Wood with abalone shell eyes and operculum shell inlaid on back; black. Length: 10¼ in. Frank Burnett Collection 1927. A2174

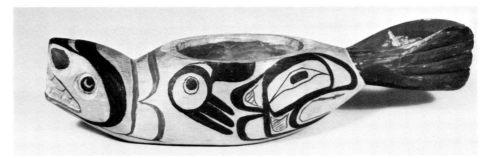

Fig. 349. Seal-shaped dish from Bella Bella. Wood; black, red. Length: 15 in. Gift of Frank Burnett 1927. A403

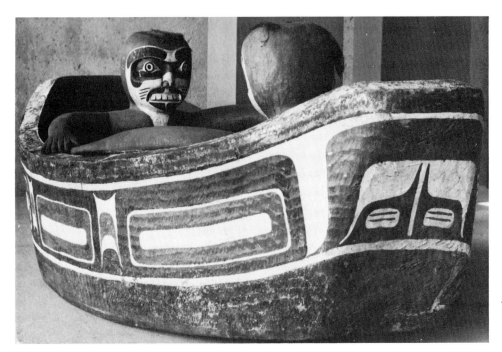

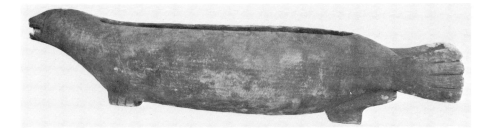

Fig. 350. Canoe-shaped feast dish with 2 figures, from Gilford Island. Wood; black, white, red, green. Length: 75 in. Walter and Marianne Koerner Collection 1976. A2524

Fig. 351. Seal-shaped feast dish. Unpainted wood. Length: 86 in. Museum Purchase 1950. A7237

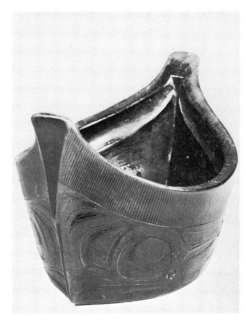

Figs. 352, 353. 2 views of canoe-shaped oil dish from Kitamaat. Wood; black. Length: 9½ in. MacMillan Purchase 1948, Rev. G. H. Raley Collection. A1798

181

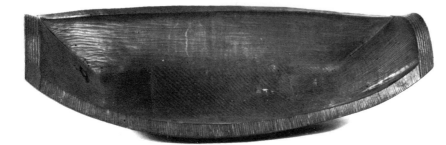

Fig. 354. Canoe-shaped feast dish from Alert Bay. Wood. Length: 29¼ in. Mac-Millan Purchase 1962. A7953

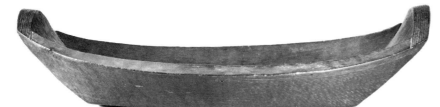

Fig. 355. Canoe-shaped feast dish. Wood. Length: 32 in. MacMillan Purchase 1948, Rev. G. H. Raley Collection. A2175

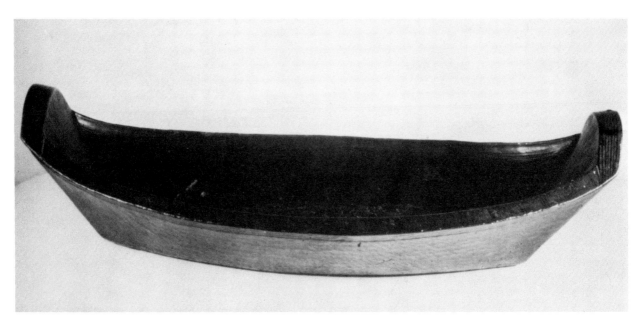

Fig. 356. Canoe-shaped feast dish. Wood. Length: 25¼ in. Walter and Marianne Koerner Collection 1970. A5323

Feast
Ladles and
Spoons

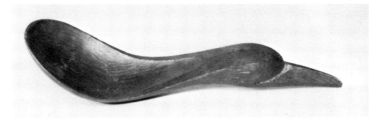

Fig. 358. Ladle from Kitkatlah, with bird's head design. Wood. Length: 24 in. MacMillan Purchase 1948, Rev. G. H. Raley Collection. A1662

Large feast ladles were generally made of wood, as were some plain eating spoons, although some smaller ladles were made of mountain sheep horn. The spoons most valued were the crest spoons of mountain goat horn (Figs. 360, 361). These delicate sculptured objects were manufactured mainly by the northern tribes, but they were eagerly sought by all other tribes and occasionally made by them as well. The horn was boiled to make it soft enough to carve, and was shaped in a two-piece wooden mold. Among the northern tribes, the bowl was usually made from another piece of horn and riveted onto the handle, sometimes with a small fragment of native copper. A bowl of different type of horn from that of the handle, such as mountain sheep, might be employed to provide variation in color and texture. The spoon handle was carved with a succession of small crest figures, following the tapering shape of the horn itself, and was sometimes inlaid with abalone shell. These small spoons were kept by the guests after the feast as one of the gifts of the occasion.

One further item of ceremonial eating was the slender spatula-shaped soapberry spoon, made of wood and used to whip soapberries *(Shepherdia canadensis)* into a froth for a dessert. The soapberry spoon shown in Figure 366 is undecorated, but others were highly ornamented.

Fig. 359. Bird-shaped ladle from Kitlope. Wood. Length: 18 in. MacMillan Purchase 1948, Rev. G. H. Raley Collection. A1565

Fig. 357. Ladle from Kitamaat, with bird's head design. Wood; black. Length: 29 in. MacMillan Purchase 1948, Rev. G. H. Raley Collection. A6522

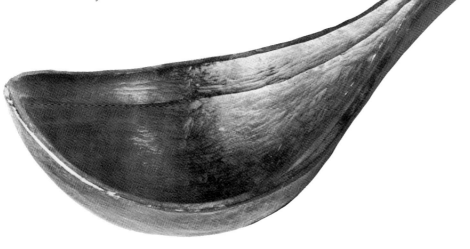

Fig. 360. Spoon from Kitamaat, with carved eagle on handle. Horn. Length: 13 in. MacMillan Purchase 1948, Rev. G. H. Raley Collection. A1711

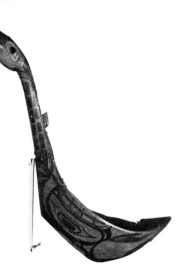

Fig. 362. Ladle from Kemano, in the shape of an eagle with a carved sculpin in the bowl and a painted design on the outside. Wood. Length: 30 in. MacMillan Purchase 1948, Rev. G. H. Raley Collection. A1740

Fig. 361. Spoon. Horn. Length: 10¼ in. MacMillan Purchase 1948, Rev. G. H. Raley Collection. A1670

Fig. 364. Tsonokwa feast ladle from Kingcome Inlet. Unpainted wood. Length: 38 in. MacMillan Purchase 1952. A3802

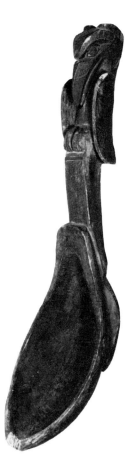

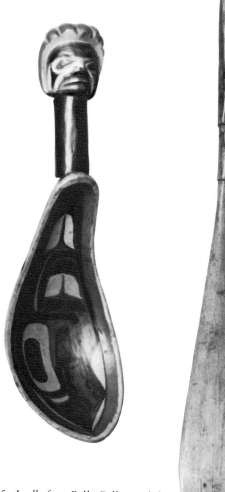

Fig. 363. Ladle from Kingcome Inlet, with carved eagle on handle. Wood; red, green. Length: 48 in. MacMillan Purchase 1954. A6428

Fig. 365. Ladle from Bella Bella, with human head on handle. Wood; black, red, green, brown, blue. Length: 17 in. Valedictory Gift 1931, Dr. and Mrs. G. E. Darby. A1355

Fig. 366. Soapberry spoon from Kitamaat. A1659

Komokwa
Masks

Of major importance in Kwakiutl myth, Komokwa was King of the Undersea World, Master and Protector of the Seals, who were a symbol of wealth. His name means "Wealthy One," and he ruled from a great, rich house under the water. His house posts were live sea lions, who guarded the entrance. The house contained great wealth in blankets, coppers, and other treasures. Many human supplicants of legendary history tried to reach this kingdom, and those ancestral heroes who achieved their goal became wealthy and powerful, returning to their home village with magical boxes full of treasure.

One of Komokwa's other names was Copper Maker, and he married a high-ranking woman named Born To Be Copper Maker Woman— Tlakwakilayokwa—a very high-ranking name among Kwakiutl women. A myth of the Bella Bella claimed that it was her return home with various of Komokwa's gifts that was the occasion of the first Dluwalakha dance.

As ruler of the sea, Komokwa was associated with loons, seals, octopods, killer whales, and sculpins. This association was emphasized by the presence of several masked representatives of these, which accompanied him in the dance. Sometimes they were also represented by symbols on the masks of Komokwa.

Komokwa is also associated with rising tides and whirlpools. Among the Wikeno, when Komokwa was about to enter the dance house attendants rushed in to report that the ocean was rising far above high-tide line. Later, seemingly terrified, they reported that the water was nearly up to the door. Komokwa then entered (Drucker 1940:208).

One of the most beautifully carved masks in the museum collection, the mask of Komokwa illustrated in Plate XVIII, was associated with a woman's face mask (Pl. XXVI A) when purchased from its owner. This probably represents Komokwa's wife, and the two may have been made by the same carver as a pair. The mask shown in Figure 369 typifies the Komokwa character. The loon on his head is carefully carved. By pulling

hidden strings, the wings and neck, jointed under the canvas covering, can be made to flap, dip, and bow in a fashion exactly imitating the motions of this water bird to accompany the arrival of Komokwa. The loon on top of the mask shown in Figure 370 is carved of a solid block of wood. No wings remain, but nail holes along the sides indicate that at one time wings were nailed to the body, whether jointed or solid is not known. The mask in Figure 372 has eyebrows, eyes, and forehead symbols cut out of sheet copper, emphasizing the role of Komokwa as bringer and owner of wealth.

An interesting point of identification associated with the Komokwa masks concerns the round protuberances seen on many of these masks. These were said by Mungo Martin to be octopus tentacle suckers. Another informant said, however, "These are air bubbles," and a third stated, "These are sea anemones eating." The only significant result of the inquiries is that all of these identifications clearly point to Komokwa's undersea nature.

Of the twenty-three masks in the museum that have been identified as Komokwa, eight have these "octopus tentacles" as a significant feature, either carved in three dimensions or painted. All are arresting and powerful masks, massive and nonhuman, characterized by round, staring eyes; heavy eyebrow ridges; a powerful, short, wide nose with flared or emphasized nonhuman nostrils; and thick lips deeply carved and emphasized by paint. Dark green is used in significant amounts as the key color, evoking the watery environment, with black as a secondary statement color. The undersea nature of Komokwa is manifested in other characteristics: carved parallel grooves, indicating gill slits; scalloped lines, representing fish scales; and bifurcated fishtail lines.

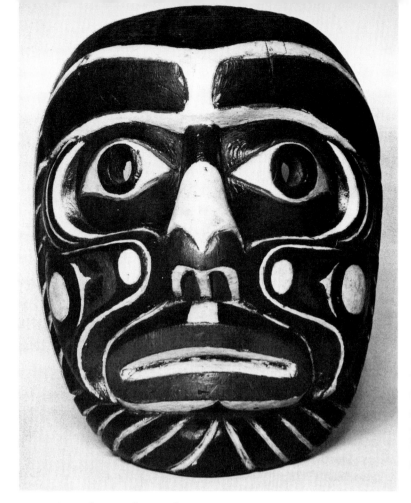

Fig. 367. *Komokwa mask. Wood; black, white, red, green. Height: 14½ in. Walter and Marianne Koerner Collection 1970. A5272*

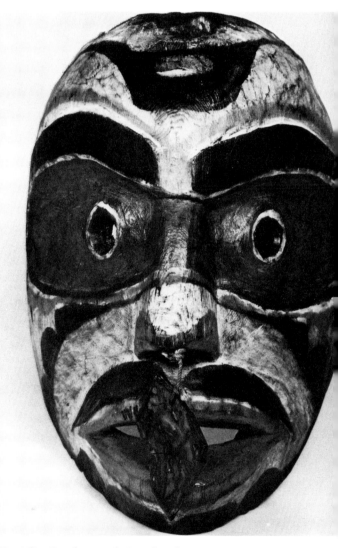

Fig. 368. *Komokwa mask. Wood with abalone ornament suspended from nostrils; black, white, red, green. Height: 12 in. Walter and Marianne Koerner Collection 1970. A5282*

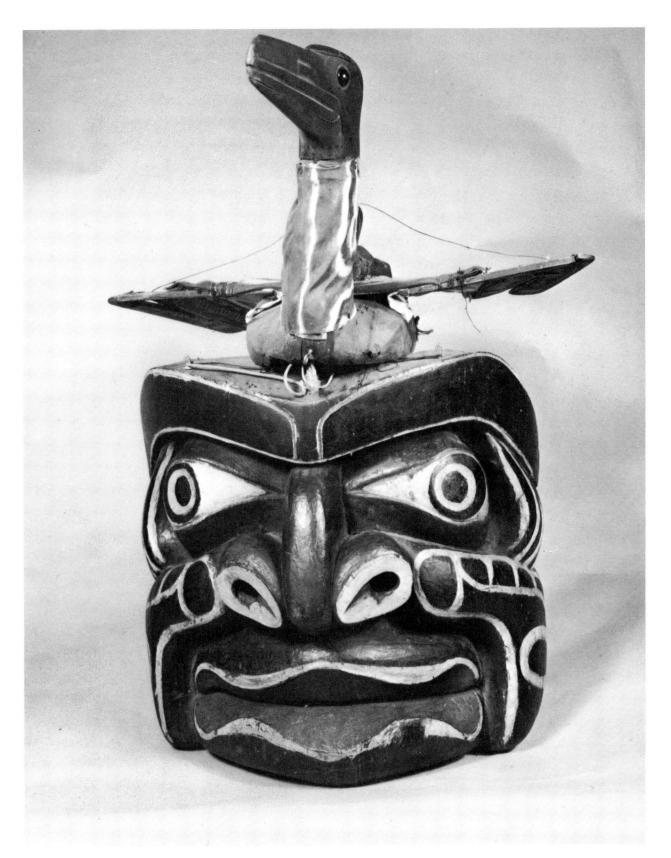

Fig. 369. Komokwa mask from Sullivan Bay, with loon perched on head. Wood, with canvas neck and back of loon; black, red, green, white. Height of mask and loon: 34 in. MacMillan Purchase 1953. A4364

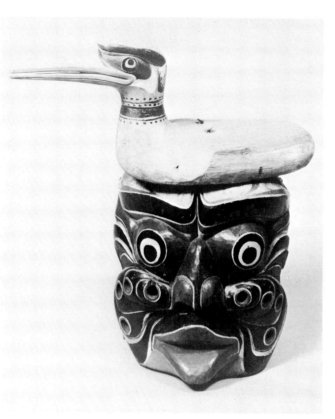

Fig. 370. *Komokwa mask from Smith Inlet, with loon perched on head. Wood; black, gray, red, green, white, orange. Height of mask and loon: 20½ in. MacMillan Purchase 1953. A6178*

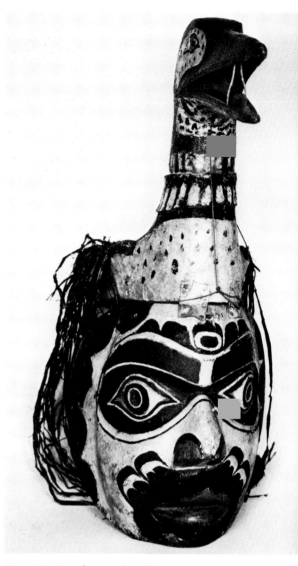

Fig. 371. *Komokwa mask with loon. Wood and cedar bark; black, white, red, green. Height: 23½ in. Walter and Marianne Koerner Collection 1970. A5292*

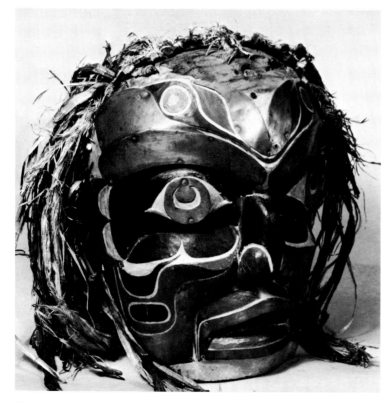

Fig. 372. *Komokwa mask from Blunden Harbour. Wood, cedar bark, and copper; red, green, white. Height: 13 in. MacMillan Purchase 1952. A4246*

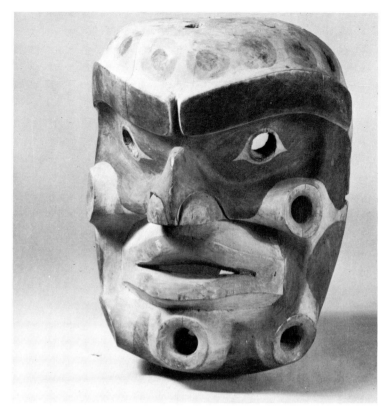

Fig. 373. Komokwa mask from Quatsino, made in 1905. Wood; red, black, green. Height: 13½ in. MacMillan Purchase 1963. A8415

Fig. 374. Komokwa mask. Wood and cedar bark; black, white, red, blue, orange. Height: 11½ in. Walter and Marianne Koerner Collection 1976. A2497

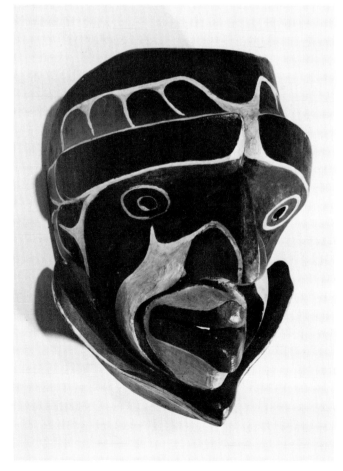

Fish, Pugwís,
and Killer
Whale Masks

Fish masks (Pl. XXVIII A; Figs. 375, 377) were sometimes highly naturalistic in representation, with self-explanatory features. In general, masks of sea creatures other than the killer whale had certain recognizable characteristics. Nose forms were either not prominent or flat. Usually there was a scalloped gill form around the cheeks or jaw, and sometimes even the forehead. Often the tail was slightly bifurcated to represent a fish tail, in contrast to the strongly bifurcated tail of the killer whale, or a fin symbol might appear as part of the facial design. There was a tendency to use white paint for facial coloring. Most of these masks had round eyes. Masks of the salmon, which was associated in the myths with twins, were always made in pairs, and these could be worn by any twin regardless of his inherited right.

Sea monsters (Figs. 376, 378) sometimes combined features of land and sea creatures. They were often associated with storms and tide rips.

In the case of Pugwís, or Man of the Sea, whom Boas calls Merman, the rounded contours of the face point downward to two large front teeth (Figs. 379, 380; see also Mungo Martin's painting, Fig. 24). Round eyes and gills are also characteristic.

The killer whale was an important character of Northwest Coast mythology, generally as a clan ancestor associated with sea beings, particularly Komokwa, sculpins, and loons. It was also associated with coppers, property disposition, and wealth. The killer whale was generally represented by masks so large that they might be called body masks, since they partially covered the body. When such a mask was worn it was necessary for the dancer to lean forward so as to bear the weight with his shoulder and back muscles, using the back of his arms to help support it. His hands were thus left free to manipulate the strings that moved the various appendages; his lower body and legs were concealed beneath a long cape of cedar bark fringe. This position and the covering of the dancer made it appear that the killer whale was floating or swimming whenever the dancer moved.

Plates XV and XVI and Figure 381 illustrate these body masks, complete with side fins, dorsal fins, and tails, all of which can be made to move sideways, back and forth, and up and down by pulling appropriate strings. In addition, three of the masks have movable lower jaws.

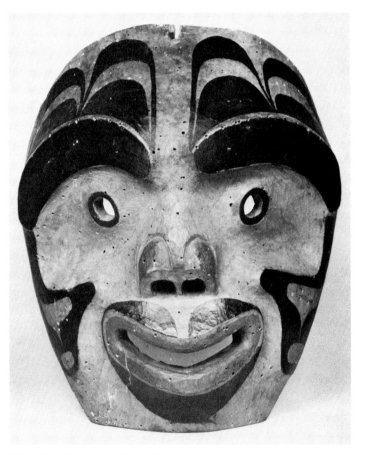

Fig. 375. Fish mask. Wood; black, white, red, green. Height: 12 in. Walter and Marianne Koerner Collection 1970. A5274

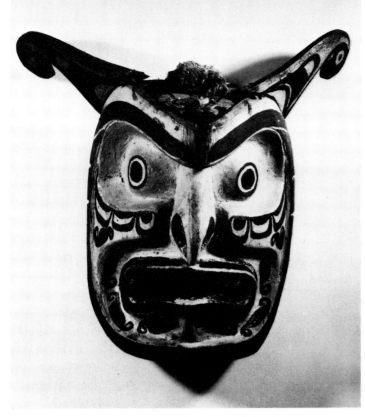

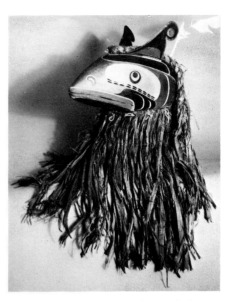

Fig. 377. *Supernatural codfish mask from Smith Inlet. Wood and cedar bark, with copper ears; silver, gray, black, white, brown. Length: 16½ in. MacMillan Purchase 1953. A6222*

Fig. 376. *Supernatural halibut mask. Wood; red, black, gray. Height: 13½ in. Walter and Marianne Koerner Collection 1976. A2504*

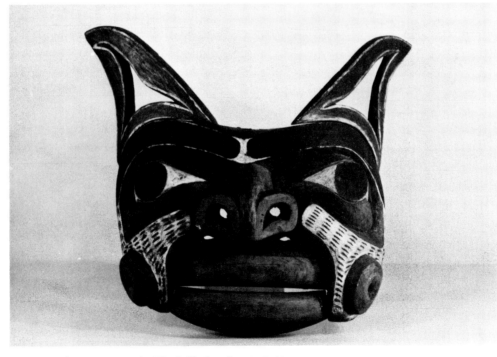

Fig. 378. *Sea monster mask. Wood; black, white, red, blue. Height: 19 in. Walter and Marianne Koerner Collection 1976. A2498*

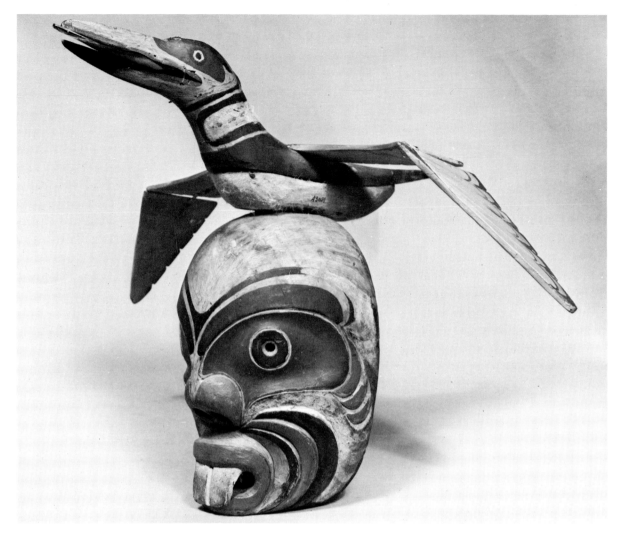

Fig. 379. *Puguís mask from Kingcome Inlet, with loon on top of head, made by Mungo Martin in 1911; cf. Boas 1908: Vol. V, Pl. XL, No. 4. Wood; gray, green, red, black, white. Height of mask and loon: 15½ in.; wingspread: 28 in. MacMillan Purchase 1951. A3659*

Fig. 380. *Puguís mask from Hopetown. Wood; black, green, red, white. Height: 11 in. MacMillan Purchase 1953. A6303*

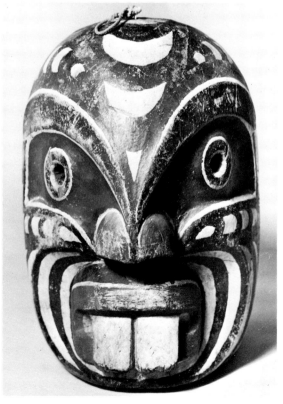

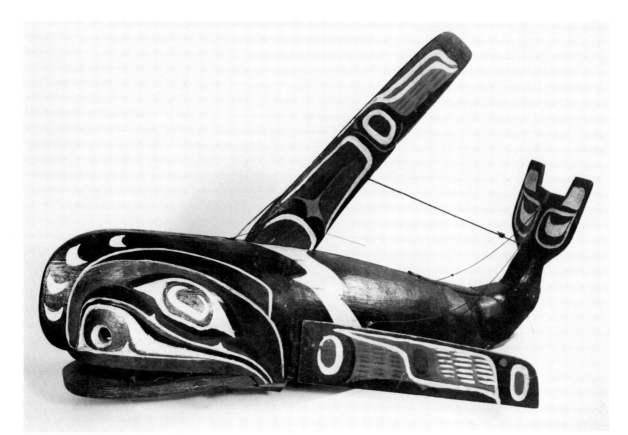

Fig. 381. Killer whale mask. Wood; black, white, red,
green. Length: 38 in. Walter and Marianne Koerner Collec-
tion 1970. A5300

Animal
Masks

There were a number of birds, fish, and other animals that had no major role in the dances and no magic tricks, but were part of the clan myths and came in when these were re-enacted. The dancers who portrayed these performed mimetically, imitating the typical cries and methods of locomotion—flying, swimming, waddling, or rolling. Their masks were usually realistic representations.

The otters shown in Figures 382 and 383 were identified by Mungo Martin as land otters, distinguished from sea otters. The frog (Figs. 398, 399) was associated with coppers in various myth contexts. When the frog looked down into the water and saw the wealthy house of Komokwa and his wife, he was given the privilege of cutting the copper. Figure 398 has teeth of copper symbolic of this privilege.

The deer (Figs. 384, 386) had the character of being very sly and sharp. He often defeated enemies, such as wolves, not only by his wits but by his supernatural gifts. One of these mentioned in mythology was a "fog box" which, when opened, let out such a cloud of fog that pursuers were completely stopped.

There were two grizzly bear characters among the Kwakiutl. The Hamatsa grizzly bear (Nanes Bakbakwalanooksiwae), one of the high-ranking characters of the Hamatsa series, had no mask but painted his face red to symbolize a voracious bear mouth and wore a costume of bearskin and long wooden claws. The Dluwalakha grizzly bear dancer wore not only a fur costume but also a mask. A myth recounted by Boas mentions that the character Grizzly Bear was an excellent hunter because he had a powerful grizzly bear mask to put on when he wished to obtain game.

Bear masks (Figs. 387-91) were characterized by a certain massivity of head and muzzle carving. The muzzle was shorter and heavier than that of a wolf, with a square end. Teeth were usually carved in the jaw and were prominent, although short and not sharply pointed. Often no ears were indicated. The eye was generally a simple eye form, and the nostril was wide and flaring with a tendency to roundness. Bear masks were usually dark in color, brown or black. Often the back of the head was covered with a piece of black fur.

Among the Kwakiutl the Walasahakw dance was a group dance in which the dancers wore forehead masks and blankets. The wolf appeared in this dance as an ancestral myth figure, but generally had no attributes of fearsomeness. The wolf muzzle is long and lean, and the teeth are usually shown, as in twelve of the twenty-one masks in the museum's collection. The forehead masks of wolves (Pl. XVII; Figs. 392-95) were either held to the head by a framework helmet made of twigs or, if they had very long muzzles, braced at the back by a stick that was anchored across the chest or around the waist. There was also a Dloogwala dance that re-enacted the initiation of novices in the same spirit as that of the Nootka, and was probably borrowed from them. In northern Kwakiutl tribes a special supernatural wolf forced the members of the Noontlem society to re-enact wolf spirit possession and to behave in a violent fashion, as a "Dog-eating Society."

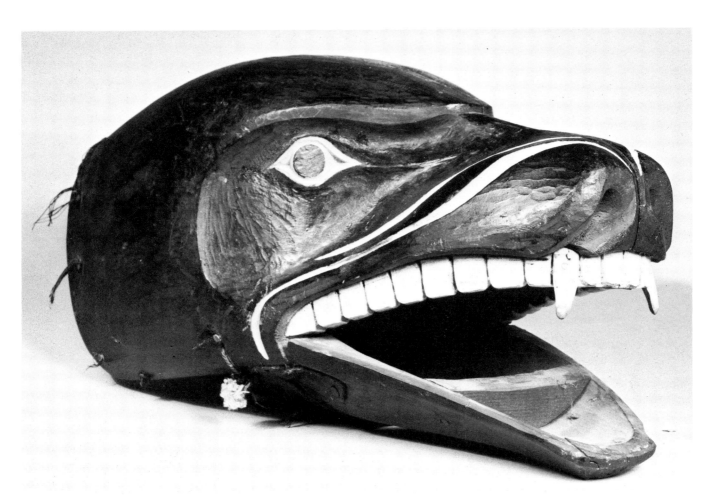

Fig. 382. Land otter mask from Kingcome Inlet. Wood;
black, white, brown. Length: 16 in. MacMillan Purchase
1953. A6207

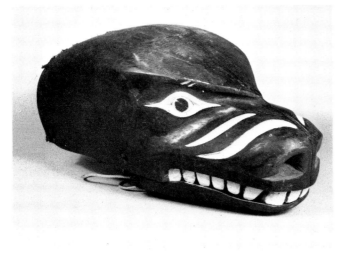

Fig. 383. Land otter mask from Kingcome Inlet. Wood;
black, white, brown. Length: 16 in. MacMillan Purchase
1953. A6208

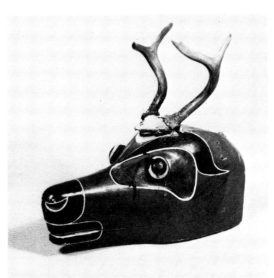

Fig. 384. Deer mask from Alert Bay. Wood and antlers;
brown, black, green, white. Length: 16½ in. MacMillan
Purchase 1954. A6359

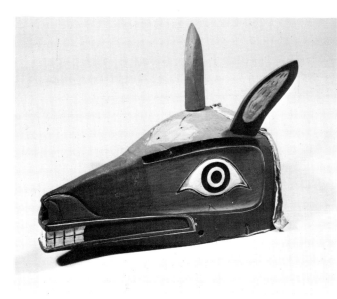

Fig. 385. Doe mask from Village Island. Wood; brown, blue, red, white, black. Length: 17 in. MacMillan Purchase 1951. A6104

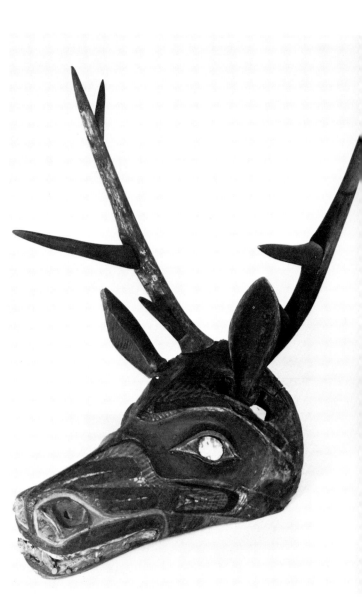

Fig. 387. Bear mask from Kingcome Inlet. Wood and bear-skin; red, green, white, black. Length: 19 in. MacMillan Purchase 1953. A6192

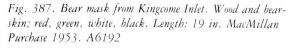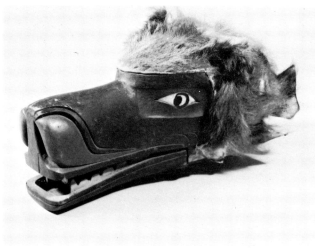

Fig. 386. Deer mask. Wood; black, red, green-blue. Height: 21½ in. Walter and Marianne Koerner Collection 1973. A17144

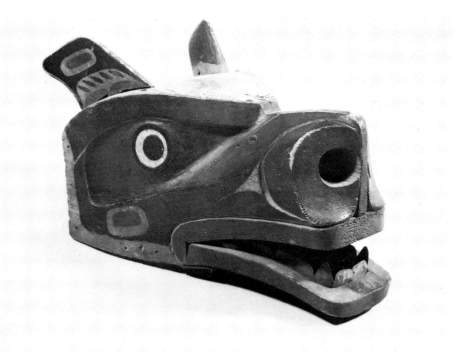

Fig. 388. Bear mask from Turnour Island. Wood and cop-
per; red, black, green, white. Length: 14 in. MacMillan
Purchase 1961. A7478

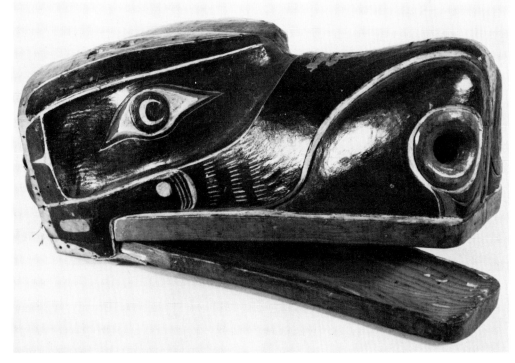

Fig. 389. Bear mask. Wood; black, white, red, green,
brown. Length: 20½ in. Walter and Marianne Koerner Col-
lection 1970. A5325

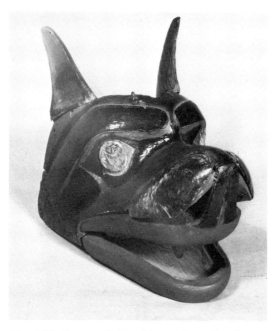

Fig. 390. Bear mask from Rivers Inlet, collected in 1914.
Wood with commercial paint, copper nostrils, abalone shell
eyes; brown, red, black. Length: 12½ in. MacMillan Pur-
chase 1962. A8056

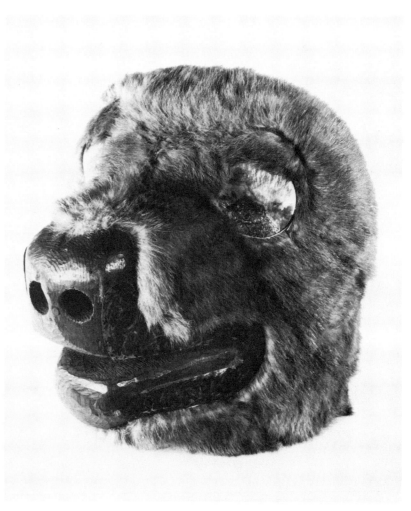

Fig. 391. Bear mask. Wood, fur, and abalone. Height: 12
in. Walter and Marianne Koerner Collection 1970. A5298

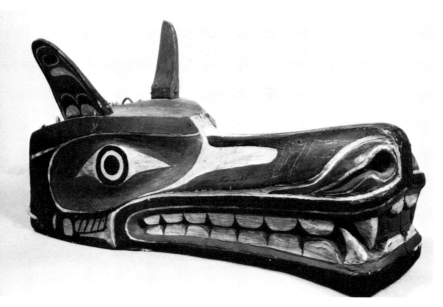

Fig. 392. Wolf mask from Kingcome Inlet. Wood; red, green,
white, black. Length: 20 in. MacMillan Purchase 1954.
A6383

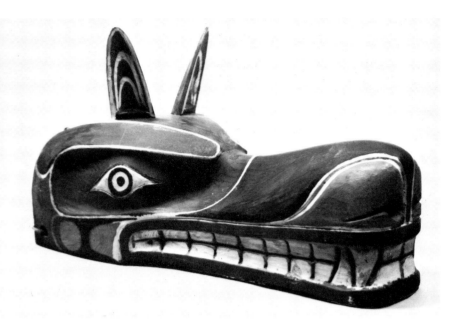

Fig. 393. Wolf mask from Smith Inlet. Wood; black, green, red, white. Length: 18 in. MacMillan Purchase 1951. A4022

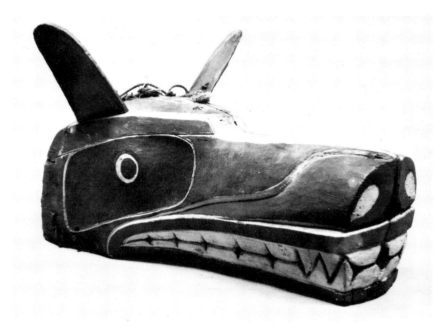

Fig. 394. Wolf mask from Kingcome Inlet. Wood; red, white, green, black. Length: 15½ in. MacMillan Purchase 1953. A6128

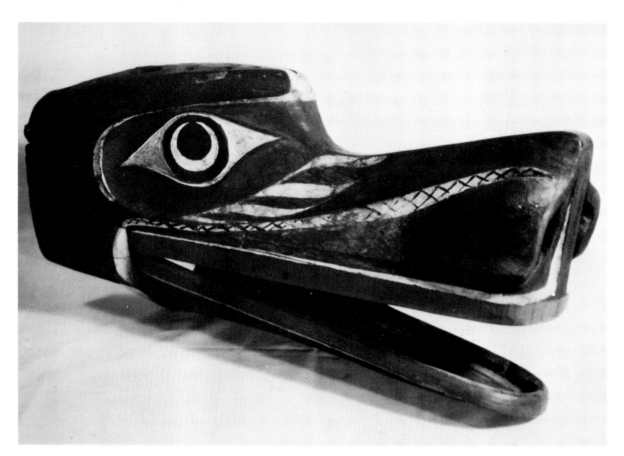

Fig. 395. *Wolf mask. Wood; black, white, red, green, blue. Length: 24 in. Walter and Marianne Koerner Collection 1970. A5271*

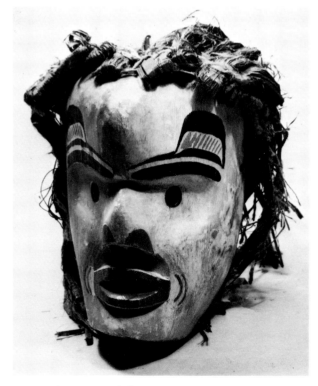

Fig. 396. *Mouse mask from Kingcome Inlet, possibly Atlakim. Wood and cedar bark; white, red, black. Height: 8½ in. MacMillan Purchase 1953. A6159*

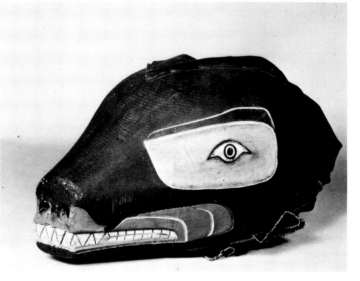

Fig. 397. *Seal mask from Village Island. Wood; black, gray, white, blue, red. Length: 15½ in. MacMillan Purchase 1951. A6105*

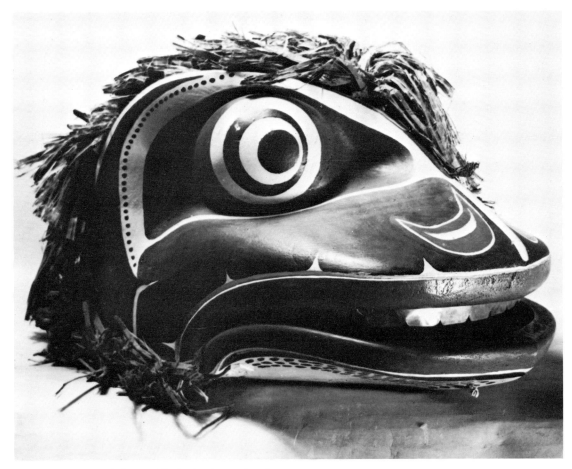

Fig. 398. Frog mask from Gilford Island. Wood, cedar
bark, and copper; red, white, green, black. Length: 19½ in.
MacMillan Purchase 1953. A6319

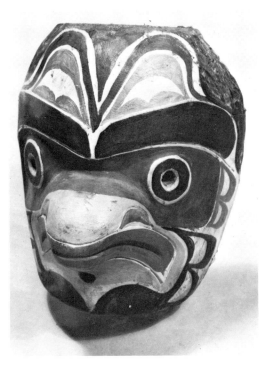

Fig. 399. Frog mask from Gilford Island. Wood; red, white,
black, green. Height: 11 in. MacMillan Purchase 1962.
A8057

Bird
Masks

Birds occurred frequently in the Kwakiutl myths. Thunderbird and his younger brother Kolus were both ancestors of the Kwakiutl; each was the parent of many children who became chiefs of lineages.

Thunderbird was one of the supernatural birds of the myths. The flapping of his wings caused crashes of thunder, and lightning flashed from his eyes. He was so enormous that he fished for killer whales as though they were small fish, diving from the sky to seize them in his talons. The masks (Pl. VII A; Figs. 400, 401) represent him with supernatural horns curving from his head. His costume was totally covered with feathers.

Thunderbird's younger brother Kolus (Figs. 402, 403), another supernatural ancestor of the Kwakiutl clan, was covered with heavy white down. According to the myth he had a tendency to perspire heavily because of his very hot covering. He was happy to remove his covering and became a man for a while (see p. 31).

Characterized by a heavy, curved beak, the eagle mask (Pl. XXIV; Figs. 404, 405) was generally worn with a coverall suit of feathers with large wings reaching from the shoulders to the wrists. These masks were usually fitted with mats on which white eagle feathers were sewn, worn to cover the head. Most of these coverings had been reduced to dust by moths before they were brought to the museum. There were no traditional colors for the eagles, which might be green, brown, or gray.

Another mythical bird was Khenkho, the so-called "supernatural crane." The masks in Figures 406 and 407 were identified by Bill Holm as being different from either Raven, Hokhokw, or Crane, but very little is known about this character. Khenkho is characterized by his long narrow beak, ears, and elaborated nostrils.

Raven, the trickster, was a Northwest Coast culture hero who brought many benefits to mankind through his greed and curiosity, leaving a legacy of many inventions and tales of his picaresque adventures. Raven masks (Figs. 408-11) can be identified by a long, clear-cut beak, curved above but absolutely straight on its underside. The Hamatsa raven is different, much more elaborate, and with flared nostrils. In color the Hamatsa ravens are restricted to red, white, and black, with perhaps a touch of orange. Non-Hamatsa masks tend to be the same, with occasional touches of blue or green. They have no red cedar bark fringes and are, on the whole, less imaginative than the Hamatsa raven masks. Figure 411 represents Raven as a human with symbolic face paintings, with perhaps some indication of sharpness and greed in his character.

Various sea birds were represented as part of the family myth characters: the merganser (usually named Diver by informants), loon, crane or heron, and seagull are among those portrayed. The loon, being associated with Komokwa and coppers, was the only one that was apparently of more than very minor significance. Other bird masks worn by the Kwakiutl and other peoples of the Northwest Coast included the grouse (Fig. 237) and the owl (Fig. 412).

Of thirty bird masks in the collection, four have been identified as Thunderbird, three are Kolus, six are eagles, six are Raven, four are Khenkho, two are hawks, and there is one owl. The hawk is frequently represented as a frontlet carving worn by chiefs, though the reason for its selection as a lineage crest is not known to me. Since any face with a short, sharply recurved beak is commonly identified as a hawk, it is quite possible that some of these are actually other beings. The loon also appears frequently on helmet headdresses.

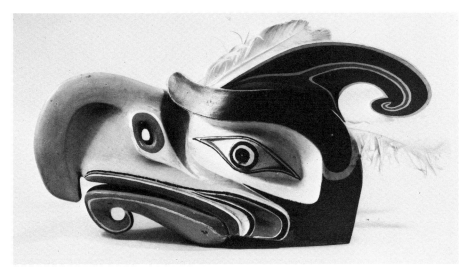

Fig. 400. Thunderbird mask from Gilford Island, said to have been made by Jim Howard and used in 1918. Wood and feathers; blue, white, red, black. Length: 25 in. MacMillan Purchase 1953. A4304

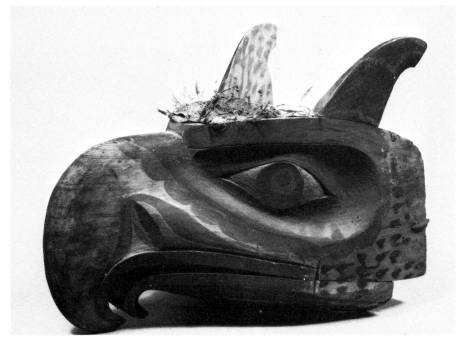

Fig. 401. Thunderbird mask from Smith Inlet. Wood; green, black, red. Length: 20 in. MacMillan Purchase 1952. A4236

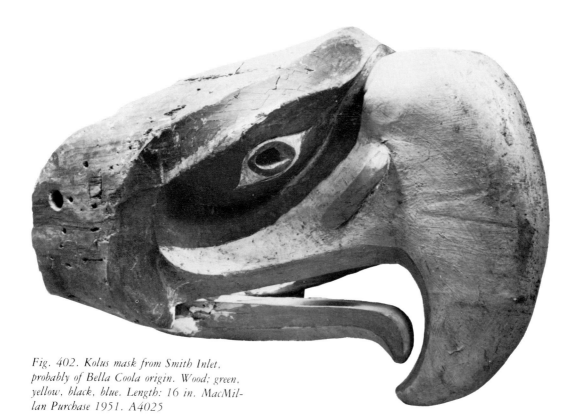

Fig. 402. Kolus mask from Smith Inlet,
probably of Bella Coola origin. Wood; green,
yellow, black, blue. Length: 16 in. MacMil-
lan Purchase 1951. A4025

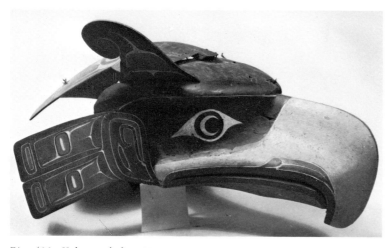

Fig. 403. Kolus mask from Kingcome Inlet.
Wood; green, white, red. Length: 22 in.
MacMillan Purchase 1960. A4500

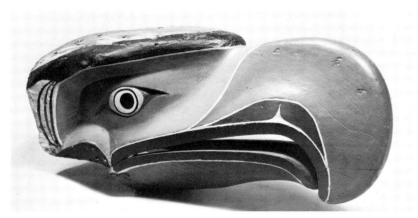

Fig. 404. Eagle mask from Kingcome Inlet.
Wood; red, gray, brown, black. Length: 22
in. MacMillan Purchase 1951. A3548

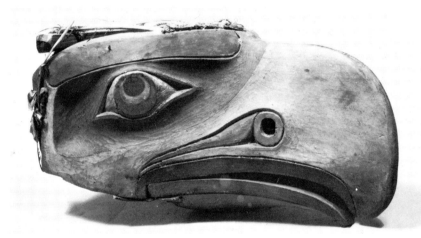

Fig. 405. Eagle mask from Kingcome Inlet.
Wood; yellow, green, red, white, black.
Length: 16 in. MacMillan Purchase 1953.
A6199

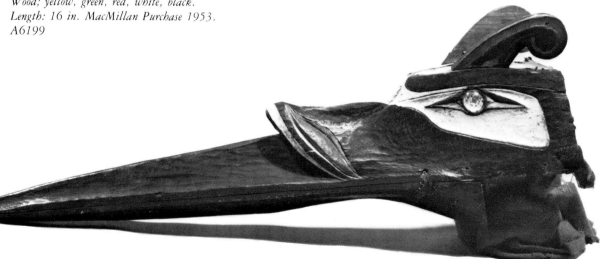

Fig. 406. Khenkho mask from Alert Bay; cf.
Boas 1908: Vol. V, Pl. XLI, Fig. 1.
Wood and woolen cloth; black, gray, red.
Length: 35 in. MacMillan Purchase 1961.
A7883

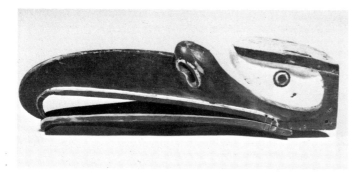

Fig. 407. *Khenkho mask from Kingcome In-
let. Wood; black, red, white, green. Length:
33 in. MacMillan Purchase 1954. A6375*

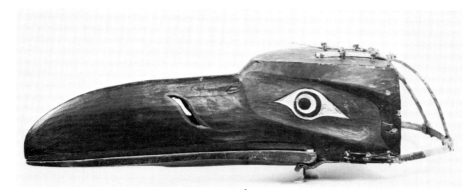

Fig. 408. *Raven mask from Village Island.
Wood; black, red, green, white. Length: 28
in. MacMillan Purchase 1952. A3784*

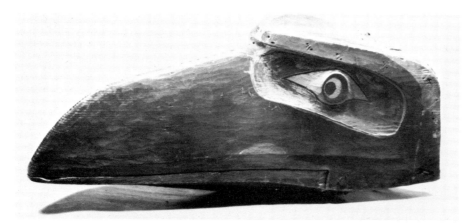

Fig. 409. *Raven mask from Bella Bella.
Wood; red, black, green, white. Length: 21
in. MacMillan Purchase 1948, Rev. G. H.
Raley Collection. A1743*

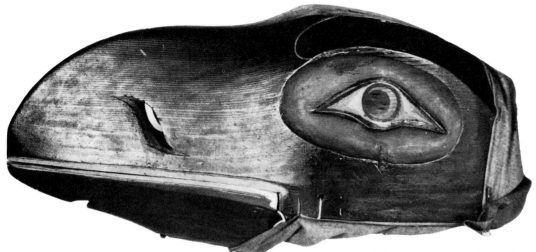

Fig. 410. Raven mask. Wood with cloth hood; black, red, green. Height: 9⅛ in. Walter and Marianne Koerner Collection 1970. A5270

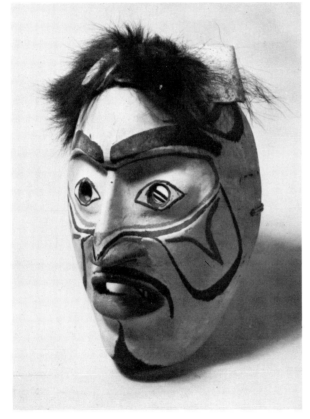

Fig. 411. Raven mask from Bella Bella. Wood and fur; black, green, red. Length: 11 in. Museum Purchase 1931. Dr. G. E. Darby Collection. A1368

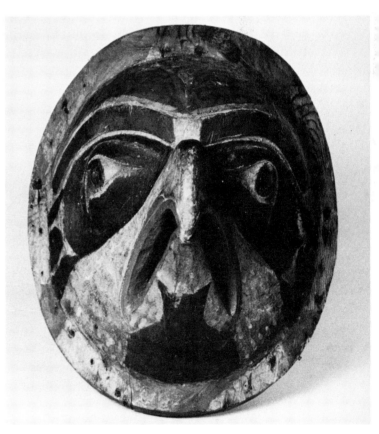

Fig. 412. Owl mask. Wood; red, green, black. Height: 11 in. Walter and Marianne Koerner Collection 1970. A5278

Insect Masks

The mosquito (Fig. 424), known as Scratcher, was one of a series of special characters who injected a comic interlude into the ceremony when they appeared. These clowns—Sneezer (see Atlakim mask in Fig. 249), Laugher (Fig. 231), and so on—entered the dance house and exerted their power upon the house officials, causing them to scratch, sneeze, sleep, or laugh. When the people laughed too merrily, the heralds became annoyed and threw the same spell onto them; then all laughed helplessly until finally the heralds relented, releasing people from the spell, and threw it back to the instigators, who then departed.

Bees and wasps had the same function, intended to be amusing in the dances: with sharp-pointed sticks in their muzzles they flitted about, stinging people by touching them with their sharp barbs. Those who were stung were paid for their "damage" by special gifts during the potlatch.

The bumblebee masks (Figs. 414-22) from Kingcome Inlet are a complete set that belonged to one family. It consisted of one large and eight smaller masks, which were worn by children. Their dance was a mimetic one, indicative of flight and hovering. Cotton cloth covered the head of the dancer.

The wasp, as represented in a photograph by Curtis, was dressed in an overall costume covered with short feathers.

Mosquitoes, gnats, and midges were said to be the flying sparks of the fire that consumed Bakbakwalanooksiwae when the ancestral hero burnt him up.

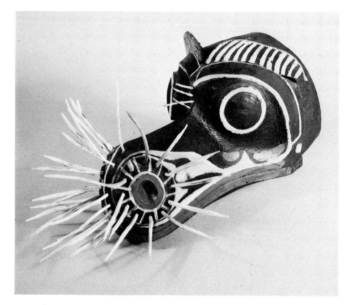

Fig. 413. Bumblebee mask from Village Island. Wood; red, white, black, green, brown. Length: 16 in. MacMillan Purchase 1953. A6336

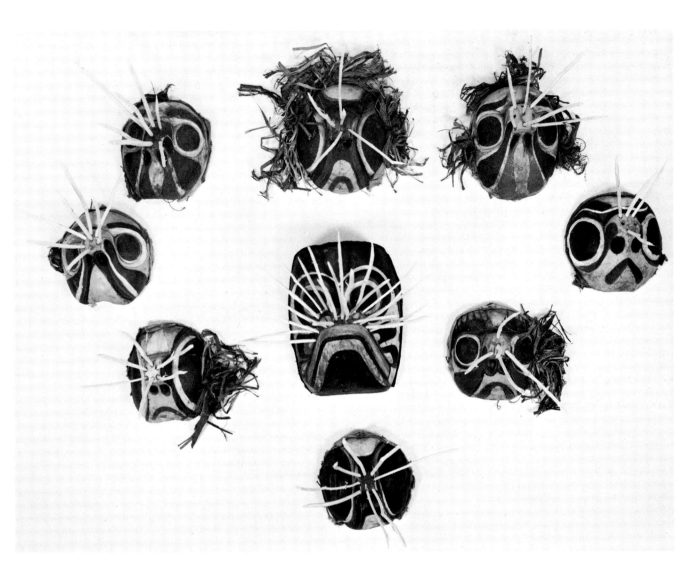

Figs. 414-22. Bumblebee masks from Kingcome Inlet, made in 1938. Wood and cedar bark. (Clockwise from top, left) 414. Black, yellow, green, brown, white. Height: 8 in. MacMillan Purchase 1962. A8245. 415. Black, yellow, red, green, white. Height: 9 in. MacMillan Purchase 1962. A8242. 416. Yellow, black, green, orange, white. Height: 9 in. MacMillan Purchase 1962. A8238. 417. Yellow, black, green, white, brown, red. Height: 9 in. MacMillan Purchase 1962. A8243. 418. Red, black, brown, yellow, green, white. Height: 7½ in. MacMillan Purchase 1962. A8241. 419. Black, white, green, brown. Height: 7½ in. MacMillan Purchase 1962. A8239. 420. Black, white, yellow, orange, brown. Height: 8 in. MacMillan Purchase 1962. A8240. 421. Yellow, black, green, red, white. Height: 8 in. MacMillan Purchase 1962. A8244. (Center) 422. Black, red, green, brown, orange. Height: 12 in. MacMillan Purchase 1962. A8237

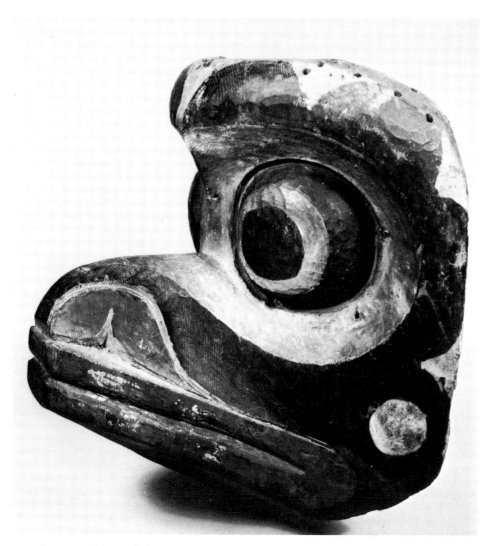

Fig. 423. Bumblebee mask from Kingcome Inlet. Wood; red,
white, black. Height: 11½ in. MacMillan Purchase 1951.
A3545

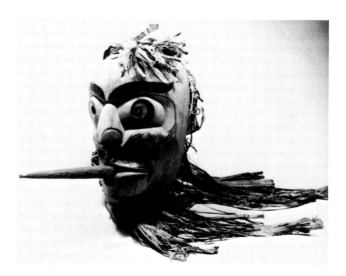

Fig. 424. Mosquito mask from Smith Inlet. Wood and cedar
bark; red, black. Height: 11 in.; length of stinger: 7½ in.
MacMillan Purchase 1953. A6213

Natural
Element
Masks

The Kwakiutl incorporated natural elements—earthquake, sun, moon, echo, and others—into their Dluwalakha and family crest dances. These were especially important among the Bella Coola, whose Sisauk dancing society was entirely made up of these beings, and the concept may have been borrowed or received by marriage from them.

Some of these masks carried on a humorous conversation with each other and with the spectators by means of squeaky whistles held in their mouths. Among these "dialogue masks" were pairs, one with a full moon and one with a half moon attached above the head, like those shown in Figure 429 and in a painting by Henry Speck (Pl. XXXB).

Echo masks were fitted with sets of wooden mouthpieces representing different characters (see Pl. XXV; Figs. 434-36). A small basket fastened at the waist carried the extra pieces. Using the dance blanket as a concealment, the dancer lowered his head and secretly fitted in a new mouthpiece. This changed the character to represent the various stages of the myth.

The headdress of the Nunalalahl, or weather dance (Figs. 430, 431), was worn in a quick, spirited, light dance that could be performed by either a man or a woman, although today it is usually danced by a woman.

The earthquake mask illustrated in Figures 432 and 433 belonged to a family along with the privilege of using a board plank that was suspended like a swing from the rafters of the house when the display was being used. At mention of the name "Earthquake," the ropes were secretly pulled in such a manner that the board slanted and tilted and those seated on it were unbalanced, to illustrate the powers embodied in the mask. This mask is noted by Helen Codere (Field notes, 1956).

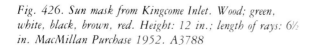

Fig. 425. Sun mask. Wood; black, red, blue. Height: 11 in. Donated by Mrs. V. H. Clucas 1960. A7035

Fig. 426. Sun mask from Kingcome Inlet. Wood; green, white, black, brown, red. Height: 12 in.; length of rays: 6½ in. MacMillan Purchase 1952. A3788

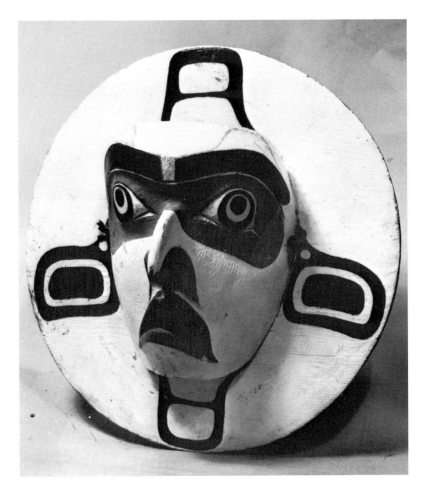

Fig. 427. Mask of raven in the sun, from Alert Bay, attributed to Willie Seaweed. Wood; white, orange, black. Diameter: 15 in. MacMillan Purchase 1953. A4511

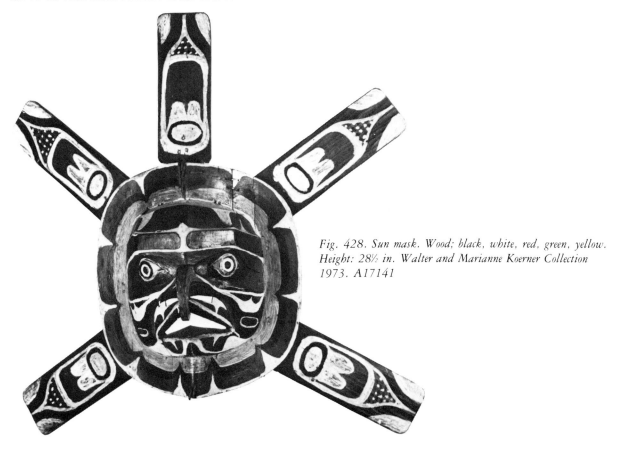

Fig. 428. Sun mask. Wood; black, white, red, green, yellow. Height: 28½ in. Walter and Marianne Koerner Collection 1973. A17141

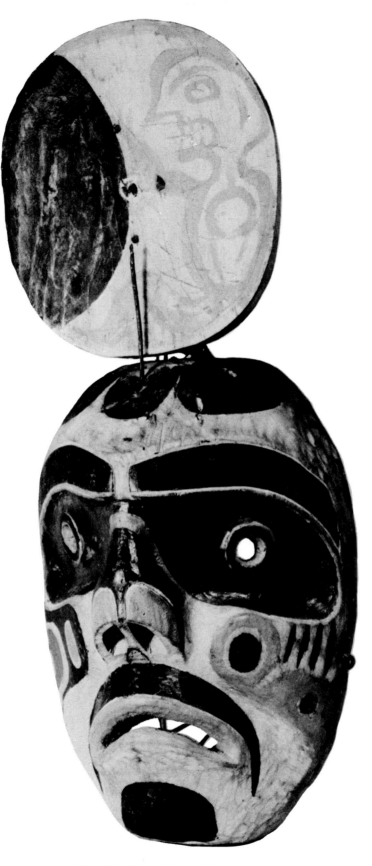

Fig. 429. Mask of human face with moon above it, 1 of a
pair from Village Island. Wood; red, black, green. Height,
including moon: 18½ in. MacMillan Purchase 1952. A3782

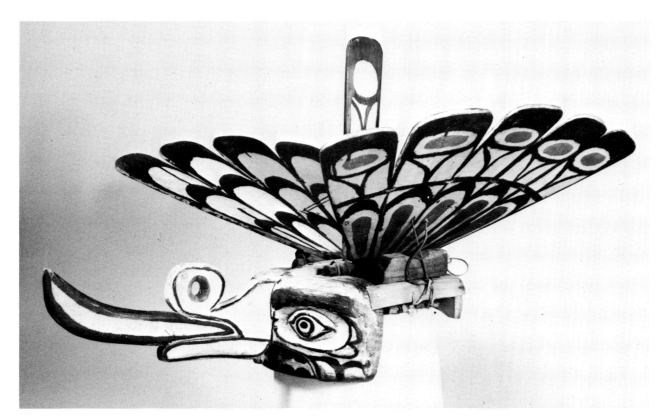

Fig. 430. Weather headdress from Kingcome Inlet. Wood;
white, black, red. Length: 21 in. MacMillan Purchase
1952. A3785

Fig. 431. Weather headdress from Kingcome Inlet. Wood and
leather; black, white, red, green. Length: 18½ in. MacMillan
Purchase 1952. A3786

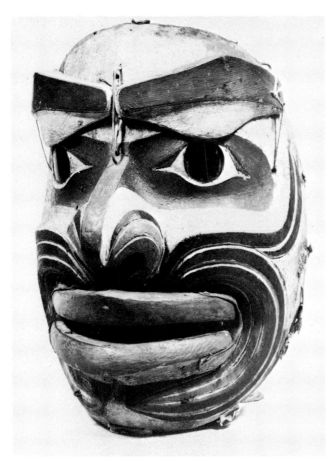
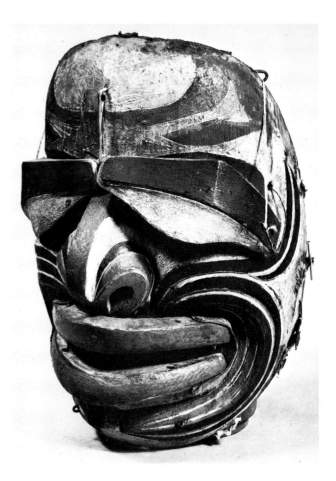

Figs. 432, 433. *Earthquake mask from Kingcome Inlet, with movable visor, shown open and closed. Wood; white, black, green, red. Height: 17 in. MacMillan Purchase 1954. A6357*

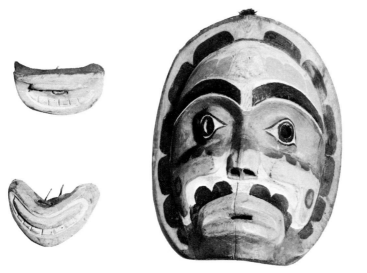

Fig. 434. *Echo mask with interchangeable mouthpieces, from Fort Rupert. Wood; black, red, white, green. Height: 13 in. Mouthpieces (counterclockwise): old man, echo, Tsonokwa, echo, bear, echo. MacMillan Purchase 1951. A3606*

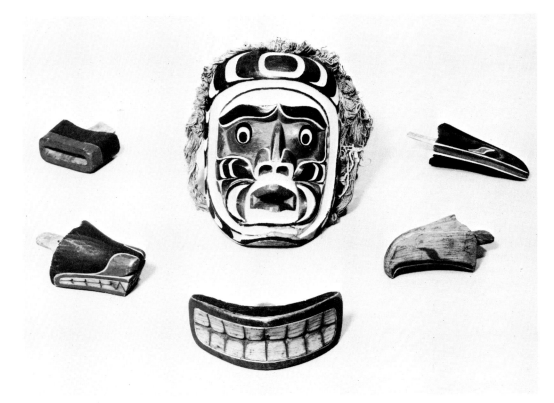

Fig. 435. Echo mask with interchangeable mouthpieces, from Blunden Harbour; made for Mrs. Charlie George, Sr., by her husband at the time of transfer of marriage privileges. Wood and hemp fiber; red, black, green, white. Height: 12 in. Mouthpieces (left to right): human, bear, human, eagle, raven. MacMillan Purchase 1953. A6243

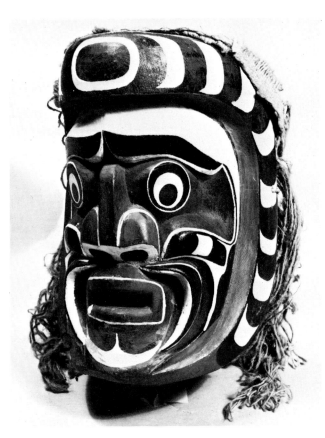

Fig. 436. Echo mask from Blunden Harbour. The interchangeable mouthpieces are identical with those shown in Fig. 434. Wood and hemp fiber; red, black, green, white. Height: 12 in. MacMillan Purchase 1953. A6244

Bookwus Masks

Bookwus, the Wild Man of the Woods, was a non-human character living in the woods. He ate ghost food and tried to persuade humans to eat it also, so that they would stay in the unreal forest world which he inhabited. He lived in an invisible house in the forest and attracted the spirits of the drowned to his home.

Bookwus was a significant supernatural character, and the masks representing him were almost always carefully carved (Figs. 437-48). The features are strong: massive, slanting eyebrow ridges; non-human eyes with round pupils; a strong, curving nose, similar to a bird's beak. Most of the Bookwus masks in the museum's collection have hollow eye sockets and cheek ridges emphasized with lines of carving that call attention to their nonhuman, almost skull-like, form. Ears, not always present, are alert and upright, like those of a feral animal. The painting is usually dark, with the primary emphasis black and gray, and white used as a third color for contrast. The mask shown in Figure 445 is a representation of Bookwus in another manner. This depiction shows a more human face, deeply lined, cavernous, almost realistic but with a haunting quality.

A companion closely associated with Bookwus was the ghost, who appeared with him at the edge of the woods, threatening and beckoning. Ghost masks (Figs. 201, 203) also emphasized skull-like characteristics, and the two sometimes overlap in appearance.

For a cockleshell carried by Bookwus, see Figure 449.

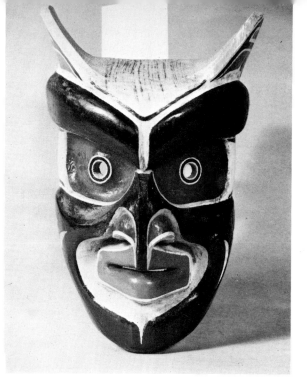

Fig. 437. Bookwus mask from Smith Inlet. Wood; white, black, green, red. Height: 13 in. MacMillan Purchase 1961. A1493

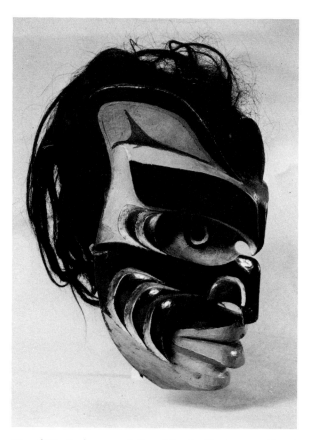

Fig. 438. Bookwus mask from Blunden Harbour, attributed to Willie Seaweed and said to have been last used in 1920. Wood and human hair; gray, red, yellow, orange, black, white. Height: 11 in. MacMillan Purchase 1953. A6242

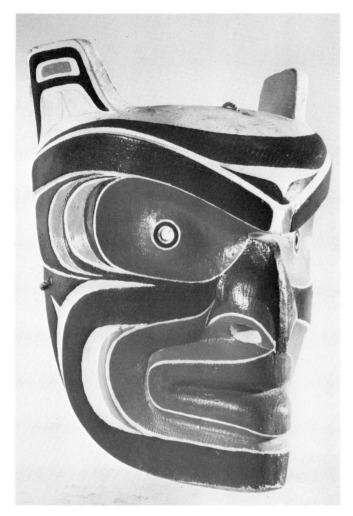

Fig. 439. Bookwus mask from Blunden Harbour. Wood; black, white, gray, red, orange. Height: 11½ in. MacMillan Purchase 1953. A3483

Fig. 440. Bookwus mask from Smith Inlet. Wood; black, red, gray, white. Height: 9 in. MacMillan Purchase 1964. A8425

Fig. 441. Bookwus mask from Smith Inlet. Wood; black, white, green, red. Height: 9 in. MacMillan Purchase 1953. A4287

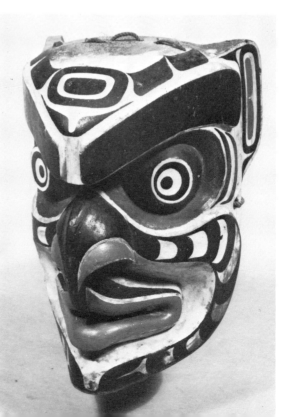

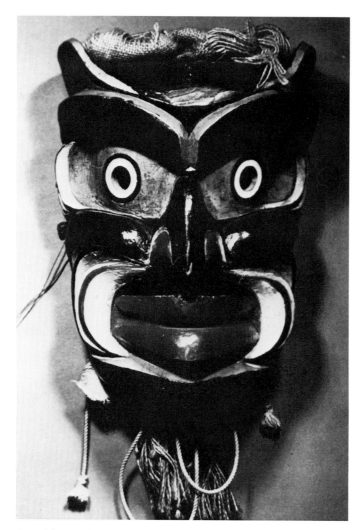

Fig. 442. Bookwus mask. Wood and burlap; black, white, red, yellow. Height: 11 in. Walter and Marianne Koerner Collection 1976. A2503

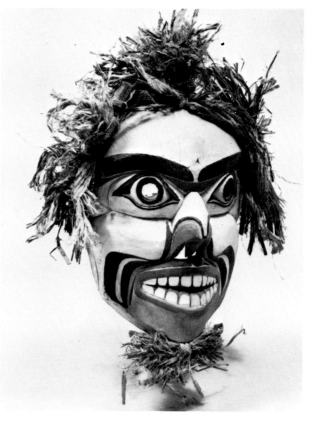

Fig. 443. Bookwus mask from Smith Inlet. Wood and cedar bark; white, red, black. Height: 10½ in. MacMillan Purchase 1953. A6220

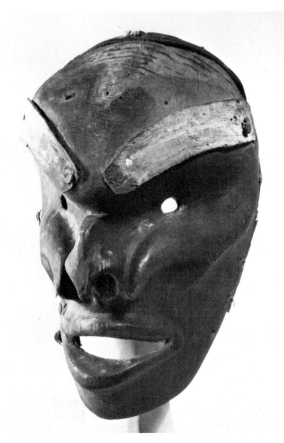

Fig. 444. *Bookwus mask from New Vancouver, very similar to one illustrated in Curtis 1915: Pl. CLIX. Wood and fur; black. Height: 10½ in. MacMillan Purchase 1954. A6371*

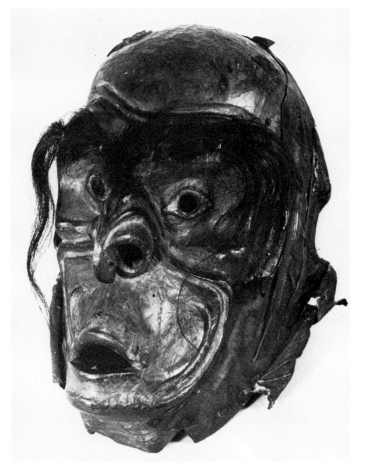

Fig. 445. *Bookwus mask. Wood, hair, and bearskin; black. Height: 11½ in. Walter and Marianne Koerner Collection 1970. A5268*

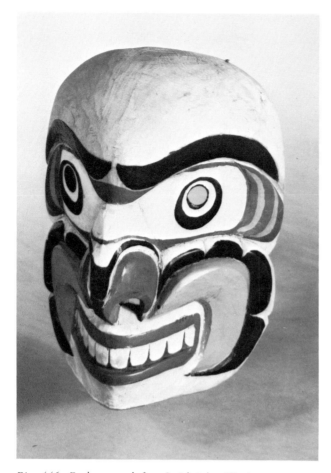

Fig. 446. Bookwus mask from Smith Inlet. Wood; orange, red, white, black. Height: 9½ in. MacMillan Purchase 1953. A6218

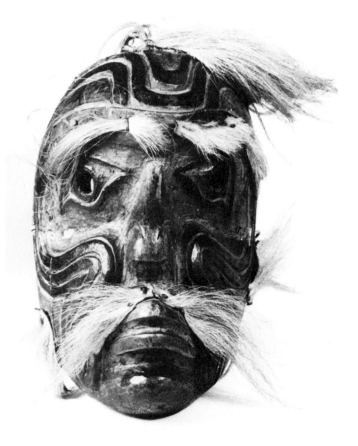

Fig. 447. Bookwus mask. Wood and hair; black, red. Height: 9¼ in. Walter and Marianne Koerner Collection 1970. A5285

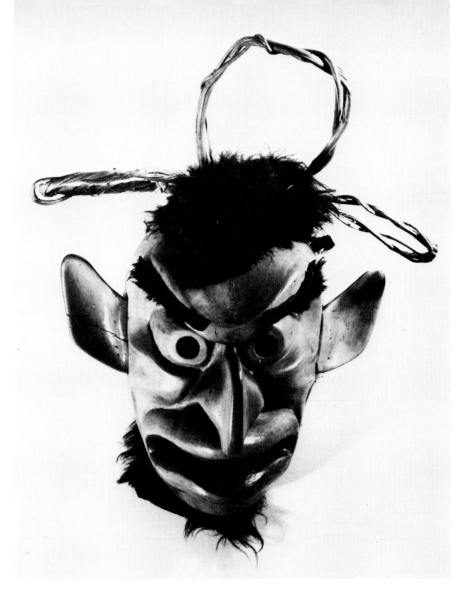

Fig. 448. Modern Bookwus mask. Wood, bear fur, and
spruce withe; orange, red, black. Height: 13½ in. Walter and
Marianne Koerner Collection 1976. A2496

Fig. 449. Cockleshell carried by Bookwus, from Alert Bay.
Wood with a black painted lining. Length: 5 in. MacMillan
Purchase 1962. A8050

Kwekwe
Masks

The Kwekwe mask originated with the Salish. Among these people it was an important crest mask worn by ritualists who inherited special powers and assisted at all life crises and social situations—birth, naming, marriage, and illness—by dancing masked, in groups of four. According to the myth, the mask's origin was from under the lake, and it was associated with earthquakes and healing.

The Kwakiutl received the Kwekwe from the Comox by gift. After having decided to wage war to get this dance and mask, they were invited in as guests of the Comox and freely given the dance and the box of associated gear.

The Salish Kwekwe masks were usually painted in three colors—red, white, and black; or red, white, and blue. Sometimes four colors were used. The Kwakiutl painted the Kwekwe in a wider range of colors—black, red, green, white, and orange (Figs. 450, 451).

Although this is a "borrowed" mask, the Kwakiutl theatrical imagination involved it in the richly varied series of interruptions and additions to their winter dance series. Boas (1897:268-71) noted that after all the Hamatsa novices had been lured from their winter dance house and had gone outside into the forest, a masked Kwekwe dancer appeared at the edge of the roof, visible through the cutout smoke hole. Then four Kwekwe dancers appeared in the house, dancing around the central fire. They sang their song (supposedly in the Comox language) and then disappeared behind the *mawihl*. This was the signal that there were to be no more events that evening, and the people went home for the night.

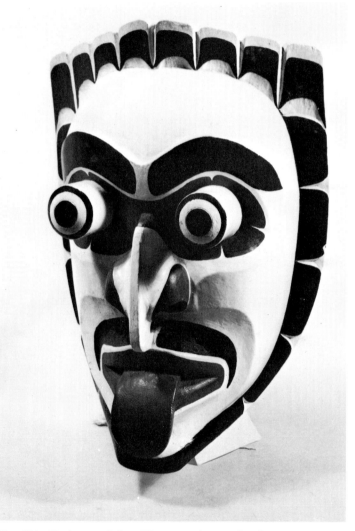

Fig. 450. Kwekwe mask from Kingcome Inlet, attributed to Willie Seaweed. Wood; white, black, red, green. Height: 13 in. MacMillan Purchase 1952. A4095

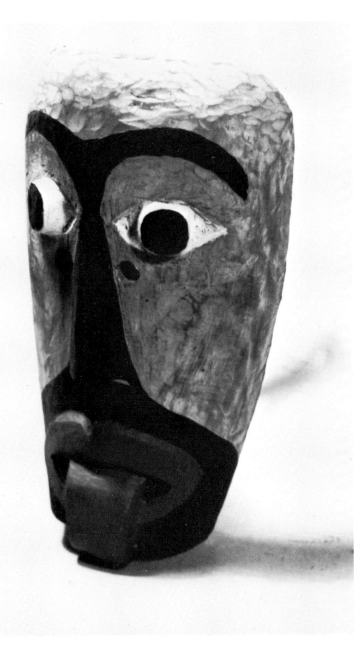

Fig. 451. Kwekwe mask from Turnour Island. Wood; natural, brown, black, red, white. Height: 13 in. MacMillan Purchase 1962. A7983

Gitakhanees Masks

The masks illustrated in Figures 452-59 were worn by Gitakhanees dancers, whose role in the Klasila is described by Holm (1972:36) as follows:

The Gyídakhanis dance is said to have been acquired as a dowry in mythical times from a Tongass Tlingit chief (Gyídakhanis is actually a Tsimshian term for the southern Tlingit). The dancers represent seven slaves and their chief or, in some versions, a family, including children. Each wears a face mask, the chief's being larger than the others. In the dance he leads the others, wrapped in his blanket and haughtily strolling around the floor. The other seven perform a lively and difficult dance with knees bent in a half-crouch, posturing in time with the rhythm of the song. They may carry in their hands white eagle tails which they use to accentuate their gestures. The dance is in imitation of the Tlingits, who do a similar dance which they consider to be derived from the Athabaskans of the interior.

These masks have human faces with various expressions and are usually identified by a plume of feathers inserted into the forehead.

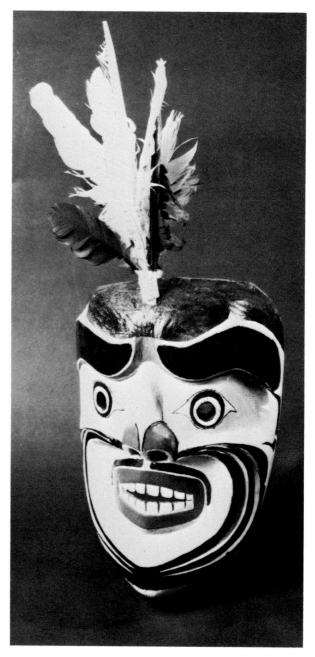

Fig. 452. Gitakhanees mask from Smith Inlet, attributed to Joe and Willie Seaweed with help from Charlie George, 1940; 1 of a set of 5 including Figs. 452-56. Wood and feathers; white, black, blue, red. Height: 11½ in. MacMillan Purchase 1964. A8428

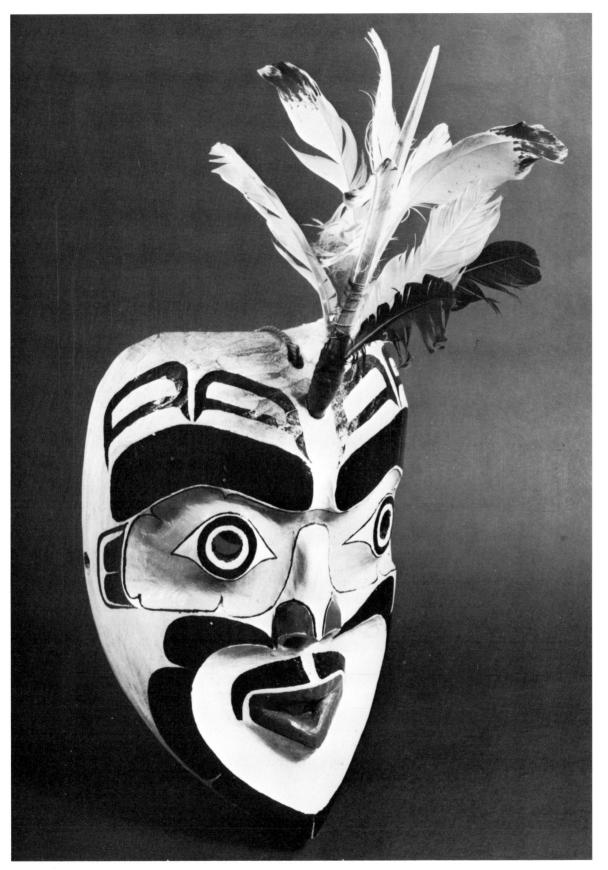

Fig. 453. *Gitakhanees mask from Smith Inlet, attributed to Joe and Willie Seaweed with help from Charlie George, 1940; 1 of a set of 5 including Figs. 452-56. Wood and feathers; white, black, blue, red. Height: 11½ in. MacMillan Purchase 1964. A8427*

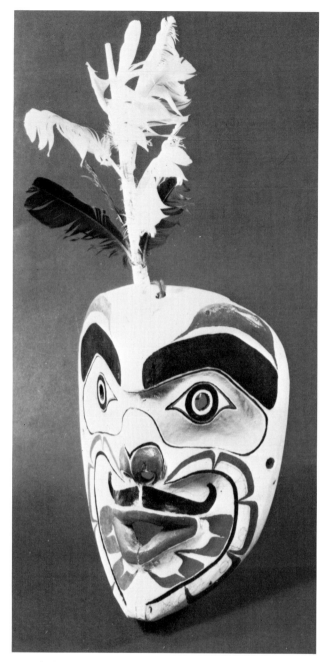

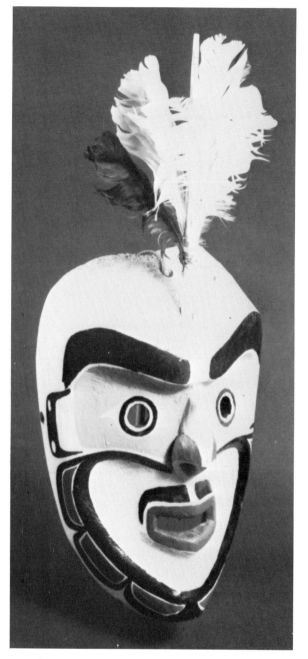

Fig. 454. *Gitakhanees mask from Smith Inlet, attributed to Joe and Willie Seaweed with help from Charlie George, 1940; 1 of a set of 5 including Figs 452-56. Wood and feathers; white, black, blue, red. Height: 12½ in. MacMillan Purchase 1964. A8429*

Fig. 455. *Gitakhanees mask from Smith Inlet, attributed to Joe and Willie Seaweed with help from Charlie George, 1940; 1 of a set of 5 including Figs. 452-56. Wood and feathers; white, black, blue, red. Height: 12 in. MacMillan Purchase 1964. A8430*

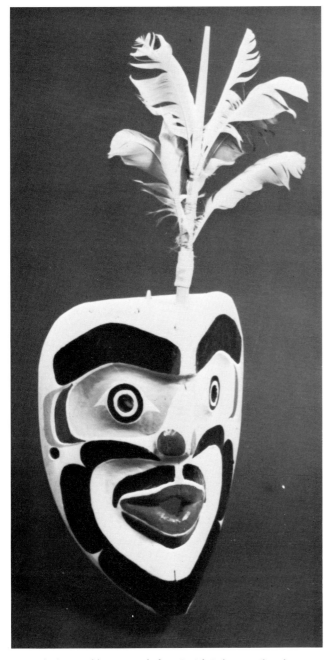

Fig. 456. *Gitakhanees mask from Smith Inlet, attributed to Joe and Willie Seaweed with help from Charlie George, 1940; 1 of a set of 5 including Figs. 452-56. Wood and feathers; white, black, blue, red. Height: 12 in. MacMillan Purchase 1964. A8431*

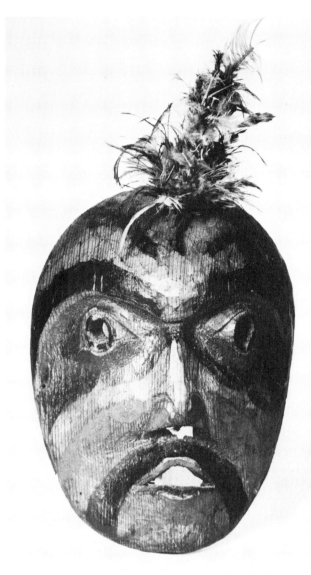

Fig. 457. Mask, probably Gitakhanees. Wood and feathers; black, red, green. Height: 10¼ in. Walter and Marianne Koerner Collection 1970. A5289

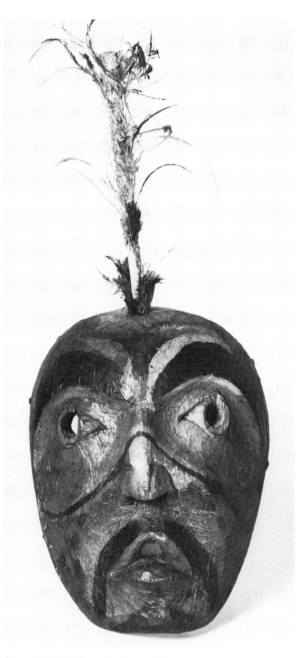

Fig. 458. Mask, probably Gitakhanees. Wood and feathers; black, red, green. Height: 10½ in. Walter and Marianne Koerner Collection 1970. A5269

Human Face Masks

This category (Figs. 459-73) is an unsatisfactory one from the standpoint of identification. Aside from the simple fact that they are human faces, they may have very little in common. The problem of identification of Kwakiutl masks, which are so tied to locality and to family privilege within one area, is an extremely difficult one. Boas noted this on his first field trip, when he tried to obtain identifications from photographs of masks he had seen in German museums. Within a region in which several tribal groups visit and communicate, there is usually somebody who can recognize the group's family masks. If the masks are not familiar, however—perhaps because they represent a privilege seldom used by a family that has many— then they may pass unnoticed.

There are, however, leads to the possible identification of some of them. The woman portrayed in Plate XXVI A is almost certainly the wife of Komokwa, and arrived with the mask of Komokwa illustrated in Plate XVIII. These two masks are quite possibly from the hand of the same very gifted carver. It is likely that Figure 463, a "ridicule" mask, which was listed in Raley's notes as being from Kyuquot, was not in fact made there although it certainly could have been obtained there. It has a strong, intense dramatic style that is lacking in the masks of that area, and it should in my opinion be placed among the northern Kwakiutl.

The face in Figure 462 represents a comic white man character in one of the small satiric skits that served as side comedies during the potlatch celebrations, as described by Boas (1897:559, 562-63). This mask has also been described by other informants as "a gambler," a character that figured in the winter dance series. Gamblers are mentioned by Samuel Barrett (Ritzenthaler and Parsons 1966: 34, 96-97, and Figs. 25-28). These entered as four masked characters, adding yet another incident to the long sequence of dramatic interruptions to the Dluwalakha series and reinforcing the Kwakiutl emphasis on the giving away of wealth. The four

masked gamblers were introduced and took their seats at the rear of the house, where they invited high-ranking guests to play at guessing which was the ace among the small bone gambling sticks concealed by the players. No matter how they guessed, the guests were lavishly repaid with gifts as high in importance as canoes.

Some of the masks in this section have been designated by various informants as "speaker masks" or "spectator masks," presumably referring to other characters in the dramatic performance, but it has proved difficult to clarify exactly what is signified by such identifications.

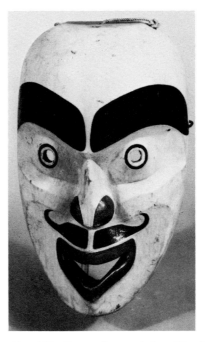

Fig. 459. Human face mask from Blunden Harbour, probably Gitakhanees. Wood; red, white, black. Height: 12 in. Museum Purchase 1953. A6238

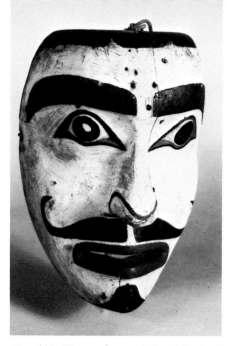

Fig. 460. *Human face mask from Blunden Harbour. Wood; white, black, red. Height: 11 in. MacMillan Purchase 1953. A4319*

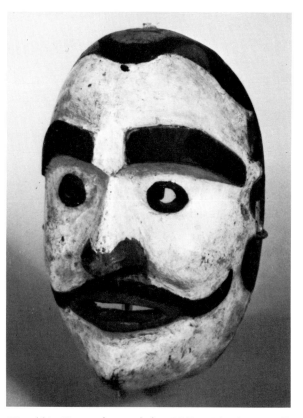

Fig. 461. *Human face mask from Village Island, originally with "a moon coming out of the forehead," now missing. Wood; white, black, red. Height: 11 in. MacMillan Purchase 1951. A6110a*

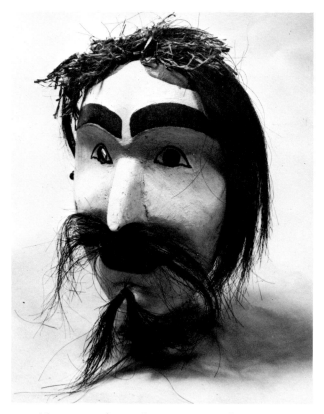

Fig. 462. *Human face mask, representing a white man. Wood, cedar bark, and horsehair; red, white, black. Height: 11 in. MacMillan Purchase 1952. A4182*

Fig. 463. Human face "ridicule" mask from Kyuquot, proba-
bly of northern Kwakiutl origin. Wood; black, red. Height:
12 in. MacMillan Purchase 1948, Rev. G. H. Raley Col-
lection. A3155.

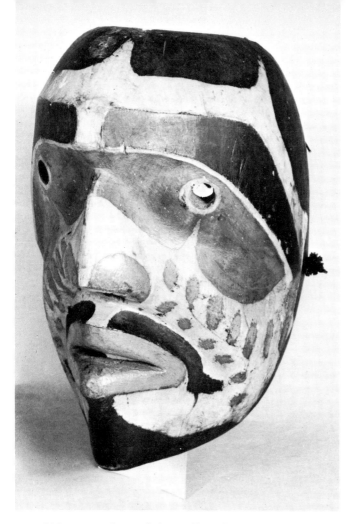

Fig. 464. *Human face mask from Bella Bella. Wood; natural, blue, black, red. Height: 11 in. Museum Purchase 1947, Dr. G. E. Darby Collection. A7943*

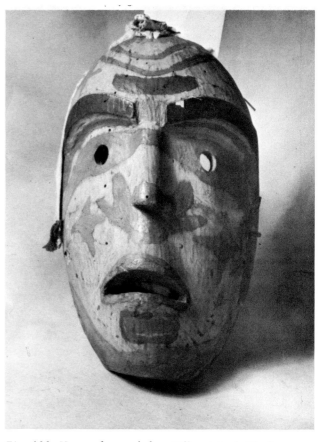

Fig. 466. *Human face mask from Village Island. Wood; orange, blue, black. Height: 10¼ in. Leon and Thea Koerner Foundation Grant 1959. A6630*

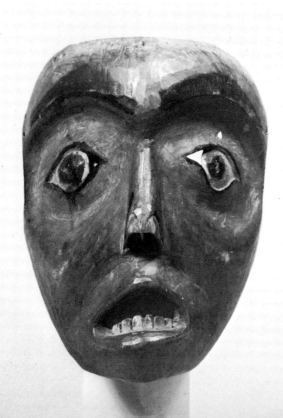

Fig. 465. *Human face mask. Wood; brown, black. Height: 8 in. Museum Purchase 1951. A4185*

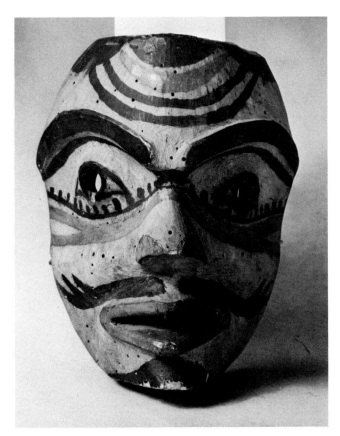

Fig. 467. *Human face mask from Village Island. Wood;
black, orange. Height: 9½ in. MacMillan Purchase 1952.
A3777*

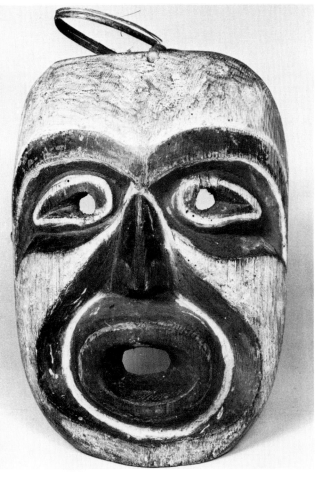

Fig. 469. *Human face mask, possibly Atlakim. Wood; red,
white, green, black. Height: 11¼ in. Walter and Marianne
Koerner Collection 1970. A5275*

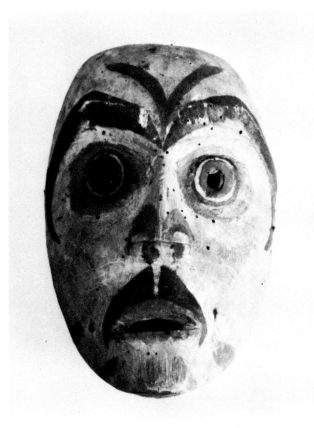

Fig. 468. *Human face mask from Village Island. Wood; red,
black. Height: 9½ in. MacMillan Purchase 1952. A4174*

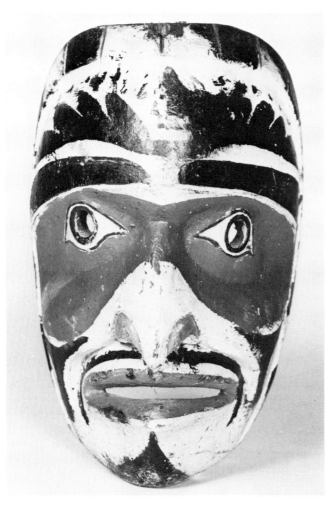

Fig. 470. Human face mask, possibly Atlakim. Wood; red, green, white, black. Height: 10½ in. Walter and Marianne Koerner Collection 1970. A5294

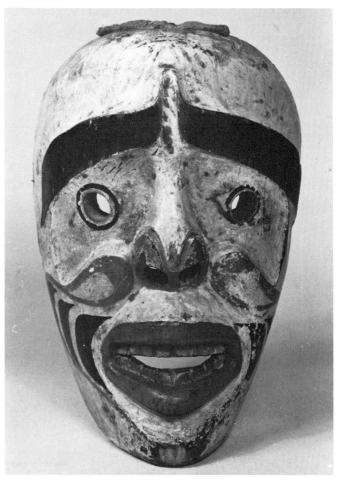

Fig. 471. Human face mask, possibly Atlakim. Wood; red, black, white. Height: 10½ in. Walter and Marianne Koerner Collection 1970. A5276

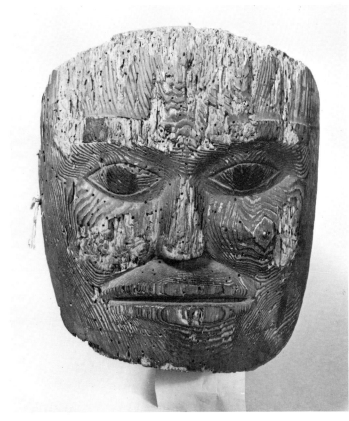

Figs. 472, 473. Twin human face masks from Bella Bella.
Unpainted wood, with traces of black paint. Height: 10 in.
MacMillan Purchase 1948; Rev. G. H. Raley Collection.
A2120a-b

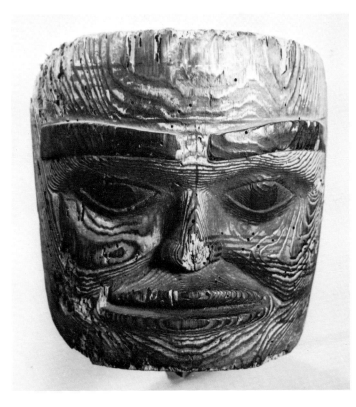

Transformation
Masks

Two kinds of masks involving multiple identity
were developed by the Northwest Coast Indians.
One of these, the mask with interchangeable
mouthpieces, allowed the dancer to change from
one character to another by inserting one of a num-
ber of distinctive mouthpieces which he kept
concealed under his blanket. This kind of mask is
illustrated by the echo masks shown in Plate XXV
and Figures 434-36.

Even more dramatic were the transformation
masks, an amazing combination of an imaginative
conception with technical ingenuity. These masks,
which reached their highest development among
the Kwakiutl, carried out the very essence of
Kwakiutl mythology by revealing the dual nature
of a mythological creature. The story of the found-
ing of the Walas gens by the mythological bird
Kolus, recounted by Curtis (1915:137), contains an
example of the kind of transformation that was
strikingly depicted through the use of these masks
(see p. 31).

Carefully carved and balanced on hinges, the
mask was intricately strung. At the climatic mo-
ment of the dance, the dancing, the music, and
the beat of the batons all changed tempo, speeding
up just before the transformation and then halting
while it occurred. When certain strings were
pulled by the dancer, the external shell of the
mask split, usually into four sections, sometimes
into two. These pieces of the external covering
continued to separate until the inner character was
revealed, suspended in their center.

Kwakiutl transformation masks are shown in
Figures 474-84. In each case the mask is shown
both as it appears when it is closed and with the
outer part pulled open to reveal the human or
other ancestor being into which the bird or animal
is transforming itself.

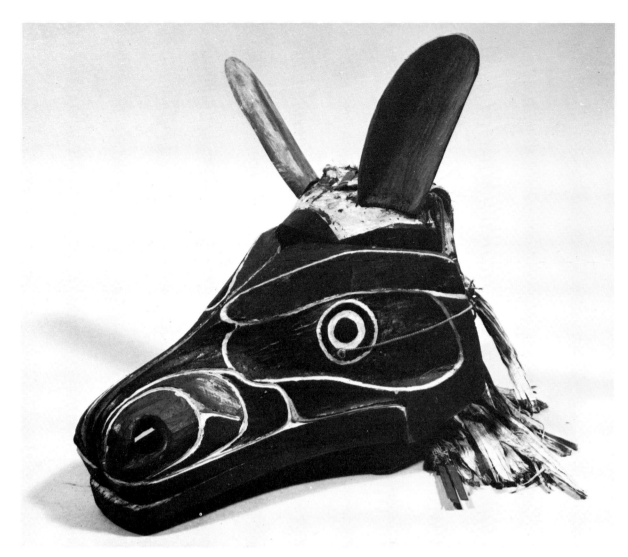

Figs. 474, 475. Transformation mask, wolf and man, from
New Vancouver; shown closed and open. Wood and cedar
bark; green, brown, red, black, white. Length: 16 in. Mac-
Millan Purchase 1954. A6373

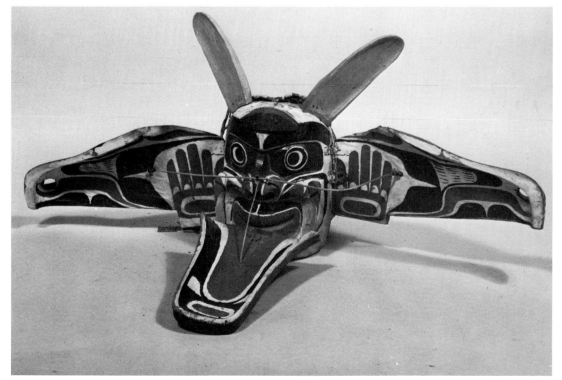

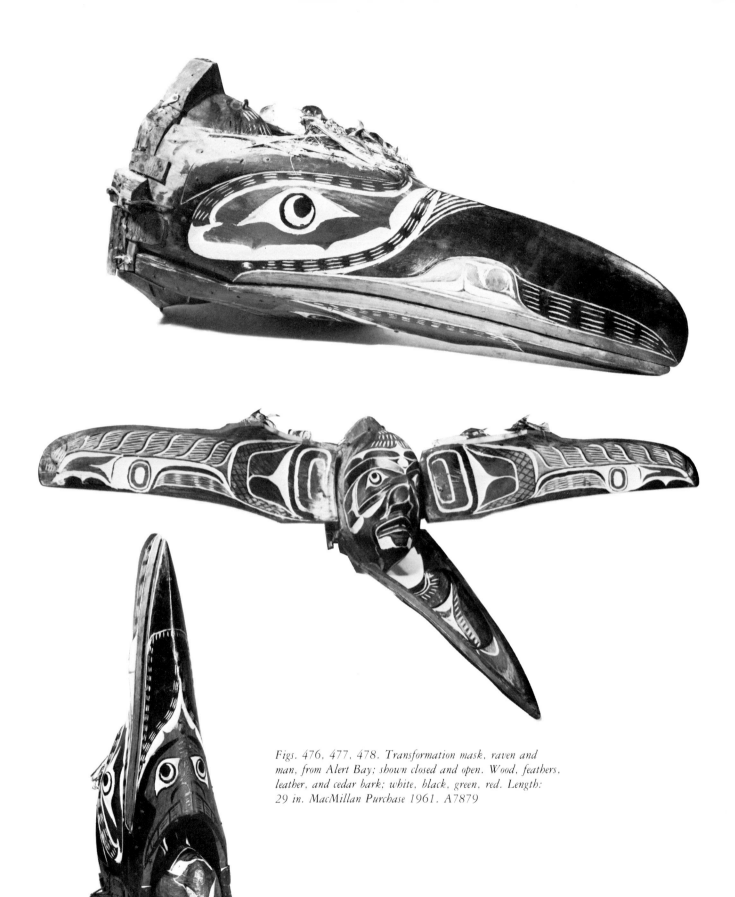

Figs. 476, 477, 478. Transformation mask, raven and man, from Alert Bay; shown closed and open. Wood, feathers, leather, and cedar bark; white, black, green, red. Length: 29 in. MacMillan Purchase 1961. A7879

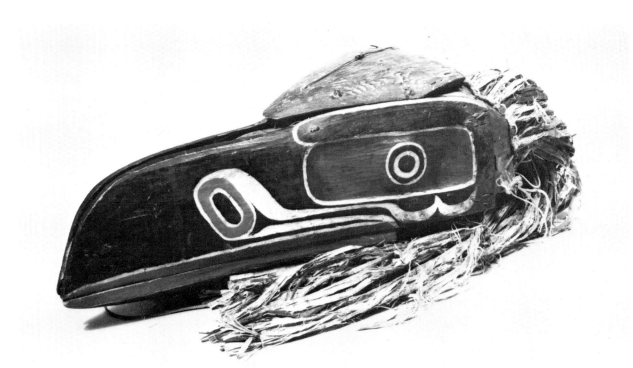

Figs. 479, 480. *Transformation mask, raven and Kolus, from Village Island; attributed to Charlie George, Sr.; shown closed and open. Wood, cedar bark, leather, and metal; black, white, red, green. Length: 23 in. MacMillan Purchase 1953. A6256*

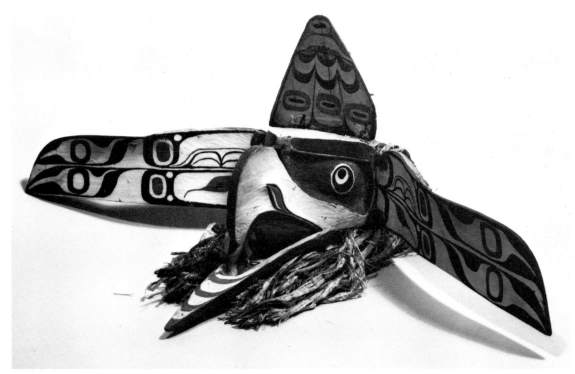

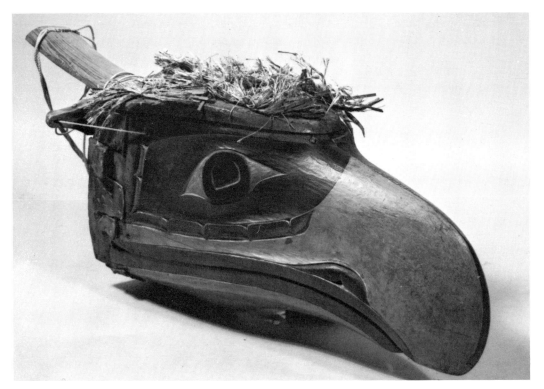

Figs. 481, 482. Transformation mask, raven and man, from
Kingcome Inlet; shown closed and open. Wood and cedar bark;
white, yellow, black, green, red. Length: 42 in. MacMillan
Purchase 1960. A4497

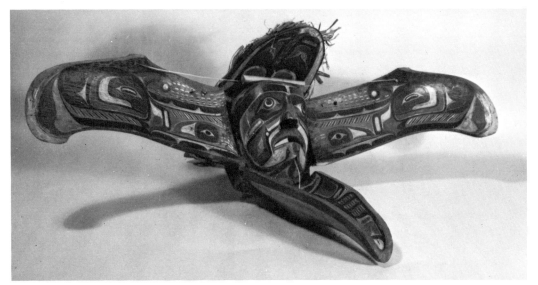

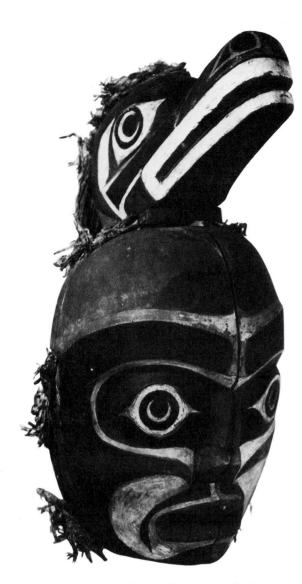

Figs. 483, 484. Transformation mask, bear and man; shown closed and open. Wood and cedar bark; black, white, red, green. Height: 22 in., closed. Walter and Marianne Koerner Collection 1973. A17140

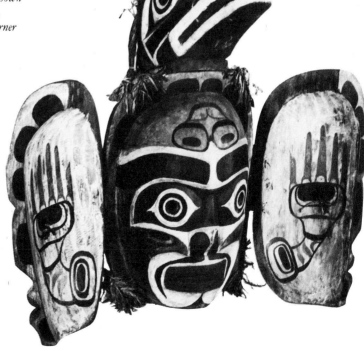

Kerfed Boxes, Dishes, and Cradles

The construction of the kerfed box, a triumph of Northwest Coast woodworking technology, is described on pages 8 and 15. Kerfed boxes are illustrated in Plate XXVII and Figures 485-93. When they were well made, they were watertight. These boxes were used as vessels for storing water or fish oil, for cooking with water and hot stones, and for storage of foodstuffs and household gear. Boxes for domestic use were attractively finished by the grooving of "fluted" patterns along the front and sides.

There were also boxes of ceremonial importance, finely carved and beautifully painted with family crests, which were used for the storage of the most valuable treasures of the family and were prized as gifts in potlatch giving. The myths contain many references to "boxes of treasure" acquired from supernatural sources. The box of whistles was of this nature, symbolizing the family crest privileges that were transferred to the bride's husband during the marriage ceremony.

Kerfed boxes were also used as drums, which were suspended from the rafters in front of the drum beater. The kerfed box in a larger size was used as a coffin.

Some of the food dishes used in ceremonial entertainment were kerfed and completed in the same fashion as the boxes. Many of these, unlike the boxes, had convexly curved sides, and they were always finely carved or painted. Of many sides, they were used for serving food or to hold the fish oil into which food was dipped. Some of the finest dishes were unpainted. These were regarded as family heirlooms and had crest names that were recited when the dishes were brought in.

Kwakiutl cradles were made of wood by the same technique as boxes (Figs. 496, 497) and, if intended to be ceremonial, were adorned with the crest carvings of the child for whom they were intended.

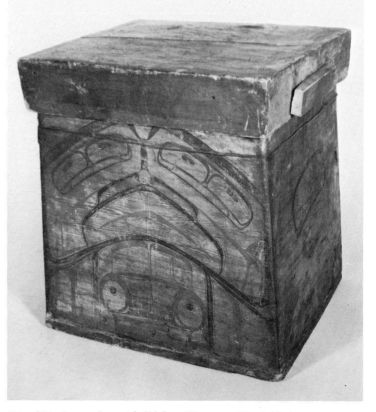

Fig. 485. Storage box with lid from Kitamaat. Wood; black, red. Height with lid: 19½ in. MacMillan Purchase 1948, Rev. G. H. Raley Collection. A4383

Fig. 486. Storage box from Kitamaat. Wood; black, red. Height: 23 in. MacMillan Purchase 1948, Rev. G. H. Raley Collection. A3576

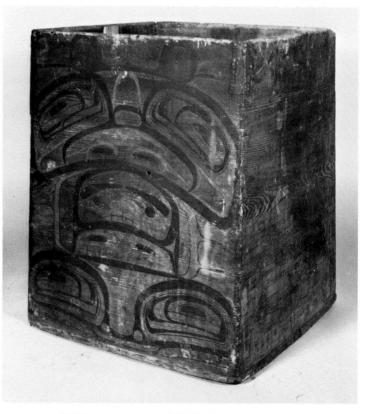

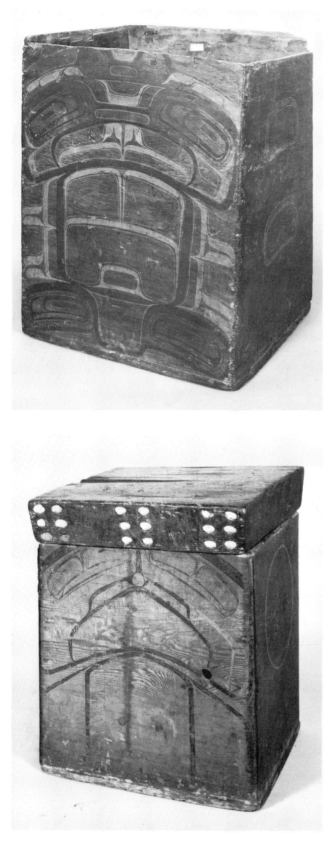

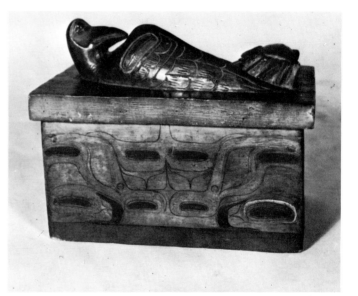

Fig. 487. Storage box from Kitamaat. Cedarwood; black, red. Height: 27 in. MacMillan Purchase 1948, Rev. G. H. Raley Collection. A3582

Fig. 488. Storage box from Kitamaat, with carved eagle and crab on lid. Wood; black, red. Length: 11¼ in. MacMillan Purchase 1948, Rev. G. H. Raley Collection. A1571

Fig. 489. Storage box with lid from Kitamaat. Wood and shells; black, red. Height with lid: 21 in. MacMillan Purchase 1948, Rev. G. H. Raley Collection. A6572

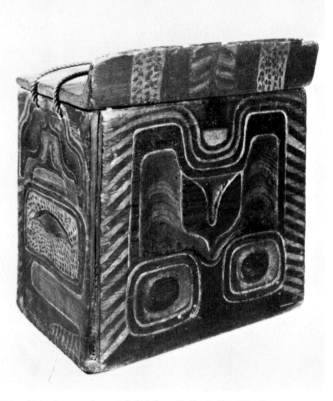

Fig. 490. Model box and lid, with rope in position, from Fort Rupert; collected in 1885. Wood with cedar bark rope; black, red. Height with lid: 7 in. MacMillan Purchase 1963. A8390

Fig. 491. Storage box with lid from Bella Bella. Wood; white, black, red. Height with lid: 13 in. MacMillan Purchase 1948, Rev. G. H. Raley Collection. A8335

Fig. 492. Storage box with lid from Blunden Harbour, with ropes in position. Unpainted cedarwood and cedar ropes. Height with lid: 20½ in. MacMillan Purchase 1953. A6321

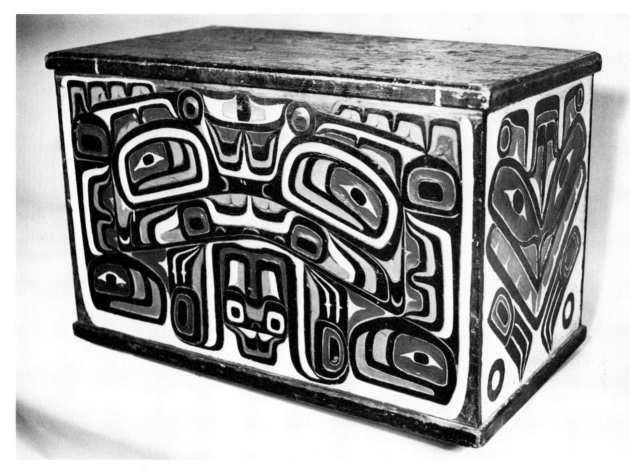

Fig. 493. Storage box with lid, probably painted by Tom Patch Wamiss of Kingcome Inlet. Wood; black, white, red, green. Height with lid: 23½ in. Walter and Marianne Koerner Collection 1970. A5307

Fig. 494. Oil dish from Bella Bella. Unpainted wood and operculum shells. Length: 6 in. Museum Purchase 1947, Dr. G. E. Darby Collection. A1944

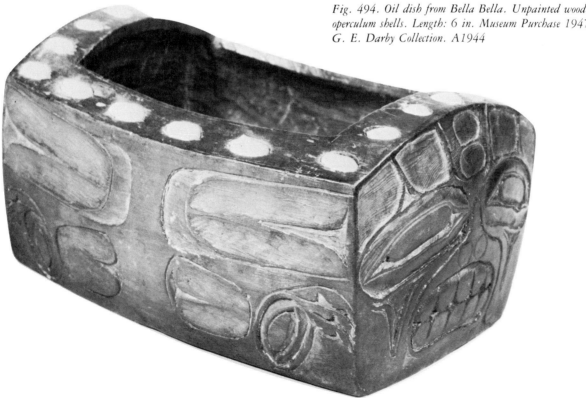

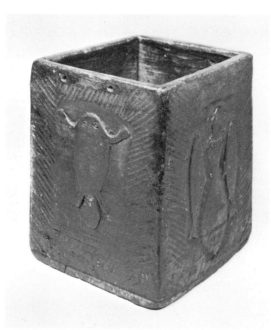

Fig. 495. Grease box from Kitlope. Unpainted wood. Height: 8½ in. MacMillan Purchase 1948, Rev. G. H. Raley Collection. A1625

Fig. 496. Cradle from Fort Rupert, collected in 1885. Wood; black, red, green. Length: 30 in. MacMillan Purchase 1963. A8388

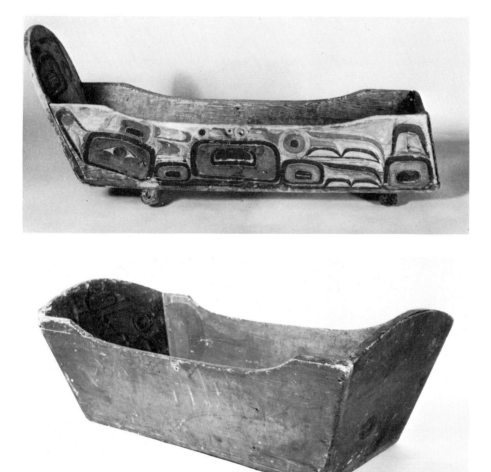

Fig. 497. Cradle from Kitamaat. Wood; black, red. Length: 39 in. MacMillan Purchase 1948, Rev. G. H. Raley Collection. A6519

Soul Catchers

These small carved objects (Figs. 498, 499) were not connected with the potlatch or the dancing societies but were part of the shaman's gear, and were used by him as an important property in his performances. A small box carved with magical symbols, the soul catcher was carried by the shaman when he pursued the soul of an ailing patient under his care. Usually at twilight, the soul, visible only to the shaman, fluttered toward the horizon. With the stopper removed from his magic box, the shaman followed it, beguiling it with incantations. When he succeeded in approaching it, he popped it into the box, replaced the stopper, and returned it to the patient, who then recovered.

Fig. 498. Soul catcher from Kitlope, a finely carved Sisiutl with a removable head on the center figure. Unpainted wood. Length: 6½ in. MacMillan Purchase 1948, Rev. G. H. Raley Collection. A1774

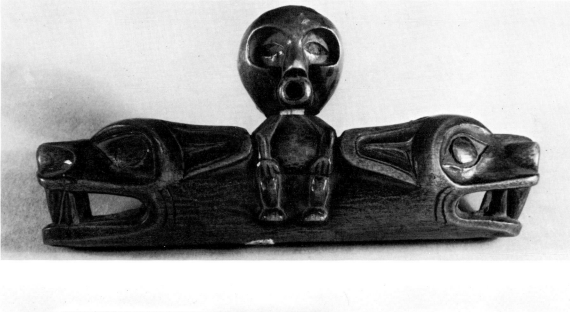

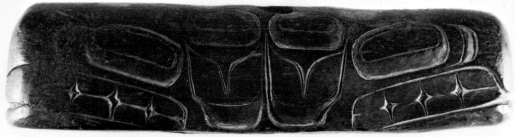

Fig. 499. Soul catcher from Kitamaat, killer whale design, purchased by Rev. Raley in 1895. Wood; black, brown. Length: 8 in. MacMillan Purchase 1948, Rev. G. H. Raley Collection. A4258

Graphic Art

Painting was traditionally used by Kwakiutl artists to enhance and embellish carvings and to decorate house fronts and other flat surfaces with crest designs. Figures representing the "spirit of the house" were painted on the large cedar plank screens used at the back of the house during the winter dances. Flat painting was also done on boxes, canoes, woven cedar bark mats, and screens.

Historically, the Kwakiutl have taken up appropriate new materials when they appeared in the market and adapted them to traditional uses (Duff 1964:58; see also p. 9, above). Hudson's Bay blankets were made into ceremonial garments with appliquéd crest designs; sheets of copper were painted and engraved with the characteristic designs; silver was beaten into flat bracelets incised with decorative and crest patterns. The muslin curtain that replaced the cedar plank screen as *mawihl* was simply cotton yard goods until it was painted with the design of the spirit of the house and brought into ceremonial prominence.

It was only a matter of time and circumstance before paper was also adapted to Kwakiutl uses. Examples of paintings and drawings by Northwest Coast artists are found in the files of museums and archives and have been printed in scholarly articles. Swanton and Boas have published papers with such illustrations, and they are found in the files of the American Museum of Natural History, the British Columbia Provincial Museum, and the University of British Columbia Museum of Anthropology, among others.

The first contemporary Kwakiutl crest paintings on paper in the museum's collection were done by Mungo Martin in 1950, during a brief period of hospitalization. Bored by inactivity, he asked for drawing materials and was given a large sketch pad and colored pencils. After the first day he became dissatisfied with the limitations of line and color, so he was provided with tempera paints, and for several weeks he found amusement and pleasure in painting Kwakiutl crest figures in black, red, and green. For these paintings he made his own brushes, trimming commercial paintbrushes to fashion the traditional tapered, slanted brush of the Northwest Coast artist. On his return to health, he identified the figures he had portrayed and dictated various anecdotes and details about them.

Of the ten paintings done at this time which are now in the museum's collection, several are shown in Plate XXIX and Figures 24, 25, 501-3. They illustrate a new convention of Kwakiutl graphic art, showing the mythological character as the central figure on a white page. The figures are outlined with a smooth and flowing black line, with red and green paint used for decoration and minor details to emphasize a key feature. The total image is firmly stated, but evinces a quality of curve and balance that give it tension on the page.

Some of Mungo's paintings depict scenes that include humans wearing masks. These he drew in positions and proportions similar to those carved on poles, with heads and bodies short and compressed, and their outlines rounded. The masks are the objects stressed in the painting, as they are in the carvings. Thus this small collection of paintings sets forth a characteristic presentation of crest beings in their simplest form, depicted in a medium that was new to an artist who was a master in the major traditional one.

It was inevitable that other graphic artists would adopt this new means of expression, especially as a commercial market developed for this art. Paintings by other Kwakiutl artists were acquired by the museum, not through systematic collection, but as various artists came to the museum. Among them was Roy Hanuse, the youngest of the group, who worked in the museum for several seasons as an apprentice in carving under Doug Cranmer (see Pl. XXXI; Figs. 504-6). Henry Speck, who painted the group of dancers wearing moon masks (Pl. XXX B), later had considerable success in selling prints and stationery decorated with crest figures. Other artists, such as Lloyd Wadhams (Plate XXX A) and Ben Dick (Figs. 507, 508), developed their own distinctive styles of graphic presentation.

It is clear that all the artists were deeply aware of the lineage animals and other characters, and had been witnesses of the dances in which they appeared. And all of them exhibit the vigor, vitality, and exuberance that are so characteristic of Kwakiutl culture, and that have kept Kwakiutl potlatches and dancing societies going long after those of other tribal groups have faltered and ceased. Today these and other Kwakiutl graphic artists, along with those of other Northwest Coast tribes, are successfully involved in a wide array of graphic expression, especially in the production of fine silkscreen prints based on, and sometimes experimentally extending, the Kwakiutl conventions of portrayal and decoration.

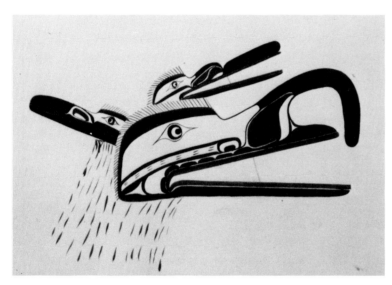

Fig. 500. Hamatsa multiple mask of Crooked Beak with Hokhokw (top) and raven (left), painting by Mungo Martin. Watercolor on paper. Width: 18½ in. Museum Purchase 1950. A9061

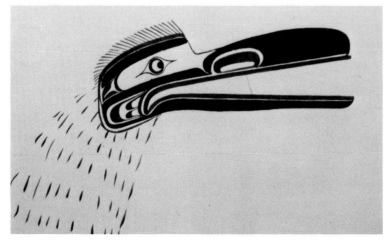

Fig. 501. Hamatsa raven mask. painting by Mungo Martin. Watercolor on paper. Width: 18 in. Museum Purchase 1950. A9059

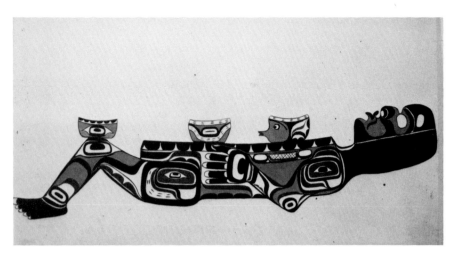

Fig. 502. Tsonokwa feast dish, painting by Mungo
Martin. Watercolor on paper. Width: 17½ in. Museum
Purchase 1950. A9055.

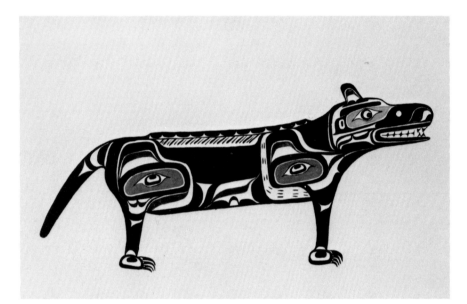

Fig. 503. Wolf feast dish, painting by Mungo Martin.
Watercolor and ink on paper. Width: 18 in. Museum
Purchase 1950. A9042

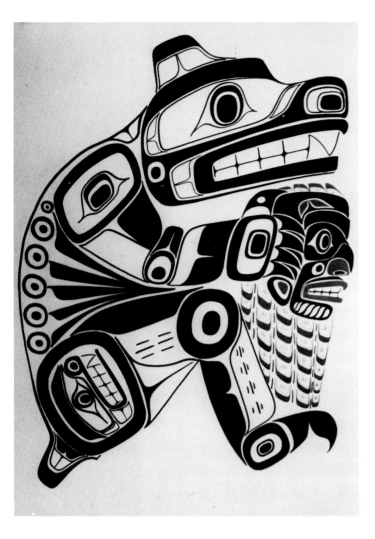

Fig. 504. Sea bear with mask of octopus, painting by Roy Hanuse of River Inlet. Watercolor and ink on cardboard. Width: 13½ in. Museum Purchase 1970. A9308

Fig. 505. Roy Hanuse at the UBC Museum painting an 11 x 16 ft. cedar screen commissioned by the British Columbia Provincial Museum, 1971

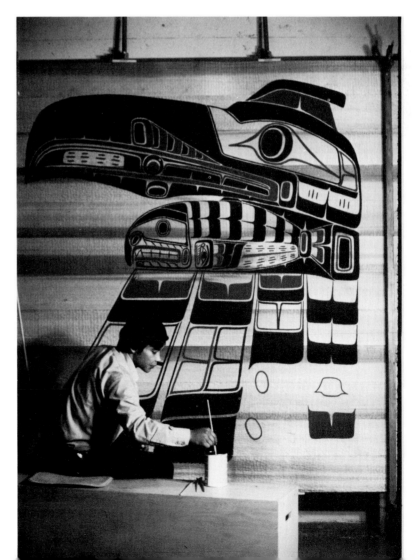

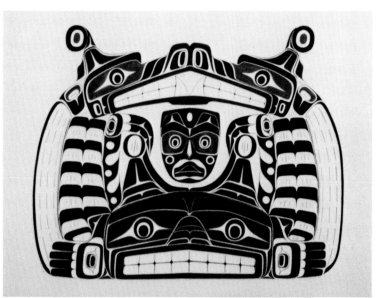

Fig. 506. "Double Headed Serpent" (Sisiutl), painting by Roy Hanuse. Watercolor on card. Width: 14 in. Museum Purchase 1970. A9306

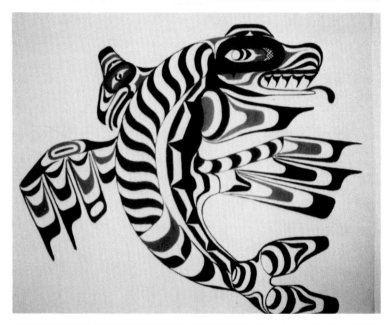

Fig. 507. "Kingcome Sea Eagle," painting by Ben Dick. Watercolor on paper. Width: 17 in. Museum Purchase 1962. A17102

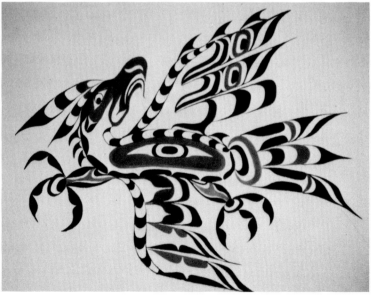

Fig. 508. Thunderbird, painting by Ben Dick. Watercolor on paper. Width: 17 in. Museum Purchase 1962. A17101

APPENDIX I

Style and Attributions

Within the many variations in traditional form, individual carvers attempted to create stylistic variation and a personal mark. Again and again, informants noted a distinctive individual style. Willie Seaweed was mentioned frequently as having strong detailed outlines as his trademark. Mungo Martin early in his career carved an oblong, rather clumsy, eye space. Such details are identifiable in carvings of both known and unknown carvers. Comments of many craftsmen and observers included: "You want to show you're smarter than anyone else, so you make it different"; "He always put something different on his carving."

It will be noted, looking at any of the categories of masks, how very different the variations are. The salient features of the Hamatsa Galokwudzuwis, for example, are a short broad beak, with some treatment of the curving, plus prominent flared nostrils. Within this basic tradition are dozens of individual styles. Informants noted particularly that the nostril form was "always" carved by Willie Seaweed in a characteristic fashion, yet examples of nostrils carved by him show not one but several forms, and unique individual manifestations of them. Nevertheless, it can be seen that an overall style characterizes all of Willie Seaweed's masks. They all show a precision, a flair, and a perfection of finish that is part of the "Willie Seaweed style."

The work of other carvers shows a similar differentiation of the single piece within the craftsman's distinctive style. It is probably this distinctive overall style that informants recognized when they looked at the masks. Feeling the need to be specific in describing the work, they chose a feature that seemed, because of some familiarity, to be "typical" carving.

It is less surprising to have some carvers clearly identified by stylistic traits than to have several serious and knowledgeable informants give conflicting identifications. It has even happened, occasionally, that a carver failed to recognize his own work from photographs of it. The presumably correct identification was made by other informants, with convincing citation of time and place. Sometimes it was recalled that several people had worked together, as in a Renaissance atelier, to produce the single carving.

It is true that a carver who was a specialist might forget a commissioned carving, for such men were in much demand and might produce many pieces in a long lifetime. Some masks were carved "between sunrise and sunset," as T. F. McIlwraith notes, and Curtis (1948:II, 54) records that two days were taken for a carver to carve many of the dance masks for a winter dance. In spite of this large output, however, most carvers did recognize their own style of carving, particularly in a mask carved for someone for a dance that had a special association, clearly remembered; the artist who failed to note one of his works would be the exception.

The most helpful Kwakiutl commentators were Mungo Martin and Dan Cranmer, both of them careful students of their own culture, anxious to pass on their knowledge and have it recorded. I have relied very heavily on identifications, interpretations, and comments from these two fine men. There were also many others seriously interested and concerned about accuracy. Their names are given in the list below.

In a few instances statements of different informants at different times and places led to conflicts of identification. Individual motives gave rise to peculiar errors. One man identified nine out of ten items as having been carved by his father, even when everyone else identified them differently. Some outstanding masks that would seem to be distinctive and easy to recognize were attributed to as many as five different carvers. In such a case the conflict in attributions is recorded in detail in the catalogue files of the museum, along with any serious remarks offered by way of identification.

Informants tended to be more in accord when placing the carvings in a time sequence. People remembered vividly the occasion for which the items had been made, and how old they themselves were at the time. This was true for both men and women of all ages. "I was at that potlatch for——— at——— when I was twelve, and I saw it then." And, of course, those who had participated as dancers were even more likely to remember how old they and their relatives had been. They also remembered clearly life crisis rites of their whole

family, such as puberty announcements and first-name potlatches for children, or the time a novice was initiated.

Not all the informants who were questioned were equally serious or well informed. Some casual informants, not always the younger ones, but perhaps less interested, made such comments as, "You can tell they are not swans. The neck is not long enough," about a set of headdresses identified by the owner as swans; or (of the Merman, Fig. 379), "This is a beaver. You can tell by his large teeth." (This particular mask was carefully identified by others and has been documented by Boas as Merman.)

Prerogatives of the Kwakiutl are very much tied to place. Most Kwakiutl informants were likely to remember the place of origin of a privilege ("from the Heiltsuk at the marriage of————with———— of————"). It was also noted that some island families tended to accumulate privileges pertaining to sea beings of one kind or another.

The close association of these ceremonial materials with vivid and meaningful events sometimes led to an extraordinarily clear recollection of details. Thus one informant noted that a certain dish was given to a specific family in 1924 at the same time as a skull that was to be worn on a neck ring as a Komunokas privilege. This concern with the importance of the details of the material culture undoubtedly helped to make the Kwakiutl culture so viable, its products almost endless, and their uses so imaginative.

Following is a list of Kwakiutl informants who assisted in identifying the various objects, with each person's village and approximate age at the time of identifying the various objects.

Mrs. Moses Alfred, Alert Bay, 72
Mrs. Agnes Cranmer, Alert Bay, 55
Dan Cranmer, Alert Bay, 62-72
James Dick, Kingcome Inlet, 66
Charlie George, Jr., Blunden Harbour, 59
Mrs. Dick Hawkins, Kingcome Inlet, 73
Tom Hunt, Fort Rupert, 60
Tom Johnson, Fort Rupert, 80
Mungo Martin, Fort Rupert, 70-80
Mrs. James Roberts, Alert Bay, 76
Bill Scow, Gilford Island, 64
Joe Seaweed, Blunden Harbour, 56
Willie Seaweed, Blunden Harbour, 93
Jim Sewid, Alert Bay, 53
Peter Smith, Turnour Island, 68
Billy Sandy Willie, Kingcome Inlet, 75
Dick Willie, Quatsino, 76

A continuing interest in material culture on the part of the Kwakiutl led them to be concerned about identifying their familiar ceremonial objects. Many of the creators of the work illustrated in this volume have been identified, but there are many others who were not named by any informant. The time span covered was at least eighty years or three long generations.

Following is a list of artists and the objects attributed to each, together with their villages and the dates of birth and death when known.

Awalaskinis: house posts (Figs. 31, 32)
Doug Cranmer, Alert Bay, 1926–: totem pole (Figs. 67-69), flying raven (Fig. 78)
Ben Dick, Alert Bay: paintings (Figs. 507, 508)
Charlie George, Sr., Nahwahto, 1889– : Hokhokw mask (Fig. 163), echo mask (Fig. 435), transformation mask (Figs. 479, 480)
Quatsino Hansen: house posts (Figs. 33-35)
Roy Hanuse, Rivers Inlet, 1943–: paintings (Pl. XXXI A and B; Figs. 504, 506), cedar screen (Fig. 505)
Dick Hawkins, Kingcome Inlet, 1896-1957; Hamatsa raven mask (Fig. 160), ceremonial skull (Fig. 199)
Jim Howard, Blunden Harbour: Hamatsa multiple mask (Fig. 171), Hamatsa head ring (Fig. 172), Crooked Beak headpiece (Fig. 174), Thunderbird mask (Fig. 400)
George Hunt: frontal pole (Fig. 48)
Mary Ebbets Hunt, Fort Rupert, 1823-1919: Chilkat cloak (Pl. IX B)
Charlie James, Alert Bay, c.1870-1938: Hamatsa multiple mask (Pl. V B); totem poles (Figs. 61, 64-66)
Jack James, Gilford Island, 1902– : Hamatsa Hokhokw mask (Pl. IV B)
Abayah Martin (Mrs. Mungo Martin), Fort Rupert, c.1890-1963: Chilkat blankets (Pl. XXXII; Fig. 295), Chilkat aprons (Figs. 296, 297)
Mungo Martin, Fort Rupert, 1879-1962: Hamatsa raven mask (Pl. IV A), paintings and drawings (Pl. XXIX A and B; Figs. 24-28, 500-3), box (Figs. 15, 16), totem poles (Figs. 57, 58, 59), sea lion (Fig. 74), Atlakim Hokhokw mask (Fig. 241), Chilkat pattern board (Fig. 294), Pugwis mask (Fig. 379)
George Nelson: house post (Pl. I; Fig. 36)
Dick Price, 1880-1936: Hamatsa multiple mask (Pl. VI B); Solatlala rattles (Figs. 146-49)
Joe Seaweed, Blunden Harbour, 1910- : Hamatsa raven mask (Fig. 159), Gitakhanees masks (Figs. 452-56)
Willie Seaweed, Blunden Harbour, 1873-1967: Hamatsa Crooked Beak masks (Pl. V A; Fig. 167), Hamatsa multiple mask (Pl. VI A); Hamatsa raven mask (Fig. 161), Hokhokw mask (Fig. 162), Noohlmahl mask (Fig. 186), Atlakim "Caller" mask (Fig. 235), Atlakim grouse

mask (Fig. 237), Tsonokwa mask (Fig. 253),
Thunderbird headdress (Fig. 321), Bookwus
mask (Fig. 438), Gitakhanees masks (Figs.
452-56)
Arthur Shaughnessy, Alert Bay, 1884-1945: sun
mask (Pl. XXIII); ceremonial curtain (Fig. 89)
Henry Speck, Turnour Island, c.1909-71: painting
(Pl. XXX B)
Lloyd Wadhams, Turnour Island, 1938– : painting
(Pl. XXX A)
Frank Walker: power boards (Figs. 220, 221)
George Walkus, Smith Inlet: Atlakim "Sneezer"
mask (Fig. 249)

Some brief biographical notes on a few Kwakiutl
artists follow. The selection reflects their connec-
tion with the museum and the collection, and of
course omits many earlier craftsmen, of whom little
was known, as well as many contemporary ones,
including some whose names appear in the list
above.

Mungo Martin

Mungo Martin, whose essential contribution to the
collection depicted in this volume has been noted
in the Preface and in the chapter on totem poles,
was born at Fort Rupert in 1879. He was the son
of Yaxnukwelas, an important person in the rank-
ing system of the Kwikwesutinux of Gilford Is-
land. His mother was Q'omiga, her English name
Sarah Finlay, daughter of a Kwakiutl woman and a
Scotsman working with the Hudson's Bay Com-
pany. Four sons were born of the marriage: Spruce
Martin; Mungo, who later took the name
Nakapenkem; and two younger brothers. Both of
the elder sons earned recognition as artists.

His father died when Mungo was a boy, and his
mother later married Charlie James, also called Ya-
kuglas. Mungo had earlier been apprenticed as a
carver to a paternal uncle, but under the direction
of Charlie James he began to be recognized as a
major craftsman. His mother had always wanted
him to be a carver, and when he was still a baby
she had held a ceremony in which his uncle said
prayers over him for power and tied two baby eye-
lashes to a brush in order to ensure this future
magically.

Among Mungo's works is a totem pole carved in
1922, collected by Barbeau in 1947, and now at
the University of British Columbia (Fig. 57). His
next commission was to design and paint the house
front of John Scow. From that time onward he was
recognized as an independent artist, whose masks,
carvings, and other productions were highly
valued.

In keeping with his role as carver, Mungo as a
young man began to take an interest in the proto-
col of the potlatch and in all aspects of traditional
Kwakiutl life. His interest continued, and in his
later years he was one of several men, along with
Tom Omhid, Willie Seaweed, and Dan Cranmer,
who met together to discuss niceties of procedure
and to plan and rehearse younger people for their
parts in any ceremony.

In 1921 the Royal Canadian Mounted Police
confiscated the goods at a potlatch being held at
Kingcome Inlet, Dan Cranmer and others were
charged, and their gifts and family heirlooms were
seized. For some decades potlatching among the
Kwakiutl continued only clandestinely, on a much
smaller scale, and away from centers where the par-
ticipants might be surprised. Many of the older
people continued to live in two worlds, valuing the
old system with its rank and order and its drama,
but forced to adjust to the Canadian economy and
its values. Mungo became a commercial fisherman
when he realized that he could no longer support
himself as an artist.

In 1950 he was invited to direct restoration of
the old totem poles at the university and later to
carve two new ones. With this new commission,
he brought to the campus his wife Abayah, and
the two of them lived on the campus. He worked
a full day, and at night, at home with Mrs. Mar-
tin, he continued to carve smaller objects and to
paint. On social evenings he used to visit with
friends on the campus and sing songs belonging to
his lineage, as well as other songs, such as those of
the Navajo and even Japanese folk songs. These he
had picked up from others who had learned them
at the St. Louis World's Fair in 1904, when many
tribal groups were gathered together, and from
Kwakiutl who had sailed to Japan on sealing
schooners.

In the Preface it was noted what an important
role Mungo Martin played in the development of
the museum and its relation to the Kwakiutl peo-
ple and in the proper documentation of family col-
lections. He continued to play this helpful and in-
terested role for some years longer, when he went
to the Provincial Museum as a carver. One of his
first great contributions there was the construction
of a large Kwakiutl house adjacent to the museum,
where a potlatch, now legal again, was held in
December 1953 to "open the house." At that time
he gave lineage names to his nephews and nieces,
and gifts and hospitality to the many guests who
came. This was an event of drama and hospitality
on a lavish scale, and for many of the younger ones
it was the first true potlatch they had seen.

With his interest in passing on his knowledge of carving and traditional life, he trained his son David, who tragically was later drowned, and his foster daughter's husband Henry Hunt, who has continued to be a fine carver. He also instructed Bill Reid, the gifted Haida carver who made the houses and Haida poles on the university campus, and Doug Cranmer, who has continued carving and teaching.

Mungo's great contribution as an outstanding Canadian was recognized by a posthumous award of the Canada Council, made by the Governor General of Canada.

He died in 1962 at the age of eighty-three, after two years of failing health. His wife Abayah died shortly thereafter.

Abayah Martin

Mungo Martin's wife Sarah (Tlakwakilayokwa), who was known as Abayah, was first married around 1910, at the age of about twenty, to David Hunt of Fort Rupert. After his death she married Mungo Martin of Fort Rupert, and for the rest of their lives they shared with each other their time, interests, rich sense of humor, and curiosity in the face of new experience.

Mrs. Martin possessed all the skills of the Kwakiutl women of her generation. She knew how to weave cedar bark clothing and baskets and how to make appliquéd button crest blankets; she was familiar with ceremonial lore and procedures; and, in addition, she could knit, embroider, and crochet, and always had some work of this kind at hand. Through her observation of Chilkat weaving, she devised a simplified form, using an upright loom about five feet high, made for her by her husband, with a crosspiece top bar (see Plate XXXII). Mungo also painted a pattern board for her to copy in her weaving. She bought thick skeins of commercial wool in black, orange, and white, but omitted the twisted cedar bark fiber core of the warp strands, an essential part of Chilkat technology.

When Abayah came to the university in 1951 with Mungo, we had the pleasure of her company in the museum during the day, and here she wove one small Chilkat blanket (Fig. 295) and two Chilkat aprons (Figs. 296 and 297). She also wove cedar bark textile cradle fittings for a baby's cradle. In her moments of leisure, she enjoyed looking through old books with plates in which she could identify places and people she once knew. It was in this way that she first saw the Edward S. Curtis photograph (Curtis 1915: Pl. 344) in which she was posed as the bride of David Hunt's younger brother Stanley, and laughed at the sight of herself

wearing a fur robe and nose ring. Abayah died in 1963, soon after the death of her husband.

Charlie James

Charlie James (Yakuglas) was probably born in Victoria about 1870. He was the son of a Kwakiutl mother and white father. When his mother died, he went to live with her people. He grew up and married at Alert Bay, supporting himself and his family by carving small items for sale to the tourists on the cruise ships going to Alaska. In addition, he was hired as a teacher of arts and crafts in the Alert Bay Indian residential school.

He was the grandfather of the carver Ellen Neel, whose recollections were published in an article by Mamie Maloney in the Vancouver *Sun,* 26 February 1966. She recalled that he most often used blocks of yellow cedar for his carvings, which were generally small and portable, and soaked the blocks in a barrel of rain water to which local herbs had been added in order to make a smooth, soft surface for carving. No one now seems to know what herbs were used. He used only a short curved knife to carve with, and he made his paints from berries, barks, and grasses. The colors are soft and rich in tone and have survived very well over time. The wood has darkened in different stages, and the carving is enhanced by an effective use of color and line.

The mythical crest characters of the Nimpkish of Alert Bay were the subjects of his carving: Thunderbirds, chiefs, killer whales, Sisiutls, bears, and coppers. His figures had a delicate balance of size and form, characterized by shallow carving and by many extraneous features, such as wings and dorsal fins, which were fitted on and glued in order to achieve variation in shape and form.

Charlie James died in 1938 at Alert Bay. His precise age was not known, but he was approximately seventy years old. Many of his pieces survive in family collections, and the influence of his style has continued in contemporary carvings made by the Alert Bay craftsmen.

Ellen Neel

Ellen Neel (Kakasolas) belonged to the Qui-qwa-sutinok tribe of Gilford Island and Kingcome Inlet. Charlie James was her grandfather, and Mungo Martin was her uncle. As a girl, she was much interested in watching her grandfather carve, and, working at his side, she used to carve the small totem poles and other items they made for sale. By the time she was fourteen she "had the spirit of

carving," her grandfather told her, and she collaborated with him on a book of designs commissioned by a Vancouver art collector.

In 1936, in her early twenties, she came to Vancouver and married Ted Neel, who acted as her assistant and manager. They had six children, all of whom, when they were old enough, helped in a family cottage industry, carving totem poles, masks, and small items, which they displayed and marketed wherever they could. In the mid-thirties and in the post-Depression years there was little interest in native art, however, and life was difficult for them. Ellen worked under great pressure to produce sufficient work and income to support her growing family. At the beginning they lived on Powell Street in a tiny shop, making whatever she could sell.

The report of a Conference on Native Indian Affairs held at Acadia Camp, University of British Columbia, 1-3 April 1948, quotes Mrs. Neel as follows:

In my family carving was a means of livelihood. My grandfather was Charlie James, the famous Yakuglas. To his stepson Mungo Martin, he taught the rudiments of his art, and we his grandchildren were brought up literally amongst his work. Totems were our daily fare. They bought our clothing and furnished our food. There was no problem of sale, since his work was eagerly sought.

Now the situation is different.

Curio dealers have so cheapened the art in their efforts to satisfy their desire for profit, that I doubt if one could find a single household where the authenticity of the work is important to them. I have striven in all my work to retain the authentic, but I find it difficult to obtain even a portion of the price necessary to do a really fine piece of work. This being so, I do not blame my contemporaries for trying to get enough for their work to live on, even though I believe they are cheapening their heritage.

Certainly a great work could be performed amongst the native people if a true appreciation of their work could be instilled into the general public.

Only when there is an adequate response to our efforts to retain the best of our art will it be possible to train the younger generation to appreciate their own cultural achievements [Hawthorn, H. 1948].

Ellen and her family sought to contribute to this interest by being willing to carve in public. In July 1948 she was given a workshop in Stanley Park, Vancouver. She was made chief carver for the Parks Board and, with her family, demonstrated carving there and at the Pacific National Exhibitions in Vancouver for several summers. In 1953 she carved a pole for the University of British Columbia which stood in front of Brock Hall, the Student Union Building, until 1973, when it was repainted and treated for weather by Doug Cranmer, and moved to the front of the new Student Union Building.

Working against the difficulties of ill health, poverty, and a limited market, Ellen Neel produced a number of carvings that have become parts of collections in Europe and North America. In 1949 she was brought to the University of British Columbia to start the restoration of the Kwakiutl poles. She spoke out vigorously against the importation of small totem poles, which sold at very low prices in local souvenir shops. Had she been living in a more sympathetic environment, with a more reasonable financial return for her efforts so that she could have taken time to develop her craft and allow her undoubted powers to develop, there would have been a commensurate gain for Kwakiutl art. As it was, her artistic skills never came to their full flowering. She died, after a lengthy illness, on 3 February 1966.

Mary Ebbets Hunt

Mary Ebbets Hunt was born in 1823 into the Tongass tribe of the Tlingit. Around 1843 she married Robert Hunt, Hudson's Bay factor at Fort Simpson, and around 1850 they came to Fort Rupert to live. She subsequently returned to her home in Alaska on a visit, and there gave birth to her twelfth child, Elizabeth. At that time, too, she reestablished contact with other weavers of Chilkat blankets and got more information which she incorporated into the blankets she wove when she returned to Fort Rupert. She wove a blanket for each of her twelve children, who passed them on in their turn.

According to family history, Mrs. Hunt learned to weave when she was placed in seclusion for her first menstrual period. She sat facing her loom while an old man stood behind her, painting a pattern board, and at the same time an old woman described to Mrs. Hunt the patterned figures being painted. At no time did she look at the patterns. At first she was unable to weave; the strands kept tangling. After four days she was able to proceed. Later, for each subsequent blanket, she had to wait for four days to elapse before she could begin weaving.

Mrs. Hunt refused to teach the Kwakiutl women at Fort Rupert her traditional skill, but four of them are known to have produced blankets. One of these is in the National Museum in Ottawa, another is in the Provincial Museum at Victoria, and two are in the Museum of Anthropology.

Mrs. Hunt died in 1919 at the age of ninety-six.

Henry Hunt

Henry Hunt came to Victoria in 1954, at the age of thirty-two, to help Mungo Martin, who was employed as a master carver at the Provincial Museum. He had been a logger and fisherman, but was sufficiently skilled in wood carving to become an assistant to Mungo.

He carved a massive canoe in the northern style and assisted Mungo in carving a number of tall totem poles. He carved a sixty-five-foot pole for Montreal's Expo '67, where it still stands, and in 1966 he won a Provincial Centennial competition for totem poles. His work has been eagerly sought, and since the death of Mungo Martin he has been one of the senior carvers of the Kwakiutl.

Henry Hunt follows Kwakiutl carving tradition, in that the carving is deep, the figures are three-dimensional, and painting is kept to a minimum, being used to embellish certain details but not as a substitution for carving. He uses traditional tools, eschewing such modern developments as the power saw, which some Kwakiutl craftsmen use in the very early stages of making the first cuts.

Doug Cranmer

Doug Cranmer is the son of Dan Cranmer (Pelnagwela Wakas) and Agnes Hunt Cranmer of the Nimpkish Band at Alert Bay. He is a craftsman of considerable training and skill, who has been a full-time professional carver for the last two decades, working in Vancouver at the University of British Columbia and in his own shop, from which he has produced a number of major commissions for museums and individuals. He is a many-faceted artist, who works with silk-screen prints as effectively as with massive carvings. In his turn, Doug Cranmer has become an important teacher, and he was a key figure in the training of the Tsimshian artists at K'san.

APPENDIX II

An Eyewitness Account of the Hamatsa Ritual

"Now from the secret room comes the sound of many whistles of different pitch, high and low, blowing notes short and long, and through all rings the hoarse, thrilling cry of hamatsa: *hap! hap! hap!* Six or eight attendants appear with their backs to the people. Their robes are fastened at the neck and tied back at the waist, so that only the back and the chest are covered, and beneath the robe each has a whistle so placed that by bending the neck he can reach it with his mouth. They keep the hamatsa hidden as long as they can, but usually he soon breaks through their line, and they run after him, trying to keep around him, and some holding him by the hemlock neck-ring as if they were restraining a wild beast. After dancing for a moment on his *yútsu* blankets he moves along stooping, sliding ahead one foot then the other. When he comes to the rear, as also when he reaches the front of the room, he always pivots on the left foot, but seldom does this elsewhere. He extends one arm, palm upward, then the other. He advances on certain lines which have been secretly marked out on the floor, and those who have been previously warned by the initiator that hamatsa will bite them sit where these lines touch the edge of the open space, so that hamatsa can easily reach them. Generally they sit out in front of the others, but with a few spectators scattered near and perhaps even in front of them, so as not to be too conspicuous. As the hamatsa dances, his attendants occasionally whisper to him the position of the next person to be bitten. It is necessary to restrict the number of those bitten, since each one must be paid. Usually a large canoe of two hundred blankets is the price, the amount depending on the rank of the bitten one. The hamatsa usually bites two or three men as soon as he comes out of the secret room.

"At the end of the first four songs, while the singers beat on the boards, the hamatsa, still stooping low, runs rapidly around the room with his arms outstretched on either side, palms downward and hands trembling slightly, as he simulates great strength. The attendants run behind, two holding his upper arms and the others grasping the hemlock neck-ring. After encircling the fire twice, he suddenly throws off the hemlock ring, wristlets, and anklets, and runs about the fire twice and still more rapidly, and finally he dashes behind the *máwihl* at the left side, while the attendants go around at the right.

"As soon as he has disappeared, the cry of *hap! hap! hap!* ceases, and the people hear the cry of the raven, *kô! kô! kô!* and the sound of raven's mandibles clapping together. Two of the singers begin to chant slowly, and there appears a man—supposedly hamatsa—wearing *kwahiwiwi hámsiwi*, the mask of *Kwáhqaqalhóhsiwi*. He faces the *máwihl*, and dances by stepping high without moving from his place. At the end of the song he leaps suddenly into the air and squats down simultaneously with the ending of the song. The singers abruptly accelerate their beating to a rapid tempo, and the raven masker goes through various motions, while squatting on the floor and holding in his hands the strings that control the beak. Thus he is unable to aid his movements with his hands, and as his performance at times amounts almost to contortions while he squats or actually sits flat on the floor with a ponderous, unwieldy mask on his head and his hands occupied with the stings, his task is not a light one. Only a very strong man can undertake it. As the singing proceeds, he leaps to his feet, the beak flies open and claps shut, and he cries *hap! hap! hap! kô! kô! kô!* to indicate that he is both hamatsa and raven. Then begins another song with the slow, measured beating, and the raven masker moves toward the door of the house, stepping high and timing his arrival at the front of the room with the end of this song, so that just after arriving there he again leaps into the air and drops to the floor as the song ends. Again the tempo becomes rapid, and the raven repeats his dance. When the next song is begun, he returns to the right, rear corner and dances. At the end of this fourth song he rushes behind the *máwihl*, and simultaneously out dashes the hamatsa from the other side, with his *hap! hap! hap! kô! kô! kô!* while the attendants pursue him. He crouches and runs rapidly round the fire four times, while the singers beat rapidly without singing. He constantly utters his cries, and his attendants hold him as before, as if to restrain him with great effort. After the fourth circuit they dash again behind the *máwihl*.

"Immediately is heard the cry, *hap, hap, hap!* *hawuwuwuwuwuwuwuwuwu!** and there is the noise of a great beak clapping shut. Then comes out another man wearing the mask of *Kalóqŭɫsuis* (*kalóqiwihámsiwi*) and performs to the same songs and in the same manner as the raven masker.

"After this masker has withdrawn, hamatsa comes again, this time with *hap! hap! hap! hô! hô! hô!* He performs just like the other two maskers. When he retires, hamatsa comes out, stark naked since throwing off the hemlock, and runs stooping around the fire four times, while the initiator rises and calls to the attendants, "Hold him down!" They leap upon him and bring him to the ground, making a great show of having to exert strength, and hamatsa acts like a wild animal. When finally they have mastered him, they hold him there, and an old hamatsa, stark naked, takes a five-foot staff and calls for an old cedar-bark blanket, which he rolls and ties to one end of the rod, like a mop. This staff is the 'tamer of the man-eater with fire.' He brings the roll close to the fire, and the singers begin to beat without singing. He swings slowly about, counter-clockwise, and when his back is to the fire the singers give a loud, abrupt stroke and he leaps into the air. He turns on around and again holds the mat near the fire. This act is repeated four times, and the last time the roll is actually put into the fire and lighted. It burns slowly, and he walks with it around the room. When he approaches hamatsa, the strokes of the batons become more violent. He waves the blazing mat four times over hamatsa and the attendants, continuing the fourth motion in a swing completely around the circle, and when his back is turned to hamatsa the singers give a loud rap and he leaps into the air. He turns on around, and repeats his motions. Every time the blazing mat is waved over him and the sparks fall on his bare back, hamatsa cries *hap! hap! hap!* The attendants crouch around him with bowed heads. When for the fourth time the old hamatsa turns away from the group, and the singers beat loudly, he throws the staff with its burning mat carelessly toward the door. Anyone who happens to be struck receives something for the damage, usually a large canoe, from the man giving the ceremony. Sometimes the initiate still wears his hemlock rings, in which case the old hamatsa tears them off and casts them into the fire.

"The initiator now calls again to the attendants to hold the hamatsa down, and a woman of high rank brings a robe, usually a bearskin and preferably that of a grizzly-bear, which she belts around the initiate's waist. Then she puts on him the red cedar-bark ornaments: the wristlets (*ts̓íts̓ihíts̓ani*) and the anklets (*ts̓íts̓ihîlts̓its̓ẽ*), consisting of four superimposed rings, the ends of the bands flowing free; the neck-ring *yóhawi*), a large, thick rope of cedar splints wrapped spirally with reddened cedar-bark cord; and the headband *yúhwu̧hi*), consisting of three rings, one above the other, each succeeding one being slightly larger and hence jutting out beyond the one below it. Then tallow is rubbed on his face, and one of the attendants crushes charcoal in his palms and powders the hamatsa's face until it is black. Another announces, 'It is finished.' The hamatsa seems now very weak. All the supernatural strength is apparently gone from him. The singers begin to sing in slow tempo, and he rises and dances quietly. Women engaged by the initiator rise in their places and perform their gesture dances. When the song ends he crouches while the attendants stand about him. Another song is begun, and hamatsa rises again and dances very quietly, while the attendants whistle less loudly. Twelve songs are repeated in this way, and each time hamatsa becomes more tranquil and the whistles more subdued. As the last song nears the end, he walks into the secret room.

"Then the speaker, for the giver of the dance, distributes miscellaneous gifts, such as canoes and guns, but not blankets, to the singers and those who have been engaged to perform in various capacities, and the people depart." (From Curtis 1915: 179-82)

* This resembles the sound made when one shivers and utters the exclamation expressive of coldness.

Glossary

This glossary contains the Kwakiutl words found in the text and captions, listed alphabetically according to the spelling used in this book. Wherever possible, each entry includes a literal translation of the term as well as a brief description of its meaning as used. Most of the words are derived from the Fort Rupert dialect of Kwakiutl. Some northern Kwakiutl words that have been borrowed by the southern tribes are also included.

ALKW. "Blood"; a chief's speaker or herald.

AMHALAYT (Tsimshian). A special type of forehead mask consisting of a wooden frontal piece attached to a crown of upright sea-lion whiskers and a trailer of ermine skins.

ATLAKIM. A generic term referring to a series of dances and their associated masks.

BAKBAKWALANOOKSIWAE. "The first one to eat man at the mouth of the river"; initiating spirit of the Hamatsa dancers.

BAKOOS. "Profane, secular"; a season; the period from March to November during which Kwakiutl social organization was based on lineage and rank.

BOOKWUS. A mythological figure, known also as the Woodman, Wild Man of the Woods.

DLOOGWALA. "Having power"; the wolf dance series of the Kwakiutl. The Nootka call this dance Klukwalla, a distortion of the Kwakiutl name.

DLOOGWI. The supernatural treasure of dancers, e.g., the Tokwit frog, used as a stage prop.

DLUWALAKHA. "Once more come down"; a word used by the northern Kwakiutl for a dancing series. The spirits who come down grant special supernatural privileges and treasures to their dancers. Used among the southern Kwakiutl for the dancing series not initiated by the violent spirits. Also called Klasila.

DUNTSIK. A Sisiutl spirit board conjured up from the ground in the Tokwit performances.

GAKHULA. "Intruder"; dancer who interrupts the Klasila.

GALOKWUDZUWIS. One of the three bird-monster guises of the Hamatsa dancer, the "Crooked Beak."

GEEKUMHL. A chief's mask; used to describe a Tsonokwa mask worn when cutting the copper.

GITAKHANEES. Tsimshian name for the Tlingit; a dance acquired by the Kwakiutl from the Tlingit.

GWISPECK. An official staff of office of the Sparrows.

HAMATSA. "Cannibal"; the name of the highest ranking Kwakiutl dancing society and its members; also used for the novice being initiated into the dance order.

HAMSHAMTSUS. "Eater on the ground"; the name of an earlier Kwakiutl dancing society and its members; also a character in the Hamatsa ritual.

HAMSPEK. Tethering pole of the cannibal dancer, against which he tested his supernatural strength.

HAYLEEKILAHL. "Embodiment of the personation of healing; the Healer"; a character in the War Spirit dance and the Hamatsa, who has the supernatural power of restoring to life.

HETLIWEY. A light forehead mask.

HOKHOKW. "Long-beaked"; one of the three bird-monster guises of the Hamatsa dancer.

HOTLULITI. "Obeyed by All"; the director of ceremonies in each winter dancing order, in its own house.

KHENKHO. A mythological bird, similar to a crane, with flaring upright nostrils and a downcurved beak.

KINKALATLALA. Bakbakwalanooksiwae's female slave, also known as Heyleegistey, who helps to tame the Hamatsa.

KLASILA. See Dluwalakha.

KOLUS. A bird creature, younger brother of Thunderbird, covered with thick white down.

KOMOKWA. "The wealthy one"; known also as King or Chief of the Sea and Protector of Seals. This mythological character is nearly always associated with wealth and coppers.

KOMUNOKAS. "Rich woman"; Bakbakwalanooksiwae's wife.

KOOSIOOT. A Bella Coola winter dancing society, corresponding to the Kwakiutl Tsetseka.

KULA. A culture hero said to have been the first to capture a whale.

KWAKWAKWALANOOKSIWAE. "The raven at the mouth of the river"; the Hamatsa raven, one of the three bird-monster guises of the Hamatsa dancer, distinguished from the clan raven.

KWEKWE. This character, who is supposed to cause earthquakes, was borrowed—complete with associated paraphernalia—from the neighboring Coast Salish Indians.

LAKHSA. Those who were initiated "in the house of Bakbakwalanooksiwae."

MAMAKA. "Thrower"; the name of a character in the War Spirit dancing society.

MATUM. The flyer, who bears the supernatural quartz crystal in the War Spirit dance.

MAWIHL. "Screen"; a ceremonial curtain or board used as a partition to form the dressing room for dancers at the rear of the house.

MITLA. In the North this is the name of a particular dancing society and its members. In the South it is a character in the War Spirit dance, portrayed by both men and women.

NANES BAKBAKWALANOOKSIWAE. The Hamatsa grizzly bear; one of the winter dancers in the Hamatsa series.

NENOLU. "Fool"; a mimic in the Atlakim series.

NOOHLMAHL. "Fool dancer"; one of a group of dancers in the Hamatsa series who act as police.

NOONSISTALAHL. "Fire Thrower"; a character in the Hamatsa series who is obsessed with fire.

NOONTLEM. In the North, a word used for a dance series; the Dog-eating society. In the South, a word used to indicate "nonsacred."

NOONTLEMGEELA. "Making foolish," or "sleight-of-hand"; a character sometimes represented by Dloogwi puppets.

NUNALALAHL. "Weather"; forehead mask.

POTLATCH (Chinook). "To give"; he Northwest Coast social institution of feasting and distributing goods to validate social claims.

PUGWÍS. Sea being, Merman.

SISAUK. A Bella Coola ceremonial season, corresponding to the Kwakiutl Dluwalakha.

SISIUTL. The fabulous double-headed serpent, an important Kwakiutl mythological character, especially important to warriors and War Spirit dancers.

SOLATLALA. The Hamatsa's attendant, traditionally a Heleega (healer).

TAKIUMI. "Holding the Upper Part"; the official in charge of the distribution of gifts at the potlatch.

TANIS (northern Kwakiutl). "Cannibal"; the northern Kwakiutl "house name" for the Hamatsa.

TCHENES. Hair ornaments.

TLAKWAKILAYOKWA. "Born to be Copper Maker Woman"; wife of Komokwa; also a high-ranking title for women.

TOKWIT (Wikeno). "To walk"; the female war spirit dancer and associated magical tricks and devices.

TSEKA. Winter ceremony, singular form.

TSETSEKA. From the Heiltsuk word for "shaman"; the winter dances which took place during the period from November to March and during which the social organization of the Kwakiutl people was based on membership in the dancing societies rather than on clan affiliations. The word implies "secret" and "sacred."

TSONOKWA. A family of giants, especially a wild woman of the woods who plays several important roles.

WALASAHAKW. A wolf dance series among the Kwakiutl.

WIKHSA. Those who were initiated but not by Bakbakwalanooksiwae.

WINALAGILIS. "Making war all over the earth"; the patron spirit of the winter dance (Tsetseka) season, initiator of all so-called "war" dancers.

YATHLA. A large ceremonial cradle used for a naming ceremony in connection with the copper.

YUKWEEWAE. A dancer's headdress with a carved frontal piece of crest design.

Bibliography

Adam, Leonhard
1949 *Primitive Art*. Rev. ed. Harmondsworth, Eng.: Penguin. (First published 1940.)

Allen, Rosemary
1956 "The Potlatch and Social Equilibrium," *Davidson Journal of Anthropology* 2:43-54.

Barbeau, Marius
1912 "The Bearing of the Heraldry of the Indians of the North-West Coast of America upon their Social Organisation," *Man* 12:83-90.
1950 *Totem Poles*. Bulletin 119, National Museum of Canada Anthropological Series. Ottawa: Cloutier.

Barnett, Homer G.
1938 "The Nature of the Potlatch," *American Anthropologist* 40:349-58.
1942 "The Southern Extent of Totem Pole Carving," *Pacific Northwest Quarterly* 33:379-89.

Boas, Franz
1890 *On the Use of Masks and Head Ornaments of the North West Coast of America*. Leiden: Internationales Archiv für Ethnographie.
1897 *The Social Organization and Secret Societies of the Kwakiutl Indians*. Report of the U.S. National Museum for 1895, Washington, D.C.
1898 *Facial Paintings of the Indians of Northern British Columbia*. Memoirs of the American Museum of Natural History, vol. 2.
1909 *The Kwakiutl of Vancouver Island*. Memoirs of the American Museum of Natural History, vol. 8.
1910 *Kwakiutl Tales*. Columbia University Contributions to Anthropology, vol. 2. New York: Columbia University Press.
1920 "The Social Organization of the Kwakiutl," *American Anthropologist* 22:111-26.
1921 *Ethnology of the Kwakiutl*. 35th Annual Report of the Bureau of American Ethnology, Washington, D.C.
1927 *Primitive Art*. Oslo: H. Aschehoug.
1935a *Kwakiutl Tales, New Series*. Columbia University Contributions to Anthropology, vol. 26. New York: Columbia University Press.
1935b *Kwakiutl Culture as Reflected in Mythology*. American Folk-lore Society Memoirs, vol. 28. New York: G. E. Stechert.

Boas, Franz, and George Hunt
1905 *Kwakiutl Texts*. Memoirs of the American Museum of Natural History, vols. 5 and 14.

Bolles, T. Dix
1892 "Chinese Relics in Alaska," *Proceedings of the U.S. National Museum* 15:221-22.

Codere, Helen
1950 *Fighting with Property: A Study of Kwakiutl Potlatching and Warfare 1792-1930*. Rev. ed., 1966. Seattle and London: University of Washington Press.
1956 "The Amiable Side of Kwakiutl Life: The Potlatch and the Play Potlatch," *American Anthropologist* 58:334-51.
1959 "The Understanding of the Kwakiutl." In *The Anthropology of Franz Boas*, ed. Walter Goldschmidt. Menasha, Wis.: American Anthropological Association.

Codere, Helen, ed.
1966 *Kwakiutl Ethnography*, by Franz Boas. Chicago: University of Chicago Press.

Coe, Ralph
1977 *Sacred Circles: Two Thousand Years of North American Indian Art*. Nelson Galley of Art—Atkins Museum of Fine Arts, distributed by the University of Washington Press.

Collins, Henry B., et al.
1973 *The Far North: 2000 Years of American Eskimo and Indian Art*. National Gallery of Art, distributed by Indiana University Press.

Curtis, Edward S.
1915 *The North American Indian*. Vol. 10 and folio.

Dall, William H.
1881 *On Masks, Labrets, and Certain Aboriginal Customs*. 3rd Annual Report of the Bureau of American Ethnology, Washington, D.C.

de Laguna, Frederica
1963 "Mungo Martin: 1879-1962" (obituary), *American Anthropologist* 65:894-96.

Dickason, Olive R.
1972 *Indian Arts in Canada*. Ottawa: Department of Indian Affairs and Northern Development.

Drucker, Philip
1939 "Rank, Wealth and Kinship in Northwest Coast Society," *American Anthropologist* 41:55-65.
1940 "Kwakiutl Dancing Societies," *University of California Anthropological Records* 2:201-30.
1948 "The Antiquity of the Northwest Coast Totem Pole," *Journal of Washington Academy of Sciences* 12:389-97.
1950 "Culture Element Distribution of North West Coast," *University of California Anthropological Records* 9:3.
1955 *Indians of the Northwest Coast*. New York: McGraw-Hill.
1965 *Cultures of the North Pacific Coast*. San Francisco: Chandler.

Duff, Wilson

1956 "Prehistoric Stone Sculpture of the Fraser River and Gulf of Georgia," *Anthropology in B.C.* 5:15-151.

1959 "Mungo Martin: Carver of the Century," *Museum News*, vol. 1, no. 1. Vancouver, B.C.: Art, Historical and Scientific Association (mimeographed).

1960 *The Killerwhale Copper: A Chief's Memorial to His Son.* Victoria, B.C.: Provincial Museum of Natural History and Anthropology.

1964 *The Indian History of British Columbia. 1: The Impact of the White Man.* Victoria, B.C.: Provincial Museum of Natural History and Anthropology.

1967 "Contexts of Northwest Coast Art." In *Arts of the Raven: Masterworks by the Northwest Coast Indian*, text by Wilson Duff, with contributory articles by Bill Holm and Bill Reid. Vancouver Art Gallery, distributed by the University of Washington Press.

1969 "La Côte Nord-Ouest"/"The North West Coast." In *Chefs-d'Oeuvre des Arts Indiens et Esquimaux du Canada/Masterpieces of Indian and Eskimo Art from Canada.* Paris: Société des Amis du Musée de l'Homme.

1975 *Images: Stone: B.C.* Seattle: University of Washington Press.

Emmons, George T.

1907 *The Chilkat Blanket.* Memoirs of the American Museum of Natural History, vol. 3.

1914 "Portraiture among the North Pacific Coast Tribes," *American Anthropologist* 16:59-67.

Feder, Norman

1969 *American Indian Art.* New York: Harry N. Abrams.

Feder, Norman, and Edward Malin

1964 *Indian Art of the Northwest Coast.* Denver: Museum of Art.

Ford, Clellan S.

1941 *Smoke from Their Fires: The Life of a Kwakiutl Chief.* Hamden, Conn.: Anchor.

Galpin. F. W.

1903 "The Whistles and Reed Instruments of the American Indians of the North-West Coast," *Proceedings of the Musical Association* (London), pp. 115-36.

Garfield, Viola E.

1955 "Making a Bird or Chief's Rattle," *Davidson Journal of Anthropology* 1:155-64.

1956 "Antecedents of Totem Pole Carving," *Proceedings of Alaskan Sciences Conference*, Washington.

Garfield, Viola, Marius Barbeau, and Paul Wingert

1951 *The Tsimshian: Their Arts and Music.* Rev. ed., *The Tsimshian Indians and Their Arts*, 1966. Seattle: University of Washington Press.

Goddard, Earl Pliny

1945 *Indians of the Northwest Coast.* 2nd ed. New York: American Museum of Natural History.

Goldman, Irving

1937 "The Kwakiutl Indians of Vancouver Island." In *Cooperation and Competition among Primitive Peoples*, ed. Margaret Mead, pp. 180-209. New York: McGraw-Hill.

1975 *The Mouth of Heaven: An Introduction to Kwakiutl Religious Thought.* New York: Wiley.

Gunther, Erna

1951 *Indians of the Northwest Coast.* Colorado Springs and Seattle: Taylor Museum and Seattle Art Museum.

1962 *Northwest Coast Indian Art.* Seattle: Century 21 Exposition.

1966 *Art in the Life of the Northwest Coast Indians.* Portland, Ore.: Portland Art Museum.

Haeberlin, H. K.

1918 "Principles of Esthetic Form in the Art of the North Pacific Coast," *American Anthropologist* 20:258-64.

Harner, Michael J.

1965 *Art of the Northwest Coast.* Berkeley: Lowie Museum of Anthropology, University of California.

Hawthorn, Audrey

1952 "Totem Pole Carver" (Mungo Martin), *The Beaver*, March, pp. 3-6.

1956 *People of the Potlatch.* Vancouver: Vancouver Art Gallery with the University of British Columbia.

1961 *Kwakiutl Art: The Paintings of Chief Henry Speck.* Vancouver: Vancouver Art Gallery.

1963 "A Living Haida Craft: Some Traditional Carving for Our Time," *The Beaver*, Summer, pp. 4-12.

1964 "Mungo Martin: Artist and Craftsman," *The Beaver*, Summer, pp. 18-23.

1967 *Art of the Kwakiutl Indians and Other Northwest Coast Tribes.* Vancouver: University of British Columbia; Seattle and London: University of Washington Press.

Hawthorn, Harry B.

1961 "The Artist in Tribal Society: The Northwest Coast." In *The Artist in Tribal Society*, ed. Marian Smith, pp. 59-70. London: Routledge & Paul.

Hawthorn, Harry B., ed.

1948 "Report of a Conference on Native Indian Affairs," April 1-3. Vancouver, B.C., Acadia Camp. Department of University Extension, University of British Columbia (mimeographed).

Holm, Bill

1961 "Carving a Kwakiutl Canoe," *The Beaver*, Summer, pp. 28-35.

1965 *Northwest Coast Indian Art.* Seattle and London: University of Washington Press.

1967 "The Northern Style—A Form Analysis." In *Arts of the Raven: Masterworks by the Northwest Coast Indian*, text by Wilson Duff, with contributory articles by Bill Holm and Bill Reid. Vancouver Art Gallery, distributed by the University of Washington Press.

1972 "Heraldic Carving Styles of the Northwest Coast." In *American Indian Art: Form and Tradition.* New York: E. P. Dutton for the Minneapolis Institute of the Arts.

1972 *Crooked Beak of Heaven: Masks and Other Ceremonial Art of the Northwest Coast.* Index of Art in the Pacific Northwest no. 3. Seattle and London: University of Washington Press.

1974 "Structure and Design." In *Boxes and Bowls: Decorated Containers by Nineteenth Century Haida, Tlingit, Bella Bella and Tsimshian Indian Artists.* Washington, D.C.: Smithsonian Institution Press.

Holm, Bill, and Bill Reid
1976 *Indian Art of the Northwest Coast: A Dialogue on Craftsmanship and Aesthetics.* Institute for the Arts, Rice University, distributed by the University of Washington Press.

Jenness, Diamond
1960 *The Indians of Canada.* 5th ed. Ottawa: Cloutier. (First published 1932).

Keithahn, Edward L.
1964 "The Origin of the Chief's Copper," *Anthropological Papers of the University of Alaska* 12:59-78.

Kew, Della, and P. E. Goddard
1974 *Indian Art and Culture.* Saanichton, B.C.: Hancock House.

Kroeber, A. L.
1923 "American Culture and the Northwest Coast," *American Anthropologist* 25:1-20.

Leechman, Douglas
1942 "Abalone Shells from Monterey," *American Anthropologist* 44:159-62.

Lévi-Strauss, Claude
1963 *Structural Anthropology.* New York: Basic Books.

1975 *La voie des masques.* 2 vols. Geneva: Editions Albert Skira.

Locher, G. W.
1932 *The Serpent in Kwakiutl Religion: A Study in Primitive Culture.* Leiden: E. O. Brill.

Lopatin, Ivar
1945 *Social Life and Religion of the Indians in Kitimat, British Columbia.* University of Southern California Social Science Series, vol. 26, no. 1.

McFeat, Thomas R., ed.
1967 *Indians of the North Pacific Coast.* Seattle and London: University of Washington Press.

McIlwraith, Thomas F.
1948 *The Bella Coola Indians.* 2 vols. Toronto: University of Toronto Press.

MacNair, Peter L.
1973-74a "Kwakiutl Winter Dances," *Artscanada,* December/January, pp. 94-114.

1973-74b "Potlatch at Alert Bay," *Artscanada,* December/January, pp. 115-118.

1973-74c "Inheritance and Innovation: Northwest Coast Artists Today," *Artscanada,* December/January, pp. 182-89.

Murdock, George Peter
1934 *Our Primitive Contemporaries.* New York: Macmillan.

Museum of Anthropology, University of British Columbia
1975a *Indian Masterpieces from the Walter and Marianne Koerner Collection.* Vancouver, B.C.: University of British Columbia Press.

1975b *Northwest Coast Indian Artifacts from the H.R. MacMillan Collections.* Vancouver, B.C.: University of British Columbia Press.

Nesbitt, James K.
1954 "Potlatch in the Park," *The Beaver.* March, pp. 8-11.

Niblack, Albert P.
1888 *The Coast Indians of Southern Alaska and Northern British Columbia.* Report of the U.S. National Museum, pp. 225-386, Washington, D.C.

Olson, Robert L.
1935 *Indians of the Northwest Coast.* Memoirs of the American Museum of Natural History, vol. 35.

1940 "The Social Organization of the Haisla of British Columbia," *University of California Anthropological Records* 2:169-200.

1950 "Black Market Prerogatives among the Northern Kwakiutl," *Publication of the Kroeber Anthropological Society* 1:78-80.

1954 "Social Life of the Owikeno Kwakiutl," *University of California Anthropological Records* 14:213-59.

1955 "Notes on the Bella Bella Kwakiutl," *University of California Anthropological Records* 14:319-48.

Read, C. H.
1891 "An Account of a Collection of Ethnographic Specimens Formed during Vancouver's Voyages," *Journal of the Anthropological Institute* 21:99-108.

Reid, William
1971 *Out of the Silence.* Photographs by Adelaide de Menil. New York: Outerbridge and Dienstfrey.

Ritzenthaler, Robert E., and Lee A. Parsons, eds.
1966 *Masks of the Northwest Coast.* Milwaukee Museum Publications in Primitive Art, no. 2.

Rohner, Ronald P., and Evelyn C. Rohner
1970 *The Kwakiutl Indians of British Columbia.* New York: Holt, Rinehart and Winston.

Rowe, John Howland
1962 *Chavin Art.* New York: Museum of Primitive Art.

Sapir, Edward
1915 "The Social Organization of the West Coast Tribes," *Proceedings and Transactions of the Royal Society of Canada* 9:355-74.

Schmertz, Mildred F.
1977 "Spaces for Anthropological Art." *Architectural Record,* May.

Smith, Marian W.
1955 "Continuity in Culture Contact: Examples from Southern British Columbia," *Man* 15:100-5.

1956 "The Cultural Development of the Northwest Coast," *Southwestern Journal of Anthropology* 12:272-94.

Spradley, James P., ed.

1969 *Guests Never Leave Hungry: The Autobiography of James Sewid, a Kwakiutl Indian.* New Haven: Yale University Press.

Swanton, John R.

1904 "The Development of the Clan System and of Secret Societies among the Northwestern Tribes." *American Anthropologist* (N.S.) 9:477-85.

1905 *The Haida of the Queen Charlotte Islands.* Memoirs of the American Museum of Natural History, vol. 5.

Stewart, Hilary

1975 *Indian Artifacts of the Northwest Coast.* Seattle: University of Washington Press.

Stott, Margaret

1966 "The Southern Kwakiutl Copper: A Study Based on the George Hunt Manuscript." Unpublished manuscript, University of British Columbia.

1975 *Bella Coola Ceremony and Art.* Canadian Ethnology Service Paper, no. 21. Ottawa: National Museum of Canada.

Stuckey-Norman, Deirdre

1974 *West Coast Indian Arts-Crafts.* Toronto: Craft Dimensions Artisanales.

Vastokas, Joan

1976 "Architecture as Cultural Expression: Arthur Erickson and the New Museum of Anthropology, University of British Columbia," *Artscanada,* October/November, pp. 1-15.

Ward, Philip R.

1976 "Preserving a Precious Heritage—the Totem Pole," *Canadian Collector,* vol. 11, no. 3, pp. 30-33.

Waterman, T. T.

1923 "Some Conundrums in Northwest Coast Art," *American Anthropologist* 25:435-51.

Index

Crane, 202. *See also* Khenko
Cranmer, Agnes Hunt, 256, 260
Cranmer, Dan (Pelnagwela Wakas), ix, 34, 159, 255, 256, 257, 260
Cranmer, Doug, 250, 256, 258
Crest figures: as major theme in art, 19, 20, 21, 26, 250. *See also individual characters and objects*
Crest pole. *See* Lineage house
Crooked Beak (Galokwudzuwis): masks of, 105, 106, 255; mentioned, 29, 45, 55, 132
Curtain: ceremonial. *See Mawihl*
Curtis, Edward S.: quoted on inheritance of myth, 31; quoted on titles of rank, 31; quoted on display of masks, 36; quoted on Tokwit dancer, 37-38; on Hamatsa ritual, 39; on theatrical illusion, 39, 40; on dancing societies, 43; describes feast, 43-44; on Hamatsa cannibalism, 45; mentioned, x, 49, 56, 159, 208, 238, 255, 258

Daggers: ceremonial. *See* Wedges: ceremonial
Dancing and dancers, 3, 39, 40, 55, 208; in winter ceremonies, 29, 36-38, 45-46, 47, 48, 105, 112, 143; Hamatsa, 29, 37, 45-46, 105, 112, 261; ghost, 29, 47; Atlakim, 29, 48; war spirit, 37, 47; Dluwalakha, 49; and *mawihl.* 87; Kwekwe, 224. *See also* Inheritance; Musical instruments; Property and privileges
Dancing societies, 37, 38, 43-44, 47, 49, 94
Darby, Dr. G. H., viii
Deer: myth and masks of, 194
Dick, Ben, 250, 256
Dick, James, 256
Dishes. *See* Feast dishes
Diver (merganser), 202
Dloogwala dance, 194
Dloogwi (supernatural treasure), 43, 49, 89
Dluwalakha: dancers, 43; defined and described, 49-51; and Komokwa, 185; dances and masks, 211, 231; mentioned, 44. *See also* Klasila; Noontlem
Dog-eating society. *See* Noontlem
Drucker, Philip: on dancing societies, 43; on Hamatsa cannibalism, 45; quoted on *dloogwi.* 89; mentioned, 36
Drums, 94; kerfed boxes as, 244
Duff, Wilson, viii, x; on identification, 30
Duntsik (power board), 29, 47, 124

Eagle, 27; feast dishes, 21; as depicted, 27; masks of, 51, 118, 202; costume of, 202
Eagle-down, 38, 165, 202
Earthquake: masks of, 211; and Kwekwe, 224
Echo, 27; masks of, 27, 49, 211, 238
Emmons, George T., 80
Erickson, Arthur, ix
Ermine, 157, 165

Feast dishes, 33, 44, 56, 124, 178, 244
Feasts, 33, 34, 38, 178; described by Curtis, 43-44
Fish, 3; as depicted, 28, 190; oil, 178, 244; masks of, 190
Food. *See* Feasts
Fools. *See* Buffoons; Noohlmahl
Forest beings, 27, 71-72. *See also individual characters*
Formline, 19, 22
Fort Rupert, vii, 32, 43, 45, 159
Frog: myth and masks of, 28, 194
Frontal pole. *See* Lineage house

Gakhula (Intruder), 49; masks of, 104
Galokwudzuwis. *See* Crooked Beak
Gamblers' masks, 231
Geekumhl. *See* Tsonokwa
George, Charlie, Jr., 256
George, Charlie, Sr., 106, 256
Ghost dancers, 29, 47, 120, 218
Gitakhanees: masks and dance of, 226
Graphic art, 250-51
Grave effigies, 50
Grouse: masks of, 132, 202
Gwispeck. See Staffs: ceremonial

Haida: style of carving, 19; shamans' society, 44; and totem pole, 70; headdresses, 165; bracelets, 173; and tattooing, 173; mentioned, 3, 31, 33, 35, 45, 80, 258
Hairpins, 173
Haisla, 45
Halibut, 178; supernatural, 28
Haliotis (abalone) shell, 9, 157, 165, 173
Hamatsa: bird-monster masks, 29, 105, 106, 111, 202; ritual, 32, 36-37, 39, 42, 43-44, 45-46, 105, 112, 116, 120, 261-62; grizzly bear, 43, 45, 116; and cannibalism, 45; bird-monsters, 45, 46, 55; whistles, 45, 94; rattles, 95, 120; associated with skulls, 105, 120; headdresses, 112; and Kwekwe, 224; mentioned, 39, 47, 118, 132. *See also* Cedar bark: in Hamatsa ritual; Head and neck rings: Hamatsa
Hamatsa raven. *See* Raven, Hamatsa
Hamber, Mr. and Mrs. Eric, vii
Hamshamtsus, 45

Hamspek, 46
Hansen, Quatsino, 256
Hanuse, Roy, 250, 256
Harpoons: ceremonial, 152
Hats, 3, 71
Hawk, 27, 202
Hawkins, Dick, 105, 256
Hawkins, Mrs. Dick, 256
Hawthorn, Harry, vii
Hayleekilahl, 47
Head and neck rings, 71; Hamatsa, 39, 46, 112, 120; non-Hamatsa, 47, 120, 157
Headdresses: Hamatsa, 29, 112; Sisiutl, 47, 124; chiefs', 165; helmet, 170
Healer dancer. *See* Hayleekilahl
Heiltsuk, 32, 45
Helmet headdresses, 170
Hemlock, 6; ceremonial use of branches, 29, 39, 45, 47, 48
Heron, 27, 202; headdress, 170
Hetliwey, 112
Hokhokw: dancers, 43; masks of, 105, 106; mentioned, 29, 45, 55, 72, 132
Holm, Bill, x, 95; on conventions in carving, 22; quoted on Dluwalakha dance, 49; on identifications, 70-71; quoted on Gitakhanees dance, 226
Hotluliti, 41
House. *See* Lineage house
House posts. *See* Lineage house
Howard, Jim, 256
Hudson's Bay Co., 33, 34, 257; blankets, *see* Blankets
Human face masks, 231
Hunt, David, 258
Hunt, George, 143, 159, 256
Hunt, Henry, 258; biography of, 260; carving style of, 260
Hunt, Mary Ebbets, 159, 256; biography of, 259
Hunt, Robert, 159, 259
Hunt, Tom, 106, 256

Iconography, 19-20, 26-30, 32
Identification, viii-ix, 30; problems of, 30, 71, 231. *See also* Attributions
Illusion, 39, 40, 45, 47, 80. *See also Dloogwi;* Echo: masks of; Transformation masks
Informants, viii, ix, 29, 56, 255; listed, 256
Inheritance, 3, 31-32, 41-42, 70. *See also* Property and privileges
Initiation ceremonies: in Tsetseka season, 36-38, mentioned, 32; Hamatsa, 36-37, 39, 45-46, 261-62, mentioned, 106, 112; Dluwalakha, 49
Insects: masks of, 208
Intruder. *See* Gakhula

271